ENCHANTMENT

On Charisma and the Sublime
in the Arts of the West

C. Stephen Jaeger

PENN

UNIVERSITY OF PENNSYLVANIA PRESS

PHILADELPHIA

A volume in the Haney Foundation Series, established in 1961
with the generous support of Dr. John Louis Haney.

Published by
University of Pennsylvania Press
Philadelphia, Pennsylvania 19104-4112
www.upenn.edu/pennpress

Printed in the United States of America
on acid-free paper
10 9 8 7 6 5 4 3 2 1

Library of Congress Cataloging-in-Publication Data
Jaeger, C. Stephen.
Enchantment : on charisma and the sublime in the arts of the
West / C. Stephen Jaeger.—1st ed.
p. cm.— (Haney Foundation series)
Includes bibliographical references and index.
ISBN 978-0-8122-4329-1 (hardcover : alk. paper)
1. Arts—History and criticism. 2. Charisma (Personality trait) in
literature. 3. Charisma (Personality trait) in mass media.
4. Sublime, The, in art. 5. Sublime, The, in literature. I. Title.
II. Series: Haney Foundation series.
NX620.J34 2012
700.1—dc23
2011030835

This book is dedicated to
Hannah and Zoe Jaeger

"O Shahrazad, that was a noble and admirable story! O wise and subtle one, you have taught me many lessons . . . I have listened to you for a thousand nights and one night, and how my soul is changed and joyful, it beats with an appetite for life."

—King Shahryar to his wife, Shahrazad, as she finishes the last story of the *Thousand and One Nights*

Utilitarian economists, skeletons of schoolmasters, Commissioners of Fact, genteel and used-up infidels, gabblers of many little dog-eared creeds, the poor you will have always with you. Cultivate in them, while there is yet time, the utmost graces of the fancies and affections to adorn their lives so much in need of ornament; or, in the day of your triumph, when romance is utterly driven out of their souls, and they and a bare existence stand face to face, Reality will take a wolfish turn, and make an end of you!

. . . The dreams of childhood—its airy fables; its graceful, beautiful, humane, impossible adornments of the world beyond: so good to be believed in once, so good to be remembered when outgrown, for then the least among them rises to the stature of a great Charity in the heart, suffering little children to come into the midst of it.

—Charles Dickens, *Hard Times*

CONTENTS

INTRODUCTION

The book on my desk, in the Loeb Classical Library series, puts together three works: Aristotle's *Poetics*, Longinus's *On the Sublime*, and Demetrius's *On Style*. The first two have a claim to a greater influence on theory of representation in the West than any others before or since. We might say, what Aristotle and Plato are for philosophy, Aristotle and Longinus are for aesthetic thought, two opposed poles, from which theory of representation evolves.

The empiricist Aristotle described genres, aspects of style, and structure, and he gave the term "mimesis" as lengthy an explanation as it would receive in antiquity—without clarifying it, at least for modern readers. Later commentators could take up "imitation," extend it to "imitation of nature," or "imitation of reality" or "re-presentation of reality," and so make realism the anchor of representation, holding the things tethered to it at varying lengths and radii, but always returning to that which held it in water however shallow, deep, or unfathomable.

"Better Than Our Normal Level"

Aristotle explained *mimesis* as "the imitation of a human action" and laid out three modes of it: "Mimetic artists . . . can represent people better than our normal level, worse than it, or much the same."[1] It would be hard to combine the brilliant and the banal as seamlessly as this passage. Aristotle recognized that Homer and Sophocles depicted elevated characters, and he mentioned the exemplary as a mode above reality. (He distinguished between an artfully painted object and reality by the degree to which the picture could collect and unite excellent forms, which in reality never come together in one person or one object—*Politics* 3.6.5.1281b.) But he had next to no interest in defining these modes in any detail. "Our normal level" is

a shaky criterion on which to base centuries of literary debate. But the study of mimesis has tended to posit something like "our normal level" and take "reality" as its instantiation. Aristotle thought that the pleasure gotten from mimesis consisted in learning, investigating causes, drawing conclusions, recognizing form, reasoning out what each thing represents. Given this scientific-intellectualist rationalism applied to poetry, he can contribute little to understanding what I will call "charismatic art."[2]

If the treatise *On the Sublime* (*Peri hypsous*) had had anything like the reception of Aristotle's *Poetics*, literary theory might have concentrated more on the ways poetry elevated its objects above "our normal level" and raised "reality" beyond the laws of nature while persuading the reader that it had not left them altogether. Its supposed author, Longinus, is the theorist of the "high" style.[3] *Peri hypsous* means "Concerning the High" (literally "height"), better translated, "On the Sublime," or "On the Lofty/ Elevated." While mimesis always looked to reality for what is being represented, *hypsos* looked beyond and above it: "[in the sublime] our attention is drawn from the reasoning to the enthralling effect of the imagination and the reality is concealed in a halo of brilliance."[4]

This book (that is, the one that you're reading) is about an aspect of the sublime style, which I will call "charismatic art." This mode also "conceals" reality—or at least clothes it—in brilliance; it diminishes the reasoning faculty, speaks to the imagination, and exercises an "enthralling" effect on the reader or viewer. A closer discussion of the sublime, the charismatic, and the mimetic follows in the first chapter. Charisma of art is one particular aspect of the high style in various media. "Mimesis" is a concern mainly as a difficult "other," which plays into sublime and charismatic art in many ways, not always adversarial.

The separation and polarization of a mimetic and a hypermimetic mode of art is a given of theory that I will argue against in virtually every section of this book. "Mimesis" has become the dominant concept in aesthetics in part because of the rationalist anchoring of representation in reality, but it owes a great deal to its prominence in one of the most brilliant and influential works of literary criticism, Erich Auerbach's *Mimesis*. This book wrote mimesis and representation of reality into the history of Western literature. By tying art to the real, Auerbach at the same time created, or opened the door to, a large project of investigating Western art and literature in their sublime, charismatic, hyperreal aspects. In the commentaries that follow here I pursue charismatic elements wherever I find them; I draw on literature, painting,

sculpture, and film. Auerbach limited himself to literature, and that narrowing and sharpening of the relevant material is an advantage my study does not have. I am acutely aware of its vulnerability to the readings of experts in the various fields that my chapters venture into. I can only hope for a benevolent reading that pardons individual faults and failures to consult all the relevant specialized literature by way of favoring a larger picture. What induced me to spread my study across so many genres of representation is that I saw common features of "enchantment" through charismatic effects shared across a variety of forms of representation, a variety broader than the (generally) "high" art and literature on which my commentaries focus. The integrity of a work on such a range of media depends on the limitations inherent in the working of charisma: the effects are limited; the causes widely varied. If any or all media offer a kind of art that exercises beguiling effects clearly parallel to the working of charismatic political and religious figures, then those effects deserve close study across the entire range of media that produce them, all the more so since there is often so little separating enchantment from seduction and exaltation from deception.

Throughout this work I focus on the congruence of experience and representation. The distinction between life and art is weakened in the eyes of the beholder when either a real person or a representation possesses charisma. The ability of a living person to sustain charismatic effects in an audience or collection of fans, worshippers, or devotees depends on his or her ability to enter or appear to enter the condition of a work of art; and conversely the work of art that does not convey the sense of living a heightened form of life and promising to transport the viewer into that world cannot produce charismatic effects. The "self as a work of art" is a well-known topic, especially of court life and courtly self-fashioning, which calls on a sophisticated artistry of the self; the work of art as heightened life is also well known. The common effect of art as life and life as art is addressed in virtually every chapter.

The guiding conceptions of my readings and their definition are more in the foreground than Auerbach's in *Mimesis*. I hope there is more profit than loss in this approach. Auerbach's very reluctance to theorize mimesis sheltered his conception, highly open to revision and criticism, of the history of Western literature.[5] An odd fate for a critical concept: it proves the more vital and durable the more it recedes from definition.[6]

"Charismatic" is a subcategory of the sublime. Many aspects of sublimity accommodate and describe the charisma of art, but it will be important

to distinguish among them. It is also useful to refer to the sublime by way of defining charismatic, since charisma has next to no commentary in aesthetic theory.[7] I develop the concept in my introduction and apply it in a series of commentaries on specific passages in works of art from Homer to Woody Allen.

Auerbach is the constant companion of this book and has been since its conception. My commentaries, sometimes on the same works Auerbach chose, are more complementary than adversarial to his. I adapt the form and historical trajectory of *Mimesis*, its adherence to textual commentary and to deriving concepts from analysis of texts. Auerbach is the giant on whose shoulders I am standing. I do not see farther than he saw, but I do see differently—by looking in the opposite direction.

The Effects of Art

Auerbach approached each text he examined in *Mimesis* with an analysis of rhetoric and literary style. Frame the approach as analysis of charismatic representation, and the focus rests necessarily on techniques of exaltation, rhetorical, visual, conceptual: in narrative, the creation of character and the unfolding of a destiny charged with redemptive force and imitative allure; in visual art, qualities that raise the subject above the ordinary, suggest indwelling forces, exercise some kind of visual arrest on the viewer. This perspective brings with it an element that was relatively unimportant for Auerbach, the emotional response of the reader or viewer. The response to the work of art is central to my study. The sublime and its close relative the charismatic verify their existence by their effects, by the response of the recipient far more than by any definable qualities inherent in the sublime object or the charismatic person.[8] Longinus defines the sublime by its action on the observer: "The effect of the Sublime is not to persuade the audience but rather to transport them out of themselves. Invariably what inspires wonder, with its power of amazing us, always prevails over what is merely convincing and pleasing. For our persuasions are usually under our own control, while these things [i.e., sublime elements] exercise an irresistible power and mastery and get the better of every listener. . . . A well-timed flash of sublimity shatters everything like a bolt of lightning."[9] Whereas Auerbach could focus each of his chapters on works with significant stylistic elements as markers of mimetic representation, a project on charismatic art

must work from a shaping effect the work has exercised on an audience and relate the effect to qualities of the work that inspired it. Since individual response to art and literature is always only anecdotal, open to question as a generally valid commentary on the work to which it responds, the charismatic effect becomes demonstrable when the influence is widely shared and the effect registers in a large number of viewers or readers. The works I have selected have both enjoyed wide popularity and exercised a demonstrable educating or transforming influence. The questions put to them here are, what are charismatic effects? What qualities of living persons or works of art exercise them? Most of the following chapters address those questions; others concentrate on works that reflect on rather than represent charisma and charismatic effects (*Don Quixote*; Rilke, "Archaic Torso of Apollo"; Woody Allen's films).

It follows that one of my questions is, what qualities consitute charisma in art? It is related to the questions posed by W. J. T. Mitchell, "What Do Pictures *Really* Want?" and to the direction in aesthetic thinking marked out by David Freedberg in *On the Power of Images* and by Alfred Gell in proposing an "agency" in art that aims at a variety of effects on the viewer, prominent among them a form of "enchantment" worked by intricacies in pattern and design and furthered but not exclusively activated by pictorial representation.[10] A common idea of Mitchell and Gell is that works of art possess a dynamism that has the qualities, or at least the effect, of living beings: will, desire, the ability to generate certain kinds of action in the viewer. This approach is commodious to the idea of charisma of art and charismatic effects. But narrowing to charisma the broader question of what art wants and what it does, sharpens the focus on a particular human quality, or human potential. Its nature and its effects are approachable via the parallel to the quality of lived charisma. My approach also invests more in the question of the interaction of artwork and recipient than either Mitchell's or Gell's. Their studies posit responses generated by the agency or the desire of art, but are not particularly interested in the specifics of interaction between viewer and image. From the point of view of charismatic art, the particular relationship of a perceived authority of the image or text and its successful assertion of influence on the viewer and reader have to be the key elements in understanding charisma in art. This book is perhaps best characterized as a study of response to art, above all its educating and transforming effects. How art produces charismatic effects is a question that resists unequivocal answers, and while there do seem to be

some general characteristics that recur in my various chapters, I have avoided any attempt to systematize the subject of this study. This book offers a series of readings of individual texts and works of art, not a systematic theory of representation.

Also, I am not—or only marginally—concerned with aesthetic judgment or connoisseurship; the quality of art is one aspect among many able to rouse certain emotional responses in a particular set of readers and viewers. The judgments of critics, scholars, and connoisseurs are of peripheral help in locating and analyzing the charismatic effects of art. The effects of art that interest me happen in the state of semi-intoxication that my title indicates. The critic and connoisseur are virtually obliged to sober up from the spell of art and to shed the effects of enchantment, maybe even to downplay or discredit them, in order to do their job.[11] Confessional statements of fans and devotees (including my own confessions), the testimony to broadly transforming effects on a large audience, communal or even national, and charismatic relations modeled in literature and art, are the best witnesses. Response to movies and television shows, rock music, poster and advertising art, religious and other cult phenomena, are useful. The responses of cults to representations are especially valuable for my enterprise. They are no less exemplary of charismatic effects than are cult responses to political figures or religious leaders—the context in which the most influential studies of charisma, those of Max Weber, are set.

Charisma, a Useful Concept

What follows in this section is a survey of studies of the concept "charisma." This might be a good moment for the reader not interested in the academic discussion to head for the first chapter, perhaps with a glance at the last two pages of this introduction.

I said earlier that charisma has only rarely and recently been a subject of serious discussion in aesthetics and critical theory. Academic study of this strange kind of body magic has virtually restricted itself to politics, sociology, and religion. Max Weber's studies of charismatic leadership[12] put the concept on the map, and it has more or less remained where he put it: in sociology and political science.[13] Weber's ideas have dominated virtually every discussion of the concept, apart from history of religion, until very recently.

This predominance has fixed the subject in its late romantic, post-Nietzschean mold. There is a built-in romantic structure to the theory of charismatic rule among the sociologists following Weber: a once vital model remains artificially in place in the twentieth and twenty-first centuries. The trend started by Weber questions whether "genuine" or "pure" charisma is at all realizable in the present, since media create charisma artificially, and that inner excitability, which is the primal determinant of charisma, has faded or, if present, then only as a cultivated, artificially reconstructed, not an inborn quality.[14]

The skepticism of academic commentary toward contemporary charisma assumes that its artificial cultivation, its "production" and staging, began in the twentieth century. In fact the cultivation of charismatic qualities is a feature of public life in classical antiquity, the Middle Ages, the Renaissance, and beyond. Those periods have left a number of tracts and books on the subject (the counterpart of the masses of self-help books on charisma currently available in the United States): Cicero and Quintilian on the orator, Baldesar Castiglione and hosts of followers on the ideal courtier. Lisa Jardine has applied the concept to the public career of Erasmus.[15]

The metastasizing popular use of the term is taken to confirm those Weberians convinced that all contemporary charisma is trumped up and that the ecstatic excitability which makes it genuine has shriveled to packaging. But inferring banality from banal usages of the term is shortsighted interpreting. The near saturation of the culture with the term is more likely a sign of its prominence and a provocation to assess the phenomenon in its many instantiations. Academic intellectuals who regard only the classical formulation of the concept or the "pure form" of the phenomenon as valid rob themselves and their readers of an insight into its depth of penetration into the culture. If the concept were restricted to religion and politics, studied only by academics, absent from business, popular culture, commercial art, and show business, would that suggest its "purity," strength, and vitality?

In the area of religion, its sociology, history, and psychology, there is both a tradition of studies and an abundance of contemporary interest. However that trend also confirms the Weberians, since the primitive authority of charismatic fundamentalists appears as a throwback to the primal condition of charisma, surviving into the modern age the way Stone Age tribes preserve archaic customs in exotic corners of the world.

Interest in the concept fades as we approach the humanities. The recent, excellent *Encyclopaedia of Aesthetics* has no entry on "charisma," and the word does not occur in the index.

Literary studies? Forget it. Neither the traditionally oriented *Princeton Encyclopedia of Poetry and Poetics* nor the trendier *Johns Hopkins Guide to Literary Theory and Criticism* mentions it. Raphael Falco's studies of charisma in tragedy and the recent work of Eva Horn (see note 5) are an exception. Falco says that he has no predecessors in his approach, and I cannot find any either.

It is surprising to me that film theory has made little use of the concept (see Chapter 11). A recent book by Joseph Roach studies charisma, its hypnotic qualities and its powers of seduction in stage and film performance. The admirably clipped title: *It*.[16] The author sees "It" as linked to a welter of charismatic effects that range from religious experience to political and theatrical performance, historically from the Old Testament to ancient Greece, Renaissance Italy, seventeenth- and eighteenth-century English theater (the latter, one of Roach's two focal points), and the modern cult of film stardom (focal point number two).[17] It is an influence exerted by "abnormally interesting people." Roach uses "It" interchangeably with "charisma." The quality produces a loss of reality on the part of the charisma-bearer and the charisma-smitten. Both tend to see fictions and illusions merge with reality—and accept the effacing of that ordinarily uncrossable boundary. That merging, delusional but perceived with the force of experienced reality, creates the possibility of "enchantment," or, seen in the historical frame Roach puts it in, the "reenchantment" of a human perceptual apparatus disenchanted by the reign of reason and skeptical thought since the Enlightenment: "The It-effect often takes on a powerful and sometimes even fearsome religiosity of its own, making everyday experience seem not only strange but also enchanted, as if possessed by the mischievous spirits of portentous little gods" (*It*, pp. 16–17).

An actor's roles form a patina of associations around her/him, which exists only in the mind of the viewer/fan/audience. Roach calls this accretion "effigy," the phenomenon "ghosting." A stage or film actor is like a king or popular political figure in possessing "two bodies," "the body natural, which decays and dies, and the body cinematic" (p. 36). Roach's "effigy" and "ghost" are close to what I'll call "aura," the accretion of associations around a person, object, or experience, a kind of invisible but perceptible amplification of the self. I will try to bring my usage into focus

with the extensive discussion of Walter Benjamin's orphic pronouncements on aura.

The terms "charisma," "aura," and "enchantment" can be profitably rehabilitated as critical concepts to analyze art, literature, and films, their aesthetics, their impact on the audience, and the psychology of both star and fan.[18] They have the advantage over "glamour," "It," "stardom," and so forth of reaching beyond film and stage performance, linking theatrical enchantment with others in its extended family. The reach of "charisma" of course is huge; "aura" and "enchantment" set the subject at a logical crossing point of film magic and other occult and magical phenomena.[19]

The aesthetics of charisma can never move away from its fundamental form, an effect of physical presence. Max Weber pondered whether objects could possess charisma—a throne or royal regalia, for instance—and decided that it was exclusively a characteristic or an effect of living persons. I agree (if we add "represented" persons). An epic landscape or a quality of prose may be charged with force, charm, the ability to please and entice, but charismatic effects must always be referred to a quality of personality. Body parts of saints and celebrity memorabilia are mediators that continue the diffusion of personal charisma, but they convey force by extending or replacing personal presence. I distinguish charisma from objects charged with force, authority, or sentiment by the concept "aura," which I will develop in several of the chapters that follow.

I understand charisma of person as a kind of force and authority exercised by people with an extraordinary personal presence, either given by nature, acquired by calculation, training, or merit. In contrast to most forms of authority, charisma is always seen as benevolent and life-affirming, at least until disenchantment sets in.

The effect charismatic personalities have on those in their orbit varies widely, from an evanescent buzz and a brief affection, to love, passionate devotion, elevation, and transformation, to destructive obsession. Whatever the range or intensity, I will call the effect of charisma "enchantment," engaging the whole range of meaning of that word from a shallow moment of pleasure ("Enchanted to make your acquaintance") to a spellbound state of participation and imitation, to idolatry and transformation.

Texts and artworks can also exercise enchantment.[20] A passage from Michael Taussig's book *Mimesis and Alterity* seems to me amenable to my reading of enchantment by art. He takes mimetic verisimilitude as the textual quality that makes this effect:

Can't we say that *to give an example, to instantiate, to be concrete,* are all examples of the magic of mimesis wherein the replication, the copy, acquires the power of the represented? And does not the magical power of this embodying inhere in the fact that in reading such examples we are thereby lifted out of ourselves into those images? . . . If I am correct in making this analogy with what I take to be the magician's art of reproduction, then the model, if it works, gains through its sensuous fidelity something of the power and personality of that of which it is a model.[21]

For my purpose it would be important to limit the realm of "sensuous fidelity" to an elevated, exalted reality.

Given the relation of living model to a represented world as the core of charismatic representation, I begin with a discussion of charisma of person.

1

Charisma and Art

Charisma of Person

Max Weber's much-cited definition holds up well in reference to personal charisma. Weber refers to charisma as

> a certain quality of an individual personality by virtue of which he is set apart from ordinary men and treated as endowed with supernatural, superhuman, or at least specifically exceptional powers or qualities. These are such as are not accessible to the ordinary person, but are regarded as of divine origin or as exemplary, and on the basis of them the individual concerned is treated as a leader.[1]

Broaden the context from religious authority ("divine origin") in rulers, and this applies well to many charismatic figures: teachers, movie actors, presidents. Charisma is a quality allied with talent and other sorts of gifts (Gk. *charismata*), which may easily be perceived by the admiring beholder as beyond the attainment of normal human beings, as supernatural, or divine.

My argument is that charisma is also a quality of works of art and of characters represented in them, which or who can inspire the same sort of admiring wonder and urge to imitate as living charismatic figures. And conversely, that personal charisma, whether natural or cultivated, or a mixture of both in whatever degree, is itself a form of representation and its bearer a kind of living work of art.

Charisma of art develops, through artifice and imitation, out of embodied and lived charisma. Charismatic art is a mimesis of charismatic presence; like effects derive from living and from represented charisma. For

that reason I start with observations on charisma of person and its effect on the giver and the receiver before moving on to charisma and the arts.

Enchantment: The Giver

Maxim Gorky's *Reminiscences* of his friend Count Leo Tolstoy include a portrait of Tolstoy, which amounts to a paradigm of charismatic effects. One day he happened on the old man while he was sitting by the edge of the ocean:

> He was sitting with his head on his hands, the wind blowing the silvery hairs of his beard through his fingers: he was looking into the distance out to sea, and the little greenish waves rolled up obediently to his feet and fondled them as if they were telling something about themselves to the old magician. . . . He seemed to me like an old stone come to life who knows all the beginnings and the ends of things, who considers when and what will be the end of the stone, of the grasses of the earth, of the waters of the sea, and of the whole universe from the pebble to the sun. And the sea is part of his soul, and everything around him comes from him, out of him. In the musing motionlessness of the old man I felt something fateful, magical, something which went down into the darkness beneath him and stretched up like a search-light into the blue emptiness above the earth; as though it were he, his concentrated will, which was drawing the waves to him and repelling them, which was ruling the movements of cloud and shadow, which was stirring the stones to life. Suddenly, in a moment of madness, I felt, "It is possible, he will get up, wave his hand, and the sea will become solid and glassy, the stones will begin to move and cry out, everything around him will come to life, acquire a voice, and speak in their different voices of themselves, of him, against him." I can not express in words what I felt rather than thought at that moment; in my soul there was joy and fear, and then everything blended in one happy thought: "I am not an orphan on the earth, so long as this man lives on it."[2]

Gorky frames the figure significantly. He approaches from behind the old troll, as if to say, *"I'm keeping my own insignificant existence out of this force field. Elemental things—like the creation of the world, its magical transformation*

into life, and its final destiny—are being arranged here. Mortal that I am, I have no right to intrude into the magical circle where the wizard works." Tolstoy and nature form a great unit, but not because Tolstoy is a part of that greater space, nature. Rather nature is part of him; it flows out of the old man. The waves themselves fawn on him and beg for a moment·of his time to tell him their secrets. The sea is his external soul; earth and sand, an outgrowth of his body. He is Jehovah, the demiurge and primal matter rolled into one—the creator of it all—and what he has given in the beginning of time, he may well take back now—or twenty million years from now; he hasn't yet made up his mind. Since creation is a personal emanation, he may well, if he gets up abruptly and walks away, kick the planets out of their courses and shake the surface of the earth as casually as when a tablecloth catches on the belt of a quickly exiting dinner guest.

But what in this stony primal scene accounts for the ecstasy of the observer at its end, the joy and fear in his soul? The thought that he will never be an orphan exhilarates Gorky. Not that he will always have the companionship of Tolstoy, an uncomfortable companion, as is clear from other parts of the *Reminiscences*. But rather Tolstoy is a family-like nurturing force, a huge human fortune in everyone's bank account, and Gorky's happy life is guaranteed from the interest and the surplus Tolstoy generates. There may also be a reminiscence of the Gospel of John 14:18, Christ to his disciples announcing his coming crucifixion: "I will not leave you orphaned; I am coming to you." Even if unintended by Gorky, the lines might evoke the parallel to Christ in the mind of the reader tuned to Tolstoy the charismatic religious leader.

Gorky's vision is a response to a human being in whom myth lives and breathes. He knows Tolstoy, talks with him; he is real. His friend, a landowning Russian nobleman and well-known author in the realm they both call reality, happens also to be a magician-demiurge, someone who confers with the Norns on extending nature's lease. Some confluence of qualities visible to Gorky exalt him into the supernatural. It may be his response to Tolstoy's appearance, part-gnome, part-titan; it may be fear of the explosive irascibility he knows is concealed beneath the contemplative surface; or it may be admiration of his talent as writer, or of his role as social reformer and religious leader. They all flow together like the sea lapping at his feet and his soul.

Gorky introduces this scene with the comment, "I see what a vast amount of life was embodied in the man" (p. 54), and the vision elaborates:

his will rules the waves, the clouds, and shadows, stirs the stones to life. The force of his person vivifies all of nature: "everything around him will come to life, acquire a voice, and speak." Tolstoy's being is so huge, it won't stay within the bounds of his body. His vitality suffuses the world around him: no stone that does not become a poet; no tree or animal that doesn't sing. And that's just the overflow. What he contains in himself is a force greater than the derivative one that brings nature to life.

Gorky's Tolstoy has in common with other charismatic figures that he stimulates the imagination, evokes life-giving visions. Charisma affirms whatever is experienced and inspired in its spell. That includes enterprises that reveal themselves as demonic and destructive once its spell fades. Tasks for the mind and imagination proliferate under its influence. Gorky says, "He always roused in me sensations and agitations which were enormous, fantastic . . . they made [my soul] more sensitive and capacious" (p. 56).

Tolstoy gives life to Gorky, not just a moment of bliss. Tolstoy ends Gorky's thoughts of suicide, if he had any, and wards them off, if he didn't. "*Life is good*," might be the generalized reaction to the experience: "*I'm part of the great union of creatures living life through Tolstoy. I will continue to live it.*"

The source of affirming power in charisma, at least one of them, is that it seems to transport the enchanted person into a world where human limits are abolished, at least extended far beyond the commonplace. The spellbound person feels that redemption from misery or transformation from the commonplace is available.

That exhilaration produces ecstasy; it generates images of doors to hidden kingdoms springing open, treasure-chests offering their bounty, boundaries falling away, "yet-undreamed-of realms" opening (see Chapter 10, on Stefan George).

Enchantment: The Receiver

Gorky is not writing poetry here in the sense of crafted utterances. He is just reacting to, being stimulated by, the hormones of creativity that Tolstoy secretes. He is himself the raw stuff of poetry, and Gorky sponges it up and translates it into words or images. In Gorky's state of enthusiasm things beyond nature become possible, seem and feel real to the observer. The charismatic figure turns his admirer into a poet and a genius. The fact that

Gorky already is those things is irrelevant. He is in a spell. He feels magically transformed and elevated, his imagination aroused. He sees visions of gods, supernatural creatures, mythic events. This is the state I'll call "enchantment." Two states of preparedness make devotees and fans especially vulnerable to enchantment: need and aspiration.[3]

Need

Charisma has this effect on people who are neither geniuses nor poets, the fans of rock stars for instance. The rock concert exercises both a mass and an individual enchantment. Fred and Judy Vermorel published testimonials of fans writing to and about rock stars in *Starlust: The Secret Life of Fans*.[4] Many of the documents in the book are taken up with sexual fantasies, desire being a strong charismatic effect. But it is the sensed power of the star to transform, exalt, redeem, and to inspire love, which resonates most broadly with other charismatic effects. The Vermorels' fan-informants imagine themselves enjoying secret and supernatural communication with the idol; or in some other way participating in the life of the star ("It's as if he or someone or some silent voice or a force inside me thinks it's important that I know about him"—p. 50). The informants are generally women, decidedly not poetic or religious persons, but sponging up the raw matter of poetry from their idol, who gives them fantasies about a good life, great sex, marriage with the star, redemption:

> "Sheila" [fans are only identified by first names] on David Bowie: "to me he came to us a bit like Jesus . . . they are both very wonderful, special people . . . [Bowie] has the same aura about him as Jesus. It's what I call beautiful, mysterious, and, above all, inspiring." (pp. 70–71)

> "Marcel" on David Bowie: "I wanted to have and be part of his life. . . . The impression he gives is of a personal God." (p. 71)
> "Melanie" on David Bowie: "Bowie has moulded the shape my life has taken." (p. 72)

> "Alison" [married with two children, she spends extravagant amounts of money on her obsession, and sees her marriage undermined by it] on Barry Manilow: "He has shown me that I can feel love again. . . . Now I'm alive inside . . . I'm not emotionally dead

any more . . . I've also become aware of the beauty of nature. Every-
thing has come to mean more—sunsets, sunrises, bird song . . . I
feel more confident, more my own person . . . Barry gives me every-
thing I need in inner happiness and peace of mind as well as a spirit
of adventure—everything I've not had for so long." (pp. 188–91)

"Marnie" [in the middle of a sexual fantasy about David Bowie]:
"Bowie places his hands on my shoulders and I'm filled with this
super strength and bouncing energy like I'm just raring to go. I feel
like I could climb a mountain or run the longest marathon in the
world and still have super strength left over at the end of it. Then it
suddenly comes to me . . . Bowie is feeding me with this super new
life force . . . and it's thrilling! Fascinating! Sensational!" (p. 202)

"Carolyn" [age fifty-two with two careers and two husbands behind
her]: "I would play records [by David Bowie], and I got into dancing
and singing—there was a lot of creativity, and I wrote lots of poetry.
Reams of poetry just came out of me. It seemed like some force was
taking me over, and I was like an automaton. . . . I had specific
visions. Like I would see him with light rays coming out of him. . . .
At one time I thought he was Christ. When I found out he was
Jewish I was positive. . . . For some reason I felt I had been given a
lot of power. I'd been touched with power. . . . I firmly believe that
some spirit or god or my guide or some higher power is using David
Bowie to educate me. Some thing, some force, some power is work-
ing through me and I have an enormous personal relationship with
this thing or this person or this force. . . . David Bowie is the one in
the middle. It's like David Bowie is the mailbox or something. We
communicate through David Bowie." (pp. 232ff.)

Clearly these fans are getting something immensely important—along with
vicarious sexual satisfaction—something emotionally and spiritually nour-
ishing, from their idols. Their experience is very close to that of medieval
mystics and contemplatives, male and female, led by meditation on the
image of Christ to the vision of physical intimacy. Various of the "visionar-
ies" cited in *Starlust* lie in their rooms surrounded by posters of David
Bowie and imagine him physically present. The same psychological mecha-
nism evokes the following vision in the mystic Angela of Foligno (d. 1309).

Her meditation on the cross leads to an understanding of its meaning: "this perception of the meaning of the cross set me so afire that, standing near the cross, I stripped myself of all my clothing and offered my whole self to him. Although very fearful I promised him then to maintain perpetual chastity and not to offend him again with any of my bodily members, accusing each of these one by one."[5] The divinization of the idol and the sexual fantasies, whether explicit (*Starlust*) or shamefaced and renouncing (Angela of Foligno), tap into a mechanism that turns an admired figure into a god or a god into a person and focuses the force of an overcharged imagination to make the object of worship either physically present or intimately accessible. The desire for the real presence of the absent idol is a constant of the state of enchantment.

There is a tendency to regard celebrity worship as a kind of sickness,[6] but its sufferers share the state of health of the culture that produces it. We get the kind of charismatic figures and relationships we deserve. The psychological mechanism at work is not fundamentally different along the entire spectrum of charismatic experiences, whether the idol is Jesus, Tolstoy, or Elvis Presley.[7] Saturate the vision with the image of the desired person and it produces a consistent effect: the imagination of the devotee intensifies the transfigured image and the dreamer experiences vision and fantasy as though it were reality. The experience of the imaginary as real and present is central to enchantment.

If the dreamer also projected into his or her fantasy a landscape, color, mood, perhaps music, a world suffused with the ethos of the devotee's idol, peopled with villains who oppose it, perhaps a plotline leading the revered one through abasement to glory, then the dreamer would be at work on charismatic art, whether or not the vision is ever formulated in prose, poetry, or paint.[8] The revered figure is, like Tolstoy to Gorky, art prior to composition, as it exists in the mind of the artist. The landscape injected with the force of a charismatic personality, functioning in a narrative (visual or written), conspiring with or against the main character, is what I'll call a "realm of enchantment." The enchanted realm is easily envisioned by calling up the world of Homer's *Odyssey,* the forest of adventure in chivalric romance, or Shakespeare's "green realm," the forest of Arden or Prospero's island.

Whether imagined in a fully developed narrative world, or simply as a physical presence in no particular context, other than beaming bliss to the hopeful devotee, the vision of the revered figure is exalting. For "Alison"

and "Marnie" their obsession with their rock star idols makes a better world; if their middle-class existence falls apart because of it, it does not matter. The private cult of the idol is better. One woman confesses how her attachment (purely fantasy) to a star improves her marriage; another describes the breakup of her marriage over her mental adultery—and sees it as improving her life. She's happier to be alone with her imaginary god/lover than with her husband living and present.

The enchanted fan loses reality. She or he loses it gladly, or at least without resistance, because the advantages of the enchanted state are so great. It makes the devotee a visionary and makes her or him feel intensely alive; in it the fan experiences the world as beautiful and meaningful; and in its afterglow, temporary happiness.

Starlust records not just hyperreal exaltation, but also a fair amount of ugly aggression directed at the star. The authors/compilers confess their shock at the vehemence. It is often generated by the bursting of the illusion, the realization that the inspirer of blissful dreams is all tinny show, not a god at all. It also takes the form of the fan imagining that the luster of the idol will become his if he kills him. The shooting of John Lennon is one spectacular case. The impulse to destroy, slash, throw acid on, or pound to bits famous works of art can have a similar motive,[9] and this too connects charisma of person and of art.

Idolatrous love is a charismatic experience. The passages from *Starlust* set it in a narrow context. The sexual character of these confessions doesn't extend to charismatic experiences in general. Not all charisma is libidinal. Tolstoy's certainly is not. The compilers of *Starlust* stress how the producers of rock stars and rock spectacles play to the sexual desires of their audience. The fans get out of rock stars the "poetry" built into the staged and arranged presence. The same is true of Tolstoy, Socrates, and Jesus. The visions and desires they inspire are individually determined, not by any collective human libidinal needs that remain consistent over a wide range of charismatic figures. If there is a consistent goal that defines charismatic effect generally, it is probably "redemption." I (and my sources) use the term in a broad sense, which will become clear in the course of the studies that follow. For the moment let's say that "redemption" is the rescue, in a critical moment, of life, freedom, and human dignity from a condition that ignores or suppresses or denies it. Gorky and the rock fans experience it in that sense.

The idolatry in fan worship is a variation of the same experience in real love relationships. There is a special constellation of lovers, in which the one in love experiences the spell of charisma. She or he adores, worships, and idealizes the beloved and goes slightly crazy in the pursuit of her or him. I will use that experience regularly for comparison to the spell cast by charismatic people and charismatic art (and will analyze it in the chapter on Hitchcock's *Vertigo*).

So, Gorky's reminiscences and those of Sheila, Marnie, and the other idolizers of singers and rock stars, different as their social and cultural milieus are, both attest to the magical charge set on a certain kind of physical presence. The charismatic presence beguiles, rouses love and longing, enchants, creates the illusion of full participation in a higher kind of life and a higher kind of world.

Aspiration

Aspiration feeds on charisma, looks to role models and inspiring figures who embody the goal of aspirations. I will look in a sphere where we might expect to find clearheaded, realistic judgment: the military, officers facing battle. Tolstoy, connoisseur of the military, debunker of Napoleon worship, and charismatic figure, can again help. A scene from *War and Peace* gives us a splendid example of enchantment through aspiration. It is the review of the troops of the combined Russian and Austrian armies in Olmütz just before the battle of Austerlitz (Book 1, Part 3, chapter 8). The ambitious young cadet Nicholas Rostov, presenting himself along with the forty thousand Russian troops, responds to the presence of the Tsar Alexander:

> Rostov standing in the front lines of Kutuzov's army which the Tsar approached first, experienced the same feeling as every other man in that army: a feeling of self-forgetfulness, a proud consciousness of might, and a passionate attraction to him who was the cause of this triumph.
>
> He felt that at a single word from that man all this vast mass (and he himself an insignificant atom in it) would go through fire and water, commit crime, die, or perform deeds of highest heroism, and so he could not but tremble and his heart stand still at the imminence of that word.

Each regiment stands in place "lifeless"until the tsar reaches it, "but as soon as he came up it became alive":

> The handsome young Emperor Alexander, in the uniform of the Horse Guards, wearing a cocked hat with its peaks front and back, with his pleasant face and resonant though not loud voice, attracted everyone's attention.
>
> Rostov . . . with his keen sight had recognized the Tsar and watched his approach. When he was within twenty paces, and Nicholas could clearly distinguish every detail of his handsome, happy young face, he experienced a feeling of tenderness and ecstasy such as he had never before known. Every trait and every movement of the Tsar's seemed to him enchanting.
>
> Stopping in front of the Pavlograds, the Tsar said something in French to the Austrian Emperor and smiled. Seeing that smile Rostov involuntarily smiled himself and felt a still stronger flow of love for his sovereign. He longed to show that love in some way, and knowing that this was impossible was ready to cry.[10]

The leitmotifs of the passage, clearly, are love and self-sacrifice: "How gladly would he have died at once for his Tsar!"; "'Oh to die, to die for him!' thought Rostov"; "Rostov . . . shouted . . . he would like to injure himself by that shout, if only to express his rapture fully"; "'At a time of such love, such rapture, and such self-sacrifice, what do any of our quarrels and affronts matter? I love and forgive everybody now'"; "'My God, how happy I should be if he ordered me to leap into the fire this instant!'"; "[The emperor's] every word and movement was described with ecstasy"; Rostov wanders around the camp "dreaming of what happiness it would be to die . . . simply to die before his eyes He really was in love with the Tsar and the glory of the Russian arms" (chapters 8–10, pp. 312–25).

Three days later in the middle of a prebattle skirmish the emperor rides by close to Rostov:

> He was filled with happiness at his nearness to the Emperor. . . . He was happy as a lover when the longed-for moment of meeting arrives. . . . He was ecstatically conscious of *his* approach. . . . As *he* drew near everything grew brighter, more joyful, more significant, and more festive around him. Nearer and nearer to Rostov came

that sun shedding beams of mild and majestic light around, and already he felt himself enveloped in those beams, he heard *his* voice. . . .

The Emperor drew level with Rostov and halted. Alexander's face was even more beautiful than it had been three days before at the review. It shone with gaiety and youth. . . . The Emperor's eyes met Rostov's and rested on them for not more than two seconds. Whether or no the Emperor understood what was going on in Rostov's soul (it seemed to Rostov that he understood everything), at any rate his light-blue eyes gazed for about two seconds into Rostov's face. A gentle, mild light poured from them. (pp. 322–23 [bk. 1, part 3, chap. 10])

The experience of ecstasy and rapture is so much the more intense for being shared by the mass of soldiers ("the same feeling as everyone else in the army"). The young man "loses himself" in the experience. Gone is any whiff of skepticism or critical sense ("even this indecision [when the emperor hesitates for a second and seems uncertain] appeared to him majestic and enchanting, like everything else the Tsar did") Rostov is giddy. His state is not different in degree of intoxication from that of the young women made foolish over popular singers. Rostov's friend Denisov teases him:

"As there's no one to fall in love with on campaign, he's fallen in love with the Tsar," he said.

"Denisov, don't make fun of it!" cried Rostov. "It is such a lofty, beautiful feeling, such a . . ." (p. 325 [bk. 1, part 3, chap. 10], elision in original)

There is the mystical light flooding—not the scene, but Rostov's mind. The halo, the heavenly glow, seems to surround the emperor. All of reality as Rostov experiences it is light-filled and elevated ("brighter, more joyful, more significant, more festive"). The writer rummages through the vocabulary of mystical-magical effects: "rapture," "ecstasy," "enchantment." And finally, there is the event we will see often as the life-giving moment in charismatic experiences: reciprocal gazing. The tsar's eyes meet Rostov's and the light from them intensifies. It is the experience of the icon worshipper, of Nicholas of Cusa in his "Vision of God," of Proust's Marcel levitating into the Olympian world of the high aristocracy upon mystical election

through the eyes of the Duchess and Princess de Guermantes—and in a variety of myths and legends of living artworks.

So, is Rostov's mind clouded, is he in a state that disables a man for practical affairs? Just the opposite. Everything is clear suddenly and the entire will, personal and collective, unites around the figure of the tsar and what beams from his body. No king, general, or president could hope for a state of mind in his soldiers more oblivious of self-preservation, more in love with battle, death, and victory. And no general could hope to enchant his army by a means so cheap and available as the mere physical presence of an admired leader. So while Rostov's will is firmed up and focused on an ideal, it is also surrendered; it is no longer his own; the instinct of self-preservation is shed, probably just a humiliating reminder of a much humbler state, reality. The star-struck, tsar-struck Rostov would ride off a cliff if the emperor commanded it.

Charismatic Effects

At its narrowest, charisma charms. It is a winning quality useful for that reason for politicians and sought by businessmen and leaders. But the reactions that fan out most broadly are these:

1. It compels people to follow by the force that I've called "body magic." It causes the lessening or surrender of the will (and for that reason it is potentially dangerous, highly exploitable by political and religious leaders, seducers, fakes, and confidence men).
2. It inspires a sense of affirmation in the viewer or follower, of self, of the cause or mission of the charismatic, an affirmation of life itself. And it effaces any sense we might have of faults in its possessor, any will to find fault.
3. It uncouples the critical sense, overrides judgment, as it lessens individual will. It also overrides personal conviction. When the charismatic addresses crowds, they become like-minded, however diverse they were prior to enchantment.
4. It enlarges the person who possesses it, or some simulation of the person constructed either in the mind of the charismatic person or in the minds of the devotees, or in a negotiated arrangement within that circle. This "enlargement" heroizes, sometimes deifies the idol.

5. It inspires imitation, awakens the urge to be like the charismatic person, draws the spellbound admirer into the world of the charismatic, makes him want to live in that world and according to its values.
6. It stimulates the imagination, makes the spellbound fan or disciple dream the dreams of the leader, which emerge in the mind of the fan as a heightened vision, poetry prior to composition.

A relationship of mutual reinforcement of the charismatic person's stature develops between the admired figure and his admirers. It lives from a mind-set of the followers that enables them to dream the master's dreams, to create or acknowledge a higher world in which he lives, to be deaf to criticism, resist with aggression any attempt to undermine the idol, and long to live in that world themselves. It is a condition in which the mind is under a spell and in the grip of an uncritical awe that extends to selfless devotion and beyond, to self-sacrifice. The unthinking devotion of mesmerized devotees appears at its most dangerous in the political realm. In the presence of the king or the messianic ruler, the follower would gladly sacrifice his life to maintain that of the king, or just to please a whim of the king in an extreme case—Nicholas Rostov for instance. The adoration of movie fans and rock music fans can reach a comparable pitch.

The effect on the idol is hardly less disorienting than on the admirer. The charismatic figure/celebrity/star comes to live in a world that is part fiction. Life becomes the staging of that scenario on which the idol and the audience have come to agree. Katharine Hepburn and Marilyn Monroe both made much-quoted statements about their fabricated role. Their life consisted of slipping into it in public and out again in private. The adored person has to agree to participate in the mythmaking process, in some cases even has no more power to control the process than the followers. Idols may make modest assurances that their admirers are mistaken, that they are really just ordinary people, but if they persuade the crowd, then their admirers simply find in the idols' claims of ordinariness proof of their superhuman character; the modesty enters into and becomes part of the myth.[11] Self-denial can be a powerfully charismatic quality—the case of St. Francis.

Out of the dreams of the followers something like a myth of the idol arises. Through him the troubles of the world will end; he will redeem from its dreariness a world threatened by disenchantment. He embodies renewal. He awakens extravagant hopes in the devotee, visions of happiness, heroism,

divinity, the restoration of the spirit, and the realization of fantasies. The charismatic and the followers create and share a world in which the boundaries of reality become unclear. Dreams and impossible or unlikely enterprises appear realizable, the deepest hopes and desires appear attainable.

The dichotomies of real and illusion, life and art, so fundamental to the cultic experience of art in the West, are resolved in the medium of charisma. In this medium those opposites coalesce. Stories confirming the idol's heroism or divinity become a necessity, and if they are not true, they have to be reshaped; if they are true, they have to be embroidered. The aura around the charismatic has to be filled, in the imagination of the followers, with narrative. It is that magnetic pull that made Gorky's imagination bubble over in the presence of Tolstoy and "Carolyn's" in the represented presence of David Bowie. Garry Wills, who brought a strong sense of personal charisma to his studies of John F. Kennedy, Ronald Reagan, and John Wayne, says of Reagan: "Reagan runs continuously in everyone's home movies of the mind. He wrests from us something warmer than mere popularity, a kind of complicity. He is, in the strictest sense, what Hollywood promoters used to call 'fabulous.' We fable him to ourselves, and he to us. We are jointly responsible for him."[12] In Wills's metaphor (Reagan plays in the "movies of the mind"), we recognize the process of collaboration between the idol and his followers at work on the image of the idol. He stimulates the imagination, his own and theirs, and they both "fable" about him.

Reagan was the best maker of his own myth. Voters saw, incarnate in him ("ghosted," Joseph Roach would say), the cowboy riding out of the west with a staunch moral sense, for whom a punch in the nose or a shot from a six-gun settles most problems, or the World War II flier filled with devotion to country and willing self-sacrifice. This personal aura was reinforced by his movie roles, his own self-conception, the efforts of image-makers, and the fascination of the press with the blending of entertainment and politics. I'll call this accretion of myth and mystery on personal presence "incarnation" when it presents itself in reality and "layering" when it presents itself as art.

Imitation and Transformation

Followers want to be like the admired person and change their walk, tone of voice, way of dressing accordingly. This effect is closest at hand in the

phenomenon of fashion, a close relative of charismatic effects. What makes one teenager or socialite want to dress like and adapt the lifestyle of an admired model? And more profoundly, to be like the admired person? Fashion is the low-level diffusion of charisma. The higher level is imitation of the qualities of a person (role model). Model (= mannequin) is to role model as fashion is to self-fashioning.

The reproductive force of personal presence is a constant of human anthropology[13] and a prominent element of charismatic force. Some cultures make conscious use of it. One of the major works of Christian devotional literature is based on it, "The Imitation of Christ." Other cultures, like ours, allow it free operation in personal relations and popular culture without paying much attention to it otherwise. (Imitation of the teacher is not part of institutionalized education in the United States, for instance, as it was in earlier periods of the West down to the eighteenth century.)[14] In charismatic relationships a model is a model whether it's a platonic archetype or a fashion model. Both, and all intermediate forms, exercise a magnetic force shaping the admirer in the image and likeness of the idol. Undoubtedly many of those affected by charisma will have dealt with shattering disillusionment, even on a national scale (Nazi Germany).

In the post-Renaissance period the take on charismatic figures and their influence hardly gets more idealistic than Ralph Waldo Emerson's essay on "Representative Men." His vision of representativeness is based on the replicating force of what he called "greatness." He assigned it a virtually messianic role. The mass of humankind tends to mediocrity, unreason, disorder, and self-delusion, he complains. Greatness or excellence in a single person redeems the mass from those states. For Emerson, one heroic character raises all in his spell to heroism; a single great writer exalts armies of mediocrities: "Mankind have in all ages, attached themselves to a few persons, who, either by the quality of that idea they embodied, or by the largeness of their reception, were entitled to the position of leaders and law-givers. These teach us the qualities of primary nature,—admit us to the constitution of things."

Emerson did not develop his view of the functioning of this process of "attaching" and "teaching." It simply happens. "We learn of our contemporaries what they know, without effort, and almost through the pores of the skin. We catch it by sympathy . . ." (p. 627), or as we catch a disease: "There needs but one wise man in a company, and all are wise, so rapid is the contagion" (p. 626), or by osmosis: "This is the key to the power of

the greatest men—their spirit diffuses itself" (p. 631). "Greatness" was for Emerson a power of genius to impart itself to others, which raised them up to some approximation of itself.[15]

Charisma and Representation

The embodied quality of charisma ordinarily presents itself via some kind of performance. It is that form of self-presentation that the self engages in in everyday life,[16] only intensified and refined to the point of a staged performance. The need to act a part imposes itself on the charismatic person, and the prearranged, precalculated performance of that part heightens the expectations of adoring followers. The charismatic self is itself already a representation. It is a projected "persona" (the word means "mask" in Latin)—not exactly illusion, but hard to distinguish from deception, as those who embody it recognize. Recall Garry Wills's comment that "Reagan runs continuously in everyone's home movies of the mind": his alluring self lights up the mental screen and creates a psycho-cinematic feedback loop. The minds of the fans reproject myths and aggrandizing narratives back onto the person who has inspired them. The same process can be activated on a movie screen or in a work of art or in poetry. The charismatic person is in his or her fashioned self already a work of living art. The step from embodied to represented charisma, from life to art, is a short one.

The presence of charismatic force in art is as relative to the perceptions of the viewer as the presence of charisma in a politician. I never felt any charismatic force radiating from Adolf Hitler or Ronald Reagan, but many people did. In the same way, the charismatic effect of art does not derive from objectively definable qualities of the artwork. It depends on the chemistry that art generates between the work and the viewer.

Charisma of Art

The book of the Arabian Nights ends with the conversion or transformation of its main listener, King Shahryar. When the clever and beautiful narrator, Shahrazad, ends her 1,001st story, the king exclaims, "O Shahrazad, that was a noble and admirable story! O wise and subtle one, you have taught me many lessons. . . . I have listened to you for a thousand nights and one

night, and how my soul is changed and joyful, it beats with an appetite for life."[17] We can add to the king's list of benefits that his murderous vendetta against all women has evaporated in the course of the thousand and one nights. The betrayal by his first wife clouded his soul, turned him into a monster, made his soul beat with an appetite for death, and spread fear throughout the land, since no one was free from the threat of the homicidal tyrant who ruled it. Then came the curative spell of the thousand and one stories. Now the stories of Shahrazad dissipate the cloud and end the threat. A new man, he has an "appetite for life" that he had not felt for more than three years.

This passage opens some basic charismatic experiences to view: transformation, joy, life. The work exalted the king, restored him to humanity. My book will have failed if it does not persuade readers by the end that there is a kind of art that accomplishes this effect and that artists and writers given the right subject aim at this effect.

The latter is easy to show: artists want life and redemptive force in their works. An easy test is how to insult an artist or writer, any artist or writer. Here are two possibilities: (1) *"Your work has no meaning"*; and (2) *"Your work has no life."* To the first, the artist responds, *"It's there. You just don't get it. What do I care?"* To the second, *"Anything but that! I'll rewrite, redraw, rethink, or toss it in the recycling."*

The tensions between meaning and life in a work of art are a theme of Federico Fellini's *8½* (1963). The movie director Guido Anselmi is in a creative crisis. The acidic, pompous French critic hammers away at his script for lacking depth and meaning. Finally the director sentences him to die by hanging (in his imagination). In the final moments of the film, when the crisis suddenly ends, the same critic babbles on inaudibly about meaning, while the director's suddenly active imagination bubbles over with all the characters in his past and arranges them into a dance of life.[18] Meaning means far less to authors and painters than life.

Since that term—"life"—comes uncomfortably close to an empty cliché,[19] a few pages devoted to it might help raise it to the level of, if not a concept, at least, a usable term of charismatic aesthetics.

The Life in the Picture

For books are not absolutely dead things, but do contain a potency
of life in them to be as active as that soul whose progeny they are;

nay, they do preserve as in a vial the purest efficacy and extraction
of that living intellect that bred them.

—Milton, *Areopagitica*

Fra Lippo Lippi: Better Painted

Robert Browning's poem "Fra Lippo Lippi" gives us a core text on the
artist's urge to create work that swells with life. The painter of Browning's
poem has covered a wall of a new church with a fresco. The brothers admire
its realism, but the seniors of the monastery criticize him; the prior is
shocked to see his own niece represented in the flesh: Too much body, not
enough soul. Why can't you be more like Giotto? All soul. Lippo Lippi
confesses that he will have to leave soul to Giotto. True, he has made the
prior's niece beautiful and given her a role in sacred history. What's wrong
with that?

> Suppose I've made her eyes all right and blue,
> Can't I take breath and try to add life's flash,
> And then add soul and heighten them three-fold?

His great rival, Giotto, seems able to reproduce soul without recourse to
body, Lippo Lippi laments; he himself can never "unlearn the value and
significance of flesh." "Right and blue" is not enough; that's nothing more
than technique. He will only be satisfied with the Pygmalion effect, "life's
flash." But the "life" of art is hardly more than a cliché by the nineteenth
century. The resonant concept is "heighten it three-fold." This phrase
issues the challenge to reality and realism. Lippi will only be content with a
woman yet unknown to the real world. To "heighten" is to make it better
than it is in reality and multiply that effect. The world as it is made is
ordinary. The painter is there to educate the vision by teaching how to see
it heightened:

> We're made so that we love
> First when we see them painted, things we have passed
> Perhaps a hundred times nor cared to see;
> And so they are better, painted—better to us,
> . . . Art was given for that. (lines 300–304)

There are some basic concepts here to which I'll return often. The purpose
of art in this view is far beyond reproducing the appearance of things—the

simple monks were content to admire the lifelikeness, the verisimilitude of his fresco. The painting must breathe with heightened life. Maybe that means, project the living beauty into the divine (turn the prior's niece into the Virgin Mary or the goddess Venus—layering). Given those qualities, the vivified image has surface allure, depth, and destiny. The prior's niece moves in time and space. She feels. And perhaps more important: even though she breathes, she doesn't die.

Charismatic art, like personal charisma, projects a vitality that has the peculiar effect of transmitting itself to the observer or reader. "Life" is the term that is regularly employed to convey that effect. As an aesthetic quality, the bare term requires some unpacking. It means, heightened life, intensity, strong emotions, hypermimesis of hyperemotionality. It is like the "excitement" and "enthusiasm" that ground the enchanting power of the charismatic leader in Max Weber's exposition. So it is something closer to Lippi's "heightened three-fold" than to bland resemblance of life. Experienced by the viewer it is the quality that makes everyday life seem bland and in need of excitation; it is what stirs love, desire, admiration. It is closely related to the intensity of falling in love. The common outcry for the one who represents or who suffers the first stages of love is *"At last, I feel alive."*

Master Frenhofer: Overflowing Superabundance

Imagine "life" as something really appropriated by an artist: the tone and temper of the flesh, the personality radiating from the eyes, the timbre and resonance, the indescribably emotion-filled pitch of the voice that sets the inner world of the hearer vibrating in the same key; imagine a work of art or literature that had absorbed a living human being—not any, but rather a human being gifted with the force at issue here. Imagine that the artist had dismantled the character of the living person, whims, moods, tastes, talents, and soul, and composed his work out of those qualities. The charisma donor is not necessarily visible on the surface of the canvas or of the narrative; he or she may appear now in any of the characters—now in the voice of the narrator, and again suffused in the mood of the work—or he or she may appear fully in his or her own person excluding everything else from the viewed surface.

Balzac's story *The Unknown Masterpiece* turns on those circumstances.[20] The great master painter Frenhofer reaches the apex of his great oeuvre, or aims to reach it, in a painting that actually lives. His ideas on art point to

that undertaking. He scolds a pupil for his lifeless canvases: "You have the semblance of life, but you aren't expressing its overflowing superabundance, that indefinable something, which may be the soul, hovering like a cloud above the outer husk; in short, that bloom of life which Titian and Raphael captured" (p. 99). His own teacher, Mabuse, has died and taken the secret of living art with him: "Mabuse alone possessed the secret of giving figures life." To Master Frenhofer, Mabuse's only student, this secret would be worth pursuing to hell itself: "I'd go after you in the underworld, heavenly beauty! Like Orpheus, I'd descend to the Hades of art to bring back life from there" (p. 111). The secret of "living art" is that it is "not painting, it's emotion, passion!"

And yet no paintings by Frenhofer are known. He allows no one to see them. He has worked for years perfecting his masterpiece, a woman's portrait, of which he says, "It isn't a canvas, it's a woman!" He never finishes, since to finish would be to betray his art and expose his woman to profane eyes, which see only a painted portrait and not a living woman. Finally he shows the "living" portrait to his pupil and to his pupil's friend, the young Nicolas Poussin who has bought the visit by bargaining away his mistress, so obsessed is he with Frenhofer's unknown work. As Frenhofer unveils his masterpiece to the two dumbfounded admirers, he comments on their reaction: "Ah ha! You weren't expecting such perfection! You're standing in front of a woman, and looking for a picture. There's such great depth to this canvas, the air in it is so real, that you can no longer distinguish it from the air that surrounds us. Where is art? Lost, vanished! Here are the very forms of a girl. . . . But she just drew a breath, I think! . . . that bosom, see? . . . The flesh is throbbing. She's going to stand up, just wait" (p. 127).

One look at the painting shows the shocked viewers that the old man has gone insane. The canvas is nothing but a chaotic jumble of colors, streaks, and lines, from which, at the very bottom, a woman's foot emerges. Poussin humors him for a while, but then bursts his illusion by pointing out that there's nothing on the canvas. The old man rails at him as a philistine who can't appreciate perfection. But then he capitulates to a reality he has resisted during his entire life as an artist. He breaks down, dissolves into tears, and dies that same night, having burned all his canvases.

Frenhofer's ambition is to create a work that overcomes the boundaries between art and life. His failure represents the impossibility of that ambition.[21] He wants not just to copy life, but to create it, to make the painted

image actually be, not merely seem alive. As Orpheus wanted, impossibly, to restore the dead Eurydice to life, charming and seducing the god of death by his music, Frenhofer wants his creation to rise above the limits of canvas and paint and reproduce the living woman. Frenhofer wants to be not just Frenhofer, but Jehovah and Prometheus. His design is even greater than theirs. They just created humans, humdrum and ordinary with a few exceptions. Frenhofer wants some essence, some quintessence. He wants to "revive heavenly beauty," and that is more than gods or titans aim at in creating the human race. Balzac's story exposes this ambition as a form of madness. Illusion will never become life.

But the impulse is one that viewers, museum visitors, moviegoers experience more weakly but still distinctly. Rationally speaking, the boundary between art and life is impassable. And yet a certain kind of art overrides rational judgment and insists on the reality of an intermediate realm between art and life. Charles Peirce described the passage between the two realms: "In contemplating a painting, there is a moment when we lose consciousness that it is not the thing; the distinction of the real and the copy vanishes, and it is for a moment a pure dream—not any particular existence and yet not general."[22] Georges Poulet describes the "spell" cast by reading: "When I read as I ought, i.e. without mental reservation . . . my comprehension becomes intuitive and any feeling proposed to me is immediately assumed by me." The state of being "gripped" amounts to the "possession of myself by another. . . . When I am absorbed in reading, a second self takes over, a self which thinks and feels for me. . . . The work lives its own life within me."[23]

If a work of art captures "overflowing superabundance" and an "indefinable something," then the life in it is as present, visible, and detectable as, say, the talent in a world-class athlete who happens to be standing next to you in a crowded airport. If you look carefully you can see it, infer it from the proportions of the body and the few curves available to view. The comparable effect of art displayed in a museum is available only if the sensibility of the viewer is prepared to receive it, either by need, aspiration, instinct, or education—lots of pictures filled with life and vitality, exerting will and exuding desire. The museum visitors who listen to guided tours with earphones have next to no hope of experiencing "life's superabundance" in art. The recorded guided tour is to art as a tutor is to the act of sex. Its job is to transmit knowledge and explain what you are to see and why—not to help you to lose yourself in the act.

In Love with Lady Agnew

John Singer Sargent's Lady Agnew sits comfortably in plush and boring Victorian surroundings in a chair crowded with ornament, backed by heavy, luxurious wall coverings (Figure 1). Her clothes are virginal and her furnishings proper. But I stop in my tracks because she has riveted me with her direct, almost indiscreet gaze, and it is far out of sync with her surroundings. Why does a woman dressed as she is, sitting in a chair like the one she's sitting in, look like she looks? Her beauty, the mystery of her dark smile, are at odds with her straitlaced Victorian propriety. And in the same way, her relaxed posture—crossed legs, a slight slump into the wing of the chair—is at odds with the gesture of her left hand. At first glance it looks as if it is hanging casually; in fact it is clutching the lower edge of the chair arm as though she were bracing herself for a shock. It is not the only sign of tension and instability. Her face and her whole presence are filled with a nervous sexual energy.

Her coal black hair, heavy eyebrows, dark eyes, and shaded lids are too shameless and gypsy like for her station in life, too robust for her white skin, too witchy for her flouncy purple ribbons and sash, her lumpy pearl pendant, and especially for the white rose falling from her right hand. A white rose? Shift attention back and forth between the face and the hand, and the hypocrisy of the flower gradually becomes evident. Are we supposed to believe the message of the white rose—purity, sanctity, the housing of the blessed in Paradise? At least the artist owns up to the discrepancy: her hold on the rose is loose: it sits precariously on her twilit thigh, as if about to fall to the ground, and so suggests her frail hold on innocence. Her head is slightly lowered (the dark pupils nestle into the upper eyelids) and her right eyebrow is slightly raised, questioning, inviting, intimate, and enigmatic (Figure 2). The gaze might be that of a woman of severe self-control considering a declaration of love, a proposed love affair—and consenting to it. Or perhaps smiling at her new secret with gentle, restrained self-satisfaction—after consenting. The artist seems to have caught her at the moment when she breathes easy at last, when the tension of anticipation and moral dilemma are followed by the relief of surrender—a surrender whose emblem is the released white rose. The prison house of chiffon and ornament, the bonds of purple silk cannot confine the other, darker, more secretive woman, in spite of the seeming acquiescence to this subjection. The full frontal view of the face is intrusive, indiscreet. It forces me to look at her with a directness that I could only experience briefly in reality, especially in communion with a woman like this,

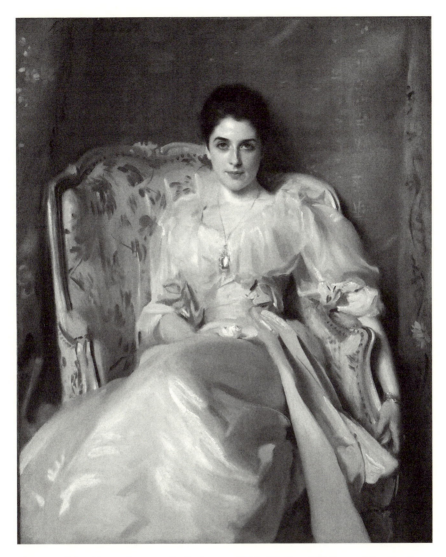

Figure 1. John Singer Sargent, *Lady Agnew,* 1893. (National Gallery of Scotland, purchased with the aid of the Cowan Smith Bequest Fund 1925)

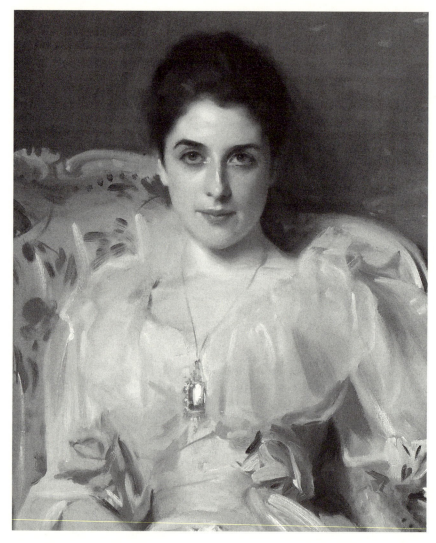

Figure 2. Sargent, *Lady Agnew* (detail).

from another world, a world where you do not gawk straight on and close
up into the face of highborn ladies. Sustained, this gaze becomes insistent. It
forces me to ask, *"Why are you looking at me like that?"* The look, full of
erotic interest, is an indiscretion. It ushers me, whom she doesn't know from
Adam, into intimate secrets in which I am privileged to participate. *"Why are*

you looking at me like that?" has a strong erotic edge. Her faint smile shades into gratitude at a shared secret.

Her aura is constituted once by the sense of reciprocal gazing and twice by the ambiguity of the gaze. The strength of her aura is in the portrait's luminous offer of intimacy. That gaze that knows secrets and shares them with a visitor to a crowded gallery breaks through the capsule that separates her from me, resolves the two realms—that in which Lady Agnew "lives" and that in which I look at her effigy—into one. That is the charismatic force of this work of art: it weakens the distinction between life and art and blurs the border between illusion and reality. If you know how to commune with this woman as her portrait invites you to, you can cross it.

Now admittedly the chemistry of this "relationship" is entirely personal; another viewer would find naive girlishness, uncompromised innocence, and sovereign self-possession in the portrait. However anyone else might react to Sargent's *Lady Agnew*, the flirtation with the image that I've just sketched makes a more general point: present but hidden on the surface of the work of art is a personality, a will. Its silent voice speaks to you; you hear it; you feel its authority, or charm, or hatefulness; you live briefy in its field of forces. The will and desire of the work of art operate on the viewer. Generally, distracted by crowds, by recorded art appreciation messages, and by hall upon hall of pictures waiting to be viewed, we sense them without being conscious of them, the way satellites feel the gravitational pull of distant planets. It doesn't matter if we "understand" the painting; it's just there doing what it does, behaving as it behaves. It has the potential to exercise an effect like a strong personality. But if a strong personality capable of loving passionately happens past you on the street, and you take it in, glancing up from the crossword puzzle, it seems ordinary and any intimate communication pointless.

Divinity Incarnate

Charismatic art sanctifies the immediate so as to create the momentary illusion of divinity in the individual, or of the eternal in the moment, or of indestructible existence, or of unfading beauty in what has long since passed, of happiness and its availability, or of the impotence of death. It lends charisma to the living being and bends metaphysics to the immanent,

as the tattoos of the harpooner Queequeg (see Chapter 2) coat him in cosmology, wrap metaphysics around his body like a mantle.

A distinctive element of charismatic art is a human "presence" in the artwork greater than that of the viewer, great enough that it often presents itself as godlike. Lacking that element, the charismatic effect is absent. If the superhuman figure is hidden in the veil of the everyday, then the effect can be so much the greater. Elia Kazan's *On the Waterfront* (1954) had as its main character a broken-down prizefighter who had sold out his integrity. Kazan cast not a pathetic loser but Marlon Brando in the role. Brando had already played Emiliano Zapata, Stanley Kowalski, Mark Antony, and was cast as Napoleon in the movie *Desiree*, in production when *On the Waterfront* appeared. These big figures were "ghosted" into the main character; Brando came to the role of the washed-up boxer trailing the aura of the man of overpowering force. His character cowers about, pitying himself and blaming palookadom on others, until the end of the film when humiliation, love, and revenge move him to a redemptive heroic act. While religion plays only an indirect inspiring role, it is powerfully present in the form of Father Barry (Karl Malden), rousing the cowed dockworkers to resistance and Terry Malloy (Brando) to lead them. Anyone inclined to do so can connect Malloy's victory over the corrupt union boss with Father Barry's speech rallying the workers to action (to the effect of, *"In every just act, Jesus will be with you"*). While many viewers will have made the connection between Malloy and Jesus, Terry's role of revolutionary redeemer stands without it. In this epitome of the American neorealist film, the fundamental contradiction at the heart of a literal-minded realism is evident. The story of *On the Waterfront* cannot work unless luminous heroism is hidden in the skulking main character, waiting for its moment of revelation. The implausibility of the conversion of Terry Malloy is overridden by the charisma of the star. The young Brando was often called "explosive" (like the young Robert De Niro). His self-abasing posture in the beginning of the film is an *actio humilis* joined to *sermo humilis*. Hidden among the characters "ghosts" and waiting to come back to life is a powerful, proud, dangerous, tough character with a soft soul (he loves Eva Marie Saint and pigeons), a strong conscience, and an inner nobility so much the more powerful for his earlier self-betrayal. The dynamics of the story required the resuscitation of a sort of superheroism; they hooked into the viewer's sympathy by suggesting that such a downtrodden character could beat John

Friendly (Lee J. Cobb) to a bloody pulp and end his tyranny over the work-
ers. "Realistic" elements in this film are subservient to its clear intent to
stage the resurrection of Terry Malloy and the resurrection of the workers
through him. The film sets hopelessness and moral degeneracy in place in
order to topple them in an act of courageous resistance. But the "realism"
of despair is no less contrived than the idealism of redemptive rebellion.
The film had to have a powerful and charismatic actor play Malloy in order
to override the common judgment that such transformations are not plau-
sible because not "realistic." In this case, and in many, realism is one tool
available to heighten charismatic hyperrealism, to create a disguise of
wretchedness from which heroism can emerge.

Charismatic art regularly taps into the experience that in religion is
called "epiphany." Epiphany is the sudden appearance of a character who
seems to have walked in from another world.[24] Epiphany gives the person
who observes it the sensation of the limits of common humanity overcome,
of the real existence and sudden embodiment of a spiritual world—as when
Christ, recently crucified and buried, appears to his disciples on the way to
Emmaus. Film lends itself especially to the creation of moments of epiph-
any: lighting, music, the size of the screen, and the response within the film
of an astonished observer of the epiphany. When Harry Lime (Orson
Welles) appears, suddenly lit up, framed in a barren house entrance, about
two-thirds through the film *The Third Man* (dir. Carol Reed, 1949), he
arrives with the force of a man returned from the dead. When Judy Barton
(Kim Novak) steps out of a bathroom in the Empire Hotel in Hitchcock's
Vertigo, she appears to the dumbstruck Scottie Ferguson (James Stewart) as
a lost love returned from the land of the dead, and the supernatural charac-
ter of the epiphany shows both in the green light that bathes the resurrected
Madeleine Elster (also Kim Novak) and in the quivery bliss that shows on
Scottie's face.

Epiphany appears to mediate real presence. What is dead, lost, invisible,
or unattainable walks, talks, and eats. It/he/she is not a sign pointing to a
meaning. It doesn't want to mean, it wants to be; it wants to get out of
meaning into life. One of the fundamental grounding forces of Western
religious art is the desire for the real presence of Christ. This desire is only
the religious counterpart of much more widespread and diffuse psychic
needs. Hypermimetic readings of art have to regard metaphysics not as part
of the ontological structure of the world, but as one of the illusions available

to the artist to satisfy fundamental needs. Who says that beauty is truth? Beauty is beauty and nothing else, or whatever else it is is purely accidental and available to modeling and shaping in many forms and directions by the artist, truth being one of them. It is a quality of the surface, of works of art or persons.

Hypermimesis–The Sublime–Charisma

An approach to art through hypermimesis and charisma opens theory of representation to many vectors, which mix in infinite permutations in various works of art. But at its most general, the argument opposes "hypermimetic" art to mimetic. Hypermimesis includes all modes that violate the mimetic and ignore or subordinate realism and the real. It embraces the sublime and the charismatic, in fact all representation that rises above what Aristotle called "our normal level" (see Introduction) and much that goes far beyond that level. Science fiction is hypermimetic and it is often sublime. It always violates or extends or redefines the laws of nature as we can experience them in everday life. Stanley Kubrick's *2001: A Space Odyssey* (1968) is the quintessence of hypermimesis; it has elements of sublimity that invite comparison with Dante's *Divine Comedy*. But it is anything but charismatic. It reduces humans to the impotent playthings of inevitable forces; it reveals worlds and dimensions of experience undreamed of in the quotidian. It leaves the viewer awestruck but does not, cannot, inspire imitation. Charismatic representation is a very specific form of hypermimesis; it makes common cause with the mimetic and disappears without it—as opposed to the sublime, which can shed mimesis altogether and accommodate the most extravagant fantasy. The sublime magnifies its effect the further it tends to the boundless, even the chaotic in nature. Charismatic art aims at heightening the human presence. It rises above mimesis of the ordinary, but does not abandon it. Charismatic art is beyond and above nature, while remaining within human bounds. Phidias's statues of the gods were recognizable as human beings, just humans of extraordinary size, strength, and beauty. The magnified semblance of life that it projects is authenticated and made plausible when its grandiosity looks mimetic or even when it is concealed in a dismal and unredeemed world, in which hidden powers of redemption assert themselves and win the victory over the opposing forces, as in the Gospels and *On the Waterfront*. Mimesis is a

mask that the grandiose assumes in order to appear real; it is a rhetorical trick to lure the reader/viewer into the belief that the hyperreal is real; it is what Roland Barthes would call an "effet du réel," a mimed appearance of reality with an ulterior motive.

The Illusion of a Reliable World

Charisma of art accordingly operates through grandiose illusions, which will appear to those not in their spell as phony or outright deceptive. Rational, critical thought mistrusts and resists charisma. Charismatic art requires mechanisms that break down the resistance to illusion. Astonishment is one of them. The apparition of beauty or courage beyond what anyone can observe in real life rouses astonishment. The appearance of the supernatural, the fabulous and the fantastic or the heroic, at work in everyday life also has that effect. Narrative trajectory can diminish the resistance to illusion, as I will argue in a section on narrative "dynamics" in Chapter 3.

Once the viewer accepts illusion as representing an attainable world, it becomes possible to live in the work of art and refashion life in imitation of that higher model. Love, desire, admiration, and envy also work to erode the resistance to illusion. Fear, terror, and threat, the abject and the terrible sublime, do also, but without the irreducible effects of charisma: identification, participation, imitation, affirmation.

Sigmund Freud addressed the power of illusions in deconstructing what he took to be the illusory character of religion. Religious beliefs are without substance, says Freud, though different from "errors" and "delusion." They are a form of wish fulfillment. The powerful need for a strong father who protects the helpless youth gets projected into the supernatural to create God the father. Comforting illusions are "an enormous relief to the individual psyche if the conflicts of childhood arising from the father-complex, conflicts which it has never fully overcome, are removed from it and brought to a solution which is universally accepted."[25] He did not question the efficacy of such illusions to influence behavior but rather their "truth value" and their "reality value." Illusions that "prove true" may be uncommon. But that influence, which we might call the "micro view" (the influence of individual embodiments of ideas on individuals) was far outbid by the "macro view" to which Freud widened the argument: the failure of

religion to allay the widespread discontent within civilization; the general immorality of the human race; the inevitability of disillusionment through fabulous, unprovable claims and the danger of discrediting the moral system that rode on them.

The only interest of a study of charismatic aesthetics is the power of illusions to influence behavior for good and for ill (and it does not exclude the "pure entertainment" value of illusion). I am just extending the discussion to a class of illusion that did not enter into Freud's essay: art.[26]

The influence of religious beliefs on individuals is an obvious fact of human life, but a fact so much in the force field of doctrines and metaphysical beliefs that their connectedness with the entire range of charismatic effects tends to be forgotten or overlooked. It is possible to see admiration for Mother Teresa as the diffusion of a larger admiration for Jesus Christ; but it is also possible to separate the two models starkly and see the former as a case of a much more general admiration for self-sacrificing devotion to the poor, the weak, and so on. Our admiration for Mother Teresa does not depend on the divinity or even the humanity of Jesus Christ. In the same way, humans admire acts of courage with or without any metaphysical grounding: if some bystander rescues a child from drowning or from a burning house; if a soldier throws himself on a bomb and dies rescuing his platoon—these acts have a power to inspire and encourage imitation that is not linked to any system of beliefs. If that force is captured in a narrative or a film, its inspiring power is harnessed. The decisive point for my argument is that that power is hardly diminished if the inspiring figure is purely fictional: the heroes of the Trojan War and the *Aeneid* in the ancient world, Roland, Tristan, and virtually every hero of medieval epic and romance, and so on down to Pierre Bezukhov, George Bailey, and most characters played by John Wayne. In fact, purely in terms of the power to inspire imitation, fiction is more malleable than reality and can exaggerate, aggrandize, fashion a world and a social situation that justifies and enhances many forms of imitable behavior with a freedom that is never granted to the real and the living, mediated by anecdote or journalism. It may be that religious beliefs and religious history are precisely such creations that heighten and aggrandize a small kernel of historical reality. To regard Christianity and Buddhism as personality cults, legend and doctrine as a fashioned charismatic world, is not far off the mark. And just as the moral status of big illusion does not necessarily depend on verifiable historical reality, so also it is not necessarily linked to conventional morality. The main character of

the film, *The Matrix* (dir. Wachowski Brothers, 1999), was a slick, handsome character called from his loner, loser role as computer hacker to be savior of the real world, which he rescues from a diabolical conspiracy of machines with the help of mystical powers of motion and invulnerability and a huge arsenal of firearms.

The Keanu Reeves character loomed in a number of copy-cat murders. There is now a legal strategy called the "Matrix defense," which has been an effective form of insanity defense. The film evidently had a part in inspiring Lee Malvo, the Washington D.C. sniper, and it has been mentioned in connection with the Columbine High School killings, which happened less than a month after the release of *The Matrix*.[27]

The power of charismatic figures to "educate" in the sense of creating individual values that work on behavior over a long term seems not in doubt. The corresponding effect in art is a matter of debate, but generally in the naive sense of questioning whether the values represented in fiction and film and embodied in charismatic figures are positive or negative. Their power to influence is not in question.

The Charismatic World and Its Effects

Charisma of art creates a magnified, exalted semblance of life. Its basic impulse is to create a world grander than the one in which the reader or viewer lives, a world of beauty, sublime emotions, heroic motives and deeds, godlike bodies and actions, and superhuman abilities, a world of wonders, miracles, and magic—in order to dazzle and astonish the humbled viewer and lift him, by emulation or envy, up to the level of the world or the hero represented.[28]

The grandeur of a charismatic world makes it desirable, places it just beyond human and natural proportions, and inspires imitation in the viewer/reader. That is, it has effects on the viewer/reader like the embodied quality of charisma. I do not know of scholarship broadly treating the imitation of art *by the beholder*, but it is an appealing topic.[29] Edmund Burke regarded imitation of art by its recipient as "one of the strongest links of society" and assigned to art a role second only to the living model: "[Imitation] forms our manners, our opinions, our lives. . . . Herein it is that painting and many other agreeable arts have laid one of the principal foundations of their power."[30]

Charismatic art gives the viewer the experience of "enlargement." Heightening, elevating, magnifying are in part the vocabulary of charismatic effects.[31] Hans-Georg Gadamer provided a marvelously compact German term for the effect. The experience of beauty, says Gadamer, produces a "Zuwachs an Sein," something like "growth in being," "increase of being."[32] Gorky's soul was sensitized and enlarged by the "enormous, fantastic sensations and agitations" that Tolstoy roused in him. The critical discussion of "the sublime" regularly treats the "enlargement, expansion, development," that flows to the subject from the experience of the sublime.[33] Longinus had chided an earlier writer for failing to recognize how through the sublime "we may be enabled to develop our natures to some degree of grandeur" (*On the Sublime*, 1.1).[34] Goethe gave a radical pronouncement on the "enlarging" effect: "the work of art raises man above his limits and deifies him for the present moment, which enfolds the past and the future" (see Chapter 9 below).[35]

Again, it's important to see the relationship of charisma to the sublime. The latter is a much broader category; the former a subcategory, the sublime encapsulated in a human presence. The imitative response cannot be roused by Alpine landscapes or volcanoes, only by an admired person.

The ability of charismatic art to captivate constitutes its transforming force. It asserts itself often as an "educating" force, taking the word in the sense of charismatic teaching, formation of character and personality, not transfer of knowledge.[36] The superhuman qualities of the hero can come to life in the enchanted reader, who can live the heroic life or experience the heightened reality vicariously. Charismatic art is functioning when it makes the reader want to live in the higher world it depicts, to think and behave according to its laws. The higher the epic world is elevated above the normal, everyday real, the stronger the magnetism that draws the reader upward out of the everyday into the realm of enchantment.

This effect registers vividly in the fan culture that develops around movies and television series. Out of the TV series *Star Trek* a culture has developed that is understated by calling it a cult following. It has strong reverberation even in the supposedly practical, reality-oriented world of science.[37]

The huge proliferation of *Star Trek* relics, the products and books spun off the show, the real-life imitations, and especially the "slash fiction" it inspires, are expressions of the fans' desire to keep the world of Captains Kirk and Picard alive and to live in it. So bound into that world is the

imagination of the enchanted viewer, that he or she thinks it out when it happens not to be playing on the TV screen, gives its characters new life, produces situations in which the viewer has an active role in it, where the world of Kirk and Spock widens to include and to affirm the fan's own world. Henry Jenkins, who along with other students of fandom has given the study of fan culture intellectual legitimacy, articulated this form of participating in fictional worlds: fan culture constitutes "a subterranean network of readers and writers who remake programs in their own image. Fandom is a vehicle for marginalized subcultural groups (women, the young, gays, and so on) to pry open a space for their cultural concerns within dominant representations. . . . For these fans, *Star Trek* is not simply something that can be reread; it is something that can and must be rewritten to make it more responsive to their needs, to make it a better producer of personal meanings and pleasures,"[38] and, I would add, to keep the fictional world alive, thriving and growing in the imagination, enriched by a role in it that the fan has imagined for him or herself. Jenkins referred to this fan activity as "textual poaching." But the term suggests a sneaky intrusion, trespassing on the property of others. I would say rather that the imagination of the fan, its intended recipient, "owns" the fiction, is the legitimate executor of the fictional inheritance. Kirk, Spock, Uhura, Scotty, stay alive in an escrow account controlled by the fan when the TV screen goes black; even without the TV set, their story "runs continuously in [the fans'] home movies of the mind" (Garry Wills's phrase). The fan as continuator is participating in the logic of a charismatic relationship. Kirk and Spock have to continue to live and act in the fan's inner world. They commune there, continue and deepen a relationship with the fan. The fan's life is absorbed temporarily into a heroic world; the fan lives adventure and high-mindedness and high-toned companionship, highly eroticizable. The laws governing intellectual property do not apply in the not-for-profit enterprise of the imagination.

It follows that the acceptance of illusion, the ability to live, at least temporarily, uncritically in an artificial world, is fundamental to charismatic art, as it is to the followers of charismatic personalities. Some form of belief is required: belief in the greatness of the person either present or represented. Beauty, eloquence, allure, the things that person promises or seems to promise, can generate that faith. However, that bridge to fictional realities via faith also points up the frailty of the connection. Both charismatic and mimetic art are charged with a high potential for instability,

since charismatic experience gives way to disillusion, and mimetic art to the corrosion of reality.

While charisma raises up the viewer, it also creates the greater space to fall: that is the grounding of the disillusioned fan's aggression toward the idol and of the intellectual skepticism that big illusion invariably provokes. Charismatic art creates a huge psychic investment in the model; one's self-definition derives from it. The discrediting of the charismatic figure is a diminishing of the self. In this it is the opposite of mimetic art in the narrower sense of realism. Pure mimesis is narcissistic and ends, like its patron god (apologies for the heaped sibilants) in stagnation, sterility, and suicide.

The imagination is a form of craving, like sexual desire and spiritual need, lodged between those two in the economy of the psyche. Some of the elemental desires most prominent in the inventory of needs of the human imagination, viewed collectively, are love, invulnerability, happiness, order, affirmation of self, destiny (a conviction of a sense in life and a goal toward which it moves), power, and control. If a person real or fictional appears able to provide access to those states, or even to persuade us of their attainability, we will surrender our will and critical sense to him or her in the degree to which we need them.

Transformation and Redemption

Charismatic art has a hypnotic and destructive potential, evident in the Nazi cultivation of charisma in sculpture and film, but also, closely allied, it plays on the messianic expectations of its subjects. These may sit at the grandest level of religious belief, but generally, and more relevant to this study, they are present in readers and viewers, reduced to human dimensions and transferred onto art and literature. One of the foundations of enchantment is an inner need for redemption, where the religious experience is the larger example of many more ordinary ones, rescuers of the spirit and soul in everyday life. I resist the tendency to regard movies and popular entertainment as "escapist." If redemption through the movies is escapist, then so is redemption through religion.

I mentioned earlier James Kirwan's skepticism about the sublime as a "life-enhancing" force (see note 33). Approaching the question from that

subspecies of the sublime, the charismatic, makes transformation through aesthetic experience plausible. If a charismatic personality can effect a transformation in a devotee—an effect that is unquestioned, to my knowledge—then so can a charismatic work of art. And we know from relationships in love, politics, and religion that embodied charisma transforms, overrides sentiments and convictions forming or formed, replaces them with others embodied by the charismatic person, and perceived by the beneficiary as higher.

Charismatic art enlarges because of this same ability to override personal conviction, suspend individual identity and judgment, and transport the beneficiary to a realm preferable to everyday reality where he or she vicariously feels and acts like a character more than able to master destinies that crush others, to rise above and overcome disasters with which that realm confronts him or her. That is why the opprobrium of "escapist" or "just entertainment" does not come to terms with the operation of charismatic art. To regard charismatic art as escapist is to insist that the only really engaging art is its opposite: art that stimulates critical thought, provokes analysis, shakes conventional values, challenges readers/viewers to solve enigmas.

While I don't doubt that charismatic effects can often be as evanescent as the buzz after a good movie or the resonance in body and mind after a great concert, I question that more lasting effects are nothing more than a romantic confection plumped up by misty-eyed aesthetic theorists. I can imagine a conversation of James Kirwan with Maxim Gorky or with "Alison" or "Carolyn" (contributors to *Starlust*), in which he explains to them how mistaken or shallow is their conviction that charismatic figures change, heighten, and sustain their lives.

The role of charisma in education is a case where charismatic effects are demonstrably more than "vague and arbitrary" products of an overenthusiastic theorist. No one would question that charismatic teachers or religious leaders can have a powerful transforming effect on the lives of their students or followers. Why should it be different with a literature or art that similarly inspires and leaves its mark on the recipient? Needless to say, that mark will vary widely with aspirations and need; it depends on the chemistry at work between fans and artwork.

The passage from Dickens's *Hard Times* that introduces this work sets out a mechanism within which the educating effect of aggrandizing fictions

is at work. Dickens claims the redemptive power of "dreams of child-
hood—its airy fables; its graceful, beautiful, humane, impossible adorn-
ments of the world beyond." The fragments of imaginative literature that
impressed the child in early youth, do not die out in the psychic life of the
adult. They provide a vision of grace, beauty, and humanity that remains
luminous within, though unseen. Those elements of life so difficult to sus-
tain against reality are alive and unconsciously active, Dickens would claim,
however corrupt or locked into "reality" the individual. He does not have
to believe in the dreams of childhood of a world beyond, just remember
them: "so good to be believed in once, so good to be remembered when
outgrown." I will return to this extravagant idea in discussing "the Rosebud
effect" (see Chapter 13).

James Kirwan could no doubt quibble with Dickens's claims, but aca-
demic intellectuals have different needs and aspirations than intellectually
starved children, romantically starved rock fans, or wealthy has-beens, once
vital, at the end shriveled up in their humanity, like Charles Foster Kane,
whose last word is the name of the sled he had owned as a boy.

The Redemption Narrative

In Chapter 11 ("Grand Illusions") I distinguish the "happy ending" from
"redemption narrative." Let's say, to put it briefly, the "happy ending" is a
cheap evasion of reality for maximizing film profits and pleasing uncritical
audiences, whereas the "redemption narrative," which also ends happily,
works within the dynamics of charismatic narrative, which are anything but
cheap.

Charisma works on the enchanted viewer or reader along the scale
between diversion, escape, redemption, exaltation, and transformation.
Hard times in real life increase its power to enchant and its usefulness to
the reader/viewer. When the individual or the populace experience reality
as dreary, boring, degrading, inhuman, or horrifying, then grand illusion
counts more than critical thinking and realistic representation that unmask
and reveal the very anxieties and horrors that one feels in abundance. Rea-
soned critical judgment and level-headed realism hold us captive in a world
we can neither tolerate nor change. The reality principle is a jailer. We slip
out of its strictures willingly in exchange for a life of fulfillment, beauty,

excitement, romance. This is the crisis to which the "redemption narrative" responds.

On the Waterfront, already mentioned, would serve to illustrate it. Chivalric romance in general is a premodern "redemptive" genre (see Chapter 6). At this point I'll just illustrate it with one example and leave further commentary to the chapters that follow.

In the movie *As Good as It Gets* (1997), the crabbed main character (Jack Nicholson), obnoxious to everyone around him, his life shrunk to a collection of eccentricities, walks through the office of his psychoanalyst, sees a group of waiting patients—anxious looks on the faces of well-educated, well-off, handsome people. He sizes up the existential problem torturing all of them, himself included, and pokes his stick into the beehive of their—and his—anxieties with the question: "What if this is as good as it gets?" The fear and alarm in their faces grow. The possibility that this *is* as good as it gets terrifies them, makes them imagine the reality they live in frozen at a moment of highest unendurability. A paralyzing thought: the amber drip encases you, the Vesuvian lava flow bakes you in place without destroying your life or consciousness. You'll be discovered centuries later, a breathing petrifact, half alive in the unending gloom of the everyday, reliving into eternity that last elastic moment of heightened tedium when a tidal wave of converging problems and irritations was poised to crash over you. There you were, calling, panicked, for the psychoanalyst, when suddenly some directorial voice rang out from on high, "Freeze the frame there, and print—over and over and over again. It gets no better than this!"

It has to get better. There has to be the person or ritual or magic word out there somewhere that will redeem the patients in the psychoanalyst's waiting room from the present. This quandary is so prevalent in the human condition that it guarantees the continuous urgent demand for a source of redemption and transformation. Religion is the most prominent source. The present study argues the role of art and literature in supplying it. The plain, unhappy, burdened waitress (played by Helen Hunt) is the messiah of *As Good as It Gets*. Its happy ending is the stock-in-trade of the redemption narrative.

The Jew or Christian in extremis calls for help "from the depths," *de profundis*. The psalm of the secular realm, of the world of habit and convention, is *de quotidianis*: "*Oh lord*"—or whoever: artist, athlete, hero, politician, psychoanalyst, rock musician, movie director, movie star, or the waitress in the café—"*oh, rescue us from the ordinary!*"

2

Living Art and Its Surrogates:
The Genesis of Charismatic Art

There [is] a basic level of reaction that cuts across historical, social, and other contextual boundaries. It is precisely at this level—which pertains to our psychological, biological, and neurological status as members of the same species—that our cognition of images is allied with that of all men and women, and it is this still point which we seek.

—David Freedberg, *The Power of Images*

The Body as a Work of Art

Imagine the living body as a medium of art, the way stone or brass are media of sculpture. Anthropologists know well the benefits of reading the body as an artwork. Bronislaw Malinowski, one of the founders of social anthropology, envisioned a "new humanism," not based on the study of classic works, but rather of living man, living language, and living facts: "and *mildew, patina, and dust* would not be like a *halo on the head of a saint, making a broken, putrid, dead thing the idol of a whole thinking community, a community that monopolizes thought. A man of genius gives life to these things, but why should he not be inspired to this by life itself, why should he not take life as the first subject to analyze and understand, and then with its light to get the other things unraveled?*"[1]

The logic of this plea suits my enterprise, but Malinowski privileges one-sidedly the object of his own discipline and puts down one of the

richest partners in the interactions of art and life, namely its written, painted, sculpted images. Malinowski sees "old" humanists as cultivators of "mildew, patina, and dust," and "classics" as their gathering surface. His point is that the makers of that monopolistic idol-worshipping community of thinkers tend to the opposite extreme: they lose sight of life and the living human being as the aboriginal of art, literature, and philosophy.

A return to traditional societies gets us fully into the logic of charismatic art in its original medium, the human body, which is the canvas, the uncut marble, the story seeking form and language, of primitive art. The decorated human body, the body in its representative function is art *avant la lettre*.

One of the fundamental impulses of charismatic art is to make the life force of the dead, of spirits, gods, or other higher beings, be present in the living and to represent this presence visibly. Body decorations are the instruments of this incarnation.[2] Tattooing and other forms of body art accomplish a kind of representation that does not divide, as western art does, into life on the one hand and art copying life on the other.

The body art that is widespread among both Western, first-world cultures and traditional societies—tattooing, mask making, body painting—joins life and art in the medium of the human face. Tattooing was practiced widely in the South Pacific islands prior to the French colonizing in the nineteenth century, which virtually wiped it out as a tribal custom. It was resuscitated in the twentieth century, though its ties to myth and ethnic identity had largely faded. The full meaning of the remarkable tattooing of the Marquesan islanders and the Maori of New Zealand is probably lost to recovery. But not entirely.

The vivid forms of tattooing in these cultures have a variety of meanings and purposes: they are believed to ward off evil, give strength and invulnerability, give fertility and sexual attractiveness, mark identity, cultural and personal.[3] Claude Lévi-Strauss can attest to the sexual attractiveness of tattooed Caduveo women (Brazil) by reporting with Gallic earnestness the reaction of European outlaws and adventurers, some of whom "described to me with quivering emotion the nude bodies of adolescent girls covered with interlacing arabesques of perverse subtlety."[4] Karl von den Steinen shows that the tattoos are meant generally to "heighten" various functions. They may protect the decorated parts from disease. They shield warriors, who receive them in initiation or prior to battle. Near the genitals, they give potency and fertility.

Figure 3. Maori facial tattoo (H. G. Robley, *Moko, or Maori Tattooing* [London: Chapman and Hall, 1896], fig. 6.1).

The tattoos were immensely important to the culture that created them; their meanings fan out broadly. Maori tattooing is "a visible embodiment of Maori culture."[5] Maori men say that without tattooing they are not complete men. Untattooed men are regarded as stupid, their faces bland and empty, a quality described in the Maori language as *papa-tea*, which means, "bare-boards."[6] In the period of Marquesan cannibalism, an odd prohibition had it that the nontattooed were forbidden to eat human flesh,[7] that is, they were excluded from one of the high prerogatives of the warrior

class. The chance of birth does not establish the right of warrior commu-
nion; tattooing does. And in the same way, the face is, in effect, not a face
until tattooed. The value of tattoos registers also in the pain it cost to get
them. They are applied by chisel ("face-carving," James Cowan calls it).
The face swells badly; it takes days if not weeks to recover. In the meantime
the tattooed person has to eat through a funnel.

Identity, both personal and cultural, is created by the tattooing patterns.
A simple illustration is that Maori chiefs dealing with Westerners signed
documents by drawing the patterns of their facial tattoos on them.[8] "In
native thought," Lévi-Strauss wrote, "the design *is* the face, or rather, cre-
ates it. It is the design which confers upon the face its social existence, its
human dignity, its spiritual significance."[9] Certain patterns could be the
prerogative of chieftains; they marked rank, power, and prestige.[10] Others
marked aristocracy. They were anything but interchangeable; they could
not be selected from stereotypes the way young people choose patterns
from a set of models available to anyone who happens into the tattoo
parlor.

A Maori legend tells the origins of tattooing. The story opens to view, I
believe, the grounding conception of formal tattooing among the Marque-
sans: a man visits his ancestors in the realm of the dead. They ask him,
"What brought you here?" He answers, "To obtain your services to make
on my face the lines I now see marked on yours." They paint his face, but the
paint washes off. He wants marks like theirs, which are permanent. They
send him to another set of ancestors, who carve his face and inject pigment.
These marks stay.[11] From this and analogous beliefs it is clear that the tat-
tooing has a vital religious role in a cult of ancestors; it represents funda-
mentally the presence of ancestors on the living body of the tribesman. The
foreground meanings of the tattoos, the constitution of tribal and personal
identity, flow from this belief.[12]

Tattooing joins the wearer with his or her ancestors; the living body
of the tribesman is signed and sealed with their "signature." The tattooed
face is the badge of identification with Maori of the past.[13] The living
human being looks out through the grid of a design work that superim-
poses the represented past on the living tribesman. In this the Maori and
Marquesans realized a goal that other peoples sought in the impermanent
means of body painting or masks.[14] The mask served the purpose of locat-
ing a god or totem or ancestor or hero on the body of its wearer. But
being removable it was only a temporary residence. Tattooing gives the

Figure 4. Maori chief's tattoo pattern (H. G. Robley, *Moko, or Maori Tattooing* [London: Chapman and Hall, 1896], plate 7).

ancestors a permanent abode on the body of the living, assures continued life as long as the traditional patterns are unbroken. (One can now imagine the kind of trauma generated in tribesmen denied the practice of tattooing by colonial powers: it meant severing the tie to their ancestors and the end of cultural tradition.) The tattoos are a mediating art form joining the present with the past, the natural with the supernatural world, the living with the dead.[15] Think of the tattoo pattern as a fingerprint in art, so to say, but that of a dead ancestor, which then becomes at the same time that of the living man. It is wrong to imagine the tattooing by itself as the work of art. The living man fully decorated is the work of art, whose meaning is reduced to that of a cipher if separated from the living body. The body gives life to the art and the art gives aura to the living.

A parallel conception comes from the African Bantu.[16] They conceive of a human being less as a physical creature than as a collection of forces,

called *muntu*. *Muntu* is the word for human being (it is the singular of *bantu*). Its root word, *-ntu*, means "force." *Muntu* conceives individual life as the sum total of the life forces that inhabit the individual at any given moment. Those forces include the living and the dead, the past and the present.

This conception of being as a force extending potentially across time, space, and modalities of existence erases the barriers between past and present, living and dead, reality and representation. It is possible for the dead to inhabit happily the living body of a single person: "A man was not only himself, but the karma of all the generations past that still lived in him, not only a human with his own psyche but a part of the resonance, sympathetic or unsympathetic, of every root and thing (and witch) about him." That's a quote from Norman Mailer's book *The Fight* on Muhammad Ali's fight with George Foreman in Zaire, otherwise known as the "rumble in the jungle."[17] Mailer read up on Bantu philosophy on his way to Africa and recognized in it something like his own convictions about the way people work, as well as ideas that applied well to the psychological sparring between Ali and Foreman—which he turns into contests of competing *muntu*.[18]

By living in successful negotiation with all the inner forces, a man can increase his own life force. It can also be increased by external ornament: a beautiful dress contains its own *kuntu* (a state of being in its visible form) and increases the *muntu* of the one who wears it, what Hans-Georg Gadamer would have called an "increase of being" (see Chapter 1).

Janheinz Jahn's book *Muntu* explains *kuntu* and *muntu* as not only philosophical and religious but also aesthetic concepts. If *muntu* is life force, *kuntu* is the external, visible characteristic, marker, adornment, that indicates the stature and character of the inner world. Jahn's book is partly about Bantu art. *Kuntu* is a modality of existence manifested. Happiness is *kuntu*, for instance, so are laughter and beauty. Hence image and form are among the constituents of *kuntu*. Masks give *kuntu*; so does rhythm, either in language, song, dance, or drums. Jahn explains this idea in the context of art, and of special importance is wood carving. Wood is the preferred material of art, because the tree lives and sends its roots down into the realm of the dead. The tree is "the road of the invisible ones." Stone, clay, and bronze are merely things (*kintu*), but wood enjoys special respect and reverence because it is living material and a means of transit for the dead into the realm of the living: "The respect . . . is never for the wood itself,

but for the Muntu-beings who have chosen it as their 'seat.' . . . 'Things' are 'available' to the muntu" (p. 156), but wood is especially so. It follows that the wood-carver shapes the wood to bring *muntu* into the state of *kuntu*, to make visible a composite of indwelling and inflowing (like sap from the roots to the branches) forces. The carver of a human figure is not representing an individual, but rather the "Muntu-face" given to the entire tribe in some primal time by an originating ancestor (p. 162).

For the Bantu, only art can function to reproduce life force outside a living being, but only under the limited circumstance of a medium that can claim contact with the bazimu, the dead who live, or at least survive, vicariously in living flesh and sort-of-living wood, a communication system between the two realms.

Also, the sculptor does not "think up" the tribal face; he has two sources: previous representations, and—more important as an immediate link to the past—the wood itself. The material of the art dictates to the artist what is to be carved. That is, the image is already in the wood, in the same state between life and death in which the *bazimu* exist. The idea will recur in this book in very different contexts, so I'll try to give it a clearer shape. The work of art originates outside of the artist; it has its own ontology separate from the mind of the artist, exists in a condition between life and art, resides in a prototype that gives its form, energy, and soul to the artist, who functions in the role of a mediator, one among many "creative" forces,[19] a transmitter of preexisting forms and stories into visible or legible form. Western traditions have fetishized the artist, but plenty of artists and writers have declared themselves "finders" of their works, not creators. Proust's Elstir, a painter so original that Marcel can compare him with the creator of the world, comes to believe late in life "that a not inconsiderable part of beauty is inherent in objects," and he may be voicing Proust's attitude toward his own work late in life: "I had arrived then at the conclusion that in fashioning a work of art we are by no means free, that we do not choose how we shall make it but that it pre-exists us and therefore we are obliged, since it is both necessary and hidden, to do what we should have to do if it were a law of nature—to discover it."[20] Hélène Cixous gives an impassioned statement of the idea: "If someone paints, what happens to the model? What relation does the painter have to the model? . . . It's the model who gives life whereas we think it's the painter. The painter is the one who takes the model's life. A metaphor for all the arts."[21] The prototype of the carved image is not anything in the external world. Bantu carving

has nothing to do with mimesis in the sense of "imitation of nature." Its purpose is "to 'reveal' behind the visible world 'a universe of hierarchically ordered life forces'" (Jahn, *Muntu*, p. 161). The carved wooden effigy conveys the existence of ancestors: "The Muntu face has . . . for example among the Yoruba, the expression of a person ecstatically united with the Muzimu" (p. 162; *Muzimu* is the dead ancestor, the singular of *bazimu*, as *muntu* is the singular of *bantu*). The ancestors bubble up through the root system, lodge in the wood, and are helped into their "Muntu face" by the action of the wood-carver removing superfluous material and allowing the contours of the universal tribal face to swell, recede, sharpen and round themselves into something approaching their original form. This is, of course, very different from the "Muntu face" of the living tribesman. Both transmit the ancestors, but only the tribesman lives; the effigy does not. It remains a special form of *kintu*, or thing. The distinction is important. Bantu art is not charismatic; neither is any primitive tribal art separated from the living body. Only the decorated living person is. No Maori would fall in love with the statue of a god or ancestor; no one would long to be like the carved statue, except in the sense of adapting the "Muntu face" to his own. The habitus of Maori behavior is no doubt formed in part by the sedimented customs, beliefs, and manners of the ancestors, but the statues of the ancestors have no teaching power.

And yet the full effect of charismatic presence is at work in the decorated tribesman. The tattoos or masks or paintings add to his existence and make his *muntu* strong. He beams depth, tradition, authority. Warriors admire and women desire him. The Muntu face with its strong *kuntu* makes him into a charismatic force.

So again we have a belief in the living body as a host for the ancestors. The richer and deeper a person's *muntu*, the greater his personal presence and authority. It follows that for Bantu the ultimate loss of stature is to die without progeny. It kills off the entire line of ancestors who have accumulated in the bodies of the host family.

Similarly the "carved" face of the Maori is a prototypical example of charismatic art—not yet displaced from its most ancient medium, the human body. The persona of the tattooed person is visibly "layered"; the facial grid reveals the relationship of natural to cultural and social man, of face to tattooed pattern. It also shows the element of "incarnation" that keeps close company with charismatic representation among Bantu and Maori as among Christians. The tattoos create a channel through which the

dead can pass into life and bridge the two realms. Once carved on a face or body they radiate the aura of a supernatural force occupying the living human being.[22]

Alfred Gell has argued in an influential essay that the arresting force of wood carving exemplifies a "technology of enchantment and the enchantment of technology." The "enchantment" flows from intricacy of design. The labyrinthine complexities, for example, of wood carving patterns, envelop and entangle the senses of the close observer. They draw him into a state like the one I have called "enchantment": diminished will, subjection to the wizardlike power suggested by technical complexity. Gell's main example is the carved prow board of outrigger canoes, which functions within the system of goods exchange (*kula*) in the interisland economies of the Trobriand islanders. "The purpose . . . is to demoralize the opposition, so that they will lose the capacity to drive hard bargains." The prow board, says Gell, exercises a magical captivating force by virtue of its technical virtuosity: "the opposition . . . cannot mentally encompass the process of its origination, just as I cannot mentally encompass the origination of a Vermeer."[23]

While the technical virtuosity of the kula prow board is indeed impressive, I am skeptical that carving skill is primarily the force that softens the bargaining tenacity of the opposition. The carvings themselves—not only the prow boards, but the ship boards as well—are crowded with coded references to birds and animals credited with special talents precisely in outsmarting opponents. The ancestors, or at least, heroic bargainers of the past, are present as well. A recent study of kula art says it plainly: "The significance of *kaidada* [a carved board] is related to its association with 'coming first' and may be connected to the competition between Vakutan men to 'come first' in kula by attaining the most valuables. At a more abstract level, the association of the *kamkokola* [carved yam house pillars, whose designs recur on the prow boards] and *kaidada* with a deceased man has relevance to the promotion of men beyond their lifetime as individuals whose names are worth remembering."[24] Enchantment through technology is a weaker explanation of the force of the kula board than enchantment through the carved presence of animals and men, living and dead, who lend their powers to the canoe owners and so "magnify them," "increase their being." The prow undoubtedly radiated power and inspired awe, but the mysteriously hidden life force in it spoke louder than the intricacy of design, though the two work together. Technology enchants, but not as much as ghosts, whether they appear in flesh or wood.

Another element in the prow boards and the boat carving generally is human charisma. The men who operate in the boat and benefit from its charming and intimidating force also lend their own charming qualities to the carving. Winning qualities of the kula bargainers are imprinted on the abstract patterns of the carvings: "Among the chief requisites of the men who take part in the *kula* are an attractive body and face and skill in speaking. When a man goes on a *kula* expedition, he uses betel red coloring to attract and influence his partner. The capacity to charm people with words and the semantic beauty of sentences are also of fundamental importance. These elements . . . have parallels in the *lagim* [prow carving]."[25] According to Giancarlo Scoditti, the terms for prow and ship are also the words for "face" and "body." The prow and gunwale carvings taken together constitute an abstract human body, but one in vigorous action.[26] This move to inject human charisma into representation is a basic grounding impulse of charismatic art. Many examples that I cite in later chapters provide parallels to the "charm," "eloquence," and persuasive skills of the Trobriand prow boards. The means of enchantment are clearly not limited to the technology of carving.

Robert Redfield's distinction between "art" and "icon" seems useful here. "Art" is form, style, technique, all that Alfred Gell would include under the "technology" of art. "Icon" is content: myth, powers, magical forces, ancestors. You can pray to the "icon" part of the primitive statue. Worship brings its mythic powers back to life and charges them to act again in the present.[27]

These features of tattooing, mask making, wood carving in some tribal societies are widely shared in very different forms in Western traditions and in much charismatic representation generally. The common feature is the tacit claim their wearer makes that might run, if spelled out in speech, "*I am not myself alone. Gods, spirits, saints, ancestors, precursors and mythical figures live again in me; I have the nation itself in me (or the spirit of love or Truth or whatever) in its pristine form. The presence of destiny in me strengthens my existence; the supernatural beings who live in me extend my being from the here and now into the beyond. They testify to my mission in life.*"

Westerners have tried to "read" the tattoos of Maori and Marquesans. Herman Melville, who spent some years living in the Marquesas, described the tattooing process in detail in his memoirs of the stay, *Typee*. In *Moby-Dick* he gave an interpretation of the "readable" patterns of tattoos. The narrator, Ishmael, befriends the harpooner Queequeg, a tribal chieftain

turned whaler, whose entire body is covered with strange tattoos. Melville/
Ishmael explains them: "This tattooing had been the work of a departed
prophet and seer of his island, who, by those hieroglyphic marks, had writ-
ten out on his body a complete theory of the heavens and the earth, and a
mystical treatise on the art of attaining truth; so that Queequeg in his own
proper person was a riddle to unfold; a wondrous work in one volume; but
whose mysteries not even himself could read, though his own live heart
beat against them."[28] The occasion for these observations, late in the work,
is the making of Queequeg's coffin. He anticipates his death and so has the
tattoo markings on his body copied onto the lid of the coffin. Ishmael's
"reading" is a Westerner's fanciful view of what the tattoos might have
meant. But it does interpret an important aspect of tattooing in traditional
societies: the primacy of the body over the text. The chieftain's body has
high charisma and is a precious medium appropriate to tribal wisdom as a
prerogative and duty of his rank. This is far from the Westerner's begging
immortality from art and making wisdom permanent by marks on parch-
ment and paper. The tribal wisdom is recorded on the most precious
medium available: the chieftain's flesh. The body lends life force to truth
and history, gives important ideas a suitable medium. Imagine Americans
demanding that the Constitution, Bill of Rights, and Gettysburg Address be
carved onto the body of the president because mere paper and ink are
cheap and contemptible, a suggestion closer to the mindset of Kafka's story
"In the Penal Colony" than to charismatic representation. A Westerner
might well urge that it would make better sense for Oceanic tribes to write
these things out on parchment or paper. The suggestion would probably
have seemed not only ridiculous ("*Who could believe that animal skin or
dead matter channel the Bazimu and support life?*") but also demeaning to
any Marquesan. The irreplaceably valuable flesh of the chieftain is a far
more worthy medium than dead paper or animal skin. The "constitution"
of the people "lives" on the living body, but dies on paper.

It is the modern Westerner speaking also when Ishmael ends with the
mutability theme: "and these mysteries were therefore destined in the end
to moulder away with the living parchment whereon they were inscribed,
and so be unsolved to the last" (*Moby-Dick*, chap. 110). Queequeg is not
insensible of the usefulness of surrogates, however, since he has his tattoo
patterns carved onto his coffin lid, where they will outlive his body. The
choice of wood may have seemed to Queequeg (if not to the ship's carpen-
ter) a suitable medium, at least if he was privy to the notion, sketched out

above, that the living tree from which it comes once reached with its roots down into the realm of the dead ancestors and preserves elements of their life force.[29] But whatever Queequeg might have known, the gesture of moving his tattoo markings from their dying medium onto an "objective," at least no-longer-living, medium, preserving them by re-presenting them, repeats a moment in the history of charismatic art that is central in its development from living body to artifact: the move from living art to a surrogate. The coffin lid may be regarded as a splendid work of art; it may even lead Westerners to imagine some secret cosmic coding, as Melville did. But it has its charismatic charge from a living being that provided it. Charismatic art comes about in synchronization with the living work of art, and charismatic art in a nonliving medium always comes trailing reminiscences of a living embodiment behind it. It derives from some composite of charismatic force, which is either present or absent. If present, it inspires or provides the art (as does Queequeg); if absent, then by provoking recuperation or resuscitation of the lost life force.

But in this context, the primary phenomenon is the human body and the human presence. Art is an afterthought, however prominent it has become in our culture.

Art as Surrogate

We can understand tattooing and other forms of tribal art by regarding them as a kind of funerary art, which allows the dead to reside in the body of the living, lets death assimilate to life and the grave to the body. The Maori tattooed the imprint of his ancestors on his body out of an impulse at least distantly related to the one that made Queen Artemisia drink the remains of her dead husband. The story has it that she built a shrine to her husband, King Mausolus (d. 353 B.C.), had him cremated, poured liquid into the vessel containing his ashes, and drank it—a radical form of partial or artificial "revival": the king's wife shares her body with her husband's remains and so makes herself into a living tomb. Or rather, her living body becomes a medium in which the dead remains of her husband can participate immediately though artificially in life. It is analogous to the Maori tattooing, but whereas you cannot see Mausolus in Artemisia, you can see the dead ancestors in the face of the living Maori.

But ingesting the dead only partially satisfies the impulse at work. Otherwise why build the Mausoleum? The presence of the dead also had to be visible, at least perceptible, and commemoration through ingestion remained essentially a private act. It left the dead husband inaccessibly, invisibly circulating in the wife's body. The public counterpart requires ritual and representation.[30]

We now have a grasp of the logic that says, "*We want the dead to live and we want to restore their presence. Therefore we put the living body at their disposal and imprint their magic signs on it, make our face their face. That's how we give renewed life. Everyone benefits: the dead because they inhabit the living; the living because their vital force and their perceptible aura are increased by the presence of the dead.*"

But what peculiar long circuiting and rerouting occurred in the West that moved away from the living body and shifted to the work of art as the medium of incarnation? Suggest to the precolonial Marquesan that a realistic, idealizing portrait of the ancestor, or maybe a biography, or maybe a photograph, would work better than tattooing, and he would probably laugh. Why would he want his ancestor on paper or cloth when he can live again on the living body of his relative? The dialogue would continue something like this:

I: *But you're going to die. Then your ancestor will die with you.*
Marquesan: *Then my sons and daughters will wear my signs and I'll live through them.*
I: *But suppose they didn't wear them. Suppose they just left their faces untattooed?*
Marquesan: *That's unthinkable. They would cease to be Marquesan, and their ancestors would really die. No one would be foolish or arrogant enough to do that.*

The idea of making a mimetic, realistic semblance of the dead person must have appeared (and did appear) shocking and irreverent to those disposed to believe that the dead are still alive, just not as accessible as earlier, requiring mediation to make them at least partially present in the land of the living. How selfish it would be of the living to deny occupancy of the precious space of their living bodies to the dead (rather like preferring ignorance to wisdom and weakness to strength)! How vulgar to shunt off that duty to wax, stone, or canvas!

For whatever reasons, in Western traditions art becomes the surrogate; the likeness becomes an alternative life form of the dead. Charisma transfers into art,[31] not as Queequeg's tattoos transfer to the coffin lid, but in something like a living effigy of the individual. Admirers of Western art can fall in love with, grieve for, admire, feel the authority or sexual attraction of a portrait. Art and other forms of representation are regularly made into the means to overcome the impermanence of life. They have a kind of limited permanence. They confer worldly immortality, which can even be seen as preferable to the condition of the living. Keats envies the frozen beauty of the world on the Grecian urn and despises lived experience that dies away even as it unfolds. In Christoph Ransmayr's novel *Die letzte Welt* (1988), the character of Ovid, the aged Roman poet living in banishment, finds his fading mind soothed by the mere thought of a statue, balm compared to the "loathsome, stinking process of physical decay with its worms and maggots": "In comparison with this revolting state, the condition of stone seems like a form of redemption, like a gray road to the paradise of slag piles, quarries, and deserts. The meteoric splendor of life is nothing, the dignity and permanence of stone everything."[32] Petrifaction looks good when the alternative is putrefaction, though the value placed on "the meteoric splendor of life" may vary: Yeats's voice in "Sailing to Byzantium" reverses Keats's realms of desire and contempt. The old poet morphing into a work of art is moved by a deep pain at the loss of life, youth, and vitality. The cold "artifice of eternity" waiting for him gives him frozen immortality but doesn't console him for the teeming world of life he's leaving behind.

The urge for fame and immortality is another motive for replacing life with art. Jean-Paul Sartre as a young man found the realm of literature far more glorious than life, and he found metamorphosis into books the form of preservation appropriate to his exquisite mind and figure. He wrote in his autobiography,

[I discovered that in literature] I could replace the rumblings of my life by irreplaceable inscriptions, my flesh by a style. . . . I would not write for the pleasure of writing, but in order to carve that glorious body in words. . . . I, twenty-five volumes, eighteen thousand pages of text. . . . Hands take me down, open me, spread me flat on the table. . . . I flash, I dazzle, I command attention from a distance. . . . No one can forget or ignore me: I am a great fetish. . . . People read

me. . . . My blessings . . . force [mankind] to keep reviving my
absence.[33]

Notice that neither Sartre nor Ransmayr's Ovid reach for the trump card
of the philosopher or poet, the idea that they live on in their written works.
This is not a selfless, philosophical gesture, an expression of faith in the
permanence of the works of the mind. They want an alternative to the
decay of the flesh. It is egotism turned sentimental and nostalgic, the love
of self and life desperate to guard the endangered object of love by "carving
that glorious body in words," as Sartre put it. The thought is close to
Woody Allen's quip that he wants to achieve immortality—not by writing
immortal works, but by not dying.

The motives for biography bring us closer to the roots of charismatic
art. Take the example of Socrates. He wrote nothing, left no works, letters,
or memoirs. When he died his students and disciples could have compiled
his ideas in dry expositions, outlines, tracts; they could have systematized
his thought. Instead they wrote vivid dialogues evoking the presence of the
living master. The master's thought by itself was not what this was about;
that was only a part of what he meant to them. It was the charisma of
personal presence, the grace and wit of personality, the vitality, the irony,
the heroism, the timbre and inflection of voice—partly recoverable in the
sounds and rhythms of the language—the rhetorical tricks and strategies,
the rhythm of gesture, and the drama of Truth-discovered that he staged in
every dialogue, that made him the teacher he was. These personal qualities
had to be transferred postmortem into a written form that conveyed some-
thing like the charm, force, and authority that beamed from the real pres-
ence of the man. Words had to become or to re-present an exceptional
human being: "The chief aim of [Socrates's] pupils was to re-create the
incomparable personality of the master who had transformed their lives.
The dialogue and the biographical memoir are new literary forms invented
by the Socratic circle to serve that purpose. Both owe their existence to the
conviction of his pupils that Socrates' intellectual and spiritual power as
a teacher could not be dissociated from his character as a man."[34] The
memorialization of Christ took the same route. It would have been possible
to formulate the teachings of Jesus as doctrine, organizing it, say, according
to topics. Eventually medieval Scholasticism did so and brought Christian
intellectual culture to one of its low points by its rationalistic cavilings.

Christ's "system of thought" or of doctrine must have seemed to the evangelists a minor factor compared to the living presence of the teacher, from which his teaching would have appeared inseparable. At least to separate them would have robbed his teaching of its charismatic force. What they needed was not organized doctrine but an evocative narrative, a drama of his life that brought the master back and gave voice again to his own words and something as close as possible to a body for that voice.

Socrates and Christ both died martyrs' deaths: rigged trials, imprisonment, torture (mockery in the case of Christ), and death. That fate relates intimately to the recorded versions of their teachings. The precious body tortured, crushed, and destroyed gives strength to the master's ideas—he died rather than betray them. That makes them not mere ideas but the terms of a sacrifice. Ideas, thoughts, teachings may be powerful in themselves, but add to them the weight of persecution and death suffered in their name, and they are no longer merely products of the intellect, but things more precious and more valuable than life. The sacrificial death of the master lays foundations deep in the souls of the disciples, stronger and more durable than anything as comparatively trivial as knowledge—and it stokes the desire for a surrogate physical presence. This sealing and affirming effect of sacrificial bloodshed is a transference process related to charisma in art. The tragedy of the sacrificed teacher gets taken up into the ideas, as Christ's sacrifice suffuses every aspect of Christian doctrine, and the sacrificial instrument, the cross, becomes the dominant symbol of the religion.

The commemorator of a charismatic teacher, leader, lover needs to transfer the dead person's living qualities into words or stone or paint on canvas; the artist needs life in representation. A mere copy won't do it. The dilemma of the bereaved now coincides with that of the artist: how to inject life into art.

Charismatic Art

The biographer or artist or monument maker discovers charismatic representation when he realizes *the impossibility of his enterprise*. He tries to bring Socrates—or Christ, or Buddha—back to life, and he senses failure in every word or brushstroke; language reveals itself as a preservative, not a magical, life-giving salve. He compares the master's presence—transformed by

memory into a charmed vision—with his concocted words and smells embalming fluid and mummy windings. What life writing (bio-graphy) actually succeeds in rescuing is hardly a leaden echo of the longed-for physical presence. He needs more effective means of getting life back by words and brushstrokes.

It is the disappointment of the death mask or the Polaroid photograph. A direct copy of life as it presents itself at any given moment is anything but charismatic. It is flat, vulgar, and ordinary; it captures the momentary accidents of appearance, not the magical enchanting effect of gesture and expression, and it rigidifies the subject. The camera is in a sense the face of Medusa. It freezes its object in a fixed and unchangeable moment. The photograph "represents that very subtle moment when . . . I am neither subject nor object," writes Roland Barthes, "but a subject who feels he is becoming an object: I then experience a micro-version of death."[35] Any movie director knows that recording an actual event, no matter how charged with drama and meaning, is a formula for producing flat, TV-news-like, home-movie-like, reality-show-like scenes. The cinematic fact is that rolling a camera on Golgotha in the moment of Christ's crucifixion is bound to produce a trivialized, aura-deprived record of the event, which can only be reproduced with something like its human and cosmic tragic force by the whole panoply of staging: the right actor, makeup, dramatic lighting and music, a constructed—or, now, computer-generated—set, and a carefully planned script. On film Max von Sydow, Willem Dafoe, or Jim Caviezel look better as Christ than Christ himself. The acceptance of that fact can only trouble someone who still straddles the line between real and represented presence and regrets the false, cheating imitation.

In the same way the longing of the bereaved disciple for the master's resurrection can only be fulfilled by renouncing real presence in favor of symbolic. It requires a heroic act of resignation. The worshipper is placed before the alternative of the living Christ and Jim Caviezel (or some equivalent). It is the dilemma of Orpheus leading Eurydice out of the underworld. He has to have the assurance of her real presence; he can't go on without it. But that need to really see her means he loses her forever and moves forward alone into the real world where art can reconstitute a shadowed presence of the beloved—but nothing more.

The acceptance of representation is this Orphic moment, a sacrificial act that renounces the lost charismatic presence and substitutes charismatic art.

Figure 5. Tomb of Archbishop Henry Chichele, Canterbury Cathedral, ca. 1426.
(Photo courtesy of Canterbury Cathedral)

Every representation of an individual presupposes the renunciation of
the real person and his reconstruction by artifice. The dim memory of this
renunciation is buried at an early point of its aesthetic archaeology.[36] There
is not only pleasure, interested or disinterested, in looking at a portrait, but
also, more deeply buried, pain and nostalgia. Every portrait is a reminder
of lost beauty and vitality, every golden bird on the emperor's tree, frozen
into a beautiful but false artifact, points silently back to the mackerel-teeming
world. And while I may see erotic promise in the painted portrait of a
woman from the Renaissance or nineteenth century, like Sargent's Lady
Agnew, still, hiding just behind that promise, peeking over its shoulder, is
the awareness that the real, the once real woman, is a moldering corpse,
unable to give the happiness her portrait intimates. The medieval "transi-
tomb" graphically lays out the two realms of art—death and life, mutability
and worldly immortality. It is a two-tiered sarcophagus with a statue of a
king or bishop on the top decked out in greater than living splendor, while
on the lower tier, just beneath, only a little hidden behind pillars, lies an
effigy of the same man's rotting corpse (Figure 5). The medieval sculptor,
or the conceiver of the tomb, knew what a liar he was in carving glorious

kings and bishops and knowing they were stinking sinners and food for worms. So he forthrightly showed them as both glorious and putrid. Other portraits lie forthrightly; they suggest a permanence of sensuality, beauty, virtue, wisdom, splendor, and magnificence. And the decomposed quintessence of dust is not around to refute them. From pictures of dead parents, ancestors, lovers, we can only regret what is lost. Mercifully we do not see their present state.

But suffused in the aesthetic effect of art is a troubling hint of the cover-up in progress, some intimation of lie and falsehood—and consequently an inexplicable sense of loss—in the substitution of symbol for reality. Ernst Gombrich tells an anecdote of a little girl who was upset at the many Christmas cards her parents received, because she could not tell which nativity scene was the "true" one.[37] He does not spin out the anecdote any further, but we can imagine the girl even more upset when she learns that none of them is the real nativity. They are all imitations. The real one is lost to view forever and no one knows exactly how it looked. But basically all grown-ups accept the false because it at least reminds them of the "true" scene. But it is an acquired forgetting, and the false must meet various criteria so as not to stir up the ancient disappointment at unrecoverable loss. If the false scene re-creates an atmosphere of magic and miracle, that is good enough for adults.

The birth of charismatic art takes place when the artist, as agent for the mourner, discovers how to create illusions powerful enough to compensate for loss. A charismatic text is one especially capable of this re-creative act. In it the flesh becomes word (or stone or paint or sound)—not fully and adequately, any more than Eurydice's shade becomes Eurydice fully and adequately—but more intensely than in texts not based on word or picture enchantment. The charisma of the text overrides the viewer's reluctance to substitute magical symbols for charismatic presence and so facilitates the Orphic moment of resignation.

The Textual Contract

This view of the genesis of the work of art in its relation to life presupposes the primacy of the body and the living human being over representation.

The admired, beloved, longed-for, or feared body is the point of origin of art, even when there never was an actual living model.

This view posits an order of works of art made to replace the human presence, not in order to satisfy aesthetic impulses or give vent to talent, or to express something abstract like Truth or Hegel's "die sinnlich scheinende Idee." The rescuing and resuscitating impulse is the aboriginal motive of this art, its hidden inspiring force, whatever motives are at work in the foreground. Every work of art belonging to this order sublimates body and real presence into the fabric of its aesthetic.

Is this anything but a metaphor? Is it possible in any real sense for body to be present in text, but diffused and unrecognizable as body, just sensed as some kind of intensity of style or persuasiveness of evocation that is the literary counterpart of life force? It is possible, if only in the effect of the artwork on us. Any time we sense charm or erotic energy or forcefulness or vitality in a work of art, we are feeling qualities borrowed from the physical presence. Thomas Mann gave a virtuoso description of an artist sublimating the body and desire into the text in *Death in Venice*. Watching the young boy Tadzio swimming at the edge of the Venice lagoon, the aging distinguished author, Gustav Aschenbach, "felt a sudden desire to write":

> This boy should be in a sense his model, his style should follow the lines of this figure . . . he would snatch up this beauty into the realms of the mind, as once the eagle bore the Trojan shepherd aloft. . . . [Aschenbach produced] that page and a half of choicest prose, so chaste, so lofty, so poignant with feeling. . . . Strange hours. . . . Strangely fruitful intercourse this, between one body and another mind! When Aschenbach put aside his work and left the beach he felt exhausted, he felt broken—conscience reproached him, as it were after a debauch.[38]

The essay Aschenbach produces is about something totally unrelated to an old man's passion for a beautiful young boy, but it beams the sensuality and sexual tensions of their "intercourse," transformed into prose, the subject of which is unrelated to seduction and sex. Tadzio is still present in the text, the sexual tensions of the encounter still alive in the prose, but neither is perceptible in the original form, a desired and ravished body, only sublimated into the elegance of the essay.

From this point of view we must not imagine the discovery of the rescuing force of art, when separated from the living body, as somehow "progressive," as a breakthrough and an overcoming of a primitive and savage relation to art that has no use for it other than as an adornment for the body. When the living human being goes to art to ask it for immortality, he does so, not in awe of the grandeur of art (a comparatively modern attitude) but rather as a down-at-heels prince goes to a moneylender. The old arrangement ("*The body by itself constitutes my beauty and contains the combined life forces of me and my ancestors*") has lost its efficacy, and the stone and canvas copy is the best thing available at the moment, which the anxious, dying mortal accepts *faute de mieux*.

But the inducements for him to make his arrangements with texts, copies, artificial preservatives, are complex and important in understanding the genesis of charismatic art.

Bodies and texts (in whatever form: written, painted, sculpted, and so on) have complementary virtues and complementary insufficiencies. Living bodies charged with gifts and talents have life, vital force, ego, consciousness, emotion, sexuality, authority, charisma, and fate—but none of them lasts. The body ages, shrivels, fails, and dies; its qualities weaken and fade. Of course "it" (if I may generalize the agent of this wish and locate it in the body itself) wants to maintain these desirable but perishable qualities. The perishable body wants permanence; the ego tells it that it deserves it. It wants to be "the great fetish," again and again revived by mankind, compelled—to use Sartre's language—by the blessings it promises. Faced with this existential dilemma, the Westerner sought help where Sartre did: he would "replace life with inscriptions, flesh with style," would "carve that glorious body in words" (the title of Sartre's autobiography: *Les mots*). Words, poems, biographies, and novels can do that. So can statues and paintings. They last. At least they last longer than a human life span.

But they also have their own form of incompleteness. They have no substance. They are nothing in themselves but words and sounds, weaving and patching, ink and paper, stone and canvas. They are not alive, but also not exactly dead. They are worthless unless they can persuade humans that they are sublime, immortal, permanent. That is the agony of texts that answers to the agony of bodies (expressed by Sartre and Woody Allen anticipating the loss of their precious bodies). The condition of life of the work of art is illusion, imitation, artifice. The work of art is a beggar with pretensions to glory. Its existence is based on a long-term lease. It is nothing

without life, a state it always longs for, but can never attain. Art and literature need the qualities of body, which can never arise naturally from within the work of art. The body is the unique and exclusive originating place of voice, authority, grace, sensuality. Even if the artist produced, by great rhetorical skill, the semblance of a heroic human being and the whole drama of the heroic existence, it remains a form of cheating. Pictures and texts can never come to life, but they, their creators, and their readers/ viewers never stop dreaming that Orphic dream and longing for that condition. The artist is the agent of deception and illusion. The desire for living works of art, life captured in art, exists powerfully in the subject and in the work itself. The artist who negotiates between them has the qualities of a skillful salesman who will arrange the deal at all costs by making the commodity appear irresistible, the means to gratify the customer's desires.

The complementary insufficiencies of life and art are the terms of what we can regard, in a kind of thought exercise, as a contract between them. Each party to this deal has what the other wants. The body says to the text: *"Give me permanence, and I will give you life."* The text answers: *"Give me life and lifelikeness, and I will make you immortal."*

This is the birth of the charismatic work of art from the charismatic presence. The desiccated word and sign magic of art is pumped full of the charisma of the body and takes on the appearance of life. This dynamic works smoothly, because the interests of the two parties coincide perfectly. Life lives from art and art lives from life.

The working of the textual contract in Western art is evident by contrast to cultures that refused to enter such an arrangement: the stiff, hieroglyphic character of Egyptian art; the hieratic, symbolic codes of Native American art; the runic-hieroglyphic character of Scandinavian art of the Viking age. The art of heroic cultures shows in its sparseness a refusal to inject life into images, an aristocratic unwillingness to profane the mysteries of the precious flesh by copying them out on stone, canvas, or photographic paper, vulgarly publicizing and dangerously exposing them in substitute signs and symbols. Texts and artworks may be important for such cultures, but they, and not the charismatic body, are the beggars and petitioners. This posture has a counterpart in the reluctance of many cultures to make images, or to speak the true name, of their gods. The modern Westerner stands in awe in front of a portrait by Holbein. But viewed by someone from a culture not bound by the textual contract, lifelike, idealizing portraiture is dishonoring. A Native American chieftain or warrior might well wonder what kind of a

man its subject could have been to allow a workman to entrap his charisma in canvas and pigment—the better the art, the greater the self-betrayal of the subject who lent his shape and appearance to the forgery, willing submission to the theft of what is most precious. The modern Westerner, having no concept of the rejection of representation, imagines that the mimesis-renouncing culture is aesthetically less advanced than his own, since its art is so unlifelike, thinks of their art as childlike and naive. And the endpoint of this misreading is the idea that the abstractness and chasteness of nonrepresentational heroic art must, after all, be somehow lifelike and mimetic in the eyes of the cultures that produced it. It is a misunderstanding to imagine that such cultures produced stiff, or abstract, or stick-figure, hieratic art because they were incapable of mimesis, that Western traditions of mimesis represent sophisticated advances in conceptualizing and making art. Hieratic art is sparse because it refuses or rejects representation, not because it is inadequate art.

The charismatic cultures that resisted the textual contract sensed its costs and were unwilling to pay them. The Native Americans who refused to have their pictures taken because they imagined the camera would entrap their souls understood the deal representation makes with charisma. If they read Virgil, Shakespeare, and Tolstoy, they might well say, "*If it goes on like this, you won't have any more warriors and heroes—or rather, the only ones will be artists.*"

"Living Art" and Its Mythology

The portrait exists as a genre because of the need to replace the living with the artificial presence. Other genres where a text presupposes a human presence and would not exist without it are the letter, the biography, and—the form of textualizing we all will experience, charismatic or not—the gravestone. These media function to restore or reclaim or re-present an absent human being: the portrait's model, the letter's writer, the biography's subject, the grave's occupant. All of them are means developed to overcome absence in whatever form, be it distance or death. Charismatic representation belongs in this series but is different in that it is able to exist without models. It evokes human presence without depending on it. If there were no living Lady Agnew, there would be no Sargent portrait of her. But whether or not there had ever been a living Hamlet or Ophelia,

they still live powerfully in Shakespeare's evocation of them; they have a presence that in some way is comparable to that of the woman in Sargent's portrait. All of them are artificially called to life. A force field surrounds them that has the effect of a living human being, their presence, their personality and character condensed radically into a few strokes of the brush or a few acts on the stage. The insistent belief in the "life" of works of art is a symptom of that powerful need for a surrogate of a lost or missing person.

That need produced a folklore and a mythology of "living art." Pygmalion's desire for his statue is strong enough to soften the goddess into answering his prayer for a living Galatea;[39] so is Geppetto's love of his wooden puppet Pinocchio (in the Disney movie, not the original story). Religious icons have a kind of life of their own. In the mind of the worshipper they offer a temporary dwelling place for the saint or god they represent, where he or she can come to life, interact with, and affect the life of the worshipper.

There is also the phenomenon of "effigy magic," which depends on the idea of a shared life of a human being and his or her image (voodoo, *The Picture of Dorian Gray*, and so on). Legends of the origins of art commonly arise from this connection: "The belief in the identity of portrait and portrayed . . . not only seems to be associated with the origins of representational art, but also governed the formation of legends concerned with the beginning of art."[40]

The work of art served the mythmaking mind as the prototype of creation: Jehovah and Prometheus "created" the human race on the model of a sculptor shaping a statue. Jehovah was able to breathe life into the effigy shaped from earth, but not Prometheus, according to the mythographer Fulgentius. The Titan needed divine help: "Prometheus formed men from clay, but he was not able to breathe life into them," so he stole divine fire from heaven and gave them a soul. A common belief has it that life enters the work of art once eyes are set in it. Ernst Kris and Otto Kurz tell a Chinese legend of a painter who avoided putting eyes in his portraits so that they wouldn't come to life, and another in which an artist painted a picture of dragons which flew away as soon as he put eyes into them.[41]

This kind of belief weakened into the topos of the living work of art. Valerius Maximus describes a painting of a Roman woman breast-feeding an old man in prison. But the sensational and the grotesque in the painting

arrest the viewer less than the images' appearance of life: "In these mute figures they feel they are looking at real and living bodies. This must have its effect on the mind too—and painting is rather more potent in this than literature . . . in presenting events of old for the edification of people today."[42] (See also Chapter 4, "Icon and Relic.") And it is played on regularly by poets claiming the ability to keep alive those about whom they write. Theognis (sixth century B.C.) writes of his lover Cyrnus: "I have given you wings, Cyrnus, with which you will fly over land and sea. . . . At every feast and revel you will be on the lips of many a guest; lovely youths will sing your name clearly and beautifully to the music of flutes; and when you have gone down to the dead you will still wander through the land of Greece and the islands of the sea, to be sung by men of the future as long as earth and sun shall remain."[43] The lines anticipate the motif of the lover immortalized by poetry in Shakespeare's sonnets.

Legends of the artist also locate the origins of art in the urge to maintain the dead as a quasi-living presence. Kris cites an Indian legend of the origin of painting: a man begs the king to restore his dead son to life. The king asks the death god Yana, who refuses. Then Brahma commands the king to make a portrait with color. It comes to life.[44] An appellation of the sculptor in ancient Egypt is "the one who keeps alive."[45]

Superstition or not, the belief that an image of a person or thing somehow keeps him/her/it alive coincides with one of the essential impulses of art, both in its origins and in its historical and contemporary working: the urge to replace living presence with a copy. This primordial and contemporary function of art is at work in the way we bury, memorialize, and speak with the dead. Representation is never so vital and so intimately involved with the psychic life as when it tries literally to re-present, to make the dead be present again.

We can see the logic of the artist as "the one who keeps alive" at work in the Orpheus myth: Orpheus rescues his dead wife from the underworld by enchanting the gods of the underworld with his music. But he can only bring her halfway back to life. Nothing can restore her completely. Like Balzac's "Unknown Masterpiece," the Orpheus story shows the failure of art at the far ends of its natural boundaries: art can restore life, but only partially. The life it re-creates always slips back into the realm of the dead. But the Hellenic mind could imagine music as a power that could at least come close to restoring lost life. The fact that art can never do it fully doesn't prevent artists from trying.

Figure 6. Arnold Böcklin, *Self-Portrait with Death Playing the Fiddle*, 1872. (Bildarchiv Preussischer Kulturbesitz/ Art Resource, NY)

Thomas Mann wrote a wrenching and magnificent scene in the next to last chapter of *The Young Joseph* (the second volume of the tetralogy, *Joseph and His Brothers),* Jacob mourning the (supposed) death of Joseph. The grieving father refuses to accept the death of this son who is more precious to him than all the eleven others, and, deranged by grief, he plots a mission to rescue Joseph from death. He tells his servant Eliezer his schemes. The first is to go to the realm of the dead himself and bring back Joseph. Eliezer convinces him that that is impossible. His fallback is to reconceive Joseph: "I'll awaken him anew and restore his image on earth by the sexual act."

Figure 7. Lovis Corinth, *Self-Portrait with Skeleton*, 1896. Städtische Galerie im Lenbachhaus, Munich, Germany. (Kavaler / Art Resource, NY)

Impossible, says Eliezer, there's no Rachel, and the astrological moment is past. Then I'll beget backward in time, Jacob answers, backward to the moment of Joseph's first conception. That's not begetting, says Eliezer, that's creating. Jacob: Then I'll let a little creating slip in with the begetting, as I did with the white and the speckled sheep. Bring me a woman who looks like Rachel. I'll couple with her, while I look firmly at a picture of Joseph. Then she'll give birth to him again back from the dead. Finally, he calls for clay and a leaf with the name of God written on it. He'll create an effigy of a man, perform the appropriate magic, hold it and kiss it with all his love for Joseph, breathe breath into it: "Then the clay will awaken to life, open his eyes, astonished, toward me, his reviver, and say, 'Abba, father dear.'"

I'm not saying that the need to resurrect is always the immediate source of charismatic art. A deeply buried impulse may work like an instinct, unconsciously active. In Homer, the subject of the next chapter, the

"resurrection" aims at a heroic ideal that may be pieced together out of various conceptions, united and transformed into Achilles or Odysseus in an epic tradition and the mind of the author. I have been talking about the genesis of charismatic art, and it's a fair conjecture to say that the West produced such vivid means of representation, modeling, color, composition, perspective, because of its morbid fear of death and its wish to overcome it. At least the artists and activators of that impulse felt and represented themselves as working with death looking over their shoulder (Figures 6 & 7).

3

Odysseus Rising: The Homeric World

In book 5 of the *Odyssey*, Odysseus washes up on a beach, naked, brine-soaked and scum-crusted, after twenty days of struggle with the ocean. Poseidon, having learned from Zeus that he cannot prevent his enemy's return home, redoubles his efforts to make the blinder of his son, the Cyclops Polyphemus, suffer as much as possible along the way. Odysseus is at the mercy of the sea god's earth- and sea-shaking powers. His raft is smashed and the sea about to swallow him up, when a sea nymph comes to his aid with a veil that magically holds him above water. On his first thrust to land the waves hurl him against stony cliffs and, receding, tear him away again, gashed and bloodied. He swims around the island and finds a cove at a river's mouth where he washes ashore, abject and half alive, along with seaweed, driftwood, and dead fish, looking more like some primeval sea monster crept from the deep to die than a mighty king, sacker of cities and hero of the Trojan War. Once safely on shore he crawls under an olive tree and covers his exhausted and swollen body under its fallen leaves "as carefully as a farmer on a lonely farm far away from any neighbours buries a glowing log under the black ashes to keep his fire alive and save himself from having to seek a light elsewhere. And now Athene filled Odysseus's eyes with sleep and sealed their lids—sleep to soothe his pain and utter weariness."[1]

And so the episode of Odysseus on the island of Scheria, his flirtation with Princess Nausicaa, his friendship with King Alcinous and Queen Arete, begins with the hero at rock-bottom wretchedness. To understand the dramatic structure of the episode, ending with the hero's rise to royal and heroic stature, we need a peculiarly Greek aristocratic concept of charisma. The repeated staging of that quality, its spellbinding effect on his audience,

the dynamic framing Odysseus's narrative are what the episode—and that means one-third of the entire *Odyssey* (books 5–12)—is essentially about; the events of the episode and the fabulous tales of Odysseus's travels are ancillary to that staging.

Odysseus's wretchedness contrasts sharply with the Phaeacians, in whose land he has arrived. They are a fortune-favored people, wealthy and highly civilized. Their king, Alcinous, is "divinely inspired" (p. 76; 6.13) and "great-hearted" (trans. Murray, p. 235; 6.196), the source of "the might and majesty of the Phaeacian people" (trans. Murray, p. 235; 6.197–98) and as such is "as a god" (trans. Murray, p. 247; 7.11), a people who themselves are "godlike" (trans. Murray, p. 237; 6.241). They have a great gift from Poseidon: the men are skilled sailors and makers of ships, which travel with miraculous speed, "as swift as a bird, or as thought itself" (trans. Murray, p. 247; 7.36), and navigate without rudders and helmsmen; Phaeacian-made ships intuit the plans of their captains and crew. And their women have a gift from Athene: they are expert and shrewd artisans (p. 78; 7.109–11). Their privileged standing is such that the gods themselves come down from Olympus without any disguise to receive sacrifices, and they sit at the banqueting tables side by side with Phaeacian lords and ladies (p. 90; 7.200ff.). The Phaeacian land is a kind of middle realm between the gods and men.

The level of culture is indicated by Alcinous's speech appraising the athletic skills of his countrymen: while they are fast runners and good sailors, they are mediocre in boxing and wrestling, but they have always taken the greatest pleasure from "the feast, the lyre, the dance, frequent changes of clothes, hot baths and our beds" (p. 100; 8.246ff.). This preference for domestic and cultural pleasures suggests a decadent ease, comfort, and elegance—but decadent, or just pitched against the culture of warfare, it forms the starkest contrast to the state in which Odysseus arrives on the island and encounters Princess Nausicaa. She has in effect been sent by Athene to find Odysseus, but the foregrounded intention is to wash clothes at the river, so as to have a good supply. After all, the princess wants to find a husband and be attractive when he shows up.

At the mouth of the river Nausicaa's game with her playmates rouses the sleeping Odysseus. He emerges from his nest, charges at them like a hungry mountain lion, terrifying the girls: "grimy with salt he was a gruesome sight, and the girls went scuttling off in every direction along the jutting spits of sand" (p. 79; 6.136ff.). All except Nausicaa flee as though a

wild beast were attacking them. It is a half-comical moment. It both characterizes the wild state of Odysseus and ironically reverses the situation he so often faced himself: the man of culture assailed by monsters and uncivilized peoples.

He stops at a discreet distance from the princess, hails her as a goddess, wheedles his way into her private thoughts in unarranged conspiring with Athene ("'The happiest of all is he who with his wedding gifts can win you for his home. For never have I set eyes on such perfection in man or woman'"; "'may the gods grant you your heart's desire; may they give you a husband and a home'" [p. 80; 6.157–58, 181–82]). He also lets drop, tucked into a compliment to her beauty, that he was once a commander of armies.

It is the beginning of his rise. Nausicaa's first response: "'Since your manners show you are not a bad man or a fool . . .'" (p. 81; 6.187). "Since your manners show . . .": the man of the word, the *polumechanos*, and *polumetis*, the civilized man, whose weapon is subtle speech and the clever stratagem, overcomes his barbarous appearance by his bearing and his courtesy and eloquence. We might expect some observation like, "*although he looked monstrous, the wise princess could see beyond surface appearance.*" (And what an arsenal of greatness is hidden behind the surface of this anonymous piece of talking flotsam! Odysseus, man of many turnings and contrivances, king, hero of the Trojan War, architect of the Trojan horse, conqueror of monsters, lover of goddesses.) But no, Odysseus is all surface. He is what he appears, as are all the characters in Homer.[2] What Nausicaa knows after Odysseus's first words is that he is a man of smooth speech and fine manners—nothing more.

The second step in his emergence is his appearance. He asks the ladies to withdraw so that he can bathe himself without offending decency. Then he grooms himself with the help of Athene. It is a passage I will return to in this and later chapters: "Athene daughter of Zeus, made him seem taller and sturdier and caused the bushy locks to hang from his head thick as the petals of a hyacinth in bloom. Just as a craftsman trained by Hephaestus and Pallas Athene in the secrets of his art puts a graceful finish to his work by overlaying silverware with gold, she endowed his head and shoulders with beauty. When Odysseus retired to sit down by himself on the seashore, he was radiant with grace and beauty" (p. 82; 6.229–37).[3] So his exterior needs work, just as a rough carving needs sculpting and ornament, but after his divine sprucing up, he is transformed by the goddess-given

charis. It is not the idea of epiphany that is at work here; some hidden form does not step out from behind the veil or mask of an external form. It is transformation from one state to another, wretched to godlike. One skin ego (the long-suffering wanderer) is exchanged for another (the charismatic gentleman and hero).[4] The princess is entranced: "Nausicaa gazed at him in admiration and said to her beautiful-haired attendants: 'Listen, my white-armed girls, to what I am saying. This man's arrival among the god-like Phaeacians was not opposed by *all* the gods of Olympus. When we first met I thought him repulsive, but now he looks like the gods who live in heaven. I wish I could have a man like him for my husband, if only he were content to stay and live here'" (p. 82; 6.229–45). The appearance of Odysseus rouses dreams in Nausicaa; need moves over into desire. Athene antici-pated and maneuvered her toward that effect. The goddess is playing in a calculated way on the young girl's hopes for a husband. Both Athene and Odysseus know perfectly well that he is not a candidate. But they are willing to benefit from her entrapment.[5] The goddess's gift, the laying on of beauty, charm, and grace, is the instrument of manipulation that wins her over and leaves her fantasizing marriage with the man whom minutes before she could barely distinguish from a monster. The revival of Odysseus represents the spell charging of a charismatic character adequate to high standing in this magically charged land.[6]

His entry to the palace of Alcinous follows a similar dynamic. Although he now looks the part of a king, a high noble, a god, he is a stranger, and strangers are not generally liked in Scheria. But again Athene prepares the way. She shrouds him in mist until he stands before Alcinous and his wife Arete. The goddess also gives him important information, the name and family history of the king and queen. He can greet them in exact accordance with what is their due: "Arete, daughter of godlike Rhexenor" (p. 88; 7.147). Far from claiming any stature for himself, Odysseus seats himself, like a beggar, in the ashes of the fire. But again, though unstated, the rule of aristocratic inference, "*I see by your manners . . .,*" is in effect. Alcinous is urged to exercise the rites of guest-friendship, and he does so, welcoming Odysseus, still anonymous, in an elaborate ritual. He is escorted from the ashes to a polished silver chair. And now he is well on course for his second rise.

In his first narration he tells the court only the adventures that landed him on their island: departure from Ogygia, perilous sea voyage, and arrival. Sparse as his narrative is at this point, he does not omit telling them

that he was so desired and courted by the goddess Calypso that she offered him immortality and eternal youth—and he turned the offer down—that Zeus himself had taken sufficient interest in him to ordain his release from Calypso, and that Poseidon is his mortal enemy. Again he has established himself in their esteem, rising literally from ashes to become a man worthy of a king's daughter and his largesse—both of which Alcinous offers to his still unnamed guest: "I wish that a man like you, like-minded with myself, could have my daughter and remain here as my son-in-law—I would give you a house and riches" (p. 92; 7.312–14).

The dynamic of lowering his position to effect a dramatic rise is at work again in the athletic games held on the next day, where Odysseus is the guest of honor. He already has high standing, but the goddess again magnifies his appearance: "Athene invested his head and shoulders with a divine beauty, and made him seem taller and broader, so that he would inspire the whole Phaeacian people not only with affection but with fear and respect" (p. 92; 8.19–22). This time the rise is set in motion by an insult dealt him by a young Phaeacian. Odysseus refuses at first to participate in the contests, protesting his age, his tiredness from his journeying, and his long inactivity—he is out of shape. But the champion Euryalus taunts him, suggesting that his excuses are just cover for his inability as an athlete. Odysseus is stung both to strong words and an impressive demonstration of his ability: he picks up the biggest discus available, hurls it while still wearing his cloak (the equivalent of a modern athlete competing in his street clothes), and outdoes all the Phaeacian competitors.

So by now he has established his godlike and god-favored appearance, his skill in speech, his aristocratic manner, his desirability as husband and lover, and his talent in athletic contests.

His rejection of the gifts of Calypso also raises wonder and esteem, but what it establishes is more complicated than a phrase. (I'll return to it later.) He stands before them as a man who preferred his human condition to immortality.

Various modes of charismatic self-presentation are at work in these episodes: erotic, social, political, intellectual, and athletic, and if we can take the favor of the gods as indicative, then also, religious.

We might call the mode in which the Scheria episode culminates the "fabulous": Odysseus reveals his name grandly: "I am Odysseus, Laertes' son. The whole world talks of my stratagems, and my fame has reached the heavens" (p. 110; 9.19–20). This is prologue to the stories of his contests

with monsters and witches and his journey to the land of the dead. Fabulous experience powerfully heightens personal presence. In the episode with the Phaeacians, that effect is twice heightened, since it is Odysseus himself who narrates his adventures. The unusual epic mode of a first-person narrative is itself bound up with what is the clear intention of the episode: to create a social and personal drama of the emergence of Odysseus from nothing, from pure, natural, unaccommodated man, the thing itself, to a man endowed with every feature of charisma. It is not adventure that these books are primarily about; adventure and combat are present as elements along the hero's trajectory to the stature of the fabulous man.

After Odysseus finishes telling of his conversations with the dead, his audience sits in stunned silence, "held by the spell of his words" (p. 148; 11.333).[7] Queen Arete breaks the silence: "Phaeacians . . . what do you think of this man, his looks, his presence and the quality of his mind?" (p. 148; 11.336–37). An odd summation: Odysseus talks fantastic adventures, and the queen praises his appearance!

ODYSSEUS: *"I overcame the Cyclops and Circe and journeyed to hell."*
ARETE: *"What a body and what a mind!"*

Its oddity makes it worth a close look:[8] "his looks, his presence and the quality of his mind" (*eidos te megethos te ide phrenas endon*). The phrase is not easy to translate. Common renderings are "beauty" and "stature."[9] Robert Fagles reduces *megethos* to the physical: "his build."[10] But none of the English renderings conveys the kind of allure suggested by *eidos te megethos*. It implies radiance, godlike qualities. Homer uses the phrase several times in the *Odyssey*, once in his praise of Circe's godlike beauty and presence (5.217) and once in Odysseus's flattering speech to Nausicaa, comparing her beauty and stature to that of the goddess Diana (6.152). *Megethos*, meaning at its most ordinary "size," "magnitude," becomes, in the language of rhetoric and poetics, a term for "grandeur." It recurs in Aristotle's *Poetics* in that context,[11] and it is common in the treatise *On the Sublime* of Pseudo-Longinus as one of the features of that style.[12]

What logic leads the queen to turn from a fabulous narrative and its contents to the narrator's "looks" and "grand presence"? Arete's comment would have been better placed, in terms of a strict narrative logic, at the beginning of book 8, just prior to the athletic contests, where Athene gives Odysseus divine beauty and stature for the second time (8.19ff.) There his

megethos emerges as a visible quality. The words of praise spoken by Arete respond to no physical change in Odysseus, only to the accumulation of fables.

The logic that allows the queen to admire an Odysseus refashioned after his stories are told must be this: alongside his excellences—his godlikeness, his long-suffering, his cunning and machinations—some big thing has appeared that is not exhausted by a listing of his qualities and his deeds. His stories become an accretion on his body; he is what he tells. Adventures appear somehow written on his surface, as though tattooed there or transmuted into stature and beauty. That is how the queen perceives him once Odysseus's accumulated deeds are present in her mind: she sees his aura, not as a physical mark, but as a ghostly auxiliary to his person. This perception is fully in the logic of charismatic participation. (More on this later in this and other chapters.)

There is an acute awareness in Homer that wandering adventurers tell fabulous lies that no one can test. Whopping lies help construct charisma. Odysseus tells some also in constructing his false identity upon his arrival in Ithaca and is suspected of telling more. Homeric peripheral characters can never be too careful in accepting the tales of wanderers as coin of the realm. Critics of Homer have asked whether the self-narrated adventures of books 9–12 might not be Odyssean fabrications as whopping as those he tells to conceal his identity in Ithaca. As great an admirer of Homer as Pindar suggests as much:

> I think the tale
> of Odysseus is greater than his deeds, all through the grace of
> Homer.
> Upon his lies and the winged intelligence
> there is a kind of majesty; genius persuasive in speech deceives us;
> blind
> Is the heart in the multitude of men.[13]

Self-mythologizing also constructs charisma. But Homer is at pains to confirm the truthfulness of these particular tall tales, and so he has King Alcinous stamp them genuine, against the doubts that their very fabulousness rouses: "Odysseus, . . . we are far from regarding you as one of those impostors and cheats whom this dark world brings forth in such profusion to spin their lying yarns which nobody can test. On the contrary . . . you have

told us the story of your . . . terrible misfortunes with all the artistry of a bard" (p. 149; 11.362–69).

The Greeks would have called this quality by various names. The broad complex of gifts, attainments, and experiences of Odysseus, they would have grouped among the *klea andron*, the "glories of men."[14] His *eidos* and *megethos* are the physical location of charisma. His mind, manners, and deeds can shine forth visibly in his physical beauty. This ideal had a long future; instances abound from classical Greek culture. Demosthenes wrote a letter to a young man offering his services as tutor and praising the young man extravagantly: "Not even works of art executed by the skill of the best masters could do more than justice to [your beauty]. Nor is this astonishing; for works of art are motionless, so it is not clear what they would look like if they came to life. But your personality enhances in your every action the superb comeliness of your body."[15] The persona makes the body beautiful through action. So, intense beauty is virtue or excellence in action. It is a close relative of the train of thought that leads Queen Arete *to think* "*what amazing events!*" but *to say* "*how radiant this man is in mind and body!*" The Scheria episodes are largely about that radiance.

Homer needed Odysseus to enter this happy land of beauty and excellence barely clinging to life, stripped of every possession and every physical quality. His starting point had to be set low so that the rise would be all the more dramatic. The landscape of the episode is carefully prepared to produce that result. Next to the stage manager behind the scenes, Homer, the visible actress, Athene, is busy bringing it about. Everything is primed and prearranged to allow Odysseus to rise along a steep curve from wretched to glorious, and so to maximize desire, envy, love, admiration, fear, and respect in his hosts and in Homer's readers.

That same dramatic structure, at work three times in the Scheria episodes, is in place for the other grand arrival in the *Odyssey,* the hero's return to Ithaca. Here again, he is reduced as low as he can go. Athene has reversed her magic: she has aged, shrunk, and shriveled him to the stature of a beggar and dressed him in rags (13.429–38). From this low point he can make his most dramatic rise back to Odysseus. The abject state is set in place, in this case to disguise, but also to give way to exaltation. And we can anticipate the ultimate effect on his admirers, maximized by the distance from his starting point: "*What beauty, presence, stature. Surely you are one of the gods who live in the broad sky!*"

The alternations from wretched to grand in Homer's *Odyssey* open to view a narrative technique that I'll call its "dynamics." Dynamics in literature, as in music, involve change, tensions of various sorts, and might best be defined as the way, or one of the ways, the work exerts force on the reader. This is very different from how it conveys "meaning." Hermeneutics work at a level intellectually above the one on which the dynamics of character, plot, and setting operate. Dynamics are more elemental, more bound to the emotions and emotional responses—again, as in music. Dynamics are what draw the reader into the work, stimulate identification, participation, and imitation. The dynamics of a narrative work are measured by the changes in the trajectory of the hero's development. If the dynamics move from falling low to rising high, the effect, in epic certainly, is charismatic. Charged with high destiny and charismatic attraction, the hero exercises a magnetism, a gravitational pull on the mind and imagination of the reader—the urge to be like the hero, live in his world, act like he acts, relive his enviable destiny—when the reader, his mind and imagination captivated by the values the model embodies, makes them, however briefly, his own. This holds true not just in happy endings, like that of Odysseus, but in heroic deaths, like that of Achilles. The dynamics of exemplarity and imprinting are far more immediate to readers in general and far more accessible than something as intellectually highfalutin as "meaning." It is possible to experience exemplarity and imprinting and to feel the tug of the model character through the involuntary empathy that—given the right chemistry of hero and audience—is virtually an instinctual reaction. "Meaning," however, is always elusive, shifting, open to endless contestation. Meaning, assuming it is temporarily graspable, generates understanding; the dynamics of a work produce transformation, at least the will to transformation.

Fluctuations of destiny tie us emotionally to the main character: the rise in happy expectations and optimism, the fall in sorrow, pity, and fear. Balzac's *Lost Illusions* and *Splendeurs et misères des courtisanes* take the reader on a virtual roller coaster ride of dynamic rising and falling. The first novel ends with the hero, Lucien Chardon, a ruined man, self-betrayed and suicidal. Shortly before the close of the novel we see him stumbling along a country road heading for a river in which to drown himself. We meet him next at the beginning of *Splendeurs et misères* at a Paris Opera ball, handsome, beautifully dressed, witty, his stature cemented by a patent of nobility issued by the king himself. He cuts so elegant a figure that he monopolizes

attention in the highest society. He confronts his enemies and detractors from the previous novel, from whom he has suffered insults and intrigues, with confidence and repays them with acid wit. One of Lucien's enemies speaks for the astonished reader when he says to his fellow revelers, "I thought he'd fallen too low ever to rise again." His fall develops through vicissitudes as dizzying as what has preceded. In the course of the novel he is gradually worn down, loses his stature in spite of a fierce defense of it, and commits suicide in prison. Lucien's tragedy forces a reversal of any identification, any absorption of the values by which he lives. Jerked around in the anticipation of a happy life won in defiance of society, the value-forming faculty of the reader, working through admiration and identification, sees his happy life snatched away and realizes that the power of the forces lined up against the hero is irresistible. The depth of Lucien's second fall from heights hits the reader with a force that Oscar Wilde described: "One of the greatest tragedies of my life is the death of Lucien de Rubempré. It is a grief from which I have never been able completely to rid myself" (*The Decay of Lying*). Tragedy is consciousness shattering; it forces a revaluing of the values at stake in the narrative.

The opposite trajectory affirms the hero's character and values. The lower he or she starts, the more dramatic the rise. One of the most breathtaking moments in the movies is in *My Fair Lady* (dir. George Cukor, 1964), when the draggle-tailed guttersnipe Eliza Doolittle (Audrey Hepburn) appears at the top of the stairs in Henry Higgins's house, dressed like a princess, speaking English like a duchess, radiant as an angel, beautiful as a goddess. The transformation hits the viewer with the maximum power available to the dramaturge through the dynamics of "enter abject, emerge exalted."

There is a convenient German word for the positioning of the tragic hero between normal state and tragedy: "Fallhöhe," that is, "the height of the fall," the higher a character is placed, the more dramatic his fall. This structure is reversed in the *Odyssey*: its hero starts out with very spacious room available to rise up, for which I'll have to invent the term "Aufstieghöhe"—the lower he is set, the higher he can rise.

The contrast of the *Odyssey* to the structure of tragedy is interesting in other regards also. Let's compare the beginning of *Odyssey* book 6 (arrival in Scheria) with the beginning of Sophocles's *Oedipus Rex*. The play begins with King Oedipus at the high point of a charmed life: the savior of Thebes, its most famous citizen, blessed with a wife and children, a wise and just

ruler. Like Odysseus he also brings acquired aura with him: he was the savior of the city; he answered the Sphinx's riddle. He has not only eloquence and wisdom, but also skill upon skill. But a strange plague ravages the city. The king promises to get to the bottom of it, and in using his cleverness and wisdom to pursue the truth, his own life unravels, because the horrible crimes he committed unknowingly are the cause of the plague. The dramatic scheme is the gradual revelation of a terrible curse inexplicably placed on him, the wisest and best of men. At the end of the play his wife has hung herself, he has blinded himself and banished himself from the city, and the disgrace still hangs over his four children. The chorus voices the audience's shock at the change:

> [Oedipus] was honoured the highest of all
> honours; and hence he ruled
> in the great city of Thebes.
> But now whose tale is more miserable?[16]

Both works unfold within a system of values that sets high store on the blessed life lived by a man of exceptional talents and gifts. Odysseus suffers endless misfortunes to regain it having nearly lost it; Oedipus, living in the certainty of its permanence, loses it. In both works there is a malignant element of fate that tends to undermine hopes and thwart ambitions. The "happy ending" of the *Odyssey* should not conceal a dark view of man's prostration before the higher powers that guide his life. Odysseus's appraisal of the human condition—"Of all the creatures that breathe and creep about on Mother Earth there is none so helpless as man. As long as the gods grant him prosperity and health he imagines he will never suffer misfortune in the future. Yet when the blessed gods bring him troubles he has no choice but to endure them with a patient heart" (p. 242; 18.130–35)—anticipates the pessimism of the chorus of *Antigone*:

> For the future near and far,
> And the past, this law holds good:
> Nothing very great
> comes to the life of mortal man
> without ruin to accompany it.[17]

It is curious that Aristotle identified the effect of tragedy on the audience (*catharsis*), but had nothing to say about the effect of epic. Or rather, he

would have considered the *Iliad* in the tragic mode. He specifically calls the "double-structure" of the *Odyssey* the "second-best"—bad characters fall and good rise. The preference for this kind of plot is due to the weakness of the audience: "The poets follow and pander to the taste of the spectators" (*Poetics*, 13.30ff., 1453a)—early disdain for "happy endings." I will come back to the happy ending and the plot structure based on "space available to rise." For the moment I'll just reiterate that what answers *catharsis* in charismatic art is *participation* and *transformation*. As the audience follows, with rising pity and fear, the course of the hero into a tragic end, the audience of the *Odyssey* follows the rise of the hero with a sense of living in and experiencing the heroic life and so being raised up by this participation. The profit for the audience of tragedy is *catharsis;* for the reader/listener in what I've called "redemption narrative" is transformation.

I said in the introduction that charismatic art can only affirm the human condition, at least for as long as its spell lasts. Both *Odyssey* and *Oedipus Rex* are consistent with that claim. Odysseus's wit, foresight, and craftiness aid his rise, but virtue or *areté* rewarded happens at the level of the happy ending. Stronger than mere success is the commitment of the character himself to life at all costs. His affirmation of that commitment is his threefold refusal of immortality, divinity or semidivinity, pleasure, and comfort: Calypso and Circe both could make him a god, but he refuses; Alcinous could make him a Phaeacian lord and presumably successor to the kingship, but he refuses and instead heads on into suffering and tribulations to regain his comparatively modest position as island king, husband and father—and mortal man. A thing's value is in proportion to the sacrifice it takes to keep it. Odysseus sacrifices immortality in favor of mortality. This sacrifice makes the condition he prefers to divinity appear in a light that at least competes with deathlessness.

But the same affirming force is at work in *Oedipus Rex*. In both works the gods are unpredictable. They kill men for their sport, or at least as revenge for minor offenses or for envy. Human excellence seems to bring out their malignant streak: they fastened on Oedipus as their mark in order to chastise men at their best. Mediocrities can go their own way free of divine attention. The skills, talents, and wisdom of Oedipus mark him as ripe for a destructive curse—but only if he accepts both the gods and the laws of the state. In *Oedipus* the thing that is sacrificed is Oedipus himself. And he facilitates that sacrifice. He could after all protest against his fate,

curse the gods, and seek his fortune in other lands. The only consideration that forces him to gouge his eyes out is his faith in the gods and the laws of the state. He removes himself from rule over Thebes and from citizenship because he has violated the laws so horrendously, and he stops short of killing himself because he cannot face his parents in the afterlife, against whom his crimes are so terrible. So he sentences himself to a state between life and death—worse than either. He would be spared the trouble if he didn't believe in law, gods, and the afterlife.

The affirmation consists in his setting the decrees of the gods and the laws of the state above his own life. He prefers to cancel himself out rather than live in a condition he regards as cursed and polluted. The unstated claim of Oedipus's destiny is that the state and the gods are far more important than any individual—no matter how excellent. But Oedipus's act of expiation is also so majestic that it outweighs or at least weighs equal with the burden of his crimes.

In short, it would be wrong to imagine that epic shows men as godlike, while tragedy shows them as deceived fools. Both forms have, in their highest realizations in the ancient world, the effect of glorifying heroic characters and so also, the human condition.

The pessimism of Sophocles' *Oedipus* has much in common with that of the *Iliad*. Both are dark tales of unredeemable destruction; in both, heroic men are shadowed by some evil fatedness in which their blindness or foolishness conspires with the arbitrariness of the gods in the destruction of men. But the demise is always heroic and always lit by tragic grandeur. To be tragic, the tragic destiny must be a symptom of greatness.

And so we can say that Attic pessimism generally is based on a view of man that is radically affirming, in fact goes so far in its affirmation as to be immoral or impious. From Homer into the fourth century there is a strong conviction that the condition of men at their best is godlike. Pindar mused that the races of men and gods have a common origin, and while the gods have all power and men none,

> yet, somehow,
> we resemble the immortals,
> whether in greatness of mind
> or nature.[18]

The conviction that we are "somehow godlike" asserts itself constantly and the hubris it is founded on regularly draws the revenge of the gods. The central virtue of Hellenic ethics is "self-control" or "moderation" (*sophrosyne*). In its origin from the oracle at Delphi, it meant, "Remember that you are not a god."[19] To exceed the limits set to mortals in any regard is to violate *sophrosyne*, as when Achilles refuses to moderate his anger—to the harm of his fellow Greeks. The frequent cautioning against hubris is the obverse of a conviction that men of excellence are like gods.

This stuttering deification is a breathtakingly grand ideal of humanity. "Man" is in effect what the *Odyssey* is about. It is the first word of the epic: "*Andra* moi ennepe, Mousa, polutropon" (*The man* sing to me, o Muse, the many-turning one) as opposed to the *Iliad*, which opens with *menis*, the "rage" of Achilles. Man in his rich, variegated possibilities (polytropic Odysseus) is what the *Odyssey* sings. Homer's purpose is to "show the possibilities of human life."[20]

Odysseus is godlike because the gods make him so; he is human because he chooses to remain mortal. That is the logic of the constant intrusion of the gods into both *Iliad* and *Odyssey*. They cause great acts and they destroy the men who perform them. Odysseus can maintain his godlike presence, excel, show greatness, and survive because the balance of divine favor allows it. There is no human talent in the *Odyssey* that is not either magical or god-given or both. If Odysseus swims well enough to survive three days in the sea, it is because a sea nymph gives him a magic belt. He is far from surrendering all agency, since his "indomitable soul" aids divine favor.

One other broad distinction between *Odyssey* and *Oedipus Rex* turns on a conceptual pair that will be useful in later discussions. While the two works share affirming power and a magnification of man, the two operate on cognitive modes that could not be more distinct from one another. We can call the mode of *Oedipus* "enigma," that of *Odyssey* "revelation." An episode in each work, of which its hero is the main actor, introduces us to these modes. Oedipus faces the Sphinx. He answers her riddle when no one else can. It is a great victory over a superhuman creature. The destruction of the Sphinx and subsequent, temporary, rescuing of Thebes, results from the solving of a riddle. It follows that Oedipus is a wise man and a savior of the city. But he is at the same time blind, more duped than anyone in the city, and more directly responsible for the plague destroying it at the opening of the play. Enigma and tragic irony are neatly bundled into the

image of the Sphinx. Oedipus first destroys her, then he becomes her (he causes the plague). The solvable riddle of the Sphinx is outbid by the hard, impenetrable riddle of Oedipus's character. Our (and his) attempt to understand his fate ends in paradox and enigma.

The scene of the *Odyssey* in which the hero experiences most dramatically the "revelatory" mode, is the evocation of the dead in book 11. No one can speak with the dead. Odysseus has privileged access. His conversations with ghosts are an outpouring of privileged revelations, including the practical tips for negotiating his way home and his reconciliation with Poseidon given by Tiresias based on the prophet's knowledge of the future.

Enigma is inevitably tragic; revelation, redemptive. The closer human understanding approaches enlightenment in tragedy, the greater the enigma grows. Oedipus understands at the end. But what does he understand? What does the long drawn-out riddling process of uncovering guilt reveal? The mystery of human subjection to the gods' will, the futility of human intelligence and human greatness. Similarly, in Euripides' *Hippolytos* Theseus is driven to know why Phaedra hung herself. The answer forces him to exile his own son, wrongly, and that injustice leads to the son's death. Hamlet studies the question, did Claudius do it? At the same time as he approaches certainty, he approaches destruction. Knowledge in these works of enigmatic knowledge questing is not something that furthers human ends. Kafka's land surveyor, Josef K., forces his way into the secrets of the castle; but the closer he gets, the greater his distance from his goal, the greater the enigma at the heart of the castle's power.

Aristotle says, with the breeziness with which he glosses over mysteries and irrational things, that a good and lofty character commits bad acts that lead to tragedy because of *hamartia*, an error or flaw. And yet the tragedy of great men, especially when it turns on the urge to know, opens up a horrendous and insoluble paradox. Tragedy moves toward the discovery of a law or principle that governs human destiny but is not susceptible to human will and not intuitively accessible to human understanding. That is, an enigma.

The opposite is the case in redemption narratives: the *Odyssey*, the lives of Socrates and Christ. That category includes any narrative that moves toward enlightenment, fulfillment, and the rescue of an endangered character. However dark at a given moment, the thrust of the redemption narrative is toward an opening revelation. This might range from St. Augustine, *Confessions,* to the mythmaking self-narratives of political figures. In these cases insight, human understanding, and goals, human or divine, benefit

from a widening revelation, at least after the breakthrough following on the first tragic fall, or series of falls, of the hero. Human will and understanding participate in the unfolding of a beneficent destiny and are adequate to unraveling its mysteries.

The mystery novel in one of its modes (Sherlock Holmes) is a good illustration of the tensions between enigma and revelation. The story progresses from confusion and an unintelligible scramble of events, clues, and motives, to a perfectly intelligible and rational explanation. All questions are answered in the end, and the enigmas posed by characters and events are fully and completely illuminated, that is, cease to be enigmas. Mystery is replaced by order.

It is a nice coincidence that Tiresias is the mediator in both of our paradigm cases, the *Odyssey* and *Oedipus Rex*. The prophet leads Oedipus by steps to the insight that men cannot understand the forces that guide their lives, that will and knowledge are no help—in fact the very locus of blindness—that human destiny is enigmatic. But he opens a view into the future for Odysseus, one that proves reliable as a guide to the end of his wanderings and to reconciliation with the forces opposing him. Gone is the menacing ambiguity of the dark prophet. Tiresias shows him the way to a life well ended. The double-facedness of the prophet who now brings enigma and now illumination has its counterpart in the double identity of Tiresias himself, who has experienced life as both man and woman.

Enigma deprives Oedipus of the stature of a figure who can inspire imitation, as it deprives his world of the quality that can inspire participation. It inspires cathartic repulsion.

Revelation is consistent with the indestructibility of Odysseus; it guarantees survival and a course of life pleasing to man and gods, and so exercises a magnetic attraction on the audience. Enigma is the undermining of charisma; revelation, its assertion and fortification.[21]

Let's return to the Scheria episode. I want to sketch in briefly another conceptual pair that will get sharper definition in later chapters: charisma and aura. This pair is useful for illuminating the passage in the center of this chapter, Queen Arete's praise of Odysseus. His stature in Scheria was constructed by two means: his physical presence and his *aretai* were the first; his stories the other. Recall that Queen Arete, having heard the stories of Odysseus, admired his body and his presence. She is looking at the same man she saw prior to his narration, but now an invisible "increase of being"

has taken place. It is as if his stories altered his appearance, and in the perception of his audience, that is precisely what happens.

The increase of person through projected associations, I will call "aura."[22] There is another episode in the *Odyssey* that illustrates it better than Scheria, where aura is inextricably mixed with charisma. It is the episode of Odysseus's scar. The scene has been famously analyzed by Erich Auerbach in terms of Homeric style.[23] My comments can add some considerations of the scene as primarily a reflection on the coalescence of identity.

The context is this: Odysseus has returned to Ithaca and made his way into his own royal palace, still unrecognized, disguised as a ragged beggar and wanderer. His old nurse Eurycleia washes his feet, and in doing so, she touches a scar on his thigh. She at once recognizes him as Odysseus, and the touch activates the memory of two separate sets of events: first, the hunt on which Odysseus many years before received the scar, torn in his thigh by a raging boar; and second, the much earlier, we might say, primal events, that establish the identity of Odysseus, his birth, his parentage and grandparentage, the connection through his grandfather with the god Hermes (which accounts for his cunning), then the name giving, and finally the boar hunt at which he was wounded (19.386–475). So he is twice marked "Odysseus" by the events that Eurycleia recalls: his character is set, at least indicated, his birth recounted, his name given, and his outer identifying mark put in place. All of that could have been omitted if the origin of the scar were all that mattered. What mattered is the origin of Odysseus. That which established his identity at birth authenticates its revelation in the present of the narrative.[24] The physical mark is important as an outward sign, but the moment of recognition has its depth and resonance from the "involuntary memory" it awakens. The recalling of how Odysseus became Odysseus exposes, for the nurse, the false identity he has assumed (beggar). In other words, the boar hunt is a more or less superficial element of that flashback, the occasion for the scar. Its essence is how Odysseus's identity was created. That is the logic that ties the reminiscence to the recognition scene: before the narrative, he was a ragged beggar. After it, he "becomes," once again, as primally, Odysseus. The character suddenly appears to Eurycleia richly "historiated." She sees his identity doubled in time. She "experiences the aura" of Odysseus.

Once the stories of Odysseus are present in the mind of the beholder, he is perceived as the man he is. That happens to the queen of the Phaecians and it happens to Eurycleia. A person is not only the physical form that

presents itself to the viewer. He or she is also the collection of events, deeds, and accomplishments that has accreted around him or her in the course of a lifetime. That accumulation is one example of aura. Clearly aura has a major role in charismatic self-representation, and that, I believe, is in part the importance of Queen Arete's praise of Odysseus: it recognizes the invisible but highly perceptible aura of the man of many adventures. Charisma is unthinkable and nonexistent without a human presence to radiate it to an observer; aura fastens on any number and kind of objects: scars, ruby slippers, music, petites madeleines. Whatever receives and contains stories projected onto it beams the aura of those stories, at least once the memory of those stories is catalyzed in the imagination of the beholder.

A more general aspect of charisma in the *Odyssey* is the linking of the fabulous hero and the god-filled and magically charged world through which he moves. The charisma is not limited to a single person or a set of persons. It is a charismatic world, very different from that of the Western novel since the eighteenth century and its forerunner *Don Quixote*. Cervantes's novel perches on the watershed between a world perceived and represented as charismatic and a world perceived and represented as "real." It illustrates a disjointed world: a charisma-struck hero acts in a disenchanted realm. But such an unmasking structure has no place in Homeric epic. The world of the *Odyssey* is most deeply and indisenchantably magical, down to the very furniture. Alcinous lives in a splendid palace lit by two lights: the one natural (torches held by golden statues of youths), the other mysterious, a permanent, magical light like that of the sun itself illuminating the walls and roof (7.83–85). In Ithaca, Odysseus receives lighting on an as-needed basis. Athene lights the hall as Telemachus and Odysseus secure all the weapons and armor against the suitors: "Father! This is a great marvel to behold! The walls of the hall, the beautiful alcoves, the pine-wood beams and the soaring pillars all seem to my eyes to be lit up by a blazing fire. One of the gods who inhabit the wide heaven must be present here" (p. 251; 19.36–40). Charismatic force is transferred from human or superhuman beings to things. The allure of nature and created objects sublimates human virtue into things. The epic setting thus participates in the heightening effect of human charisma and gives to things their "poetic life."[25]

The discursive mode of the *Odyssey* is "magnifying"; it makes everything greater than it can appear in everyday experience. Werner Jaeger describes this quality of Homeric epic:

The epic style with its exalting, ennobling, and transfiguring power, affects more than the use of epithets: the same nobility appears in the epic descriptions and portraits. Everything low, contemptible, and ugly is banished from the world of the epic. The ancients themselves observed how Homer transports everything—even ordinary objects and common events—to a higher plane. . . . [The motive of criticizing men] expresses a pessimistic attitude which is directly opposed to the educational principles of the old aristocracy and its cult of great examples. (*Paideia*, 1:42)

That elevating quality is also a characteristic of epic generally, but only because a greater discursive mode fastened on the epic as its main vehicle, not because of some laws innate in genre, as Lessing argued in *Laocoon*. Homer does in an epic mode what poems of praise do in a lyrical or choric mode. (That is, incidentally, the only poetic mode, along with hymns to gods, that Plato admitted to his Republic.) Praise exalts, and exaltation charges the figure exalted with that force, which makes him imitable. It generates, or at least nurtures, a "cult of great examples."

It is precisely the operating mode of hypermimesis: create a higher world, invest it with beauty and heroism, and it softens the audience's resistance to illusion, draws them into the work as a true and genuine world that is a reproach to them and to the world of reality.

> Yes! Marvels are many, stories
> starting from mortals somehow
> stretch truth to deception
> woven cunningly on the loom of lies.
> Grace [*charis*], the very one who fashions every delight
> for mortal men, by lending her sheen
> to what is unbelievable, often makes it believed.[26]

"Charm" or "grace" does to the narrative what Athene does to Odysseus: makes it temporarily irresistible.

Mortal heroes are charged with transforming force. Through them godlike powers flow, which can be passed on to the readers/listeners in a kind of chain of inspiration. The German Romantic philosopher Friedrich Schleiermacher, in *The Christian Faith*, made a useful distinction between two modes of transmitting divine charisma: the one he called *Urbildlich*, the

other *Vorbildlich*. We might try putting the terms in English as "archetypal" (*urbildlich*) and "exemplary" (*vorbildlich*). The archetypal contains divinity in itself; the exemplary inspires it in others, or at least passes it on. An *Urbild* is original and originating; a *Vorbild* is mediating. Christ is *urbildlich*; St. Francis, *vorbildlich*; Athene is *urbildlich*, Odysseus *vorbildlich*. In Homeric epic the relations on the surface of the narrative are archetypal (*urbildlich*) because heroes act through the diffusion of divine power ("[Thetis] breathed in her son tremendous courage";[27] "Apollo had swept in close beside [Hector] driving strength in his legs and knees to race the wind"— (*Iliad*, p. 548; 22.243–44). The influence of the hero on *the audience* of epic—or of any charismatic art—is exemplary (*vorbildlich*). Heroic action inspires imitation in the reader, and therefore has a potentially powerful educative influence. Werner Jaeger stressed the "cult of examples" but referred almost exclusively to literary models influencing readers. Of course that "cult" was in essence based on the living model exerting charismatic force on young men. The power of myth and epic to educate is a derivative of pedagogic practice. Poetry has the advantage of comparative permanence, the living model the disadvantage of dying. Also characters in literature are far more manageable than in reality. The decadence of a family once famed for Olympic victories had to weigh on the performance of family members in any given year. But a Pindaric victory ode could hold their fame fixed and could preserve their inspiring, educating force whatever vicissitudes befell the living family members.

Poetry also had a means of compelling participation which the living exemplary model generally lacked: the beauty and rhetorical force of language. In the *Odyssey* this effect is reinforced because the adventures of Odysseus are narrated for the most part by Odysseus himself, and so the art of the narrator and the exemplary figure coincide. Odysseus's narration itself has a magical force that adds to the collective force of his presence and his deeds. This "psychagogic" function of literature is also a feature of a charismatic culture. Education takes place primarily through the imitation of models, only secondarily through the transmission of information.[28]

The working of charisma and the charismatic mode in Homer is evident in his influence. The early reception confirms his role in a "charismatic culture" in two of its aspects: poetry as the instrument of education; and "the cult of great examples." A characteristic of a charismatic culture (which I define in a later chapter) is the role of poetry as a primary medium of

philosophy and of education.[29] This applies well to Homer and his role in Greek culture. Plato's criticism of Homer in the *Republic* only confirms his immense influence: "Then, Glaucon, said I, when you meet encomiasts of Homer who tell us that this poet has been the educator of Hellas, and that for the conduct and refinement of human life he is worthy of our study and devotion, and that we should order our entire lives by the guidance of this poet, we must love and salute them."[30] While Plato recognized the educating effect of an aggrandizing poetry (the poet "clothes all the great deeds accomplished by men of old with glory, and thus educates those who come after"),[31] he could nonetheless banish Homer from his Republic because of the danger that so forceful a maker of imitations and images would replace reason as the guiding force in life and set pleasure in its place. But the passage confirms a widespread belief that Homer was in some sense the educator of all Greece.[32] The educational force does not lie in the "truth" of his narratives or in any philosophical meaning they might convey, but in the models of behavior they provide.

Another feature of a charismatic culture is the proximity of art to ideals of physical presence, indeed the subordination of aesthetic models to the great, beautiful impressive presence. As I suggested in the previous chapter, the first and most important work of art of charismatic cultures is the human presence, of which epic poems and sculpture are echoes and imitations. And conversely, the ideal living human presence in a charismatic culture is art *avant la lettre*. Hellenic culture provides good material for this comparison. The aristocratic cult of the body merged with notions of excellence of mind to develop into a general ideal of humanity of which we have vivid records in Homer, Pindar, and Greek sculpture. Werner Jaeger draws the connection:

> [The aristocratic values evident in Pindar were] the true creator of the lofty ideal of humanity which is manifest to this day . . . in the Greek sculptures of the archaic and classical periods. The athlete whom these works portray in the harmonious strength and nobility of this utmost perfection lives, feels, and speaks for us again in Pindar's poetry. . . . It was a uniquely precious moment when the God-intoxicated but human world of Greece saw the height of divinity in the human body and soul raised to a perfection high above earthly powers, and when in those gods in human shape the effort of man to copy that divine model through which artists had realized the law

of perfection, unattainable but imperious, found its purpose and its happiness.[33]

Given the proximity of social ideals to their representation in art, the comparison of the living body to sculpture or other works of art becomes commonplace. The passage from Demosthenes' *Erotikos* quoted earlier is a good example.

I can't illustrate the actual imitation of Homeric models better than by reference to the study by Froma Zeitlin, "Visions and Revisions of Homer."[34] Her study shows how deep and almost uncanny the penetration of Homer into Hellenistic culture was. Alexander the Great himself is her central example of Homer imitation:

> In the many ancient sources on the life and career of Alexander, one consistent theme is Alexander's passionate attachment to Homer, from boyhood on, especially with regard to Achilles whom he seems to have consciously chosen as his heroic paradigm. . . . On numerous occasions, at the site of Troy and elsewhere, he imitates Achilles in gesture, costume and deeds, to the extent that he comes close to virtual reenactments of Iliadic scenes, as though he saw himself as a latter-day Achilles, whose exploits, excellence and fame (*kleos*) he yearned to rival—and surpass.[35]

There is an element of theatricality in Alexander's imitation of Achilles, Heracles, and other heroes, but the show, the costumes, and the performance are outer expressions of a deep inner indebtedness to the heroic models. Zeitlin cites Cicero's *De finibus*, in which a group of young Romans studying in Greece urge a young comrade newly arrived "to resolve to imitate your heroes as well as to know about them" (*De fin.* 5.2.6). Their absorption of and into Greek culture is so intense that Zeitlin can call it "a kind of mystical communion with great spirits, halfway between dream reverie and epiphany, augmented by recollections of portraits and images already stored in memory" (p. 235).

4

Icon and Relic

Max Weber spoke of "pure forms" of charismatic personalities: shamans, berserks, prophets. The idea that some social roles might manifest charisma more distinctly than others is useful, if we put aside the romantic historicizing of Weber's theory (ancient charisma was pure, modern has weakened to artifice) and the suggestion of archetype and copy implied by "pure form." Applied to art and literature, it is possible to argue that some media and genres manifest the charismatic mode better than others. In the previous chapter I opposed Homeric epic to Sophoclean tragedy and argued that the epic aims at transformation in contrast to the tragedy, which aims at catharsis. Tragedy may draw on elements of charismatic representation, but it does not do what the epic does, magnify the subject and inspire imitation. In that sense epic is more "purely" charismatic than tragedy.

Charisma and Aura

Icon and relic are two kinds of devotional objects in Christianity that allow us to develop further the two concepts "charisma" and "aura." Neither relic nor icon is a "pure form" of either; the concepts are porous; each can contain elements of the other. But we can legitimately imagine the icon working charismatically without any element of aura, and the relic without charisma. The relic operates on aura, and charisma is an artificial overlay (invested, for instance, in the representational character of its shrine).[1] "Charisma" and "aura" are not stable and fixed categories. Setting them in a scheme of antinomies is heuristic, not a claim of watertight conceptual boundaries:

ICON	RELIC
Hypermimesis	Abstraction
Presence	Absence
Transform	Evoke

Relics and icons transmit sanctity. They purport to radiate the power of the saint whose dead body furnished the relic or whose living face furnished the icon.

Both work miracles, but the media and the—if I may put it that way—thaumaturgic style are very different. The icon reproduces or purports to reproduce the living presence in an image, while the relic is something left behind (*relictum*)—the full corpse or a part of it or some object that was in contact with it in life. Both devotional objects emit the grim magnetism of the grave. The powers of the miraculous are entombed there and stored up in the body like wine in a bottle. The yet-unused power of the dead saint still resides and ferments in them and can be tapped by the living. The power of the sacred object may even be magnified by the death of the saint. A laying on of hands by a living miracle worker is miraculous; a miracle performed by a hand severed from a saint's body adds mystery to miracle, the action of a being reaching from the other world over into this one.

To say that the miracle-working power of the relic and icon is macabre superstition is to deny the idea of the afterlife. The sacred dead are really still alive, according to the mind-set of the relic worshipper.[2] To believe that the body part or image channels the saint's beneficent and protective powers from the beyond to the here and now is merely to assert faith in the afterlife. That assertion does not strain the credulity of the faithful. Icon and relic straddle the gap between life and afterlife.

But regarded as opposed sacred forms that inspire worship and raise similar expectations, they give us a neat dichotomy and distinction between charisma and aura. The icon relies on hypermimetic representation; the relic just is whatever it is and works through accumulated associations, that is, "aura." The icon recreates presence; the relic evokes it out of absence. The dubious partner in this pair is the image. The relic is genuine; it really was part of the saint (or, if not, then it doesn't have power), it really did attach to or at least touch the saint.[3] There may have been thousands of fake relics, but there were also authentic ones. The image is a fake by its very nature.

Icon

Icons work through the life in the image. There are very few works or genres of art of which the same can be said and meant literally, not metaphorically, describing a belief of the worshipper, not a painter's ambition or a viewer's fanciful impression. The icon depicts Christ, the Virgin, or the saint as though he or she were available as a living presence, transmittable via the image. As such its stature is very different and more problematic in Christian doctrine than that of the relic. The earlier icons from around the mid-sixth century are startlingly plastic and expressive (Figure 8). Their vivid realism owes much to classical portraits. The comparison with Roman Egyptian mummy portraits shows this debt to ancient portraiture (Figure 9).

Also, the cult of the emperor's portrait from late antiquity funnels directly into the Christian cult of images in Byzantine Greek culture. The two modes of image worship are close enough together as to create serious political tensions between the imperial and the monastic realms. These tensions were an important factor in the iconoclasm of the eighth century.[4] James Francis traces the influence of the imperial cult of images in an impressive study. He reaffirms the work of others showing the development of the theology of the icon out of three streams, Neoplatonic metaphysics, image worship in Greek and Roman paganism, and Christian theology. He quotes the *Oration on the Mother of the Gods* by the emperor Julian the Apostate (d. 363), which claims that the statue of the goddess brought from Greece to Rome is "priceless . . . no work of men's hands but truly divine, not lifeless clay but a thing possessed of life and divine powers."[5] And in his letter to an unnamed priest, Julian makes the curious and provocative claim that the images of gods are not made by the artist, but by the image itself. The viewer and worshipper creates the life in the image via his or her love of the emperor or of the goddess: "He therefore who loves the emperor delights to see the emperor's statue. . . . It follows that he who loves the gods delights to gaze on the images of the gods, and their likenesses (*eikonas*), and he feels reverence and shudders with awe of the gods who look at him from the unseen world."[6]

The conviction that God gazes at the viewer from the other world through the mediating image is also at work in icon worship. Plasticity, expressiveness, and hypermimesis are marks of the sacred image as it originated in Byzantine art. The classical influences helped create those qualities, as the writings on images may have trickled into the theology of the image,

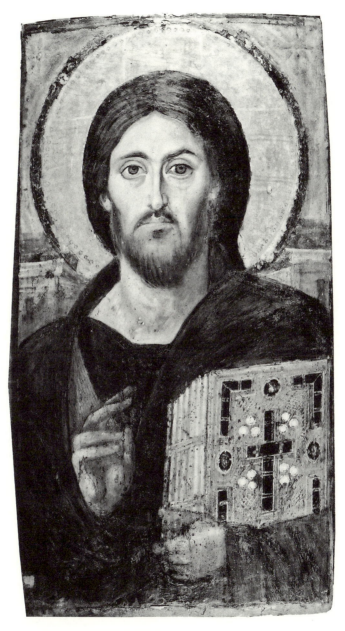

Figure 8. *Christ Pantocrator*, Monastery of St. Catherine, Sinai. (Reproduced through the courtesy of the Michigan-Princeton-Alexandria Expedition to Mount Sinai. University of Michigan, Sinai Archive)

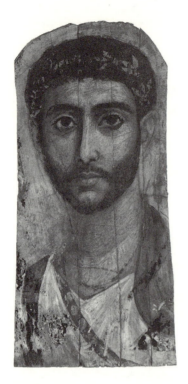

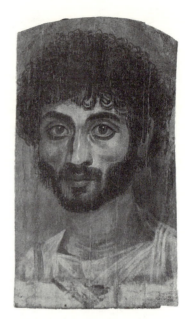

Figure 9. Three mummy portraits: *left,* portrait of a young bearded soldier, Fayum, Egypt, first half second century C.E. (Bildarchiv Preussischer Kulturbesitz/ Art Resource, NY); *top right,* unidentified portrait, ca. 160–180 C.E. (Image copyright © The Metropolitan Museum of Art/Art Resource, NY); *right,* portrait of a priest of Serapis, Harawa, Egypt, ca. 140–160 C.E. (© The Trustees of the British Museum/Art Resource, NY)

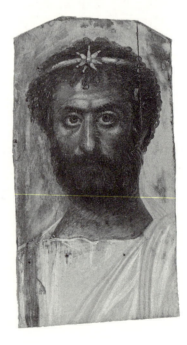

but tradition does not account for the peculiar character of icons. The intellectual and religious climate in which icon painting arose was literally a different world. While the painted or sculpted image had a long tradition and high legitimacy in antiquity, in Christianity it faced a crisis of authenticity. Paintings of Christ and the saints violate the commandment against graven images. Judaism and Islam held to this prohibition and shunned image worship as idolatry. But Christianity experienced a virtual flood of image making from the sixth century on. The doctrinal boldness of including images in Christian worship is evident in a passage from Ernst Kitzinger's study of the cult of images before iconoclasm: "In the entire history of European art it is difficult to name any one fact more momentous than the admission of the graven image by the Christian Church."[7] How exorbitant the license granted human artistry to reproduce the divine was is evident in the opposition it provoked through the early centuries of Christianity,[8] culminating in the iconoclastic movement in the eighth century.

But probably the strongest indication that its legitimacy required shoring are the miracle stories that authenticated holy images by denying human participation in their creation: the image of Christ was a "true image" imprinted miraculously on the veil of Veronica (whose name derives from this function: *vera icona*); or it is authentic because King Abgar of Edessa (d. A.D. 50) commissioned a portrait of Christ from life, which aided a miraculous cure of the king; or the painted image fell from heaven or otherwise appeared miraculously without a human intermediary (*acheiropoieton*—a variant of the story of King Abgar: the king's painter was so dazzled by the face of Christ that he couldn't paint, whereupon Christ wiped his face and gave the cloth to the king's emissary, which contained a miraculous portrait "not made by human hands"); or the original portrait of the Virgin and baby Jesus was painted by the evangelist Luke (who became the patron of painters). The claim that icons were merely a product of the imagination of a painter, hence a phantasm, emptied them of theological value. This need constrained the early Christian artist, in a way that no ancient artist was constrained (even the ones who claimed inspiration), to confront the charge that images are concocted by individuals. That charge had to be met by proof or at least a plausible claim of the divine origin of the image. Offering man-made images as objects of worship opened worshippers to the charge of idolatry.

As legends of miraculous origins authenticated the image, theology sanctified it.[9] God created man in his own image and likeness; and this was the

primal incarnation of the image; God is the supernal artist painting a self-portrait onto the soul of his handiwork, the human being. One of the major theologians of the image, opponent of the iconoclasts, Theodore of Studios (d. 826), could claim that Genesis 1:26 (man created in God's image and likeness) "showed that icon painting was an act of God."[10] The theology of the image was also deeply involved in the doctrine of the incarnation of Christ. For John of Damascus (d. ca. 749) the dual nature of Christ, man and God, must reveal itself in the painted image of Christ; the painter must create the hypostatic union of image and archetype. George of Pisidia, a seventh-century poet, calls the materialization of the icon a second incarnation; it renews the promise of salvation.[11] In the production of the image, a virgin rebirth occurs, an immaculate conception repeated in the realm of art.

The close connection of aesthetics and theology in the conception of the icon placed a great burden on the sacred image. Alongside its miracle working, it was assigned a role of repeating incarnation theology. The painter-priest becomes, in exercising his art, a miniature repetition of the creator-God, an engineer of the hypostatic union. The idea of the image as incarnation rechanneled the aesthetics of Western painting into metaphysics. The image had to represent itself as a mediator to a higher reality, a true representation of a divine archetype. Its charisma derived no longer solely from its surface, as in classical sculpture, but from that invisible and inaccessible divinity to whose presence the image granted access. This notion has a philosophical preparation in Neoplatonism, and it had consequences for the aesthetics of the icon.

The urgent need to inject sanctity into the artwork is also evident in the practice of mixing colors using holy water.

The early icon of Christ Pantocrator from St. Catherine's monastery, Sinai (see Figure 8), has extraordinary expressiveness and deeply moving personality. It is dense, two-dimensional and hyperrealistic; that means that we can penetrate neither into the depths of its own visible realm as measured off by the rectangle of its frame and suggested by the unobtrusive buildings behind Christ, nor into its depths outside of the perceptible reality it presents us with. By contrast, Albrecht Dürer's self-portraits of 1500 and 1522 are transparent (Figure 10).

The Dürer portraits show us a human subject (the painter himself) and behind or within it or superimposed on it is a god (see Chapter 7). In the Mount Sinai Pantocrator we also see a god, or the son of God, and while

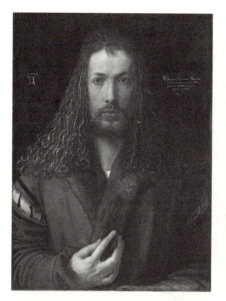 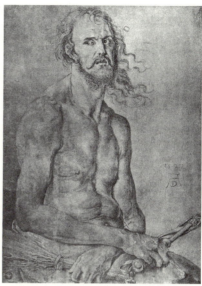

Figure 10. *Left*, Albrecht Dürer, *Self-Portrait*, 1500. Alte Pinakothek, Bayerische Staatsgemäldesammlungen, Munich, Germany. (Bildarchiv Preussischer Kulturbesitz/ Art Resource, NY); *right*, Dürer, *Self-Portrait as the Man of Sorrows*, 1522. (Kunsthalle Bremen–Kupferstichkabinett–Der Kunstverein in Bremen. Photo: Stickelmann)

his face is richly polyphonous, his qualities are exhausted by a careful study of the surface. Everything that this painted subject is, is there. It is a single-occupancy icon. Christian writings prepare the viewer to see through the son to the father, of course (Col. 1:15: "He is the image of the invisible God"; and John 14:9, Christ to the apostle Philip: "He who has seen me has seen the father"). But this portrait is impenetrable. Other examples of the Pantocrator have him enthroned and represented high in the apse of the church, as in the twelfth-century Christ from Cefalu (Figure 11).

The Sinai Christ by contrast stands in an inconspicuous landscape with token buildings in the background, certainly on earth, not in heaven. The denseness of the portrait places a greater burden of meaning on the signs of sanctity: the halo, the gospel book held prominently in the left hand, dominating about one-third of the surface of the portrait, itself dominated by its cross and jewels; finally the conventional blessing gesture of the right hand.

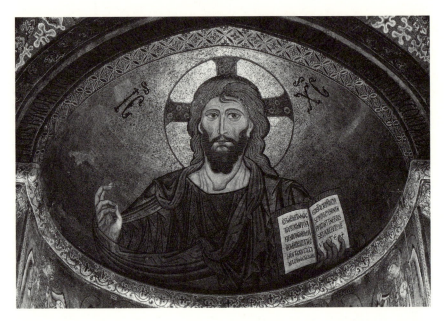

Figure 11. Christ Pantocrator, Mosaic, Duomo, Cefalu, Sicily, Italy. (Photo: Scala/
Art Resource, NY)

If we put the icon alongside a portrait of Christ from the school of Jan
van Eyck (Figure 12), we see how laden the Byzantine Christ is. The Van
Eyck portrait is also dense and impenetrable in the sense that nothing on
its surface proclaims or hints at a hidden presence, or a depth beyond the
surface into which we can enter.

The face of Christ in the icon is serene, gentle, and strong. It compares
well with Van Eyck's slightly droopy Christ, whose tiredness points to his
suffering (fairly mild) more than to his love and benevolence. The eyes of
the icon are large and soft. The contrast to a portrait of St. Theodore
(Figure 13), also in St. Catherine's Monastery, Sinai, is telling. Kitzinger
wrote of this portrait: "His small, ascetic face glows, as if consumed by
an inner fire. The gigantic dark eyes of the saint gaze directly at us with a
strength that is straight-out hypnotic."[12] While the eyes of the Mount
Sinai Christ are penetrating and riveting, they have neither the hypnotic
quality nor the "inner fire" of St. Theodore. They beam benevolence and
forgiveness, along with restrained authority and majesty. The aristocratic
serenity of the face—elegantly elongated nose, sculpted cheeks, and

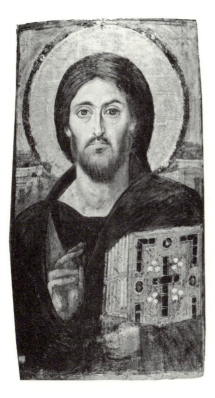

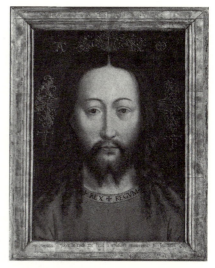

Figure 12. *Left,* Christ Pantocrator, St. Catherine's; *right,* follower of Jan van Eyck, Christ, copy of a lost original, 1438. Gemäldegalerie, Staatliche Museen, Berlin, Germany. (Photo: Jörg P. Anders; Bildarchiv Preussischer Kulturbesitz/Art Resource, NY)

arched eyebrows—express a soft and sensitive authority. While the portrait asserts the hieratic character of the icon strongly, it does not lose its human vulnerability. One recognizes Christ in the Van Eyck painting by analogy to others, or by its title, or by the context of its display, not by any markings of sanctity.

The icon holds up well alongside Albrecht Dürer's famous self-portrait of 1500 (Figure 14), christomorphic, as opposed to a representation of Christ.. They vie with each other for the gentle authority of their subject and at the same time for representing a dual nature, man and god. But the provocation of the Dürer (and the Van Eyck) portraits is that we must penetrate the surface to find out who it is that is hidden behind it. The surface is an integument covering a second identity that the first contains. These portraits have mystery, whereas the icon has sanctity without mystery. That Dürer conferred the hypostatic union on himself doesn't matter

Figure 13. Theodore Tiro, from the monastery of St. Catherine at Sinai.
(Reproduced through the courtesy of the Michigan–Princeton–Alexandria
Expedition to Mount Sinai. University of Michigan, Sinai Archive)

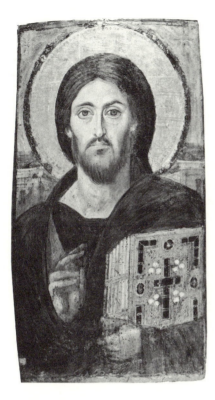
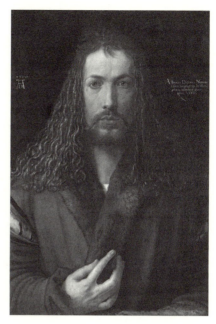

Figure 14. *Left,* Christ Pantocrator, St. Catherine's; *right,* Dürer, *Self-Portrait,* 1500.

for our context. The humanity of the divinity is realized in both early modern portraits.

But we can only find Christ in the Dürer self-portrait by careful comparison with other representations (see Chapter 7 below). That makes it very different from the icon, cluttered with emblems. It seems to proclaim, in fact, protest, its sanctity, again visibly, on the surface. Like a traveler crossing a border, Christ has his proof of identification out and showing, lots of it. That does not mean that nothing is hidden; just that all that he shows attests to his identity.

But the halo, cross, book, and blessing gesture are conventional appurtenances available wholesale to any painter in his book of model icons.[13] They recur in icons of Christ, ruler of the universe. The individuality of the face is in stark contrast to the marks of sanctity. The face is above all the place where his humanity, not his divinity resides. It is the key to the surplus of force in the portrait, the source of religious power for the worshipper.

Gilles Deleuze and Félix Guattari, rare analysts of "faciality," divide the face into "white wall and black hole," the white being the space of significance and the black the zone of subjectivity.[14] This icon divides more neatly than Deleuze and Guattari conceive it, with all the meaning-bearing signs placed outside of the face and the face itself given entirely to a deep and embracing consciousness, full of expressive force, but ultimately ineffable, inexhaustible via words. That is characteristic of many icons; the meaning is invested in the conventional signs and postures; the religious force radiates from the face, and it works because the zone of the face is freed from semiotic function and given over entirely to an individual emotionality and passion that is virtually hypnotic, at the minimum riveting, in its effect on the viewer. The halo might inspire reverence, but it is always the face that does the charisma work, as in the Abgar legend, where the face of Christ cures the king when Christ himself cannot be present; or John of Damascus, who calls the face of Christ "living and life-giving";[15] or in Peter Brown's example of a woman cured by St. Symeon the Younger (d. 592)—she takes his portrait home with her, and the portrait is credited with the same healing power as the face of the saint. Another woman requests a look at the portrait, "confident that 'if I can only see his face, I shall be saved.'"[16] The face is always the energy source. The Sinai Pantocrator beams this redemptive quality: it promises blessings and seems to indemnify the promise by divine kindness.

What need do the realism and verisimilitude in this portrait satisfy? The theology of the incarnation transferred onto the image does not require it, neither does the "hunger for accurate images of Christ."[17] The hunger for the real presence of Christ is certainly at work. But the elevated humanity of the Sinai portrait makes Christ handsome, lovable, and affable.[18] It is modeled hypermimetically to draw the viewer into Christ's world, to create the zone between the real and the represented world where the viewer can live with the person represented, immerse himself in that world, and merge with him in the limited way that participation and inner transformation can accomplish. What is important here is that it is not mere verisimilitude that is at work (*"yes, this could be a real person"*), but the magnetism of an extraordinary personality present in an extraordinary physiognomy.

The icon represents the ruler of the cosmos, but the gentleness and compassion in Christ's face plays against the expectations that role arouses. He has none of the severity and authority of ancient ruler portraits. The portraits of Roman emperors ordinarily radiate strength and authority.

They are forceful, intimidating wielders of power. The military background and tendencies show in the harsh brow of Caracalla, a consistent feature of his busts, a face without a trace of tenderness and softness. Roman emperor statues share a common commitment of the artist to strength and authority. Their charisma is strong. They model an ideal. But it is far from that of the Sinai icon. While the one radiates rule and domination, the icon Christ casts an umbra of peace, forgiveness, love, and understanding. In spite of its role as "Pantocrator," ruler of the universe, there is nothing commanding or dominating about the portrait, in contrast to the twelfth-century Pantocrator from Cefalu (Figure 15), situated majestically in the apse of the church. Along with marks of suffering there is also a harsh resolve in his face, which it does not share with the mild Sinai Christ. Also, the sweeping gesture of the right hand and the reach of the left convey both embracing and commanding (see Figure 11).

The gentle humanity of the Sinai portrait would be evident even if we viewed the image stripped of all its sacred paraphernalia. Compassion and love are in this face prior to any doctrinal concerns. The reason we see those qualities in this face is not because we know the Lord's Prayer and the Sermon on the Mount; the sacrality of the portrait does not overwhelm its humanity; far from it. This is evident from a comparison with the more hieratic icons that predominate in the type. The stereotypical icon derives from a wholly different mentality and conception of Christ. Its abstract character has itself become an iconic sign along with the sacred bric-a-brac. The division between "black and white hole" is gone, since every element of subjectivity is removed. The sense at work in the type says rather, *"Christ is too divine to receive the features of a man. Why diminish him by realism? Just indicate sanctity; that's enough."* But the desecrating effect of a claim of Christ "as he really was, handsome, loving, human," the Virgin "as she really was, beautiful, maternal, compassionate," may have urged itself on the painter. Realism shunned is a higher form of reverence; the abstract sign is more chaste than the sensuous; schematic is more pious than vivid. Makers of nonindividualized icons are not showing lack of skill; they are hedging their bets against the consequences of claiming to portray divinity.

The Sinai Pantocrator (see Figure 8) is humanized and individualized by comparison. It may be that the flaws that have been noted in the drawing are not flaws at all, or the results of bungled touching up. The left eye droops and is slightly larger than the right; the left side of the mouth is shorter than the right, possibly cut off by the mustache; the swelling on the

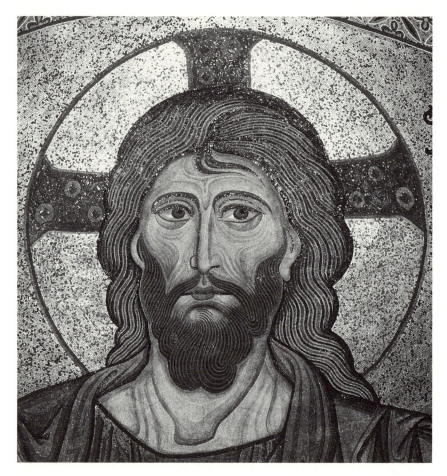

Figure 15. Christ Pantocrator, Cefalu.

neck is confusingly drawn, so that we may wonder whether Christ's neck is muscular or goitered. But the imperfections don't detract from the impact of the portrait. Christ's eyes are large and soft; they have the "living" quality that the icon painters share in common with Egyptian Roman funeral portraits (see Figure 9).[19] By comparison the eyes of Van Eyck's Christ are hard and small. They don't fill out the comparatively smaller space. White appears beneath the iris.

In sum, the portrait represents a god with two natures: human and divine. It is a sacred image, but while its sacrality is in its furnishings, its

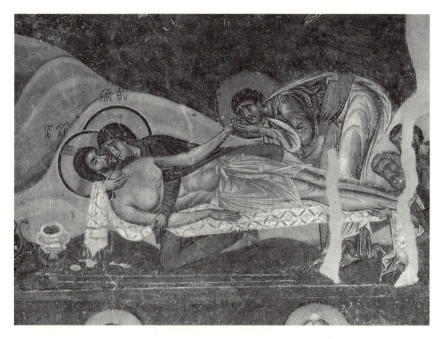

Figure 16. *Mater dolorosa,* 1164, fresco, St. Panteleimon, Nerezi, Macedonia.
(Photo: Erich Lessing/Art Resource, NY)

depth is in its humanity. It seems to say that Christ's divinity is at work in
what is human, vulnerable to emotions, passions, and suffering, inspiring
affection, but at rest in the rigid space of the eternal in his divine signs.

Its moving religious force is located in what I've called earlier its voice:
it is a soft polyphony, rich with harmonies, gentle but with a continuo that
is both strong and unobtrusive.

An image equally charged with charismatic force is the magnificent icon
of the lamentation in a twelfth-century fresco in the church of St. Pantelei-
mon, Nerezi, Macedonia (Figure 16). The overall composition is worth
noting, but particularly the representation of the Virgin (Figure 17). It is
an astonishing realization of sorrow. The mourning mother has placed her
cheek against the face of her dead son, but still raises her face with open
eyes to see him, as if to watch for signs of life, as though he might revive,
open his eyes, and speak to her. The modeling of the face stretches and
swells it to the point beyond which there is only caricature—without cross-
ing that boundary. The eyebrows arch at an angle hard to reproduce in the

Figure 17. *Mater dolorosa*,
Nerezi (detail).

human face; the furrow of the forehead and angle of the eyes follow suit.
Beneath the eyes is a trough of tears. The curve of the nostril seems set
more by the grief of the moment than by nature and genes. The Virgin's
mouth is distorted in a paroxysm of crying. The line of the mouth is drawn
in cartoon fashion. It is one point where the depiction of extreme mourning
might be said to tip over into caricature.

To say the picture holds up well against later, far more famous render-
ings is an understatement. The composition is similar in Giotto di Bon-
done's *Lamentation* (Figure 18). The dead Christ is laid out with Mary
bending over him. The dynamics of the painting follow that same extreme
diagonal, as in the Nerezi Madonna: bent with sorrow. Angels float above
the scene in both. Giotto's Virgin also goes face to face with her dead son
with the same searching scrutiny of the face (Figure 19). The mother's right
hand reaches fully around her dead son's neck, and the left hand, laid as a
caress on Christ's chest, intensifies the sense of love. But the face has noth-
ing like the emotional force of the twelfth-century icon. The modeling of
nose, mouth, and eyes is off-putting. The eyes are stretched and pinched,
the mouth poised between grieving and scowling.

The distortion both in this and the Nerezi icon recalls Lessing's argu-
ments in *Laocoon* that visual representation resists extreme pain and suffer-
ing, since those emotions force distortion and thwart beautiful modeling.
But the difference between Giotto and the Nerezi icon is clear: the symme-
try created among the facial features of the icon is answered by the unhar-
monic rendering of discrete features in Giotto. The facial features of his

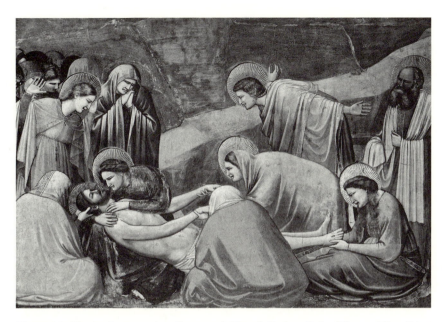

Figure 18. Giotto, *Lamentation*, Scrovegni Chapel, Padua, Italy. (Photo: Alinari/Art Resource, NY)

Virgin go their own way; those of the icon harmonize. Viewed from the distance, the shading, the upward stretch of the eyebrows, and the high-arched nose dominate the icon. Giotto's grieving Virgin is very different. At least one source of the icon's dynamism is the extreme furrowing of the forehead and arching of the eyebrows. The energy of extreme suffering gotten from this feature is evident setting the grieving Virgin of the icon next to the grieving, tortured father of the Laocoon statue (Figure 20).

While there is still genuine passion in Giotto, Sandro Botticelli's *Lamentation of Christ* (1495) seems staged and posed (Figure 21). The facial expressions might be borrowed from a painter's handbook, the suffering close to posturing. Or the *Lamentation* by Lucas Cranach the Elder (1538), its figures restrained by northern German sobriety, its passion conveyed in gesture (Figure 22).

The emotions are more forcefully represented in the Nerezi icon, and the emotional impact on the viewer is far stronger. For the Byzantine painter an extreme of suffering conveyed divinity. For the Western Renaissance painters dramatic composition replaced individualized grief.

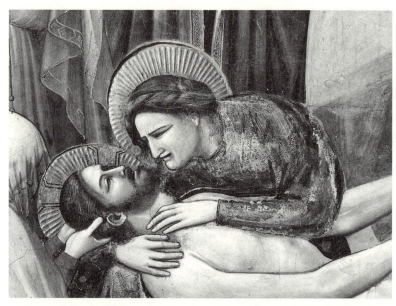

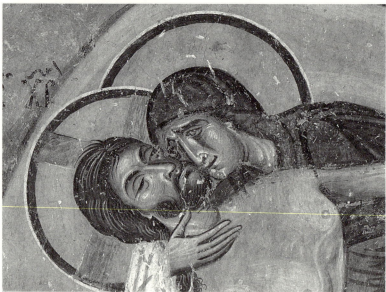

Figure 19. *Top*, Giotto, *Lamentation* (detail); *bottom*, *Mater dolorosa*, Nerezi (detail).

Figure 20. *Left*, Laocoon (detail), of the *Laocoon* sculpture group, Pinacoteca, Vatican Museums, Vatican State. (Photo: Alinari/Art Resource, NY); *right, Mater dolorosa*, Nerezi (detail).

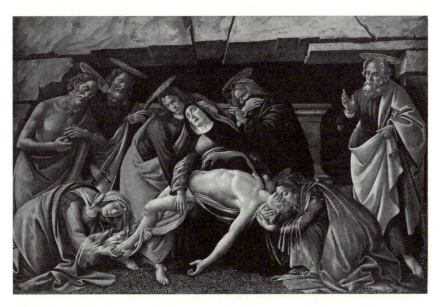

Figure 21. Sandro Botticelli, *Lamentation of Christ,* 1495. Alte Pinakothek, Bayerische Staatsgemäldesammlungen, Munich, Germany. (Photo: Bildarchiv Preussischer Kulturbesitz/Art Resource, NY)

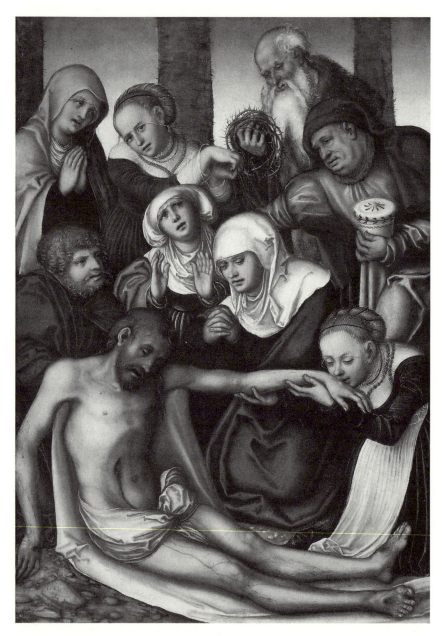

Figure 22. Lucas Cranach the Elder, *The Lamentation*, 1538. (Photograph ©
Museum of Fine Arts, Boston. Bequest of Charles Sumner 74.28)

A phase of European book illumination linked to an affective theology of meditation depicted grief by signs and signals rather than dramatic composition and individual modelling of the face, evident in a grieving Virgin from the Amesbury Psalter (Figure 23).[20] Paul Binski gives a shrewd reading of this image as a devotional object, drawing the reader into the affective world of the Mother of God, very much like the icon in its relation to the worshipper. Also the grief of this Madonna is set in place by the same drawing of features as the lamenting Virgin from Nerezi: the eyebrows arching upward, the eyes weighted down by sorrow, the lined forehead, elongated nose, and flared nostril. But the Gothic Madonna is, by comparison, cartoonlike and line drawn. The Virgin's mouth does not participate in the anguish of the eyes. It is a single straight line bent by a smudge of red. The mouth could be that of a perfectly content woman. All the facial features are drawn by a single stroke; they represent iconic signs of grief rather than a human face twisted from that emotion.

This brings us to the impact on the viewer. The hyperemotionality of the Nerezi lamentation responds to the need for visible sanctity and the experience of divine presence. It is the extremity of suffering in the Nerezi Madonna that asserts its claim to divinity. It is a good example of what Longinus, in the tract *On the Sublime*, called *enthousiastikon pathos*. This element, along with grand conceptions, says Longinus, "transports the readers [here viewers] out of themselves." Wonder and the miraculous also must be present: "Invariably what inspires wonder, with its power of amazing us . . . exercises an irresistible power and mastery and gets the better of every listener. . . . A well-timed flash of sublimity shatters everything like a bolt of lightning."[21]

An eleventh-century Byzantine intellectual, Michael Psellos, describes the effect of an icon of the Virgin. He speaks the language of the sublime in this passage (without, as far as I know, quoting Longinus). It also gives us a good clue to a charismatic reading of this and other icons: "I am a great connoisseur of icons, one of which [an image of the Virgin and Child] particularly ravishes me; as a bolt of lightning, it strikes me with its beauty, depriving me of strength and reason. . . . I do not know whether or not the image reveals the identity of its supersubstantial original; I behold, nevertheless, that the layering of paints reproduces the nature of flesh."[22] Here the ravishing effect of the sublime joins a well-known category of iconic aesthetics: "living painting." Psellos even puts aside the "supersubstantial" aspect of the image and attributes its effect

Figure 23. Crucifixion, Amesbury Psalter, MS 6, fol. 3r (detail). (Courtesy of the Warden and Fellows of All Souls College, Oxford)

to the quality of the flesh. He may even mean to say, "*and that's enough.*" Or rather, the lifelikeness, the sensual persuasion, is the guarantor of its equivalence to the archetype. It is *empsychos graphé*, "a painting with a soul," or simply "living painting."[23]

Whatever qualities of an icon will have struck the eye of a worshipper as "lifelike," the term indicates to us one of the central qualities of icons as devotional objects. By this quality above all the image established a dynamic relation between icon, worshipper, and, the invisible element, "archetype."[24] The element of icon "performance" enhanced the effect. The studies by Bissera Pentcheva argue the cinematic effect of a candlelit icon. The worshipper observing the light flicker and move across the body of the saint, experiences not only the human personality and emotionality, but also bodily movement. This apparent intensification of life in the image she calls "performance."[25] Given the intercessory purpose of the icon, the appearance of life in its contours and the suggestion of both compassion (toward the petitioner) and strength (in the court of heaven) were indispensable. "Life" is the guarantor of presence: the living Virgin or Christ may be suggested by light, color, and composition, but it is conveyed with force (a bolt of lightning) by the appearance of life. Only the "living" icon is able to "respond,"[26] to establish a dialogue of worshipper with Christ, Mary, and the saints, and transmit the petition of the worshipper to the court of heaven. The icon had to "live" in order to give life.

That most fundamental need created by the theology of the image was met by an aesthetics of beauty, allure, lifelikeness. The pressure placed on the iconodules by the enemies of the image, the fact that the image could only emerge against powerful resistance, helped develop artistry to match their theology. Men, women, and gods had to appear grander than reality because the painter painted not reality but the image of God in the subject, and only appropriated the illusion of reality to lure viewers into the unrepresentable higher world of Christ and the saints.

Painting meant making divine, as the supernal painter had made man divine by implanting his own self-portrait in him. The living painter had to "magnify the soul" by making that image of the divine appear in the vividness and *enargeia* of his painting. Origen brought the language of the *magnificat* to bear on the painting trope: "If I shall make the image of the image—that is, my soul—great, and shall magnify it by work, thought and word, then . . . the Lord Himself whose image it is will be magnified in our soul."[27]

The icon is hypermimetic for the simple reason that it depicts a god or saint. That very enterprise requires that the image go to the boundaries of the human; it does not attempt realism in the sense of imitation of humans "much the same as our normal level," to return to Aristotle's phrase. Photius said that the Virgin mosaic is an "exact imitation" (*mímesis*) of her nature (*phúsis*). The image appears to beam love on her child and to be about to speak because it is an "exact imitation" of her "real archetype." In other words, "imitation of nature" here means exact copying of an inspired vision of divinity, magnification of humanity into divinity. This form of representation makes the Virgin divine by giving her intensely human emotional qualities, especially through the fleshlike coloring and the peculiarly penetrating and moving character of her eyes.

And so in theory the icon has soul; it lives, it enters a dialogue with the worshipper (Kartsonis's phrase). And in artistic practice we can observe features that realize those elements of image theology. They are also what make participation and transformation possible. These are more sophisticated effects than miracle working, available perhaps less controversially through relics or cruder images, like the Madonna of Rocamadour (see Figure 24).

The more sophisticated effect produced by charismatic representation is imitation, that is, the urge of the worshipper to imitate the saint. Imitation depends on illusion: when the viewer accepts the painted or sculpted object as real, when the viewer enters into the world represented, he or she is roused to imitation, because the greatness of that world, or its charge of magic or sanctity, or promise of consolation, is so appealing. It works its paideic effect by showing us how minor we are and how high we can rise. The illusion powerful enough to dissolve its own illusory character and lift the viewer into a "heightened" world, accepted as real, is the prerequisite of imitation.

The advocates of icon worship had to oppose the Platonic mistrust of representation and, closer at hand, that of the iconoclasts. Michael Psellos defends icon painting: It is not a form of cheating, he says, the icon is not a fake, not something lower than nature. The icon can speak, can awaken persons and actions to life.[28] Participation of course is a fundamental religious experience: the Eucharist binds you via the drama of ritual celebration into the life of Christ and the community of the faithful. Its effectiveness depends on our accepting in some ineffable sense the bread and wine as the body and the blood of Christ. That's a big stretch. But the community of believers accepts it, trusting that it is the supernatural guarantor of grace. Eucharistic participation happens in the medium of ritual. In icon worship, it happens

in the intermediate zone between art and life where interaction between the worshipper and God or the saints becomes possible. The elevating and ravishing effect of art transports the faithful to that realm.

Accordingly, one of the functions of the icon, aside from miracle working and intercession, is transformation. It is the paideic effect of the charismatic image, as we observed in classical sculpture, here translated into Christian values, but trailing some of its classical antecedents, as the icons themselves trail their classical antecedents in their depiction of the human face. The viewer appropriates or rather absorbs the qualities of the image, which is a lesson in virtue. Its teaching is charismatic in that it transmits the qualities of the persons represented to the "audience" by some force that inspires imitation. The icon rouses in the viewer the desire to copy those represented, to experience love, compassion, and suffering like that of the saints.[29] The icon of the Virgin, says Michael Psellos, is "a living ideal image of the virtues." Being filled with higher life, it inspires the worshipper to remake his or her lower life according to the Virgin's model. The patriarch of Jerusalem Orestes (d. 1105/6), writing the lives of saints Christopher and Makarios, uses painting as the metaphor for this process of spiritual progress: "Painters, while they are compiling images on icons, look intently at ancient models. The brethren acted in the same way: when they would create the beauty of virtue in themselves, they gazed at St. Christopher."[30] Patriarch Photius, in his homily to the image of the Virgin, argues the superiority of painting to narrated tales of the martyrs, because actually to see the sufferings of the saints draws the viewers more powerfully to emulation than merely to hear their stories.[31]

Holy Men and Disciples

Disciples, devotees, followers, and fans want to live in the world of the idol they worship, share his life, be like him. Little boys replay war and action movies they've seen the night before, each vying to play the role of the admired hero. They try to walk and talk like him. This response is far from juvenile. They are experiencing the "educating" and transforming effect of a powerful personality in a strong narrative. The stronger personality has the "gift," the "charisma," to draw the weaker or younger up into his or her life force and to remake the weaker/younger one in his or her image. The Virgin Mary grieves archetypically. Her mourning is greater than

human; if we could weep and suffer as she does, we would approximate her divinity.

Another factor, perhaps the decisive one bringing a saint to life in painting, was the living presence and effectiveness in Byzantine society of the holy man.[32] We know from Peter Brown's studies the role this figure played in Eastern Christendom and what a charismatic charge society laid on him: "the whole movement of late Roman opinion . . . was towards charging the person of the holy man himself with utterly objective, inalienable power. . . . The holy man was expected to establish himself almost as a 'blessed object' in the midst of his fellows. Merely to see a holy man stirred East Romans deeply."[33] If "merely to see" stirred so deeply, and the rewards of this vision were of such existential reach and depth, then incentives to transfer the experience to art were immense. And indeed, in the course of the fifth and sixth centuries, Christianity faced the Orphic moment, looked back, and settled for the shadow, not the thing: "With only a passing challenge, from the Iconoclast Emperors, the charge that surrounded the 'God-bearing man' of the fourth and fifth centuries readily spilt over to invest the 'God-shadowed' image with much the same efficacy."[34] The holy man was credited with the power to heal, to end conflict, and to intercede for earthly petitioners in the heavenly court. It is no coincidence that icons were credited with precisely these functions. And so we have a case where the charismatic work of art distinctly takes its magical efficacy from the store of power and magic that had resided in the living body of the holy man; that figure is the charisma donor. The worshippers who needed the benefits of holiness readily made the shift; the monks who administered and the clerics who theorized it likewise entered this contract of representation with few or no scruples. It is a textbook case of a kind of charismatic art generated by the need to replace lost living, physical presence. Again, Brown puts the shift in terms suited to the transfer of embodied charisma to an external object of art: "The icon merely filled a gap left by the physical absence of the holy man, whether this was due to distance or to death."[35]

Overcoming Death

Both icon and relic respond each in its own way to death and the disappearance of holiness embodied.. Icons are, at that point of origin, attempts to artificially recall the dead to life. In the production and worship of the icon

we are closest to that deep sense of regret and loss and the instinctual human impulse to do the impossible: overcome death. It's not physically possible, because even the Christian route to redemption leads through the death of the body. But we still long for the resuscitation of the dead, however strongly we think the resurrection may come later. Much of charismatic art, as I argued in Chapter 2, represents the reluctance to accept death. With the illogic of a preconscious process, we take measures to retrieve what we've lost by death. Art is one of the means of restoration. Peter Brown concludes his chapter "The Very Special Dead," in *The Cult of the Saints*, with admiration for the "extraordinary emotional feat" of Gregory of Tours and Venantius Fortunatus of transforming the ill of physical death into the most sublime theme of the writing of late antiquity: "Without this feat, the 'perennial Hellenism' associated with the beauty of the faces in the rows of saints in Paradise who looked down on Venantius as he grew up in Ravenna, whose classical grace still haunts the visitor to that town, might have had less cause to linger in the West."[36]

Relic

When we move to that second form of devotional object and means of cheating or evading or outstinging death, we are in a different aesthetic world. All thoughts of "Hellenism," the sublime, charismatic effects, humanity, and beauty go overboard. The relic works without representation (at least, in its own physicality—the relic shrine is another matter). It does not rely on physical presence sublimated into art, as the icon does. It is the thing itself, the physical presence of the saint, or a part of it, real, not an imitation of presence. It is a part of the person left behind (*relictum*). It exists by being itself, hence does not suffer the curse of resemblance.

The relic of course is itself weighted down with artifice and phantasm, differently and perhaps not as heavily as the icon. Relic and icon suffer from reciprocal inadequacies: the icon re-presents, makes the saint be visibly present, but only through the medium of big illusion. Realistically speaking an icon is just wood and paint cunningly applied. It requires faith, animistic beliefs in the ability of a dead soul to embody itself, and suspension of the critical sense, to awaken the life and miracle-working power of the saint. But the relic has no image, makes no claims to full-body reclamation of the saint. Its materiality is not a lie, as is that of the icon. It is

genuine. (If it is a fake, then it is so by a departure from its true nature. An icon, like any pictorial representation is always by its true nature a fake.) The relic is the presence of the saint in a way far more authentic than painting, but it's only partial, in fact, often, minimal, just a bit, a finger, an earlobe, a bone, a foreskin. Therefore, while the icon makes some saint appear present again, the relic can only evoke, and while evocation is theologically more comfortable than representation, it is also more abstract. We are invited to imagine the whole from a part. Peter Brown has shown how the display of a saint's relics comes to full power in public presentation along with the narrative of his or her sufferings. Narrative, then, while not possessing the miracle-working power of the relic, is an aid to the act of evocative reconstruction to which the relic provokes the worshipper. But the relic can never do what the icon does: offer a model for imitation. We can be in awe of a relic but cannot remake ourselves in the image of the saint whose part has been left behind. Ordinarily it's best not even to try, as a look at the macabre remains of saints "blessed" with an uncorruptible body, will attest. We do not want to be like it or to grow into its greater frame. The relic does not represent, therefore it cannot transform. It can't work in the mode of Christian paideia, imbue virtues and form character. The power of relics is to evoke a lost presence, imagined and sensed but not seen.

The relic comes first in the history of Christian forms of worship, and so the order treated in this chapter is that of aesthetic, not historical precedence. The claim to aesthetic consideration of relics is slim, in fact minimal. What affect of any order related to art is to be gotten from the cabinet of horrors of relics and relic collections: ears, jawbones, fingers, and hands? That is of course the question of a modern living outside of the belief structures that made holy corpses awe inspiring. But they did exercise a huge influence over the religious imagination of the Middle Ages,[37] and that influence is part of our topic, if only as a complement to the power of charisma in icons.

To say that the role of the relic depends on beliefs in its magical efficacy explains nothing. It just moves the question to a second level of incomprehension. Relics beam a kind of enchantment, but it is far from what Alfred Gell called "technology of enchantment" or "enchantment of technology." No human skill contrived anything about a relic, other than its relatively unimportant, if magnificent, case. Even relics that purport to depict something can be homely and crude. Their effect does not depend on beauty

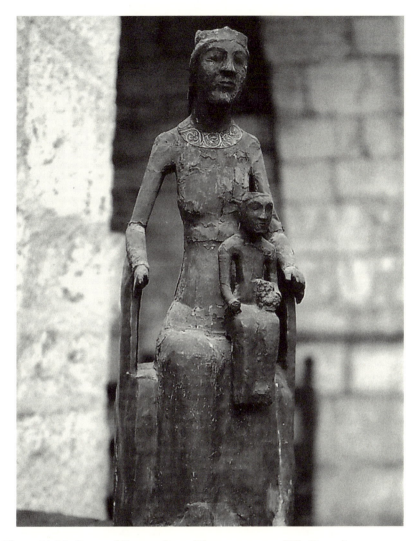

Figure 24. Madonna of Rocamadour. (Photo courtesy of Ella Rozett)

and hypermimetic effects. One of the greatest miracle-working artifacts of
the Middle Ages is also one of the crudest (Figure 24).

 The Madonna of Rocamadour is a wooden statue in one of the most
popular pilgrimage sites of the Middle Ages in the Dordogne, France. It is
an unprepossessing piece of wood, carved probably in the early twelfth

century, reputed to have performed many miracles, which include healing Kings Henry II of England and Louis IX of France. It received visits from Bernard of Clairvaux, St. Dominic, and Raymond Lull. It has powerful magic, undoubtedly, at least in the minds of those who know the legends of its powers, probably also in the minds of those who crawled on their knees, dressed in a hairshirt and laden with chains—the conventional approach to the Madonna's sanctuary for penitents—up the 216 steps to the church of Notre Dame, set in a steep cliff. David Freedberg describes the reaction of a friend who climbed the steps (not so encumbered): "I could not believe it. . . . After so long a journey, all I saw was a small ugly Madonna, with a supercilious look on her face. I was so angry with her."[38] Clearly miracle-performing power is guaranteed by something other than beauty. The Madonna is a kind of contact relic. Its power depends on the legend that it was carved by Zacheus, the tax collector favored by a visit from Christ in the Bible (Luke 19:1–10). The twelfth-century legend makes Zacheus into the husband of St. Veronica. That is, he married into a family noted for miraculous image production. The wooden Madonna was there-fore believed to have been in the presence of Christ, to have been made by a man blessed and promised salvation personally by Christ. Zacheus must also have seen the Virgin with his own eyes, and that makes the hunk of whittled wood ascribed to his art into a contact relic; it was present and nearby during the events of Christ's life, and so is laden with association, echoes and reverberations of its origin.

Splendor in the Reliquary

There is some tendency for the reliquaries, the shrines made to hold the relic, to assimilate to icons. There is a splendid and famous statue of St. Fides of Conques (Figure 25). The saint's skull was in the possession of the abbey of Conques thanks to a *furtum sacrum*. Two monks of Conques stole it.[39] Splendid or not, the real value lay in the thing itself, the body part or contact relic, not in its container, however magnificent.

The visit to Conques in the early eleventh century of a schoolmaster, Bernard of Angers, a student of Fulbert of Chartres, is remarkable testi-mony to the relationship of the relic to its shrine. This well-educated ratio-nalist came armed against golden statues of saints with a mocking dismissal

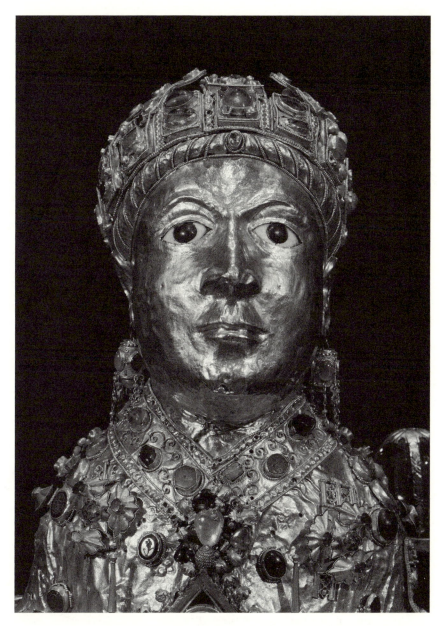

Figure 25. Reliquary of St. Fides of Conques. Treasury, Abbey of St. Foy, Conques, France. (Photo: Erich Lessing/Art Resource, NY)

that placed them in the same class as pagan idols. With a wink to his comrade, he sends a cynical prayer to the statue whom in the same breath he associates with Diana or Venus. But after reflection and a cautionary tale about a cleric who mocked the statue, then was upbraided, beaten, and ultimately killed by St. Fides herself, Bernard understands the sanctity of the statue better. It is not an idol but a shrine, a "pious reminder of the saint herself" (*sancte virginis piam memoriam*), more literally translated, "the pious memory of the holy virgin." Or, Bernard continues, "the statue is to be understood most intelligently in this way: it is a repository of holy relics, fashioned into a specific form only because the artist wished it."[40] The thrust of this comment is to deny the statueness of the statue; the statue of St. Fides is not a statue, or rather, it is less a statue than a container. It makes no claims of producing the authentic presence or even appearance of the saint. That explains the comment that the specific form is entirely the choice of the artist: no miraculous transmission of the *vera icona*, no ghostly apparition serving as an authentic model. Some mere workman with no heavenly commission thought up and made this splendid saint-shaped box. It *reminds* us of the saint, it doesn't represent her. The sensibility at work here is iconophobic, certainly idolophobic. Bernard is willing to accept the shrine in human form, only on terms other than its icon-ness.

The urge to actually depict the saint in his or her reliquary, to assimilate the relic to an icon, was minimal and marginal, probably held in check by the kind of latent iconoclasm that nurtured Bernard of Angers' initial contempt of statue reliquaries. Hans Belting thinks that the statue reliquaries are a sign of the decadence of the art.[41] It was possible to bypass the gold and jeweled shrine, but that required a large and at least somewhat presentable leftover (like the intricately carved skull of Abbot Durannus of Moissac, eleventh century). Arm and hand relics are fairly common. Clearly there was no pattern book for sculptors and goldsmiths of relic shrines (as there were painter's books for icons). It was a locus of artistic freedom.[42]

Splendor in the reliquary functioned not as hypermimetic representation but as the visible manifestation of the saint's *virtus*. It is to the grizzled contents what the halo is to the supernatural being. The impressiveness represented a dazzling advertisement of the saint's ability to cure, to protect, to remit sins, to authorize and sanctify legal proceedings, to advocate the worshipper in heaven.[43]

It was not the form, but the auratic character of the relics that gave them their power over the imagination.[44] As in other examples of aura,

the imagination of the beholder reconstructs or re-evokes stories from the fragmentary clues still surviving in the present. The visible aura of the reliquary is an aid to the process by which imagination and memory recall what, though absent and unrecoverable, still soldiers on vigorously in miracle working fueled by the relic's inherent power. Bernard of Anger stated it clearly: the shrine is not the saint herself, but the memory of her, "memoria sancte virginis."

Saint Bernard's Jaw

I experienced the aura of St. Bernard of Clairvaux some years ago in the treasury of St. Stephen's church in Troyes, Champagne. My experience is a good example of a relic projecting aura, though adjusted for a very different set of cultural presuppositions and in this case with its visible aura removed by the despoilers of churches and desecrators of relics during the French Revolution who dispersed the bones of Bernard and made authentication hard.[45] At the time I had a serious interest in Bernard's writings and his role in twelfth-century intellectual life. Stowed inconspicuously in the treasury of St. Stephen's among the gaudy bric-a-brac of the locked cabinets was a piece of a human jawbone, not displayed in a reliquary, just a piece of unidentified bone on a velvet cloth—the upper jaw, a few teeth left, part of the skull, a gray-brown color, pocked and pitted, no more auratic than some old bone of some anonymous prehistoric protoman displayed in a natural history museum. (Its bare presentation is suspicious for the church historian: the Fourth Lateran Council, 1215, forbade showing relics outside of their shrines.) I asked the guide what it was doing there. He explained that it was the jawbone of St. Bernard of Clairvaux. Then I stood there assailed by ripples of Proustian recollection. What I knew about Bernard crystallized in and around this bone: over these broken teeth had passed the words that became the sermons on the Song of Songs and the appeals that had spirited pilgrims on the way to the ill-fated Second Crusade; the accusations of heresy pronounced in Sens cathedral in 1140 to end the career of Peter Abelard had once reverberated around these teeth. This broken frame had held the tongue whose rhetorical magic converted listeners and swelled the Cistercian order. Héloïse had once sat, probably unrepentant and with deeply ambiguous feelings, opposite this jawbone when it was upholstered with cheeks and gums and attached to a living body. Some

strains of memento mori played. Reminiscences of Hamlet and Yorick's skull thickened the mix of sentiment. Time collapses; the past is present; the two merge with the emotional force of the events conjured. The blend of miraculous timelessness and grand, dramatic events and personalities gave the bone its particular aura—in my imagination.

Of course, it was all woven for the moment out of my own associations. Someone with no conception of Bernard would have seen only a bone. And of course, the relic would have reverted—without any change in its materiality—to mere old-boneness, if some hard-nosed local historian, watching me stew in sentiment, had told me that the keepers of the treasury had played a mean trick on me—that the jawbone had actually belonged to the town drunk of Troyes who died twenty years before, leaving no aura-inspiring stories behind to inhabit his bones. The ghost of Bernard would have faded as quickly as it appeared.

To summarize, "icon" and "relic" are two forms in which sanctity gets transmitted after the death of the saint. The icon transmits by charisma and the relic by aura. The icon models the saint and invites the worshipper to accept the copy as a true version of the original, or at least a version capable of hosting ghostly visitations from the soul of the inhabitant it simulates. It is powerful because it reproduces mimetically the human and divine qualities of the saint, invites the worshipper to share them and to benefit from them. The relic is a memento, not a representation. It concentrates the invisible force of the saint and makes it visible and usable. It radiates his or her aura. "Aura" is the sum of associations that collect on an object. They exist strictly in the mind of the beholder or in the collective mind of a community of believers.

The icon emerges as a significant devotional object some four hundred years after the relic. Both of them arise from the Christian death cult and in practices and beliefs associated with the worship of the saints and the holy family. Both are, in the end, about death, look toward death: the relic wards it off, keeps the dead living; the icon resurrects the presence of the living, the hyperliving saint. Icon affirms life; relic holds death at bay. Relics have nothing to do with Christian doctrine (Peter Dinzelbacher's evidence shows it); they're about preserving the precious life-force in a saint's dead body. Icons elbowed their way into Christian spirituality, brashly pushing aside the prohibition of graven images.

In the case of icons, we located the sudden emergence of charismatic representation in specific historical and social conditions—or rather, Peter Brown located it for us. Here as always, the charismatic work of art has to be understood and interpreted in sync with the living person or type or the living miracle or work of art to which it refers. There is no charismatic art without charismatic reality, whether it be in the experience or the imagination of the artist. The living presence inspires charismatic art either by actually being present, or by dying, disappearing from the scene, and so generating nostalgic desire through absence. That is the case with the flourishing of the cult of icons from the sixth century on. The icon is an attempt to inject life, force, and magic—once experienced as real, now lost and calling for restoration—into the image.

5

Charismatic Culture and Its Media: Gothic Sculpture and Medieval Humanism

The law of perfection, unattainable but imperious.

—Werner Jaeger, *Paideia*

The Gods Jealous of Artists (Hildebert on Ancient Rome)

Hildebert of Lavardin, bishop and poet, visited Rome in the last years of the eleventh century. Probably on his return to the north in 1100 he wrote an elegiac praise of the city's ancient ruins, "Peerless Rome" ("Par tibi Roma nihil"). At the poem's core is a burning admiration for the art of the ancient Romans, ignited by the sight of the pagan gods carved in marble, crumbling, loosely held in their niches and cornices, or already toppled and on the ground. In one of the most impressive passages of medieval poetry, he imagines the old gods themselves descending from Olympus, in whatever glory is left them after the advent of the new God, appearing before their statues and comparing the original—that is, themselves—with the copy:

> The art of men once made a Rome so great
> That the art of the gods could not destroy it.
> Divinities themselves look awestruck on divinities sculpted
> And wish themselves the equals of those sembled forms.
> Nature could not make gods as fair of face
> As man created the awe-inspiring images of gods.

Carved likenesses improve these deities;
They merit worship more for the sculptor's art than their own
 divinity.[1]

He invests the gods with aesthetic judgment and constructs a contest of beauty and skill between sublime art and sublime beings. That Nature creates gods—and not vice versa—is a bold idea. The outcome is also bold: Nature loses the contest to the human artist. The statues—crumbling though they are—are superior to their models, the living gods, as their artist is superior to the "sculptor" of the gods, Nature. The Roman sculptor's art does not just imitate the gods; it corrects their maker. It shows Nature possibilities beyond its own imagination. As if the Platonic process of imprinting ideas on matter were turned upside down, the copy teaches its archetype what beauty is.

It's enough to make iconoclasts of the gods. Here is the very reason gods forbid graven images: the image, and not that which it represents, becomes the object of worship ("they merit worship more for the sculptor's art than their own divinity"). The gods suffer an envious disquiet at this usurpation of charisma, since they wish themselves, in momentary forgetfulness of their stature and dignity, the equals of their fictions. They gawk at their magnificent copies, which ignore their models and gaze past them in Olympian indifference. If we could also see the bested gods collect their wits and overcome their surprise, we could imagine them challenging the artist: "How dare you depict us more beautiful than we are!" To which the Roman sculptor would reply, "Learn through me to be more godlike."

Myths of Representation

This passage from Hildebert's poem offers us a myth of representation, comparable to other myths of representation, like Narcissus or Pygmalion. In all three the created or reflected image produces a kind of enchantment in the maker or model. But in the two ancient myths, the source of astonishment is the identity of life and art (Narcissus) and the cheating appearance of life (Pygmalion). Narcissus sees an image of himself indistinguishable from the living being it reflects; Pygmalion makes a statue so close to life that his desire overcomes the narrow distance between the two conditions. Narcissus and Pygmalion are both myths of mimetic representation—

the closer the representation comes to representing life, "imitating nature," the more enchanting it is.

Against this, the hypermimesis of the medieval "myth" posits the *victory* of representation over nature. It is about overcoming and going beyond mimesis. Hildebert's "myth" presupposes an art that we can call charismatic, because it competes with the charismatic beings par excellence, the gods, and surpasses them. It is not enough within this mode of representation for art just to be like "life," merely to imitate nature, even nature as perfect in itself as the appearance of Narcissus or Pygmalion's statue. It wants to be grander and more beautiful. The beauty of the ancient statues brings the gods themselves under the spell fundamental to charisma—they want to be like the works of art: *cupiunt fictis vultibus esse pares.* Were they living beings, they might work at it, might fashion themselves according to the model of the statue. It seems likely that classical Greek statues aimed at this educating effect: to offer a model of the ideal body, of ideal composure, a sight to make the viewer envious and emulous. And we will see that there is reason to think that medieval sculpture may have had this role as well.

What registers in Hildebert's deeply resonant verses are, first, a program of physical and ethical education based on charisma, second, an aesthetic of that education, and, finally, a crisis of an ethical education.

Medieval Humanism and Charismatic Education

Hildebert's own experience of the ruins of Rome may well have shaped his aesthetic ideal in the lines quoted—statues so beautiful as to make the gods envious; an artist so skilled as to merit worship—but it is also tutored by the humanistic ideals of cathedral schools, the kind at which he had studied and taught. The cathedral schools from the late tenth to the early twelfth century institutionalized an educational discipline that aimed at fashioning the individual, his physical presence, his composure, his moral core, and that was persuaded that the formation of outer elegance and harmony would be answered by the formation of inner, ethical beauty. A handsome man, who spoke well, gestured beautifully, dressed well and decorously, must also be ethically well formed.[2]

The caricatured view of the Middle Ages as a period of intellectual naïveté and primitive manners is far from doing justice to the ideals of the

cultured and disciplined human being that developed at cathedral schools in Germany and France from the late tenth to the early twelfth century. These schools trained talented young men for administrative service in the church and the secular courts. A specifically Christian education, a preparation for pastoral duties, receded into the background and made way for aristocratic ideals, closely related to the ancient ideal of *kalos kai agathos*: the aesthetic and the ethical reinforce each other; the Beautiful is the visible, sensual form of the Good. A German schoolmaster writing around 1065 said that students are "meant to be formed by artist's hand from wet and malleable clay into vessels of glory on the wheel of discipline."[3] The "artist's hand" of course was that of a teacher. A famous schoolmaster-philosopher-mystic of Hildebert's generation, Hugh of St. Victor, gave a paradigm statement of this goal, also calling on the language of the sculptor:

> Why do you suppose we are commanded to imitate the life and habits of good men, unless it be that we are reformed through imitating them to the image of a new life? For in them the form of the image of God is engraved, and when through the process of imitation we are pressed against that carved surface, we too are moulded in the likeness of that same image. . . . We long to be perfectly carved and sculpted in the image of good men, and when excellent and sublime qualities . . . stand out in them, which arouse astonishment and admiration in mens' minds, then they shine forth in them like the beauty in exquisite statues, and we strive to recreate these qualities in ourselves.[4]

The exquisite statue here is a metaphor, a point of comparison. It tells us at least that Hugh recognized sculpture as capable of expressing exquisite beauty and combined that visible expression with the Christian idea of man's perfection, made "in the image and likeness of God."[5] But the model for the novices at his school is a living man who possesses the "excellent and sublime qualities" that inspire imitation.

Imitation of the teacher is the foundation of charismatic pedagogy.[6] Charisma stimulates imitation; the greater model remakes the lesser in its own image; the devotee's desire activates the chemistry of higher re-formation. It is a powerful and irrational principle, which, in addition to the formation of manners in young people, is also a strong component in demagogy, hero worship, and cults of personality.

Imitation as an aesthetic principle, fundamental to this study of cha-
risma and art, is profoundly related to the physical/psychological process
by which qualities of a charismatic person are absorbed by an admiring
follower. Imitation of an admired model is the form of mimesis central to
my topic. Hugh of St. Victor and others working in a charismatic culture
perceived clearly the relatedness of their teaching activity to the art of the
sculptor. Charismatic art inspires imitation of the viewer, as does charis-
matic personality. The teacher-student relationship is second only to
parent-child in the importance of the mimesis of person. The parent begets
the child's body; but the teacher forms the child's soul and spirit. The
teacher is the lesson, the teacher's appearance, way of walking, talking, and
living, is the curriculum. The Greek and Roman ideals of *paideia* reflect the
fundamental importance of imitation of teachers, heroes, ideal models in
literature or sculpture.[7] Seneca turned a phrase that had a great future in
medieval and Renaissance pedagogic practices: "The living voice and a life
shared by pupil and master will help you more than the written word. . . .
Long is the path through precepts; brief and effective through examples."[8]
A strong and impressive personality has the quality of replicating itself,
remaking others in its image. An inner force called in the Latin tradition
virtus, not very well rendered in its demiurgic character by the English
"virtue," creates this effect. The Renaissance was very aware of this force-
field-like influence of virtue. Shakespeare had Lady Percy describe the dead
Hotspur in terms of his *virtus* imprinting itself on others:

> [his honor] stuck upon him as the sun
> In the grey vault of heaven, and by his light
> Did all the chivalry of England move
> To do brave acts; he was indeed the glass
> Wherein the noble youth did dress themselves:
> He had no legs that practiced not his gait;
> And speaking thick, which nature made his blemish,
> Became the accents of the valiant;
>
>
> He was the mark and glass, copy and book
> That fashion'd others. . . . O wondrous him!
> O miracle of men!
>
> (*2 Henry IV*, 2.3.18–33)

Hotspur was a Platonic archetype, so the thrust of his widow's praise, fashioning others in his likeness. She gives no hint that education played a part in his "miraculous" presence. "Education" may not ring quite right to describe self-fashioning in the mirror and book of another man. The process of imitating a charismatic type happens instinctually, requires no institutional frame.[9] But that process was institutionalized in the cathedral schools of the eleventh and early twelfth century and served to fashion many. A prominent twelfth-century abbot and adviser to various German kings advised a young man just beginning his post as schoolmaster at Trier, "Let your mere presence be a course of studies for your students."[10]

Physical Beauty

To a degree it might startle anyone who comes to the Middle Ages as an "age of faith," or certainly a "dark age," that the ethical "curriculum" of cathedral schools and that of royal/imperial courts drew on an ideal of physical beauty. That connection is a logical continuation of the ancient ideal of the Good joined to the Beautiful. A chronicler described Bishop Gunther of Bamberg (mid-eleventh century) as "a man adorned with all the gifts of the body, in addition to the glory of his manners and the wealth of his mind. . . . He was unhesitating in speech and in counsel, learned in letters both divine and human, in stature and elegance of figure and the overall build of his body, preeminent among all other mortals."[11] The same writer observed that this bishop so far surpassed other mortals in "the elegance of his shape and the overall harmony of his body" that on a crusade in Jerusalem, great crowds gathered around him wherever he went to marvel at his beauty.

Being beautiful, Bishop Gunther must also be a good man. The logic of *kalos kai agathos* makes the body the mirror of the inner world. Compose the body beautifully, and the mind will follow, and conversely, if the inner world is harmonious and composed, the body will show it in its visible beauty. Hugh defines the discipline of manners at the school of St. Victor: "Discipline is the governed movement of all members of the body and a seemly disposition in every state and action." An odd enough idea, but the yet stranger inference follows—learn to walk and gesture well, and you learn virtue: "Inconstancy of mind brings forth irregular motions of the body, and so it follows that the mind is strengthened and made constant when the body is restrained through the process of discipline. Little by little, the mind is

composed inwardly to calm, when . . . its bad motions are not allowed free play outwardly. The perfection of virtue is attained when the members of the body are governed and ordered through the inner custody of the mind" (*De institutione novitiorum*, chap. 10, *PL* 176.935a–b). Teacher-student is the archetypal charismatic relationship. As in any such relationship (i.e., whether the mediator is a living human model, a work of art, a movie star, a political figure, or a religious leader), the transformation of the lesser into the greater is what the process aims at. But in the relationship of learner to educator, the goal is specifically to transform the learner into the teacher. An enthusiastic student of Bishop Fulbert (d. 1029) at the cathedral school of Chartres marveled at a fellow student named Hildegar who succeeded in "reproducing" Fulbert, making himself into a copy of his teacher "in his facial expression, tone of voice and manners."[12] A German schoolmaster (Goswin of Mainz, quoted above on students as "vessels of glory [turned] on the wheel of discipline") praised a former student (around 1065) because "you seemed to transform yourself altogether into your master."[13] The charismatic teacher ushers the student into the force field of his personality and transforms him, demiurge-like, into a little copy of himself. Hugh of St. Victor used the image of a seal and wax to describe this relationship: the master impresses the stamp of his character on the soft wax of the student.[14]

Men Made into Gods

A sweeping optimism about education in the period could see the process rendering human beings divine. An Italian bishop and courtier of the German emperors Henry III and Henry IV defined "virtue," the first goal of education, as "dignity of mind, nobility of soul, which makes man not just an object of wonder, but divine."[15] Baudri of Bourgueil proclaimed that "the milk of mother Philosophy" turns her sucklings into "gods, not men."[16] Sigebert of Gembloux (d. 1112) felt that his godlike gift of poetic composition imposed a special obligation to write his poem commemorating the martyrs of the Theban legion: "We whom mind and reason have made godlike, let us, having the gift of greater praise, praise more greatly."[17]

Two portraits can illustrate the endpoint of a formation through the discipline of *mores*. Meinhard, schoolmaster of Bamberg, writes around 1060, to a former student, heading toward high office in Cologne, and urges him to imitate the model of his (the student's) father. His father was "a

man instructed in every kind of virtue, a man who enjoys to an astonishing degree all the charm and grace of humanity, qualities visible far and wide not only in his dazzling blaze of manners, but also in the bright good humor which shone most graciously from his eyes."[18] The second portrait comes from Godfrey of Reims, chancellor and master of the school at the cathedral of Reims, in his lifetime (but hardly a day after it) one of the most renowned Latin poets of the day (d. ca. 1096). One poem of the slim body of works that has come down to us from Godfrey is a panegyric letter-poem to a friend, Odo of Orléans. The poem calls on a sophisticated and surprisingly worldly language of external culture. He imagines Odo appearing to him in a dream at the foot of his bed:

> There was no mistaking the man:
> Doubt not that his attitude, voice, speech, figure,
> His gait and appearance all gave off signs of an integrating harmony.
> He was not austere with morose gravity—which I hate—
> But rather serene with bright-spirited countenance—which I love.
> His face was not twisted nor intimidating with grim glances,
> Nor were his brows rigid and severe,
> But rather mild, gentle and placid as a dove, warming as the summer
> sun.
> Nor was he so gay and facile to look on
> That he would have neglected a modest appearance.
> Nor would he tempt shame by frivolous speech
> Or turn his appearance into that of a petulant boy.
> For vice is ill-shunned
> When the shunning yokes you to its opposite vice.
> He has not bathed well who washes away riotousness and gluttony
> Only to immerse himself in as indecent a fault: avarice.
> Odo holds the middle road between both extremes,
> And considers moderation safe from faults.
> He adorns himself so with temperance that his mark is
> Light good humor mixed with gravity.
> Temperance drives the swift horses of the sun,
> Temperance forms the harvests, mixing heat and cold,
> Temperance turns grapes to wine.
> This posture, this attitude are decorous; let the wretch stray
> Who swells with mendacious religion.

Let him live, mute, bitter and harsh, banished to the wilderness,
The companion of Hyrcanian tigers.
He who condemns joys and approves melancholy
Will be judged like winter and its frosty winds

. .

With such decorousness and such moderation of countenance
The poet's image [i.e., Odo] stood at our bed.
His form was not stumpy and puny,
It was the towering stature of a great man.
A sublime head set on a noble body
Magnified his appearance of height.[19]

The core of this description is its linking outer composure with inner virtues: the way Odo stands, walks, talks, and gestures and the serene expression of his face are the outward expression of his temperance, moderation, and his cultivation of the golden mean. Temperance registers in his "light good humor" and restrained affability. The lines of his body, his height and his "sublime head" are the signs of a "great man." This is a man governed by an "integrating harmony," and the things integrated are inner and outer beauty: in that symphony of speech, gesture, gait, and impressive appearance, the perfect "tuning" of his inner world registers. The Latin word for this quality in humanist parlance is *decor.*

The lines about "mendacious religion" show where this writer stands in regard to the monastic life. He berates severity, melancholy, and gloominess of countenance and praises serene, restrained good humor. A careful reading of this portrait shows the poet adapting ancient Roman ideals but using them fully in the context of those revived ideals in the intellectual culture of the eleventh century. The lack of any Christian coloring and the presence of an antireligious flavor is surprising. One reader of Godfrey summed up his theology: "He is intimately acquainted with all the residents of Olympus, but nowhere does he betray even distant acquaintance with Father, Son and Holy Ghost. His is the pagan philosophy of life."[20] Godfrey would seem to be an appropriate courtier for his patron and bishop, Archbishop Manasses of Reims (d. 1080), to whom a contemporary attributed the quip, "The archbishopric of Reims would be a pleasant thing if it did not require one to be singing masses constantly."[21] Manasses was kicked out of the diocese by the severe reform pope Gregory VII, and he spent the last years of his life a refugee at the court of the German king.

It does not do justice to this neoclassical culture generally to imagine it as uniformly irreligious. The religious reform movement of the late eleventh and twelfth century (to which Archbishop Manasses fell victim) certainly wanted to cast it in that light. Its religiosity permeates its worldliness. It lives in an atmosphere of the Christianization of ancient Roman values. This mixture had its nurturing context in cathedral school education: it was a preparation—not for monkish worship or meditation, not even for a priest's pastoral duties—but for service to kings and bishops in their courts. In an atmosphere where the king both claimed legitimacy by divine right and ruled as the continuator of the Roman emperors of antiquity, it was not illogical that an ideal court servant should combine Ciceronian statesmanship and oratory with Christian values. Cathedral school education produced an imperial Christian statesman.

Cult of the Person

Bernard of Clairvaux (d. 1153) is a good witness to this cult of the person. While he is an ascetic monk and not, on the surface, a representative of humanistic school culture, he may well be a product of it. His intellectual origins are not known. His prose style, his self-conception, and his representation by contemporaries add up to a personality in whom the charismatic tendencies inherent in the Christian preacher and proselytizer meet the neoclassical tradition of medieval humanism, which glorified the human presence. Bernard was one of the last great representatives of the charismatic culture of the earlier Middle Ages. He was an impressive and domineering character in the religious and political life of the twelfth century, an age that produced many impressive characters.

One of his gifts was pedagogy. He was evidently magically effective as a teacher and converter. His mellifluous preaching accounted in part at least for the dramatic rise of the Cistercian order in the twelfth century. It is said that mothers hid their sons when they heard that Bernard was approaching, fearing that this religious pied piper would spirit them into the monastic life by the mere sound of his voice. One correspondent (Hildebert, whose Rome poem opened this chapter) introduced himself to Bernard in these terms: "We have learned that you are the one in the church who is able to teach virtue by example and word." And a German abbot rhapsodized on this mystic pedagogy of Bernard's physical presence: "The mere sight of

him instructs you; the mere sound of his voice teaches you; following him perfects you."[22] Bernard possessed what we might call somatic force. It shows in the political power and near-papal authority he exercised north of the Alps. His word seated bishops and abbots and weighed heavily in the affairs of kings. He approved the annulment of the marriage of Eleanor of Aquitaine to King Louis VII of France, and it was annuled; he supported a trial against the philosopher William of Conches, and he was chastened; he arranged the condemnation of the brilliant intellectual Peter Abelard, and he was condemned. Bernard was a charismatic leader, but far from the "Durchbruchpersönlichkeit" (Max Weber's term) against whom the establishment must protect itself.

Bernard's biographer, Geoffrey of Clairvaux, noted the physical force of Bernard's presence, and he called it "beauty": "In his flesh there was visible a certain gift [*gratia*, the Latin for charisma], which was spiritual rather than physical. His face radiated celestial brightness [= beauty, *claritas*], his eyes shone with angelic purity. So great was the beauty of the inner man, that it had to break forth outwardly in visible signs."[23] Bernard's biographer took this description from language that Bernard himself had provided. In one of his sermons he defined "beauty of soul" as an inner beauty that bursts forth from light overflowing from the inner world:

> What then is beauty of the soul? Is it perhaps that quality we call ethical propriety? . . . But propriety concerns outward behavior. The roots and dwellings [of beauty of soul] are in the conscience; and the evidence of a good conscience is its beauty. . . . When the luminosity of this beauty fills the inner depths of the heart, it overflows and surges outward. . . . It makes the body into the very image of the mind; [the body] catches up this light glowing and bursting forth like the rays of the sun. All its senses and all its members are suffused with it, until its glow is seen in every act, in speech, in appearance, in the way of walking and laughing. When the motions, the gestures and the habits of the body and the senses show forth their gravity, purity, modesty . . . then beauty of soul becomes outwardly visible.[24]

Bernard was acutely aware of authority as something that inhered in a person. Men charged with spiritual authority possess "a certain grace that shows in the flesh." Bernard said this outright in interpreting a line from the Song of Songs, "Your name is as oil poured forth." The line applies, he

says, to "any man who perceives that he is endowed with an exterior grace enabling him to influence other men."[25] An exterior grace is the enabling instrument? Not high office, a secular arm, or the authority of the law? No, in fact that is just what Bernard means: that some men are charged with a force of personality visible in their eyes and faces and bodies, which influences other men.

Bernard not only possessed strong charisma but ruminated on it. He clearly was aware of the force of his personality. His biographer shows him at one point musing why God has chosen him for sanctity and miracle making. Bernard is speaking, quoted by Geoffrey: "Sometimes signs are made by holy and perfect men [perfectos], sometimes also by fictional men [or 'fakes'—per fictos]. I for my part am not aware either of being perfect or a fiction [a fake]."[26] Another astonishing claim is tucked into that phrase, "I am not aware." As if he would say, "As far as I know, I am not literature."[27] It is an awareness shared by charismatic personalities: the sense that his or her life is literature, a lived fiction. "My life is a story, my experiences, just as I live them, a narrative." The equation of self and representation (be it literature or fraud) points to that intermediate state between random experience and the structured events, between life and art. The sense of the self as lived art also is often accompanied by the sense of the annihilation of the self, which Bernard experienced, along with others I'll discuss later. The proportion between man and text in Bernard's life is vivid in the mind of his biographer: Bernard's character "is far more distinctly expressed in his books [than in Geoffrey's biography], and it emerges so clearly in his own writings, that it seems he had created an effigy and a mirror of himself in them."[28]It is a deepened and sharpened aesthetic sense that sees the presence of the author in the fabric of the text, subtly infused in its style, diction, impact, that sees the text doing to the reader or hearer what the man does to those in his force field. But there is also a deepened sense of authorial identity and creativity that can activate this self-injection, something quite different from the biographer's urge to inject the personality and presence of the subject into the work. This is personal charisma transfused immediately into textual form *by the skill of its possessor*, not by some admirer or biographer keen to mediate that transference from memory. Bernard shared with Goethe and Balzac the art of charging narratives with his own charisma (and this is probably the only context in which those three names can be mentioned in one breath). On the surface self-representation was not the purpose of such narratives; they presented themselves as fiction or as commentaries on scripture. Let me

suggest the word "autography" to describe this process. "Autography" is writing yourself into your own composition, not by describing yourself, but by infusing your own presence into it. The reader feels your presence, but sees someone or something else.

Bernard also knew and practiced the art of creating fictions charged with ethical force. He wrote a letter to a woman he called "the virgin Sophia." She has not been located as a historical figure and probably was, as the name suggests, an allegorical, fictional character devised to bear a moral lesson.[29] Here is his rhapsodic praise:

> O, how composed does discipline render every posture of your girl-ish body, and even more so, of your mind! It sets the angle of the neck, arranges the eyebrows, composes the expression of the face, directs the position of the eyes, restrains laughter, moderates speech, suppresses appetite, controls anger, arranges the gait. . . . What glory can compare to virginity thus adorned? The glory of angels? An angel has virginity, but no body; he is happier for it certainly, but not stronger. The best and most desirable is that ornament which even angels might envy.

This passage weds the language of ethics with the language of the sculptor. Those things that discipline "does" to Sophia are what the sculptor does in planning and executing a statue. Here we meet again that central conception of an ethical education oriented to the body: control of the body identified with virtue, the disciplined self defined as a work of art, described with the vocabulary of aesthetics, conceived as parallel to well-made statues. Aesthetics and ethics coalesce in the cultivation of external presence.

These have been some glimpses of the cult of the person in a charismatic culture—limited because they are restricted to educational values and the social role of the educated man. But charisma suffuses a charismatic culture far more broadly than just school, scholars, and educated men.

Charismatic Culture

Charismatic cultures are familiar to us almost exclusively as heroic, warrior cultures, tribal societies with a powerful sense of clan identity and aristocratic honor, and an authoritarian hierarchic structure, at the top of which

is a charismatic leader. But the warrior aspect of charismatic culture is one of many. "Heroism" is a modality that takes in other aspects of life: intellectual, sexual, romantic, poetic, and artistic. In a charismatic culture, the scholar, intellectual, and artist—and not just the warrior—operate in a heroic mode. This is not to turn poets, monks, and schoolmasters into titans. "Heroic" means action—and not reflection; presence—and not representation; performance—and not publication.[30] Common to all is the glorifying of the lived moment, the *kairos*, and of the elegant or heroic response to it—not art. For that reason the quick and witty riposte—ideally in verse and rhyme—had the honor-giving value of insults and challenges exchanged between warriors on the battlefield. The culture of medieval humanism offers numerous examples. A poet/bishop, Hugh of Langres (d. 1085), whose poetry Godfrey of Reims credited with curing him of a dangerous fever when no medicine availed, was angered when the archbishop of Laon refused to confirm a boy whom Hugh had appointed church exorcist. The vexed bishop of Langres hurled into the face of his archbishop a poem of twelve hexameter lines in rhyming couplets, and thus "removed the injury with his biting wit."[31] There is no pause to compose, no retreat to the calm of his study to file away on his meter and rhyme. The narrative presents the confrontation as if the answer was composed spontaneously in the heat of an angry exchange. Whether the bishop actually composed so quickly and well does not particularly matter. The point is, the chronicler could present it as a heroic feat of wit and skill, not miraculous but bigger than life, conceived like heroic exaggeration ("he hurled a stone that ten normal men could not have lifted"), a victory in combat, an intellectual coup. This is poetry not as an aesthetic achievement for publication and cultic appreciation, but poetry as a weapon, more crushing than prose and more cutting than spluttering inarticulate anger.

The intellectual life of the Middle Ages prior to the church reform of the late eleventh and the scholasticism of the twelfth century is ill understood as a quest for truth and understanding. Study and its expression were agonal. Writings were an insignificant part of that culture; debate, disputation, oratory were the dominant media. A famous debate between Gerbert of Aurillac and the Magdeburg philosopher and schoolmaster Ohtric took place before the emperor (Otto II) and his assembled court in 980 or 981. The debate was recorded in some detail by a student of Gerbert, Richer of Reims. Asking about the intellectual content of the debate can only leave the questioner scratching his head. There is no content to amount to

anything substantial, at least none reported by Richer. The debate was an agon, a competition to determine the winner in a contest of philosophers. Gerbert won; the emperor appointed him abbot of Bobbio shortly thereafter. Ohtric lost; the emperor denied him the archbishopric of Magdeburg (to which the cathedral chapter had unanimously elected him) shortly thereafter. Ohtric died the same year.[32]

The societies discussed in Chapter 2 ("Living Art and Its Surrogates") are or were heroic cultures, where art has meaning only in its relation to the living presence: it magnifies living presence and recalls dead ancestors into the world of the living. For charismatic cultures the body and physical presence are the mediators of cultural values. For Europe up to the twelfth century, the controlled body with all its attributes—grace, posture, charm, sensuality, beauty, authority—is the major work of art and the most memorable artifact. The human presence is the raw material to be shaped and formed like the clay on the potter's wheel or the sculptor's marble block. Alas, it is perishable and disappears like a stage performance. Charismatic cultures ordinarily do not develop charismatic literature, and they never have a cult of the artist. They barely distinguish the poet from the historian or the magician, because art's purpose is either memorializing or incantatory.

Charisma is rooted in the body. It is separable from the living presence, only in a limited way through art and in a yet more limited way through memory. Take away the physical presence of Socrates and Christ, and you remove that through which they taught. The body of the charismatic emerges most clearly as a precious cultural value when it is tortured, mutilated, and destroyed. The love of the living master may be a strong inducement to live according to his model—his martyrdom is stronger yet. (What might have become of the teachings of these two if they had received tenured academic positions with high salaries and settled in to write out their teachings in systematic treatises?) The elegance of Socrates's death and the agony of Christ's had equally wrenching impacts on their followers. Their deaths by violence established their cult as much as did their teaching. The tragic end in each case laid foundations deep in the souls of the disciples, cemented them in place with an emotional force beyond tragedy, a force far more lasting than anything as comparatively trivial as knowledge.

The values of a charismatic culture tend to register in art and literature at a point in its history when that culture is fading. At least that is a pattern observable in ancient Greece and in the earlier Middle Ages. Various

efflorescences of art and literature that we regard as "renaissances" are actually—or, also—the residue of a charismatic culture passing out of existence.[33]

Twelfth-Century Transformations

In the course of the twelfth century, society and intellectual life experienced a transformation so sweeping that it is not exaggerated to call it the change from the ancient to the modern world. Intellectual life moved from the humanistic neoclassical, charismatic form it had taken, to Scholasticism, a methodology of reasoning based on logic and rational pursuit of Truth. The small, elitist schools that had groomed young men via an orator's education for administrative positions in church and state gave way to the new institution of the university. Some late-blossoming testimony to the education cultivated at the old cathedral schools is the biographies of St. Thomas Becket, written in the two decades after his death in 1174. Becket was represented distinctly in the language and concepts of the old charismatic culture. But its program of ethical formation by imitation of great men was on its way out. After about 1180 it is no longer possible to find praise of great men gifted with the magical quality of transforming those around them.

A decline of culture? Far from it. The second half of the twelfth century saw remarkable changes: the rise of the Universities of Bologna and Paris; Gothic style in architecture, book illustration, and handcraft design; the great Gothic cathedrals of France, Germany, and England; the grand abbey churches of England; a new classicism, plasticity, and humanity in the representation of the human body in sculpture; the Latin poems of the Archpoet, of Walter of Châtillon, Primas of Orléans, and many of the *Carmina Burana*; the culture of courtly chivalry, a charming, elegant, and powerfully charismatic literature glorifying it; and the new fashion in loving that it represents, "courtly love" (see Chapter 6).

The main sources for the charismatic culture of the eleventh century are on the wane: biography, personal letters, Latin panegyric poetry, the poetic epistle. None of these are fictional or lyrical in the sense of "fiction" that swells to prominence in the twelfth century. All of them are bound to the living person; all of them are in some sense "life writing," to use a phrase that recovers the original sense of "biography." Also on the wane

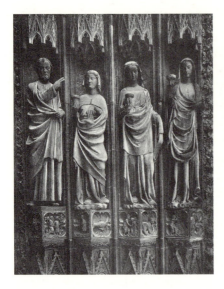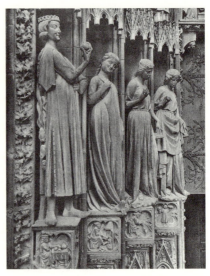

Figure 26. Wise Virgins, Strasbourg Cathedral (From Reinhardt, *La cathédrale de Strasbourg*, illus. 112); and Foolish Virgins, Strasbourg Cathedral. (From Reinhardt, *La cathédrale de Strasbourg*, illus. 111)

is the praise of magical qualities exercised by "sublime and magnificent" schoolmasters on their way to becoming bishops and kings' counselors.

They are replaced by the heroes of literature, male and female, and by figures in sculpture.

Charisma Restored in Art

The wise virgins of Strasbourg Cathedral are among the most impressive representations of women that remain to us from the Middle Ages (Figure 26). The statues (which date from around 1290) are products of high Gothic sculpture in its full blossom, the height of its dynamism, its nuanced humanity, and its hypermimetic plasticity. Extraordinary nuancing in posture and facial expression created a series of portraits in which the sculptor's individualizing and idealizing impulses are in perfect concord.

Perhaps their most striking feature is what we might call their moral transparency. They represent vices and virtues, but this meaning has to be read from their bodies, their posture, their facial expressions, the tilt of

their heads. It is a decisive break with tradition. The vices and virtues traditionally required some sort of emblem or patched-on narrative device to make the quality represented visible. Facial expression, stature, and posture played no part in identifying the symbolic meaning of the figure. In fact often enough the "good" forces are indistinguishable from the "evil"—isocephalic, as the art historians say. The difference is signaled by the emblem they wear. The virtues and vices at Notre Dame, Paris (1210), are virtually identical in appearance. Each figure holds a circle that contains an emblem. These and not their physical appearance signal their identity.

The Strasbourg virgins, by contrast, carry their identifying signs in the contours of their bodies and expressions of their face. They enact virtue or vice rather than wearing its symbol as a badge. The medium of representation has moved from the external narrative device to the "flesh" (or its imitation in stone); the mode of representation has shifted from abstract signalizing to incarnation. As long as virtue could be externalized in an emblem, individuality and plasticity of representation had no role to play. Once it was conceived as inherent in posture, facial expression, and gesture, the sculptor faced a new challenge and required new techniques of realism to make "virtue" visible in the flesh.

Each of the Strasbourg figures is recognizable and distinct from each of the others, but not as representatives of virtues. They are individuals, not symbols. We cannot say that one shows chastity, another humility, another modesty. It seems rather that a whole complex of virtues coalesces in each of the figures. The figures are complex, the symbolism of expression dense. We have moved away from the allegorical mode of tradition to the charismatic mode. The wise virgins are model figures, not ideas.

The round-faced wise virgin looking to her left seems to be drawing back as though in questioning retreat, but also perfectly poised to respond to whatever it is that faces her (Figure 27). This tension is created by angling the chin inward toward the neck with the forehead advanced very slightly before the chin. The posture conveys restrained strength and testing scrutiny, qualities conveyed in reality when the head is tilted forward while the eyes fasten on something straight ahead. The impression is strengthened in this figure by the narrowing of her eyes. The Strasbourg virgin exudes both wisdom and fortitude, and she seems tensed to exercise those virtues in the imaginary moment in which the sculptor caught her. But for the figure as a whole, any suggestion of tenseness and challenge is dissolved in the relaxed poise of the body. The left hand drops limply from the mantle

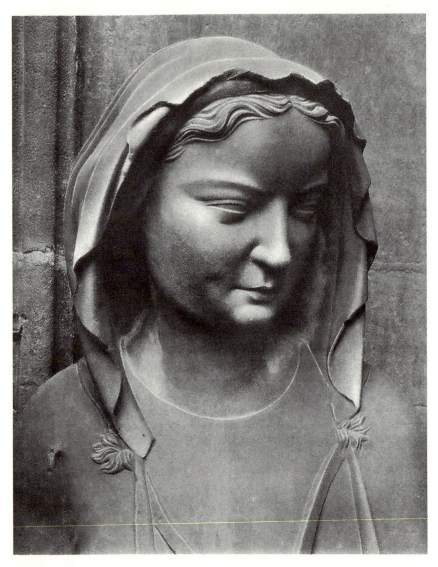

Figure 27. Wise Virgin. (From Schmitt, *Gotische Skulpturen des Strassburger Münsters*, vol. 2, illus. 144)

string, and the body is shifted slightly, its weight placed on the right foot. She is at her ease and not on guard. This backward tilt of the body answers the forward tilt of the head. The overall impression is of strength coupled with restraint and of a mean struck between opposing tensions.

The figure third from Christ's left is the most strikingly beautiful of the group (Figure 28). Her full, sensual lips are set off from her dimpled chin by a distinct tuck. Her face is narrower and longer than the others, her nose aristocratically elongated. What seems to me to give this figure her extraordinary aura is the tension between sensuality and morality. The forward tilt of the head expresses a range of qualities from humility to contemplativeness. There is a suggestion of submissiveness, perhaps even shame, but it competes so directly with serenity that this figure too confronts us with complexity of expression, and any analysis has to deal with its polyphony, not a univocal "meaning." She conveys the sexual promise and erotic potential of virginity, an impression that is strengthened rather than diminished by the reverence expressed in the angle of the head. That conflict constitutes her peculiar character: being the most beautiful and most sensual of the group, she is also the most virginal. In the soft line of her lips there is the bemused early awareness of sexuality. But the overall impression is of control and restraint. A woman so in control of her feelings as to maintain this serene half smile is also the mistress of her own awakening sexuality. This figure shows the heroism that Bernard of Clairvaux ascribed to the virgin Sophia, whose victory over temptation was the greater since she was the more beautiful and noble. The beauty of this wise virgin expresses both temptation and its mastery.

In this she is the counterpiece to the foolish virgin placed next to the tempter (Figure 29). She is flirting with the superciliously smiling figure holding an apple in his outstretched hand, the primal gesture of temptation. Dressed to kill by frontal appearance, the view of this dandy from behind shows snakes, frogs, and worms writhing in his back. The foolish virgin in his spell sees and senses neither seduction nor danger, though both are obvious to the viewer. Her broad smile, the seductive and seduced sway of her body, and the precious, affected gesturing of her hands model foolishness. Her sidling, insinuating pose shows her in the spell of the tempter. But the real conveyer of foolishness is her smile. There can be no better dramatization of gullibility than the smile of the seduced.

The wise virgins are realizations of virtue made visible. Abstract and generalized as they are in their individuality, the entire group embodies

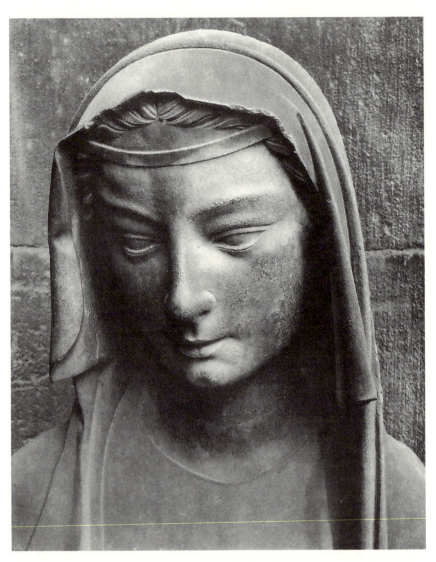

Figure 28. Wise Virgin. (From Schmitt, *Gotische Skulpturen*, 2:143, illus. 143).

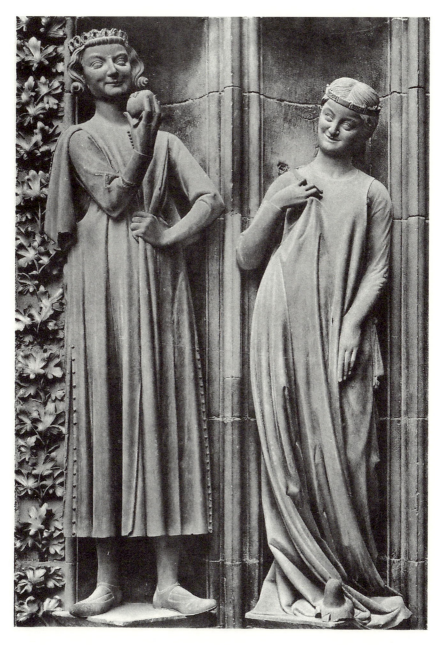

Figure 29. Foolish Virgin and Tempter. (Schmitt, *Gotische Skulpturen*, vol. 2, illus. 134)

serenity and moderation. They bear the expression of the soul in their face, to use Otto Schmitt's phrase.[34] Or to put it in the vocabulary of medieval "beauty of manners," their outward composition shows the harmony that reigns within. Their faces and figures show us not the battleground of virtues and vices, but the results of the peace arrangements. They are the offspring of wedded antinomies. In their expressions various psychomachias settle into composure.

The language to describe this group is best supplied by the moral discipline of the cathedral schools from a hundred and more years earlier. Recall Godfrey of Reims's lines on Odo of Orléans:

> his attitude, voice, speech, figure,
> His gait and appearance all gave off signs of an integrating harmony.
> .
> He adorns himself so with temperance that his mark is
> Light good humor mixed with gravity
>
> .
> This posture, this attitude are decorous

Or Bernard of Clairvaux's definition of beauty of soul: "When the motions, the gestures and the habits of the body and the senses show forth their gravity, purity, modesty . . . then beauty of the soul becomes outwardly visible." The art of the sculptor has accomplished in stone what discipline, according to Bernard, accomplished in the virgin Sophia: it "renders every posture of their girlish bodies composed, it sets the angle of the neck, arranges the eyebrows, composes the expression of the face, directs the eyes, restrains laughter, controls anger, arranges the gait." Discipline produces moderation and an "integrating harmony" holding dissonant forces in balance. The literary (assuming Sophia is a fiction) and sculpted virgins also share what I called moral transparency: goodness and humility show in their outward appearance. About 150 years after Bernard had praised the virgin named for wisdom, Sophia, for those qualities, these stone artifacts from Strasbourg are made to embody something like the glory that even angels might envy.

Historians of Gothic sculpture generally agree that a decisive shift in style occurs around 1180. Willibald Sauerländer connects this change with Nicholas of Verdun, in whose work we find "a hitherto unsuspected capacity to animate the human figure, a new exuberance of movement, gesture

and facial expression; it is as though medieval art had made its first encounter with the antique, in all its radiant sensuality. The stylistic origins remain a mystery."[35]

Erwin Panofsky agrees on the classical model: the schools of Laon, Senlis, Chartres, and Paris "reimparted to their figures a serene animation as close to Graeco-Roman *humanitas* as mediaeval art could ever come."[36] For Sauerländer and Panofsky, sculpture becomes "humane" once it comes under classical influence. The change is referred to the solution of a problem of technique, a solution supplied by a model from an earlier period. But the rediscovery of classical models does not "explain" the new style, as Sauerländer stresses: "the stylistic origins remain a mystery." The problem of analysis is comparable to the role of ancient drama in French classicism or of medieval chivalric culture and *Don Quixote* in romanticism. The earlier model supplies the form, mood, and tone that the present age needs. But no one would be content with an "explanation" of French classicism in its appropriation of classical models or of romanticism in its appropriation of medieval ones. The nourishing forces of those movements are far more complex, and the forces that nourished high Gothic sculpture were no doubt more complex. The new style is more than the discovery of technique. The "capacity to animate the human figure" and to imbue it with "exuberance of movement, gesture and facial expression" may well have been first discovered by Nicholas of Verdun as an artist's skill, but that capacity, far from being "hitherto unsuspected" had been at work in schoolrooms since the tenth century and possibly well before.

The expressiveness that emerges in Gothic sculpture responded to an earlier awareness of the suppleness of human expression. Hugh of St. Victor shows a subtle comprehension of the variety of facial expressions: "There are thousands of masks, thousands of ways of flaring and contracting the nostrils, thousands of twists and turns of the lips which deform the beauty of the face and the harmony of discipline. For the face is a mirror of discipline and it is to be shaped with so much greater vigilance, since the sins which appear there cannot be concealed. . . . Let it always have a severe sweetness and sweet severity."[37] The interrelatedness of moral discipline and Gothic representation of the human figure is a case where pedagogic practice and held social ideals shape the imaginative capacities. Classical sculpture was undoubtedly an influence on Gothic. Hildebert of Lavardin was not alone in being astonished at its grandeur. But the ancient mode of representation was an answer to problems posed by the injection of ideals

like medieval *humanitas* and "elegance of manners" (*elegantia morum*) into
the art of stone carving. Classical models may have contributed decisively
to technique but cannot claim exclusive title to the conception. The formu-
lators of *disciplina* saw in their shaping force on students an analogy with
the sculptor's art.

If the ideal of education sketched out in this chapter had an influence
on Gothic style, then we face this historical problem: *the rise of the new
sculptural style coincides with, or rather postdates, the decline of instruction in
moral discipline in cathedral schools.* I argued earlier that one set of circum-
stances encouraging the emergence of charismatic representation is this: a
social ideal of embodied charisma disappears from the scene, and writers
and artists attempt to fix its fading memory in words or images. The devel-
opment of Gothic sculpture fits that constellation. The vividness, plasticity,
and humanity of Gothic stood in this relation to the medieval ideals of
humanitas, decor, and *elegantia morum.* The same was probably true of
Greek classical sculpture in its relation to held social ideals. Werner Jaeger
sets the poetry of Pindar and Theognis in precisely this relation to aristo-
cratic ideals and the art and sculpture that came to idealize them. These
poets of the old nobility "were defending a dying world. . . . Their poetry
did not commence a renaissance of the aristocracy in political and social
life; still, it eternalized the aristocratic ideal at the moment when it was
most gravely endangered by new forces, and it made the socially construc-
tive forces of that ideal into a permanent possession of the Greek nation."
The sculpture of the classical period must be studied, says Werner Jaeger,
"as an expression of the ideals already stated by the poets,"[38] that is, by
poets who had preceded it by a century or so. Change the names and dates,
and we have here a good description of high Gothic sculpture in its relation
to the humanistic ideals to which it gives expression.

A grammarian and professor of literature from the mid-thirteenth cen-
tury, John of Garland, is a good witness to the role of the living teacher
usurped by an idealizing art. He wrote in a passage commending good
behavior to students, "Declare the sculptures of our church to be models
of civility, / Living pictures, to be borne in mind indelibly."[39]

John of Garland clearly thinks that sculpture can actually exercise a
paideic effect, that it can have the same or a similar effect on the admiring
viewer as the physical presence of an admired human being. Art in his view
can and should work charismatically. Again, the parallel to classical Greek
sculpture is useful. Werner Jaeger sees it arising at a critical turn in Greek

culture in a passage already quoted but worth quoting twice: "It was a uniquely precious moment when the God-intoxicated but human world of Greece saw the height of divinity in the human body and soul raised to a perfection high above earthly powers, and when in those gods in human shape the effort of man to copy that divine model through which artists had realized the law of perfection, unattainable but imperious, found its purpose and its happiness" (*Paideia* 1:205). John of Garland was a master of the University of Paris and of the cathedral school of Toulouse. These institutions had given up the ethical education of the cathedral schools in which masters were the curriculum, revered as paragons.[40] The ethical goals were not forgotten. In fact you might say that they were everywhere in aristocratic culture. They became the social ideals of medieval and modern Europe. But the discipline is no longer institutionalized in the schools, and the sources that convey these ideals are no longer about real people, but about fictions and artists' conceptions. The exemplary role of charismatic presence has passed to the realm of art and literature. That transition represents a significant arc in the history of charismatic aesthetics: its passage from the living human body to representation.

The Strasbourg wise and foolish virgins express ideals that had a grand future in the Western aristocracy, but whose institutional underpinnings as educational ideals had vanished. The sculptor-teachers now work on stone, not on flesh and spirit, as had Hugh of St. Victor. A look into the pages of John of Garland's "Moral Lessons for Scholars," from which I just quoted a passage, shows us in painful clarity the distance of the fall from eleventh- to thirteenth-century ethics. His precepts are banal and rustic in the extreme, both the advice on table manners and on behavior in school and at court. Comparing for instance John's descriptions of table etiquette—rudimentary and crude—with those from the lives of Thomas Becket (late 1170s and 1180s)—elaborate, sophisticated, reeking of cultured refinement—we see that we are in a different world.[41] It is impossible to argue that little had changed in the life of the schools and of their intellectuals. John urges the imitation of great men, as had Hugh of St. Victor and William of Conches, but he conceives greatness differently. He holds up as a model William of Auvergne, Bishop of Paris, 1228–1248. The William described by John of Garland would make a proper monk and a correct and respectable Christian.[42] He (or rather the model described) is as far from Odo of Orléans or Thomas Becket as Gregory the Great is from Alexander the Great.

Art and Nostalgia

We can generalize the historical logic at work here and in other comparable periods (this is a dynamic that recurs now and then, not an invariable historical progression) as follows: the art of a charismatic culture is not charismatic. The closer art is to the lived experience that has inspired it, the less "realistic," the less hypermimetic the representation (archaic Egyptian, early Christian, Viking, American Indian). Heroic cultures, be they the cultures of prophets, warriors, courtiers, or intellectuals, or all of these at the same time, do not produce charismatic art because they do not need it. Christianity in its earliest beginnings produced no great basilicas, filled no vast walls with frescoes and mosaics. The catacombs were an early site of Christian art, but the art of the catacombs is not the reason why Christ was not yet commemorated in impressively realistic portraits. Much more is involved than a need to decorate sanctuaries and illustrate moments in Christian history. The dialogues of Plato were only possible and necessary after Socrates was dead; the Gospels only possible and necessary after the crucifixion. What need would have generated works like these during the lifetime of their subject? As long as the charismatic figure is present, his reproduction in art is not necessary. Copied semblances are substitutes; the living model is far more efficacious than the spoken or written word, as Seneca had claimed. Petrarch, in a letter in defense of learning by example, would reiterate the priority of the lived presence precisely compared with the charismatic force of sculpture: "If the statues of illustrious men can ignite noble minds to the zeal of imitation . . . how much more does virtue itself exercise this influence, being put forward not in shining marble, but in a living example. It may be that the lineaments of bodies may be expressed more forcefully in statues, but the awareness of deeds, of manners, and of the attitudes of mind are undoubtedly expressed more completely and more perfectly in words than in sculpture."[43] The death of the charismatic figure generates the need to recapture and hold firm his image. It is passed along through those nearest the master, who become, as it were, living contact relics. Then that force too fades. Finally writing and effigies become the transmitters. Charismatic representation emerges when the sensed force of living presence weakens.

Given the lateness of humanism in Gothic sculpture compared to the lived ideal on which it is based, we can imagine a little drama of noble men and women looking at the Strasbourg group (or virtually any other high

Gothic human figures) in the way that John of Garland recommended, taken with an envious longing to be like those wise virgins and noble kings of earlier days, and rather disappointed in their own moral transparency. The beauty of sculpture will appear to them "imperious but unattainable." The drama is not entirely fanciful. Hildebert of Lavardin staged and predicted something like it in imagining the ancient gods alive and looking at the statues of themselves carved by Roman sculptors:

> Divinities themselves look awestruck on divinities sculpted
> And wish themselves the equals of those sembled forms.
> Nature could not make gods as fair of face
> As man created images of gods.
> Carved likenesses improve these deities;
> The sculptor's art deserves worship more than their own divinity.

We know that several generations of living human beings had valued grace, charm, serenity, beauty, striven for it in their own presence and self-presentation, and imagined such qualities as constituting a godlikeness of the human form. The experience of finding those qualities better represented in stone than in their own flesh was available to the European aristocracy, educated and uneducated, as early as 1180–1190. By that time, the human grace and beauty that astonished gods and made angels envious has passed out of the province of teachers and into that of sculptors. Hildebert's Rome poem dramatizes aesthetic change as cultural change. The superseded gods stand for the passing age, the charismatic statues for the coming one; the gods stand for the declining mode, for lived or embodied charisma, the statues for an ascending one, art. The date of Hildebert's poem, circa 1100, is a significant perch from which the poem looks in two directions in time and intellectual history and reflects on the cultural transformation in progress.

6

Romance and Adventure

The truest poetry is the most feigning.
—The fool Touchstone, *As You Like It*, 3.3.18

One of many bizarre incidents in the romance *Lancelot, or The Knight of the Cart* by Chrétien de Troyes occurs in a churchyard cemetery. Lancelot is in quest of his mistress, Queen Guinevere, who has been kidnapped by a villainous knight named Meleagant and is held captive in "the land from which no stranger returns."[1] Lancelot comes mysteriously upon this church. Its walled cemetery abounds with "beautiful tombs" (line 1857). Each is inscribed, marking it out as the future grave of a great knight: "Here will lie Gawain," "Here will lie Lionel," "Here will lie Yvain." The finest and the largest of the tombs is covered by a gigantic stone slab and inscribed, "He who will lift this slab by his unaided strength will free all the men and women who are imprisoned in the land whence no one returns . . . neither clerk nor nobleman has been freed or returned home since they were first imprisoned" (1900–1906). Lancelot lifts the slab with no effort at all and marks himself as the redeemer by this act combining muscle, a predetermined destiny, and messianic promise. Chrétien's lines vibrate with undertones. Several layers overlay the episode and create its surface force.

The slab that turns light at the touch of the hero destined to lift it is a selection test, like the sword in the stone that intuits the true king of England. However, the chivalric/warrior character of Arthur unsheathing the sword in the stone stands out clearly from the funereal character that marks Lancelot's selection. He lifts the stone that covers his own sarcophagus, the coffin in which he will eventually be laid, if the authorless predictions of the graveyard

prove true. One odd element after another in this most quirky of romances wafts off into the realm of the inexplicable, or, we might say as modern readers less gripped by the world represented, the atmospheric. While the writer passes lightly over the macabre aspects of the scene, those aspects are distinctly part of a web of images that make this romance into the most morbid, the most consumed with wounds, blood, bleeding, and death, of all Chrétien's works. Death and morbidity become part of the epic staging: coffins and dead people appear mysteriously; funeral trains pass unidentified; hardly has the news of the queen's kidnapping reached Arthur's court, when all anticipate that she is already dead and in her coffin; Lancelot repeatedly wishes for death in the face of minor disappointments and failings in the service of his lady; the land of Guinevere's captivity is named Gorre (no stranger returns from it), a name that may associate it with the Celtic underworld. It is unquestionably meant to evoke a death realm. Seldom has so tomb- and death-obsessed a layer settled so lightly on chivalric romance. It hardly interferes with the love interest in its core; we never have to remind ourselves that this is a love quest ending in a chivalric rescue, written by a *romancier* best known for his witty and light, ironic style.[2]

Chrétien has set pathos so deftly on the foundation of romance that the comparison to Lancelot lifting the heavy stone slab suggests itself. A yet heavier stone slab is lifted and set effortlessly onto Lancelot's role: Guinevere's captivity and the love-driven mission to free her is layered with a quest central to Christian salvation history, Christ's harrowing of hell and the redemption of the dead. The unhappy captives in the land of Gorre can look to their release when a redeemer frees even one of them, and that redeemer is Lancelot. He fights Guinevere's captor Meleagant, essentially to a draw with an agreement to fight again in a year, but the combat satisfies the conditions of release of Guinevere and the captives, who rejoice at their redemption.

What does this Christian allusion mean? Are we to read the work, riven with irony, as an allegory of Christ's unwavering love of mankind, acceptance of the shame of incarnation, and conquering of death? Almost certainly not. Just posing the question highlights the ironic distance that separates Lancelot's love service to his cruel mistress from Christ's redeeming mission.

Chrétien likes to weave Christian allusions into his romances, at least his later ones, *Yvain, or The Knight of the Lion* and with least ironic distancing, his final, unfinished work, *Perceval, or The Story of the Grail.* In

the episode that frames the romance of Yvain, Yvain's cousin Calogreant tells of a failed quest for adventure he had undertaken some seven years earlier. Wandering in search of the forest of Broceliande, he found a narrow path that leads him off to the right. He fights his way through thorn thickets an entire day and arrives finally at the castle of a good host, who entertains him well and sends him off in the morning. When he undertakes the adventure of the fountain, he is beaten in combat by the defender of the well. The conquered Calogreant strips off his armor and returns on foot and in disgrace to the castle of the good host, who receives him as well as before.

The only element of the narrative that points to a religious overlay is the narrow path to the right. But that single detail evokes an allegory of salvation, and the other details of the adventure fall into place: Calogreant is the soul of everyman, his setting out is baptism, the good host is Christ, his opponent is the devil, the forest monster who points the way to adventure is allied with Satan, his failure is sin, and his return, forgiveness. Likewise nothing in the narrative discredits the objection that this allegory is just constructed from the slightest indication and projected onto a story where in the greater scheme of the plot it has no or little relevance.[3] Other scenes in *Yvain* have elicited this kind of reading, for instance the revival of Yvain from his insanity: rejected and denounced by his lady, Laudine, Yvain loses his mind and wanders in a forest for an entire year as a wild man, unclothed, unwashed, and ill-fed. He is revived one day when three courtly damsels find him unconscious and naked by the side of a road. One of the three brings a magic salve and spreads it on his naked body. It revives him and restores him to his former self. The scene resonates with that of the three Marys bringing ointments to the grave of Christ.

These fragments of Christian elements seem like stations on the way to Chrétien's grandest narrative, *Perceval, or The Story of the Grail*. Perceval's grail quest becomes explicitly associated with both his chivalric education and his salvation. The love interest is present but subordinated to the quest for redemption.

But the Lancelot romance is very different in character from the grail romance. The earlier narrative is about adulterous love, slavish, self-destructive devotion to the wife of another man who happens also to be the king to whom Lancelot owes loyalty. That moral framing is made to support the heavy weight of Christian salvation history in the figure of the messianic Lancelot and his task.

The Trinity of Romance Modes: Pathos, Exemplarity, Irony

The author's purpose in the Lancelot romance is almost certainly not religious. But then why freight a tale of love service so heavily?

Whatever these fragmentary allegorical/religious elements patched onto the romance may mean for some morality hinted at above the literal level of the romance, on its surface they create aura. Anyone is free to take the messianic Lancelot seriously, and probably Chrétien would be glad if they did. But it is an act of allegorizing we might say almost frivolously engaged in Christian doctrine. The pathos of Christian allegory in Dante's *Divine Comedy* stands out starkly against Chrétien's opportunistic use of it. In Chrétien's irony the charade character of religious profundity is clear. Its purpose is to astonish the reader, to hook into the reader's empathy, and to create the identification with the hero necessary to generate admiring imitation by the appearance of depth.

This process of generating identification and emulation is a more important function of Lancelot's messianic role than any amplification of Christian doctrine got by associating Christ with a courtly adulterer. The author seems to be provoking his readers, as if he were exposing them to a test to ask how much improbability they can swallow, how much pathos Lancelot will bear without tipping over into parody and burlesque. Or has he already tipped over into parody? Not the least improbable explanation of the tension between secular and religious is that the religious mocks the credulity of a lay audience. (If they believe this, they'll believe anything.)

Heroes are always exalted. Praise and more-than-human deeds are part and parcel of heroic literature. But Chrétien has pushed magnification into a dimension beyond the ordinary heroic. And that move into the fantastic generates a dominant trinity of romance modes, unique for this form, peculiar in its incommensurable elements: pathos and exemplarity joined by irony. The strange mixture of the impossible and the exemplary was to remain influential for centuries to come, though hardly another author sets the heavy slab of Christian allegory so deftly onto the brittle frame of chivalric quest.

Fantasy and Social Forms

Elevating the virtue of paragons to heavenly heights is in part responsible for the powerful shaping force of Arthurian romance on courtly culture,

responsible also, no doubt, for a comparable shaping force working on the individual knight, cleric, and lady in the audience, and that means exercising the whole range of influence that fashion can possess. It will lead some into courtly virtue and others to the degradation suffered by Paolo and Francesca, or the derangement suffered by Don Quixote. Its transforming force is great whatever the ultimate results for the readers in its spell.

Courtly romance emerged in the middle of the twelfth century. A series of "romances of antiquity" in the 1150s and 1160s heralded the new form. They transformed Aeneas, Odysseus, Paris, and Helen into chivalric knights and courtly lovers. The real innovation, however, was the Arthurian matter, which had no written tradition, at least none worth mentioning prior to the quasi-historical work in Latin prose by Geoffrey of Monmouth, *History of the Kings of Britain* (ca. 1135). Romances of King Arthur and his knights appear to be the original creation of Chrétien de Troyes, a French cleric, whose Lancelot romance is our point of entry into this chapter. Chrétien was followed in short order by three genial German poets, Hartmann von Aue, Wolfram von Eschenbach, and Gottfried von Strassburg, and a host of followers of more ordinary talents. Chrétien's innovation was significant in many ways, not least because with Arthurian romance, courtly narrative abandoned any claims it had on historicity, or most of them. Romance faced the reproach of being lies from its earliest appearance. Released from an obligation to a historical source, the imagination of the authors headed for ever-higher levels of fantasy.[4]

It was nonetheless—possibly because of that—wildly popular. It was a vehicle for new fashions in love, combat, and conduct among the aristocracy. It had a grand future in literary history, not only because of its popularity, but also because it furnished the prototype of the modern novel, especially the "Bildungsroman." Courtly romance must be central to a study of charismatic literature, because its impact on the imagination of the West, its social values, and the political institutions of aristocratic society, is demonstrably so huge. The romance narratives participated centrally in one of the great transformations of the Western aristocracy, the change from warrior ideals to courtly Christian social values. They provided a scenario for court style and courtly pageantry into the sixteenth century and periodically beyond. Chivalric romance possessed qualities that gave it a virtually hypnotic power over aristocratic society. Nothing short of such a power could move a warrior class to entertain, as an ideal, a form of behavior that subjected war and combat to love,

that insisted on refined, polished manners and even a certain level of education of soldiers.

The warrior class had no indigenous tradition of courtliness, courtly love, or civil manners prior to the age of courtly romance. The traditions of the nobility were military.[5] The courtly ethics of chivalry (as opposed to the warrior ethics) originated not among the lay aristocracy but in that class of worldly learned clerics who shared the humanistic education of Godfrey of Reims, Meinhard of Bamberg, and Hildebert of Lavardin, the subject of the previous chapter. That culture of Latin learning was in crisis around 1150. At the very moment when an old, humanist program was collapsing and being forced out of the schools of Paris, the new narrative form, created by humanistic clerics like Chrétien, some of them displaced from the schools and seeking employment at worldly courts, developed into a "novel of education," a category that fits the major courtly romances. The creators of the chivalric romance form brought with them ideals of polished, restrained, and disciplined behavior, civility, and courtesy learned at cathedral schools, and fused them with warrior ideals of the feudal class to form the ethical core of the new narrative form. In other words, courtliness, courtly love, and chivalric ideals were learned ideals first, next were transmuted into literary forms, then adopted as the social ideals of lay aristocracy. For secular nobles fiction preceded social form.

In this sense the chivalric ideal was quixotic from the outset. It goes against the grain of warriors to defer to others weaker than themselves, to act with restraint, speak with polish, to read, and especially to court women and cultivate their love with a shy, modest demeanor. Warriors love men, their partners in battle, a kind of love in which there is no weakness. Weakness, from the unregenerated warrior's point of view, is in the love of women.

And so courtliness, out of place among soldiers, was in a precarious position. Its representation in literature is an instance of transposing a lived or once-lived ideal into text, the textualizing of a charismatic culture, as I've called it. I articulated in the previous chapter the cycle at work in the transition from the twelfth through the thirteenth century: a charismatic culture fades, its ethical ideals create charismatic works of art, which then bring forth a new social ideal available for appropriation, participation, imitation, in the realities of medieval aristocratic society. Clerical culture, deployed at worldly courts, brought forth courtly romance, and courtly romance made, at least helped shape, courtly society. Charisma of the body,

which had previously defined itself as sculpture-like and the envy of gods and angels, now was reincorporated in courtly literature. The vernacular romance narrative of the thirteenth century represents a heroic culture of warrior elegance by refashioning the fading charisma of a culture of personal presence into new fictions. A fundamental gesture in the genesis of courtly narrative is the fictionalizing of virtue and the enfabulation of charisma. It is projected into the realm of the "marvelous," the *merveilleux*. Charisma emancipates itself from dependence on real presence. In the courtly romance it becomes purely fictional. Fictional kings, knights, and ladies, and not living or once living bishops or learned gentlemen, have become the bearers of exemplary force and givers of pleasure. Virtue is enfabulated.

The result is a narrative form far more alive and captivating than anything the preceding culture ever wrote. It is hypermimesis in full bloom, a narrative more fantastic than anything the West has seen, which rivals classical narrative, Homer and Virgil, for its power to impress models of action on the mind of the reader, its power to transform. The shift of the European nobility from warrior to civil social values is a fact of social history. The most effective instrument of this transformation still visible and accessible to us was courtly romance.

The influence this narrative genre exercised on society, on its self-representation and on the psyche of the knight, gets us centrally into the nature and workings of charisma in literature. Two themes predominate and are the main bearers of charismatic effect: romance and adventure.

Adventure

The stories of King Arthur and his knights, in the form created by Chrétien, had powerful dynamics. They knit tragic failure and epic optimism: a knight of high promise disgraces himself, violates laws of courtesy, humanity, or religion, or all three, and plummets to the depths of humiliation and despair, is rejected by Arthurian society, or, worse yet, by the lady he serves. But having hit bottom, he begins a gradual self-rehabilitation. Some recognition takes place, mediated by despair, that results in reversal, *metanoia*. The result is not Sophoclean succumbing, but Pauline renewal. The hero on the path to tragedy becomes a new man. He shuffles off his flaws and blindnesses and begins a life of chivalric deeds that expiate his moral

failings. He rises from the depths to become a model of chivalric and romantic prowess and ends in the favor of God, the world, and his ladylove.

This narrative structure, what the Germans call "doppelter Kursus," is at work in Chrétien's major romances. It operates on the dynamic of the hero's rise common in charismatic narrative. The formula for Homer— "Enter abject, exit exalted"—might be varied for romance—"Enter ambitious, sink to the abject, rise up exalted." In the romance of Perceval, or Parzival, and the Holy Grail, even more than in Homer, the author maximizes the distance that separates the hero at his debut from his final exaltation: Parzival rises from bumbling fool to Grail king. In Homer the humble posture was a disguise; in Chrétien the foolishness is genuine.

There is an embracing medium in which this development takes place. The sources call it "adventure," Old French *aventure*, Middle High German *aventiure*. For understanding the charismatic force of courtly romance we can substitute "adventure" for the highly misunderstandable term "education." Adventure is the medium in which the moral and martial education of the knight takes place.

What is adventure? A resonant question. The beginning episode in the romance of *Yvain, or The Knight of the Lion* by Chrétien and his German adapter Hartmann von Aue, offers an answer. It opens with the frame story of Calogreant's shame mentioned earlier. Here I'll follow the version of Hartmann von Aue, who is true to Chrétien in detail but also in bringing out things only suggested in his source.[6]

The knight Kalogreant, Iwein's cousin, rode out in search of adventure one day, into the forest of Broceliande. On his second day of wandering he comes across a strange and frightening scene: a monstrous, giantlike creature sits surrounded by wild animals. The animals are fighting furiously and making such a terrifying din that Kalogreant hides behind a tree. The forest monster has ears hairy and big as an elephant's, teeth like a boar's, a face flat and wide and covered with hair. He is hideously ugly and carries a large club. Kalogreant eventually plucks up his courage and approaches the creature, who seems peaceful enough, if grim and terrifying in appearance. A delightfully naive conversation between the two follows:

KALOGREANT. Are you good or evil?
MONSTER. If you do me no harm, you'll have me as your friend.
KALOGREANT. But tell me, what kind of a creature are you anyway?
MONSTER. A man, as you can see.

He explains that his job is to tend the animals. The timorous Kalogreant asks if he does not fear injury from them. "They're lucky if I don't hurt them," he replies.

> KALOGREANT. Tell them not to hurt me, then.
> MONSTER. Don't worry, they won't hurt you as long as I'm here.—
> But now I've given you a full answer to all your questions. Now don't hesitate to tell me what you're looking for here. I'm at your service.
> KALOGREANT. I must tell you: I am seeking adventure.
> MONSTER. Adventure? What's that?
> KALOGREANT. I'll explain it to you.

It is an improbable moment; strictures of hierarchy are forgotten. In a class-bound, self-encapsulated narrative form of an elitist, self-absorbed, self- and privilege-obsessed feudal nobility, one of its members accounts for himself to a creature at the far end of the scale from the civilized to the primitive.

Kalogreant continues: "Notice how I'm armed. I'm called a knight, and my purpose is to ride about seeking a knight who will fight with me. If he conquers me, he has praise. But if I'm victorious, I'm considered a man and my worth increases."

I am skeptical that what we have in this episode is a definitive word on the nature of *aventiure*.[7] I can imagine that the rough-and-ready arm break-ers and head splitters in Hartmann's audience might have warmed to the idea that adventure is knocking a man off his horse, winning prestige and an extra horse for it. But the scene is a satire directed at a cowardly knight operating on a shallow conception of knighthood and out of place in the forest of adventure, and those at medieval courts with an understanding of adventure as courtly education will have recognized it as such.

True adventure is more than knocking an armed man off his horse. The motif of the selection test is a simple example. The sword in the stone reacts to chivalric/aristocratic/royal identity. It senses the nature and destiny of the man who puts his hand on it. It is the administrator of electedness. It is an artificial contrivance, dependent on a magic whose source is nowhere in evidence, as if aristocratic social values and the political order had become laws of nature. That magic suffuses the landscape through which the Arthurian knight wanders. It is "a world specifically created and

designed to give the knight opportunity to prove himself."[8] In this world Nature knows and recognizes prowess, merit, rank, destiny, and royal bloodlines—it puts in place tests of legitimation. Drawing the sword from the stone places any questions of right of succession to rest. Legitimacy is hardwired in the elect knight, planted ineffaceably in the genes of the true king. There is an animistic relatedness between the true heir and the contrivance that tests him. It operates on a powerfully aristocratic law of personal election, of which Nature is the supreme court judge.

From this point of view, Kalogreant's failure at the adventure of the fountain is chivalric satire, a mocking pre-playing by a bumbling comedian of true adventure, as his cousin Iwein (Yvain) will experience it.

A more complex example of true adventure (as opposed to Kalogreant-like head banging) is the episode of the "castle of marvels" in Wolfram's version of the Perceval/Parzival romance. It is Gawain's great adventure and runs parallel to Parzival's adventure of the Grail castle.[9] The Castle of Marvels is ingeniously contrived by the magician Clinschor, a nobleman whom a jealous husband once upon a time before the beginning of the romance caught in bed with his wife and castrated. The only life left to Clinschor once he is "made smooth between the legs," as Wolfram puts it, is study. He becomes expert in magic, constructs the Castle of Marvels (*Schastel Marveil*) out of mysterious components sent to him from Africa. What he is building from magical lumber is a house of revenge, specially fashioned to avenge its architect for the wrong done to him by Love. Once the castle is ready he kidnaps lovers and holds them captive in it, confining them tantalizingly within sight of each other, but far from touch.

The scene that Gawain enters, then, is charged with erotic tensions. He defies the most dire warnings. He enters the castle and steps onto the floor of a grand hall, which turns out to be slippery as ice. He can barely maintain his footing. But he gropes his way to the object in the center of the hall, a magical bed, the *lit merveilleux*, bed of wonders. He leaps onto the bed. It begins to surge back and forth wildly, hurtles this way and that like a wild horse ridden for the first time.

A bed? An ungovernable bed? Not the kind of antagonist common in chivalric adventure, dragons, giants, and so on. The slippery floor and the dangerous bed are accoutrements of an erotic adventure, where the character of the challenge is tuned to the character of the challenger, a more elaborate form of selection test. The dangerous bed was meant only for Gawain, because in overcoming it, he is overcoming what is most vulnerable in his

character. No chaste knight would have been elected to take or at least to survive this text. Gawain is far from chaste and anything but restrained in his love relations. The adventure of the Castle of Wonders is strategically situated in his amours. He is desperately in love with a femme fatale named Orgeluse. She is irresistibly beautiful. Every man who sees her (except Parzival) falls in love with her, and every man who falls in love with her is sent to his doom. She is a beautiful monster, a revenge machine. She uses up men, and, as is eventually revealed, her motive is nearly noble: she wants to get revenge against a knight named Gramoflanz, who had murdered her beloved husband. She was nice enough to warn Gawain away from her service, and when he refused to heed the warning, she sent him into a series of perilous adventures, one of which is *Schastel Marveil*. Gawain faces the mortal dangers of love service both in the reality of the narrative and in their symbolic framing of the castle's dangers.

Back to the adventure of the castle: Gawain wrestles the bucking bed to a standstill. But hardly has the wild ride stopped, when the ceiling opens, and a hailstorm of stones and arrows rains down on him. He takes shelter beneath his shield. The stones bounce harmlessly off, the arrows penetrate and score his flesh, but only slightly. Here and in another great romance, the Middle English *Sir Gawain and the Green Knight*, Gawain's destiny is to face the dangers of courtly love service and come away—wounded but not dead, his honor imperiled but intact. He performs a tightrope walk suspended between love and disaster—and keeps his balance. The shallow wounds of the arrows are a good symbol of this destiny. The arrow, the weapon of love, can kill a man not protected, or leave a man with an impenetrable shield untouched, but the arrows shot at Gawain leave only flesh wounds, and that symbolizes the effect on Gawain of dangerous love. He overcomes it scratched, scored, and bleeding, but not mortally wounded. Wolfram states his role outright: "Though caught in the snares of love, he is not disgraced."

Finally (the trials of *Schastel Marveil* are not yet over), a lion enters the chamber. A weakened Gawain defends himself desperately. The lion leaps onto his shield, plants his paw in its center, and Gawain lops off the paw with a single blow of his sword.

That stroke ends the final combat. The spell on the castle is broken; the imprisoned lovers are magically freed, and they reunite. Once Gawain recovers from his wounds, he is lord of the castle, and one of the terms of his courtship of Orgeluse is met. Some time later he turns up on the field

of battle and Wolfram tells us, almost in an aside, that the lion's paw is still stuck in his shield, an extraordinary bit of unhygienic neglect, easily cleared away with a stroke of the sword. But that misses the point. The lion's paw remains in his shield because it has become a heraldic device. The token of an active adventure transforms itself into a symbol of the victor's identity.

This is adventure at its best. Yes, it involves combat, but the combat shades over into psychological allegory. The knight does battle against his own weaknesses. Overcoming them is the way to destiny. Through adventure, one enters into one's identity. Adventure then is the medium of a process of development and self-formation. It produces the harmonious governance of the inner world, a kind of chivalric *sophrosyne*. The German lyric poet Walther von der Vogelweide said it outright: "Who slays the lion? Who conquers the giant? Who overcomes this one and that one? Anyone who masters himself and brings his body under his own control, rescuing himself from the wilds into the haven of unwavering courtesy."[10] From this point of view, adventure is self-realization through combat.

There is a strong element of pedagogy in courtly romance. Many romances make the development of a knight to restraint, courtesy, self-domination their central theme. *Parzival* fits this description. It is sometimes referred to as the first bildungsroman. The Old French *Prose Lancelot* has a long section on the education of Lancelot to knighthood by the Lady of the Lake. When her ward turns eighteen, she questions him on his future. His wish is to "go to a place where I could work at advancing myself." King Arthur's court seems to him the place for it. The worthiest men are at that court, and it follows that he would absorb their virtues.

"If you knew what a great burden knighthood is, you would never be tempted to take it on."

"Why, my lady?" he said. "Do you mean that knights have to have stronger bodies and better limbs than other men?"

Then follows a catechism on knighthood:

"A knight needs things that other men don't need, and if you heard them named, even *your* bold heart would tremble."

"My lady," he asked. "Are these things traits that can be found in a man's heart or body? . . . Everyone should always aspire to improve himself and acquire good qualities. And a man should hate

himself if he lets idleness rob him of something that everyone can
have; I mean the powers of the heart, which are a hundred times
easier to have than the powers of the body."

"What difference is there,"said the Lady, "between the powers
of the heart and those of the body?"

"My lady," he answered, ". . . a man without bodily virtues can
still have virtues of character. He can be refined and reasonable,
gracious and loyal, fearless and generous and bold. . . . Traits of
character . . . are within the grasp of anyone who is willing to make
an effort; everyone, I'd say, can develop courteousness and gracious-
ness and the other qualities that stem from the heart. . . . If a man
fails to become worthy, it is only for lack of will."[11]

The passage speaks a language of personal development: "becoming,"
"improve oneself," "acquire good qualities," "having traits of character,"
"developing courteousness and graciousness," "becoming worthy." "Train-
ing" for knighthood is above all ethical training, development of virtue,
gotten in part by contact with men who possess it, in part by coaxing it out
of its seedbed in one's own heart. The virtues of the body are relegated to
a comparatively low place, as they are in Chrétien's and Hartmann's
romance of Yvain/Iwein.

Adventure has another obligatory element: its setting. A knight's prog-
ress toward realization of his destiny only happens in a magical zone, an
otherworld of enchanted forests and castles. That shrewd technology
whereby fountains, trees, stones, and even beds know the soul and the fate
of the elected knight, and reject the advances of those who lack the requisite
qualities, has to be switched on and operating. The Arthurian world sends
meaning-filled and mysterious dangers at a knight who is out seeking them.
The authors of romance share the presuppositions about the world they
describe. It does not exist, but everyone knows what it is like. The details
vary but the mechanisms and the operating laws remain consistent over the
whole stretch of the history of chivalry and beyond. The enchanted realm
offers an enlarged existence, free of the strictures and limits and prohibi-
tions of reality. There is a strong element of wish fulfillment, of dreaming,
of constructing an earthly paradise of love and honor, to which you, elect
hero, and you, reader, losing the contours of your identity in the greater
ones of the questing knight, have privileged access. The romance works by

baiting and luring the individual to believe in the attainability of the impossible. The more unattainable the vision the stronger the gravitational force pulling the weaker individual up into the charmed world of the knight.

The "enchanted realm" is a useful term to describe the space in romance-like narratives where the transformation of the hero can occur. The "green world" of Shakespearean comedy is an enchanted realm; so is the forest of fairy tales. The "secret garden," Alice's Wonderland, Dorothy's Oz, Peter Pan's Never Never Land, and Narnia are obvious examples in children's literature. It can also operate in romance-thrillers, like Hitchcock's *To Catch a Thief* (the rooftops) and Ang Lee's *Crouching Tiger, Hidden Dragon* (the forests and tree groves). The laws of "real" nature are suspended in the enchanted realm, superhuman powers and a grand destiny are posited for the hero; and access to it incomparable with any unenchanted realm is fully open. It is a benevolent realm. Evil is present—not to predominate, but only to facilitate by conquerable barriers the realization of a character's destiny. The enchanted realm is a world where charismatic effects operate exclusive of contingency and failure (at least irreparable failure). Tragedy here is a temporary hindrance on the way to a happiness virtually guaranteed by the laws of operation hidden in enchantment.

Exemplarity and Education

Gottfried von Strassburg built charisma and charismatic effects into the dynamics of love in his romance of Tristan and Isolde.[12] His heroine is made expressly into a charismatic figure, as in the spirited oration that Tristan delivers to the court of King Mark in praise of Isolde's beauty. He is persuading the king to send a wooing expedition to Ireland to win the princess as Mark's bride: " 'Isolde,' said Tristan, 'is a girl so lovely that all that the world has ever said of beauty is nothing beside hers. . . . Whoever looks Isolde in the eyes feels his heart and soul refined like gold in the white-hot flame; his life becomes a joy to live. Other women are neither eclipsed nor diminished by Isolde in the way many claim for their ladies. Her beauty makes others beautiful, she adorns and sets a crown upon woman and womankind' " (trans. Hatto, p. 150). Her beauty presses on beyond all archetypes. She makes Helen of Troy seem plain and transports the prize for perfect beauty to Ireland. It is the technique of comparison I've called the "plusquamperfect" of the sublime style; posit unsurpassable

beauty and claim to have superseded it. Language fails before her perfection; she renders the old language of praise out of date and useless. It is time to scrap it and invent a new one, more intense, more heated, drawing on the metaphor of a purifying flame: her light dazzles, she radiates, she blazes like the sun, she shines like gold, she relocates the sun and stuns the cosmic order itself by rising—in the west, over Ireland! Her light has transforming power: "Her beauty makes others beautiful." Isolde is not exactly a Platonic archetype stamping out others in her mold, but rather a magical light transforming whatever it illumines. Shine it on men and it purifies them morally, makes better men of them. The white-hot flame does not destroy, it gives happiness.

This rhapsody is crowded with the language of charisma. The logic of charismatic effects (if nothing else) links Isolde with Shakespeare's Falstaff, who claimed, "I am not only witty in myself, but the cause that wit is in other men" (*2 Henry IV*, 1.2.9–10). Isolde is the cause that beauty is in other women. The transforming force of her presence is set out in language like Wibald of Stablo's praise of Bernard of Clairvaux: "The mere sight of him instructs you; the mere sound of his voice teaches you; following him perfects you."[13] Gottfried had ascribed this same charismatic power to Tristan's mother, Blancheflor, in her youth a woman so beautiful that "no man of flesh and blood had ever gazed at her with enamoured eyes and not loved woman and noble qualities better ever after" (trans. Hatto, p. 50).

This miraculous effect of women is not an idea of Gottfried von Strassburg, and while it became a convention of medieval and Renaissance romance, the underlying psychology is not the property of a particular age. Proust described Marcel's gazing at Albertine in this way: "If we thought that the eyes of such a girl were merely two glittering sequins of mica, we should not be athirst to know her and to unite her life to ours. . . . It was . . . her whole life that filled me with desire. . . . It offered me that prolongation, that possible multiplication of oneself which is happiness."[14] The force that shines from Isolde's eyes also magnifies and gives happiness. What Proust calls "prolongation and multiplication" might be Gadamer's "Increase in being" (see Chapter 1, above). For the medieval audience the force that flows from the eyes of the beloved bestows goodness, courtesy, and "noble qualities."

The figure of the courtly damsel was the heiress of the traditions of charismatic pedagogy that I discussed in the previous chapter. Peculiar as

that shift of operations from teacher to beloved seems, it is clear: the heroines of romance take over functions of the schoolmasters of that dying charismatic culture of the humanist schools.[15] A decade or two prior to Gottfried's *Tristan* (ca. 1200/1210), Andreas Capellanus, a chaplain of the king of France, had written a kind of textbook on courtly love, *De amore* (often translated as *The Art of Courtly Love*, ca. 1185). This work has the charm and versatility lent it by a skilled writer widely versed in aristocratic love, and at the same time the banality of a how-to-do-it book by an author who positions himself at an ironic distance above and against his subject. All three members of the romance trinity (irony-pathos-exemplarity) are at work in Andreas, though pathos is the weakest.

The effects of love, according to Andreas, are of the miraculous sort that Isolde and Blancheflor bring about; they have transforming force. Love turns the avaricious man generous; it makes the rough uncultivated man blossom with beauty; it enriches even the lowborn with "nobility of manners"; it turns arrogant men humble; and it "decorates" a man with the virtue of chastity (because he wants only one lover). Andreas's summation: "What a remarkable thing is love, for it invests a man with such shining virtue, and there is no-one whom it does not instruct to have these great and good habits in plenty."[16] All virtue and courtesy flow from women. Even crude and brutal men can receive these softening, beautifying, and civilizing effects.

Women also become literally teachers of men in Andreas's work. The curriculum is good manners, virtue, and courtesy. In one of the imaginary dialogues between women and their suitors that make up the greater part of book 1, the man begs instruction in the art of love from the woman, because he admires her "comprehensive knowledge of the art of love." He knows that all urbanity, all good deeds, and all kindness flow from love's teachings. The woman assents after initial hesitation because she feels that "experts" should not refuse their learning to the less learned who seek instruction (1.6). Her teachings are closer to a school curriculum for educated gentlemen/chevaliers than what we associate with the art of love: he must be generous, humble to all, and ready to serve all; he must never speak ill of anyone and silence anyone who does; he should not quarrel and argue too much; he should study the stories and deeds of the ancients and try to emulate them; he must show boldness and courage in battle.

The romances of Chrétien de Troyes turn this kind of instruction in love into a narrative form. In two of his works (*Yvain, or The Knight of the*

Lion and *Lancelot*), the loving man loses the love of his beloved by some
kind of trivial misbehavior, a minor omission that is magnified by the lady
into an offense so great that the man must do long and arduous penance,
subjugate himself to the woman's will, show his virtue and boldness in the
performance of good deeds, expunge his failing by performing its opposing
virtues, before she will readmit him to her favor.

Again, the education of the knight dominates in the trajectory of the
plot, even in the context of courtly love. Men are disciplined by women to
love courteously.

Pathos: Love and the Sublime

While education looms large in Gottfried von Strassburg's *Tristan*, the
remarkable element of that romance is the combination of pathos and exem-
plarity. *Tristan* is a love tragedy. It ends with separation and miserable but
romantic death. The Tristan romance is virtually alone in a narrative world
of happy endings. Classical chivalric romance ends in success: the knight
overcomes fantastic difficulties and wins or wins back the lady he serves; they
marry and he becomes king and master of the lady's lands and castles. So
Gottfried defies narrative conventions. Charismatic representation in general
calls for a happy end, the world and human destiny affirmed, the life force
triumphant. These are the narrative elements that most rouse identification
and imitation: success, happiness, and long life secured by invulnerability—
powerful incentives to live in the illusion. But the courtly period discovered
the ineffable benefits of tragic love-death, and it has this discovery in com-
mon with eighteenth- and nineteenth-century romanticism.

Gottfried von Strassburg's rhetoric and strategy of presentation helped
establish a tragic model, made tragic love-death seem like a higher form of
existence, happy endings trivial and vulgar. Unthinkable in classical trag-
edy, which has a cautionary and cathartic element: do not act as this man
did. Gottfried affirms precisely the passions and actions that led to the
destruction of the lovers. His prologue to the romance is a defense of the
virtue-giving, exemplary force of the story of Tristan and Isolde: "It will
make love lovable, ennoble the mind, fortify constancy, and enrich their
lives [i.e., the lives of the readers]. . . . Wherever one hears or reads of
such perfect loyalty, loyalty and other virtues commend themselves to loyal
people accordingly" (*Tristan*, trans. Hatto, p. 43). Tristan and Isolde are

living the model life, even though their love is adulterous and threatens to dishonor the lovers and to destabilize the nation of which the cuckolded husband is king. Still, in his prologue the poet confronts precisely the objection that tragic love is sad, and people don't want sad tales of love. He rescues his poem through esotericism and elitism: he writes for the few "noble hearts" who can appreciate the ineffable advantages of suffering and tragic passion. There is of course the world of the many, the great herd, who "are unable to endure sorrow and wish only to revel in bliss" (p. 42). But he writes for the few who understand the bliss of suffering both joy and sorrow in love.

There is rhetorical bravura in wringing exemplarity out of forbidden love. The poet constructs the narrative and the characters so as to reinforce them as models of the amatory life. The story is offered to the reader as a sacrament, set parallel to the bread and wine of the Eucharist. The following lines end the prologue and even in translation suggest the dithyrambic upswing of the verse and the coinciding of sublimity in language and *enthousiastikon pathos* in the subject:

Although they are long dead, their sweet name lives on and their death will endure for ever to the profit of well-bred people, giving loyalty to those who seek loyalty, honour to those who seek honour. For us who are alive their death must live on and be for ever new. For wherever still today one hears the recital of their devotion, their perfect loyalty, their hearts' joy, their hearts' sorrow—

> *This is bread to all noble hearts. With this their death lives on.*
> *We read their life, we read their death, and to us it is sweet as bread.*
> *Their life, their death are our bread. Thus lives their life, thus lives their death. Thus they live still and yet are dead, and their death is the bread of the living.*

(trans. Hatto, p. 44)

The ecstatic but slightly thumping swell of assonance and rhyme sounds clunky in translation, but in the original it punctuates the parallel that the lines establish between the suffering and death of Tristan and Isolde and that of Christ. The passage ascribes to the love story a life-sustaining, redemptive, eucharistic force, and the music of its rhetoric is in line with

that extravagant claim. Not even Christianity argues that to die on the cross in imitation of Christ is sublime; but rather that the crucifixion overcomes death. The courtly Tristan romance makes romantic death seem sublime.

Charisma and Love

This is perhaps a good point to reflect on the similarities between charismatic relationships and love relationships. There is often an element of love, or something close to it, in the admiration of the devotee to a charismatic person. Filmgoers fall in love with movie actors and actresses; students fall in love with their teachers; patients, with their analysts. In charismatic cultures, the love relations between master and student were an obvious element of pedagogy.[17] Both love and awestruck admiration are spells to which the human mind is susceptible. Both are productive states: Love relations move toward the self-replication of lovers in children; charisma exercises the reproductive force by the imitative impulse it releases in the devotee. Both assert themselves as irrational and inexplicable forces, real as their effects are. Both tend toward ecstatic states in their extreme manifestation. Charisma and romance have in common that they place the person captivated in the spell of a single person. The lover or devotee pursues that person, by compulsion, not, or only in exceptional cases, by any reasoned process of thought ending in a sober decision. Both charisma and romance lead one to visions and fantasies; in both there is a tendency to deify the idol: whatever he or she does is good; the world is full of promise; the devotee is constantly in a state anticipating fulfillment of that promise, everything is infused with the good that the beloved is, everything pregnant with that person's gifts. And finally, both love and charisma make those in their spell susceptible to seduction and have a path to disillusion and hatred built into the experiences.

Imprinting Chivalric Idealism

With the possible exception of the Homeric epics, I doubt that any narrative form in the West has had a sustained shaping influence on a culture comparable to courtly romance. Chivalric ideals set the social mores of the European aristocracy and, in a descending line of influence, of the middle

classes. Romance and courtly love lyric were the original vehicles of the code of refined manners known as "courtliness" or "courtesy" and of the fashion of refined love that has come to be known as "courtly love." The new narrative had a powerful imprinting effect on noble society. The great studies by Joachim Bumke have shown how knighthood developed from a military class into an idealized social class: that development followed and was determined by courtly literature. The chivalric knight of romance was first and foremost "an educational idea of great significance,"[18] not a social reality to which literature responded. The reality of a chivalric society emerged in imitation of literature.

Didactic writers urge the chivalric code on the nobility and make the knight and lady of romance into the bearers, models, and charismatic pedagogues of the new ethic. Thomasin von Zirclaere offers a short treatise on the courtly education of children in his long poem *Der welsche Gast*, one of the most detailed books from the Middle Ages on court life, its values and manners, written in Middle High German around 1215.[19] Courtly romance in Thomasin's view provides models to imitate. He urges young women to listen to the story of Andromache, take her as model and good lesson (1029ff.). They should hear of Enite and follow her willingly. They should also follow Penelope, Oenone, Galjena, Blanscheflor, and Sordemor. Young men should hear of Gawain, Cligés, Erec, Iwein and should orient their lives to the pure virtue of Gawain. Follow the great king Arthur, Thomasin urges; he teaches you good lessons. Hold Charlemagne firmly in your mind. For courtly manners, follow Tristan, Segramors, and Kalogreant. Do not follow Sir Key (1041–64).

The inclusion of Tristan and Kalogreant show how immune the idealizing is even to the morally problematic, how idealism overrides it. Lancelot was certainly to join the ranks of the imitable, even though the outcome of his affair with the queen had catastrophic results. The writer/scribe of a late medieval version of the Old French *Prose Lancelot* commended the story and its heroes in glowing terms in his prologue: "In this book you will learn of things delightful and worthy of being memorized by all, especially those who wish to attain the pinnacle of honor in arms. . . . Pluck the flower of the best in conforming yourself by imitation to the great deeds and the glorious virtues which flourished and abounded in Lancelot." He does go on to warn away from Lancelot's faults. No one is perfect, after all, only God.[20]

The impact of this literary ideal of courtly chivalry was vast. It created a new fashion of imitating romances among the nobles, expressed in pageantry and ceremony, in fashions of clothing and naming. Rituals, court decoration, tournaments, clothing fashions, and the new code of social behavior called "courtliness" or "courtesy" come to dominate the domestic life of the high nobility.[21] By the fourteenth century chivalric orders began to flourish dedicated to honor, fame, nobility, and courteous love. In short, a literary form and fashion created social forms. Literature shaped life, not the other way around.

The Magnetism of the Grandiose

I said in an earlier chapter that the basic impulse of charismatic art is "to create a world greater and grander than the one in which the reader or viewer lives, a world of sublime emotions, heroic motives and deeds, godlike bodies and actions, and superhuman abilities, a world of wonders, miracles, and magic—in order to dazzle and astonish the humbled viewer." That astonishment overwhelms the narrow rationalism that sees in the work of art only illusion, not higher or heightened reality.

The distance separating paragon-hero from ordinary reader-listener charges the narrative with charismatic authority. Precisely that distance, the gap between the ideality of the hero and the reality of the reader produces the magnetism that draws the reader up into the greater model and transforms him in the image of the admired figure. The gravitational pull of the sublime hero is disorienting, like the mechanical rabbit in a dog race or the white stag in romance. The pursuer never gets it, but it does not prevent him from chasing it with enthusiasm shading over into fanaticism.

The comparison to a mechanical spellbinding force is not purely whimsical. The courtly romance may well be the narrative form best contrived to illustrate a technology of enchantment and the enchantment of technology. The romance landscape is cluttered with magical instruments, swords, stones, jewels, belts and gloves, things made by fairies on the Isle of Avalon, or by Morgan la Fée herself, or by the master craftsman and wizard Trebuchet. Lifelike automata that operate on cunning mechanical forces were endlessly popular.[22] When the lovers Flore and Blanchefleur are taken for dead a pompous grave monument is created for them: exact bronze replicas of the two lovers; when the wind blows through certain pipes, the two

statues turn to each other, bow and speak a few words of French, greeting each other and protesting their undying love. The appetite of the medieval audience for descriptions of monuments, statues, buildings created with magical properties and ingenious technologies designed to set the reader's mind in astonishment, was vast. The description of the Grail castle in Albrecht von Scharfenberg's continuation of Wolfram's fragment of a Titurel romance is hundreds of lines long.[23] These contrivances often are in the narrative as display pieces, but they also often participate in the destiny of the hero in a way that adds to the enchantment of hero identification the enchantment of technology (as in Gawain's adventure of *Schastel Marveil* mentioned earlier, Parzival and the Grail castle, Tristan and Isolde and the cave of lovers).

And finally, we can round off the discussion of Lancelot with mention of one further feature of romance calculated to engage and beguile the reader: the suggestion of higher meanings, the allure of some hinted-at allegorical level. The educated *romanciers* of the twelfth and early thirteenth century knew very well that the myths and epics of antiquity were read in the schools as allegories, especially allegories of education, ethical life, the operations of the mind and emotions. Why not invite their readers to see such depths in their own narratives, whether they could supply them fully or not? Marie de France begins her chivalric fairy tales, lais, with a suggestion that her own work contains subtle levels of hidden meaning, in the manner of the ancient authors, and the reader is invited to discover that meaning. She also fortifies the suggestion with a rhetorical gesture: those who cling to the literal meaning are of less worth than the questers after obscure wisdom. These and other claims of the *romanciers* have sent many a modern reader on long and ill-rewarded quests for continued allegories beneath the surface of romance narrative.

But romance does not "educate" by meanings first and foremost. It does so by coaxing the reader into the illusion of participating in the world represented and in the destinies of its heroes. That sense of participating in a fantasy world is far more primitive than knowledge and understanding. The educating force of charismatic art generally is exercised by the authority gathered on the narrative or visible surface. *"What does it mean?"* is an all but irrelevant question. "Meaning" is a technical term like "form" and "style" and "structure," useful for analysis but not really central—in fact a hindrance—to participation in the life of the work of art. The question to put to this kind of art is not *"What does it mean?"* but rather, *"How must*

I act to be like Gawain, Tristan, or Lancelot, Jesus or Buddha?" Meaning, interpretation, hermeneutics, the apparatus of commentary inherited from Western exegetical tradition are minor in the face of charismatic force. They are an intellectual charade played behind or above the surface drama of authority and influence. Charismatic art is an art of the surface. If the surface can evoke greater forces, like God, the messiah, the path to redemption, with yet great authority behind the surface, so much the greater the effect of the surface.

The ancients understood very well the educating force of a literature of fantasy and exaggerated idealism. The "cult of great examples" required an epic with "exalting and ennobling" force.[24] "Exaltation" and "ennobling" are the main activities in nurturing a cult of great examples, because magnification charges the exalted hero with imitability, and that charge accounts for its "transfiguring" and "transporting" force.

The "greatness" of characters and grandness of narrative worlds are inseparable from charismatic literature generally. The exalted hero rising to glory in an enchanted world took the reader along with him. Longinus remarked that the Sublime "develop[s] our natures to some degree of grandeur." That dynamic is not at all limited to ancient writings or to any single age of the aristocracy. The link formed between model and imitator by the enthralling and captivating force of the model is a fundamental element of human psychology and anthropology, observable still in rock concerts, political rallies, religious revival meetings, and occasionally high school and university classrooms.

Chrétien's *Lancelot* instrumentalizes the Christian faith itself, not as prose-lytizing or religious edification, but as a means of heightening and exalting the hero and his otherwise questionable story of shame, humiliation, and heroism in the service of the queen. The graveyard episode and the messianic allusions are accretions on Lancelot's skin-ego, not Christianizing metaphysics. The pseudo-religious element injects large doses of religiously/mythically charged charisma into the hero. His messianic role is charisma steroids. With dubious legitimacy it co-opts a powerful authority source for the narrative while seeming to convey some metaphysical message.

7

Albrecht Dürer's Self-Portrait (1500):
The Face and Its Contents

The suggestion of a living force present in the person or the world depicted is a strong element of charismatic art. What I see in Sargent's *Lady Agnew* and what Rilke sees in the headless statue of Apollo is more than what the naked realism of the work "by itself," stripped of charisma and aura, conveys. When that force is both human and superhuman, natural and supernatural at the same time, the magnifying and awe-inspiring effect is so much the greater. It plays into and draws force from a perception of art as alive or living. If the viewer does not come away with a sense of astonishment or, at the minimum, awe, the charismatic work has not made its effect. Astonishment is necessary, as I said earlier, to overwhelm the viewer's critical sense, as the Olympian gods are awestruck at their own "amazing" images in Hildebert's Rome poem, Rilke is "dazzled" or "blinded" by the vision of light breaking from the torso of Apollo.[1] This sense of transport overcomes the rationalism that insists the work of art is illusion, not vision. It makes it possible to live in the work of art and refashion life on that higher model.

The Individual and the Incarnation/Layering

Earlier I called the accretion of story, myth, mystery, ghostliness, or the supernatural, on personal presence "aura." When the presence of a ghostly person seems to emerge from a living human being, we can call it "incarnation." When it appears in a realistic representation of someone other than

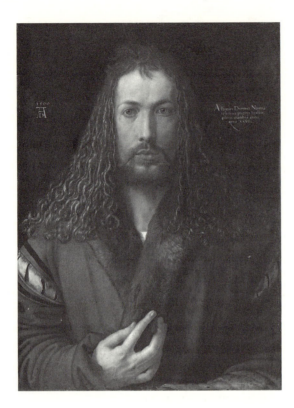

Figure 30. Dürer, *Self-Portrait,* 1500. Alte Pinakothek, Munich.

that person, we can call it "layering." From the aura of a multipersoned figure beams that message formulated earlier, "*I am not myself alone. Gods, spirits, saints, ancestors, and precursors live again in me, and their presence strengthens my existence, extends it from the here and now into the beyond, and testifies to my mission in life.*"

I want to analyze some examples of layering in portrait painting and in literary portraits, starting with one of the most famous paintings of the northern Renaissance, Albrecht Dürer's self-portrait of 1500 (Figure 30). An anecdote from a colleague in art history at the University of Illinois confirms for me its charismatic quality. In the course of a lecture at Urbana the Harvard art historian Jeffrey Hamburger showed and discussed the Dürer self-portrait. After the lecture a graduate student in the audience told my colleague, "I'm in love with Albrecht Dürer!" Charismatic art clearly

takes us far from a Kantian aesthetic of detachment and a pleasantly disengaged "free play of the imagination and understanding."

Virtually any portrait from the European Renaissance strongly suggests "the individual." "Similitude," the actual physiognomy of the subject, "seeing the soul expressed in the body," "the inner self shining through the body" are some of the critical terms that describe individualizing portrait painting.[2] But layering is prominent among the techniques of creating charisma and "giving face."

Dürer's self-portrait takes its authority from the suggestion of a supernatural force alive and at work in the living being. The portrait presents itself to the viewer as a precisely observed rendering of an individual, evoking a living presence with such skill that we can virtually experience the fading of the distinction between art and real presence. We enter a relationship of "I and Thou" to the artwork, no longer "I and It." The inscriptions in the margin of the painting also proclaim individual identity: it is firmly located in time by the date "1500" just above the artist's monogram "AD" in the upper left corner, and further localized by the inscription on the right, in which "I, Albert Dürer" states that he depicted himself thus "according to my own proper appearance at the age of twenty-eight."[3] The man himself according to his own appearance could hardly emerge more assertively and nontransferably—as himself and no one else—than in this portrait. Joseph Koerner describes it as follows in a masterly study: "Dürer gazes out at us from a completed world in which every hair, every visible surface, is wholly accounted for—as if the moment of self-portraiture had indeed been the total and instant doubling of the living subject onto the blank surface of the panel."[4]

Dürer–Christ

And yet dense as it appears, the portrait is layered. Erwin Panofsky sums up a consensus of art historians in commenting, "The effect of this hieratic arrangement [exactly vertical, fully frontal] is paralleled only by half-length images of Christ, and this resemblance is strengthened by the position of the hand which occupies the same place as the blessing right of the *Salvator Mundi*. . . . Dürer deliberately styled himself into the likeness of the Saviour. He not only adopted the compositional scheme of [Christ's] image, but

idealized his own features so as to make them conform to those tradition-
ally attributed to Christ."⁵ Dürer has given himself features conventionally
used to represent Christ.⁶ The aura of the face is established in no small
degree by its sacred contents.

Joseph Koerner can strengthen the arguments for Dürer as imitator of
Christ by regarding the portrait as an "imprinting miracle" and showing
its association with the veil of St. Veronica, on which Christ's face
imprinted itself miraculously on his way to his crucifixion. Like Christ's
image on the veil, Dürer's seems not to have been painted at all, Koerner
argues. It presents itself as an image not made by human hands, an *acheiro-
poieton*, as though Albrecht Dürer had repeated on canvas the miracle of
Christ's laying his face on the veil of Veronica. The result is a work of
miraculous reproduction. It shows, says Koerner, "a purity of origination
comparable to the Virgin birth."⁷

Dürer's self-stylization as Christ has posed problems of interpretation
that range from blasphemous self-glorification to humble imitation of
Christ. It may represent a claim of the divine origins of human artistic
talent, an announcement of a new Renaissance sense of the divinity of the
artist, perhaps also a sense of the emergence of a titanic, quasi-divine art in
a new epoch of history beyond the "Middle Ages" (this watershed indicated
directly by the significant date "1500").⁸ The portrait was interpreted as an
effigy of Christ in Dürer in the following century. The German baroque
artist Georg Vischer, lifted his depiction of Christ from the self-portrait in
his *Christ and the Woman Taken in Adultery* (Figure 33).

The precise meaning of Dürer's Christlike self-portrait is not of any
particular interest to my project. That is, I have no interest in extracting
from the daring portrait an idea that could be weighed and measured in its
relation to Christian doctrine. I resist the idea that the portrait is an allegory
or the visual realization of an idea. More important is to understand the
way the portrait operates within the logic of charisma and charismatic art.
It makes Christ look like Albrecht Dürer; it also makes Albrecht Dürer look
like Christ. It puts the two of them into the same face. Dürer's physiog-
nomy in other portraits appears cruder. Compare for instance his self-
portrait of 1498 (Figure 34). If the hair were not similarly curled, it could
be a different man. The eyes are narrower, the bend in the bridge of the
nose more pronounced, the physiognomy less refined. In the portrait from
two years later the artist has straightened the nose that appears bent at the

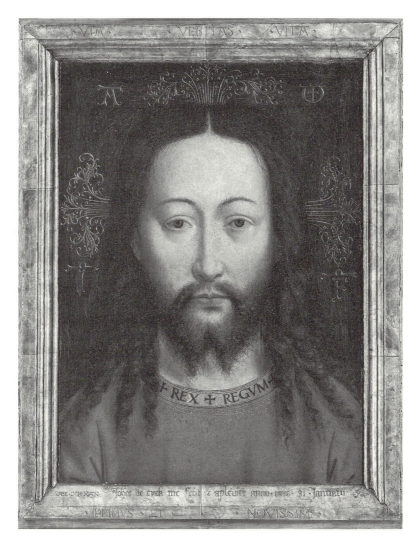

Figure 31. Follower of Jan van Eyck, *Christ*, 1438.

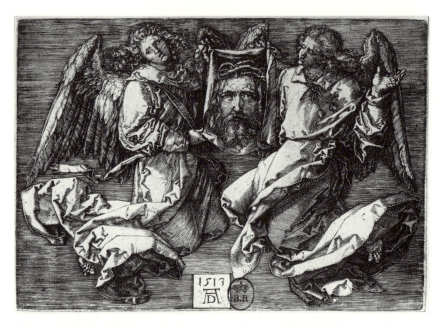

Figure 32. Albrecht Dürer, *Sudarium*, 1513. (Photo: Bridgeman-Giraudon/Art Resource, NY)

bridge and bulbous at the tip in other self-portraits. The eyes are widened and softened. There is love, gentleness, and luminosity in the Munich self-portrait but none in the portrait from two years previous. The aforementioned graduate student who was "in love with Albrecht Dürer" might well have reacted differently to the man in the 1498 painting.

Image and Archetype: Nicholas of Cusa

The theologian and philosopher Nicholas of Cusa had posited a relation between God and man analogous to model and portrait in his work *The Uneducated Man on the Mind* (*Idiota de mente*, 1450). He likened the individual human—that is, the living human—to a self-portrait of God in which the image is capable of growing more and more like his model.[9] This idea tells us how to read the Dürer self-portrait from the point of view of charismatic effects. Dürer has represented himself in the way that the archetype, Christ, has molded, transformed, and improved him, not in the way

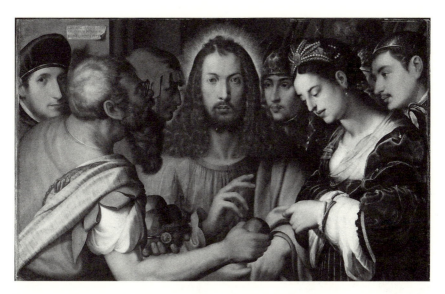

Figure 33. Georg Vischer, *Christ and the Woman Taken in Adultery*, 1637. Alte
Pinakothek, Bayerische Staatsgemäldesammlungen, Munich, Germany. (Photo:
Bildarchiv Preussischer Kulturbesitz/Art Resource, NY)

he appears in reality. It is an imitation of Christ but one that operates
within the logic of charismatic effects. The charismatic model remodels its
admirer, like the effect of Goswin of Mainz, whose student was able to
"transform himself altogether into the master." Dürer presents himself in
his self-portrait of 1500 as the completion of the process of assimilation of
man to God. The painter, operating in "momentaneity," can do what the
writer, operating in the flow of time, cannot: make the mere undescribed,
uninterpreted presence be in the same instant both man and god, make
incarnation an unmediated aesthetic experience. If we see a changed and
improved Albrecht Dürer in the 1500 portrait it is because the artist has
imagined himself transformed in the image of Christ. This self-portrait cap-
tures the final moment of that process. While Hildebert of Lavardin had
cleverly reversed that logic—the gods wish they were like their carved
images—Dürer has realized it in representing his own person: the good
Christian artist wishes to be like his God, and remakes himself in His image
and likeness. We see in Dürer a heightened Albrecht Dürer and at the same
time a reincarnated Christ. Christ lives in Dürer. They share a single physi-
ognomy, greater than its borrower, less divine than its lender. Dürer places

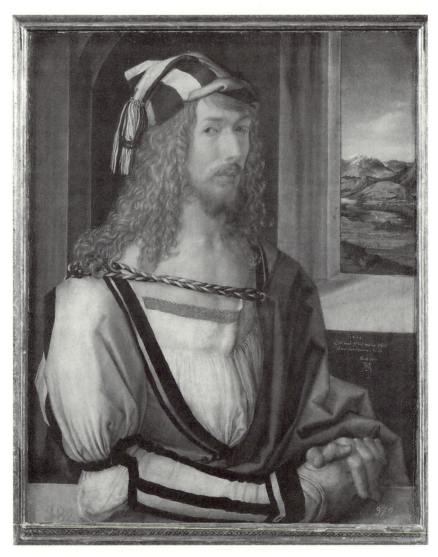

Figure 34. Albrecht Dürer, *Self-Portrait*, 1498. Museo del Prado, Madrid, Spain. (Photo: Erich Lessing/Art Resource, NY)

himself in a relation to Christ comparable to the relation of the tattooed Marquesan to his ancestors. Just as the ancestor looks out of the face of the living tribesman through the grid of the tattooing, Christ looks out at the viewer through the eyes of Albrecht Dürer. The representation raises the claim that the spirit man lives again reembodied in the living man.

The self-portrait is a significant moment in the theology of the image in Christianity. It overcomes the division between ego (the artist's) and image (Christ's); it overcomes the dualism of God and individual. God and man remain separate so long as the one is archetype and the other image. The full identification of the individual with God must have appeared borderline blasphemy, though early Christianity and the Middle Ages flirted with the idea. Peter Brown describes how community is established in early Christianity via the conviction that the Christian life joins men as links in a chain diffusing the charisma of Christ, which passes first through saints, then through monks and holy men, then bishops and priests, ending in laymen. The internal receptacle of this force is the image of God within, and the presence of the saint or holy man, the "Christ-carrying man," by himself brightens and partially restores this image dimmed and obscured in normal humans.[10]

Imprinting Christ

But in pictorial representation the Middle Ages maintained the dualism of individual and God, and so the full identification suggested in the Dürer self-portrait was not possible. Franciscan spirituality with its preoccupation with the humanity of Christ came close to realizing the idea of second and multiple incarnations of Christ in living men. The stigmata of Christ appear miraculously on St. Francis's body. That is, it is no longer an "inner image," the "image and likeness" of God we're talking about, but Christ physically imprinted in the flesh. Fleshy though it is, it is still imagined and represented as imprinting. But it is far from an identification of Christ with St. Francis. As if to cut off any thought of a second incarnation, the iconography of the stigmata stresses separation. It has the crucified Christ floating in the sky above the saint, wound joined to wound by lines of light or mystical force, which maintain real participation and keep it at a distance at the same time. The stigmata are imagined in terms of metaphysics: the giving body is heavenly and in a sphere above nature; the receiving body

physical. Christ is matrix; Francis the medium of the imprint. The portrait of Francis is a kind of visual narrative. The viewer reads its elements, which present themselves with the clarity of a diagram to which it would be easy to add annotations: here is Christ in heaven; here his power emerges from his wounds; these lines show how it flows to earth and connects to the corresponding points on the body of Francis. We are still far from a reincarnation of Christ in the body of the saint. In Dürer's self-portrait we have full identification, not imprinting from the supernatural archetype.

It might be possible to object that this reading of the Dürer self-portrait denies it "depth." What it means, however, is that the depth of the portrait resides on its surface. I once showed my daughter Giotto's *St. Francis Receiving the Stigmata* (Figure 35). Her comment was, "It looks like the saint is flying a kite." It was a good reading of the painting as all surface, erasing its metaphysics; it insists that all elements of the painting operate in a natural world. The Dürer self-portrait flies no kite, visible or invisible. It does not "mean" Christ or "godlike artist." It simply is those things. Nothing in the portrait is assigned explicitly to a supernatural world. Goethe would have called this full identification of surface and meaning an "Urphänomen," a primal phenomenon. It is a concrete, sensual object that embodies rather than conveys meaning, a thing itself, not a sign. Such phenomena, in themselves, just as they present themselves to the eyes, are mysteries of great profundity (so says Goethe)—though their depth is visible on the surface—and the response of the viewer in the moment of recognition is amazement, maybe even terror.

Allegory–Incarnation–Force

From this point of view "force" describes the effects of the face of the divine man better than "meaning." It is not an allegory; allegories always "fly kites," separate meaning from representation. Allegory is a mode ordinarily starkly opposed to charisma. Dürer's divine man is an incarnation. Christ is resurrected and lives again in the face of Albrecht Dürer. Whatever construction we put on this double occupancy of a single face, the result is an extraordinary individual aura, the aura of a man in whom a divine presence lives and works. The portrait conveys no message; it conveys force. The first reaction is wonder and perplexity. The recognition breaks through calm reflection and shatters analysis and judgment. It is the reaction of Michael

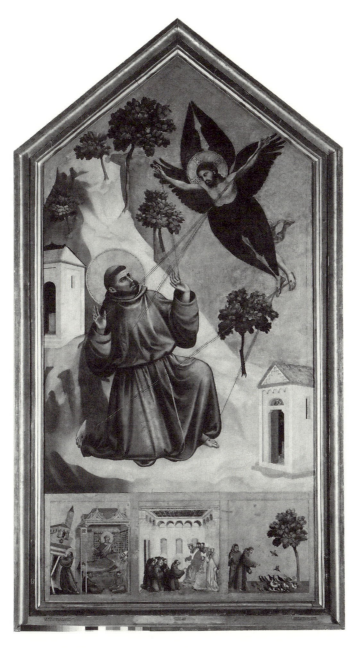

Figure 35. Giotto, *St. Francis Receiving the Stigmata*, ca. 1320. Louvre, Paris, France. (Photo: Scala/Art Resource, NY)

Psellos to the icon of the Virgin, which "ravishes me; as a bolt of lightning, it strikes me with its beauty, depriving me of strength and reason. . . . I do not know whether or not the image reveals the identity of its supersubstantial original," and close to what Longinus had described as the effect of the Sublime, which is to transport the audience "out of themselves [through its ability to inspire wonder and amazement.] . . . A well-timed flash of sublimity shatters everything like a bolt of lightning."

As a technique of representation layering is understandable in terms more general than a conception hatched or at least employed by Dürer peculiar to the medium of painting or to the age of the Renaissance. Nor does it emerge in the Renaissance in the context of the theology of the image. It's true that Dürer made use of it in the specific terms of Christian iconography, devotional concepts, or of a theology of the self or of the artist; it may also be true that he used it as a celebration of a new kind of divine art and artist emerging on the threshold of a new age. But the technique is present in earlier other far less impressive and impressively conceived portraits.

Portrait painting is virtually always charismatic. The genre has built into it the need of the artist to elevate the subject, we might say, to give face to it. The portrait commemorates; it conveys the subject's rank and standing, self-image, historical role, and, last and least, his or her actual physiognomy.[11] Of course it can vary from this idealizing role to a realism like that of Rembrandt's portraits. But the necessary collusion of painter and sitter tends to favor heightening the aura of the subject.

Here are two instances of layering from Italian Renaissance painting. Andrea Mantegna's portrait of Cardinal Ludovico Trevisan (ca. 1459–1460) is modeled on a classical Roman bust (Figure 36). The portrait suggests that the cardinal brings to life in his own person an ancient Roman senator, though given the hardness of the features and the odd greenish coloring of the face, "life" seems not quite the right term. It is more as if the cardinal were morphing into ancient marble. Dürer absorbed the presence of Christ into his own person; the Roman senator image seems to absorb Cardinal Trevisan.

Less subtle yet is Agnolo Bronzino's *Andrea Doria as Neptune* (Figure 37; early 1530s). As admiral of the naval forces of Emperor Charles V, Andrea Doria was no doubt flattered by the amalgam with the Olympian commander of the seas, and it is unlikely that the unsubtle layering was intended as mock heroic. It shows how a surface, though layered, can lack

Figure 36. Andrea Mantegna, *Cardinal Ludovico Trevisano,* ca. 1459–1460. Gemäldegalerie, Staatliche Museen, Berlin. (Photo: Jörg P. Anders. Bildarchiv Preussischer Kulturbesitz/Art Resource, NY)

any depth.[12] The profundity of the surface depends on the extent to which the hidden supernatural presence can appear to have fused with the human represented. Andrea Doria as the god Neptune, with trident and naked chest, has no depth. It is nearly comical, still layering but not yet allegory, more like a masquerade costume than an incarnation. Dürer's self-portrait is in stark contrast, since it shows a perfect balance in revealing and concealing the divine presence in the human.

Both the Italian portraits and the Dürer self-portrait are engaged in a process that Lisa Jardine has called "constructing charisma." She uses the example of Erasmus who self-consciously arranged, for self-promotion and public consumption, she claims, an image of himself that evoked St. Jerome reborn. The portraits of Erasmus by Quentin Metsys and by Hans Holbein the Younger both bear out the identification of Erasmus, the Renaissance scholar, with St. Jerome, the patristic Bible scholar and translator.[13] The submersion of the mythical or ancestral identity into the realistic present is not complete. The identification is evoked by composition and allusion via emblems shared by the living scholar and his ancient counterpart. This is not a "primal phenomenon" that strikes the viewer with amazement once the hidden presence emerges in the consciousness of the viewer. It is rather visual narrative writing a "myth" of Erasmus as he replays in the modern world the role of Jerome in the ancient. Jardine identifies this process with contemporary (i.e., twentieth-century) image making through manipulation of the media and seems to think of it in terms of what Erving Goffman would call "face-work." But that is a drastic narrowing of what is really at work. The principle of historical recurrence, "figura," typological thinking, describes better what is at work here. Erich Auerbach described "figural" representation as a kind of horizontal symbolism in which a connection or identification is made between one moment, event, or figure in the past and another in the present.[14] In this sense, Jerome "prefigures" Erasmus in a preordained scheme of Christian salvation history, and Erasmus is a fulfillment of what was predicted in Jerome.

The suggestion of supernatural forces living in and working through an individual is one of the standard ways of constructing charisma in life as in art. The claim of a god within (or ancestor, or saint, or hero) is something like a universal in the construction of charisma, though the means of representing the claim differ widely. I have given examples of this kind of representation in tattooing in an earlier chapter and will discuss examples in

Figure 37. Agnolo Bronzino, *Andrea Doria as Neptune,* ca. 1530. Pinacoteca di Brera, Milan, Italy. (Photo: Erich Lessing/Art Resource, NY)

modern literature, art, and film later. My point is that the Dürer self-portrait is one example of a widespread technique of charismatic representation. Its aggrandizing effects are available to glorify its object, to inspire awe, religious adoration, or love.

The Picture Looks Back

Incarnation accounts in part for the charisma of Dürer's painting. But just as strong a factor is its gazing. All communication to and from the painting is limited, by the position of Dürer's head and eyes, to a stark and uncompromising reciprocity; nothing happens in the frame of the picture but what passes between his eyes and ours; nothing engages Dürer but the viewer's eyes. Nothing distracts the viewer from this arresting gaze: no background, no events on the margin, no mountains or buildings. The soft, melancholy intensity of this gaze puts me in mind of the question of Dostoevsky's grand inquisitor, his fanatical will momentarily softened in a duel of reciprocal gazing, to another reincarnated Christ: "Why do you look silently and searchingly at me with your mild eyes?" The directness of the gaze and the rigid frontality of the head are almost intrusive, suggesting a gentle, compassionate aggression, at least a completely uncompromising engagement with the viewer.

Its aura is established in no small part by its "ability to look back at us." We might use Walter Benjamin's phrase and say that we "invest" Dürer-Christ with the power to look back, but let's face it: he is looking at us more intensely than we at him—and there is more at work when he looks than when we do. It's more accurate to give in and say that, faced with this much stronger presence, we simply do more or less what Rilke does faced with the statue in the Louvre: nod in assent at the force that fixes us in that stare.

An important element of charismatic painting is reciprocal gazing. In a later chapter (10) I discuss Walter Benjamin's comment that "to experience the aura of a thing means, to invest it with the ability to look back at you." It might well guide an analysis of Dürer's self-portrait. But some observations of Nicholas of Cusa on reciprocal gazing are closer to Dürer. Cusa produced a remarkable meditation on what we might call the "theology of gazing" in his work *On the Vision of God* (*De visione Dei*, 1453). He develops the nature of God out of his reflections on "omnivoyant" portraits, effigies that seem to look directly at the viewer from whatever angle

the viewer approaches them. Cusa takes as his point of departure a self-portrait (now lost) of Rogier van der Weyden and certain images of Christ. The work takes the form of a monologue of Cusanus directed immediately to God as represented in the artist's image of God. The effects of the viewed image are extraordinary, but entirely human, that is, they are psychological, not miraculous, understandable apart from any belief in the God represented. A reciprocity develops between viewer and viewed so complete that the one is absorbed into the other, and the other into the one: "O Lord, when You look upon me with an eye of graciousness, what is Your seeing, other than Your being seen by me?"[15] The sense of illusion fades. This is heightened by the form of address: Cusanus speaks with God (second person, I to Thou), who is imagined as present and visible, as if the man-made portrait were the unmediated and interactive beatific vision.

The depth of immersion in an image, in which the person represented seems an unmediated presence, is entirely realizable, in fact a common experience, as common as the complete absorption into an opera, play, or movie. I quoted Charles Peirce earlier on this experience: "In contemplating a painting, there is a moment when we lose consciousness that it is not the thing; the distinction of the real and the copy vanishes." That experience, passage through the illusion to the thing itself, the sense of participation and reciprocity, is the fundamental experience of charismatic art. Works of art exert their authority on viewers when the viewers take the representation for reality, as Cusanus does in his dialogue with the icon and Rilke in his gazing contest with the statue of Apollo.

Cusanus's vision of God is premised on reciprocity of viewer and object viewed. He seeks a condition ". . . when my every endeavor is turned only toward You because Your every endeavor is turned toward me, when I look most attentively only unto You (never turning the eyes of my mind away) because You embrace me with a steadfast look, and when I turn my love only toward You because You, who are Love, are turned only toward me."[16] The theology of gazing is compressed in a dense comment in his meditation on the all-seeing icon, in which he defines his existence by Christ's gaze: "I am because you look at me" ("Ego sum quia tu me respicis").[17] Or we might rewrite the phrase, "Tu me respicis, ergo sum." "You look at me; therefore I am." That change in the phrase enables the comparison with Descartes, for whom it is thought, and not vision, that proves existence ("cogito, ergo sum"). For Cusanus, the godlike gaze does much more: it creates being, or at least awakens it. Cusanus's claim represents a short-circuiting of the arduous

processes of creation, development, conversion. That whole process is framed as a single act of seeing God. Charismatic effects don't get any more powerful than that: gazing creates being.

In both the Rilke poem "Archaic Torso" and Cusanus's dialogue with Christ's portrait, the authority of the image is established by the life in its eyes and the consequent ability of the image to look back at the viewer (especially striking because the statue of Apollo in the Rilke poem has no head, but its eyes have migrated downward, multiplied and suffused the remaining body with vision). This reciprocity is what Benjamin called "experiencing the aura" of a thing. Very much like Cusanus's "your seeing is your being seen by me" or like Rilke's "There is no inch of the surface that does not see you." Cusanus's "I am because you look at me" has its distant echo in the statue's patriarchal edict to Rilke, "You must change your life."

Dürer's Realism

The recent study of Dürer by David Price has reminded us of the impact of the self-portrait in Dürer's lifetime.[18] No one remarked on the aspects I just discussed. No contemporary of Dürer's expressed concern about either edification or blasphemous self-aggrandizement at the artist's imitation of Christ; indeed, no one seems to have noticed it. It was the verisimilitude of Dürer's art that impressed contemporaries, at least those who commented on it and whose comments have been recorded. The portrait's impact registered first on humanists and provoked praise and interpretation from the humanist perspective: "As far as their reactions are recorded, Renaissance viewers did not acclaim any religious concept but rather, first and foremost, the phenomenal success of the likeness."[19] The self-portrait first got Dürer the epithet of "second Apelles," or "the German Apelles," Apelles being the legendary Greek painter whose art was reputed to be indistinguishable from life. The humanist appreciation of lifelikeness showed also in the revival of Pliny's story of the painter Zeuxis, whose painting of grapes so deceived the birds that they picked at its painted fruit. Contemporaries hatched a similar legend for Dürer. His friend and associate Conrad Celtis composed an epigram on the self-portrait relating that Dürer's dog took the likeness for the living master, rubbed against and licked the portrait.[20] Price can cite a number of other elements of the portrait that show its obligations to humanist

stylistic trends rather than to any religious motive. The earliest recognition of Christ in Dürer is the painting of Georg Vischer cited earlier, *Christ and the Woman Taken in Adultery* (see Figure 33), in which the baroque artist represented Christ by borrowing Dürer's physiognomy from the 1500 self-portrait, good confirmation of what is now an accepted reading of the portrait, but remarkably slow in dawning on viewers. A century and a half after the self-portrait, its Christomorphic character is noted.

Dürer's contemporaries admired the lifelikeness of the portrait. The palpable, sensual quality of details like the hair and beard, the fur on the coat, the folds of the sleeve, the subtle play of light and shadow, evoke a living reality closely observed, astonishingly minutely reproduced. "Illusionism," Price calls it. The richness of the self-portrait is only enhanced by recognizing the play of iconic evocations and realistic details. Of course, we're not talking about a visual *sermo humilis*. The richness and realism of details heightens and magnifies the personality of the subject. The realistic details are not those of a humble and everyday world. Every detail, every hair on the painter's coat is richer for the multiplicity of reference. The position of the hand evokes the conventional *Salvator Mundi*, but it is immediate, in the surface reality conveyed, the instrument of creative genius.

The realism of this portrait is one of the techniques of enchantment. Its uncanny character resides first in the sense of being drawn into the lived reality of a master artist, second in encountering a god there. The cooperation of sensuous reality and hyperreality together account for the power of this image. But one never has the sense of a reduced world, one never hears an assertion that real life as lived and experienced is ordinary, threadbare, a world of vulgarity and the humdrum. Realism has been subordinated to charisma and serves it. If a work of art has charismatic effects, then this will always be the relationship of realism to hyperrealism. What appears as a tool of creating the experienced world is in fact the principle instrument of deception. This hierarchy of causes ending in the effect of enchantment is nowhere more distinct than in the cinema. (I've already given the example of down-and-out Terry Malloy bursting into heroic stature in the "neorealism" of American cinema.) Film is a medium that makes it possible to combine magnification of image with a sensuous realism, however contrived. That effect in classic Hollywood films was worth mentioning in this context (more later) because it gives us a series of examples of realism as a technique of charismatic art and not only a mode into which hyperreal elements now and then intrude.

8

Book Burning at Don Quixote's

Obsessive reading of chivalric literature turns the mind of a respectable elderly gentleman. He is seized by a fascination with chivalry so consuming that he regards himself as a knight-errant out of season, called upon to revive the glorious institution of knight-errantry but bedeviled by malicious and envious enchanters who succeed in transforming the chivalric world into something ugly and deformed—which the rest of us take to be everyday life. His reading in romance is so extensive, his knowledge so abundant, his memory so capacious, and his genius so sharp that he combats every argument against his *idée fixe* with arguments that silence his adversaries and rouse wonder at his intelligence. The books of chivalry are for him an elevated world into which his life is absorbed, a world with a claim on reality that no consensus of "normal" voices can refute.

Early in the narrative, when Don Quixote returns home from his first knightly outing thrashed within an inch of his life, his friends institute a book burning to preempt further infection. The priest, Doctor Pero Perez, and Master Nicholas the barber, part-time literary critics, try to rescue the deluded old man from his phantoms by separating him from their source. They decide to get rid of the books that have deranged him. The campaign against the books takes the form of an inquisitional hearing. They join forces with his niece and housekeeper, both of whom want all the books without exception burned as heretics. But the priest agrees only to open a hearing to condemn offenders to the flames. The niece opposes such a hearing because it grants legal rights to the accused and creates the option of pardoning innocents. The stable-minded housekeeper also senses coming vacillation. All alike are guilty of the master's insanity; all alike should burn. But the warning goes unheeded. The ensuing trial bears out her worry

that the judges will go weak-kneed and grant mercy when actually faced with the accused.[1]

The priest first receives the four books of *Amadis of Gaul*—and pardons them. Then follows a series of condemnations and then exonerations: *The Mirror of Chivalries*—saved from the pyre but sent into exile; *Palmerin of England*—not only pardoned but preserved for posterity, enshrined in a marble casket that sets it equal to the works of Homer and equates its rescuers with Alexander the Great; *Don Belianis*—delayed sentencing pending editing; a slew of pastoral romances—half of them spared, the rest delivered over to the secular arm of the housekeeper (one romance is declared the most delightful book written "since Apollo was Apollo, the muses muses, and the poets poets"); a work by Miguel de Cervantes, *Galatea*—remanded to custody pending further investigation, house arrest in the barber's library. Twice books are headed for the pyre when a chance reveals one that the inquisitors cannot bring themselves to condemn. The priest says, clutching the just rescued *Tears of Angelica*: "I would have shed them myself . . . if I had ordered a book like that consigned to the flames. For its author was one of the most famous poets not only in Spain, but in the world" (1.6, p. 63).

Of course, it is a great opportunity for Cervantes to survey contemporary and recent writers and issue judgments, but the underlying theme—the culpability of books for deranging a man—is serious and corresponded to notions of the causes of insanity widely shared in learned and popular culture (I'll talk about them later).

The reaction of the priest to *Tirant lo Blanc* is the paradigm case of what I take to be an underlying but major element in the psychology of Don Quixote and of most other characters in the novel: the charm of imagined worlds trumps the priority of the real and the normal, trumps even sanity. The barber announces that *Tirant* is next in the dock: "Good heavens!" the priest exclaims, "Give it to me, friend, for to my mind that book is a rare treasure of delight and a mine of entertainment. . . . For its style it is the best book in the world" (1.6, p. 60). Forgotten is the declared wickedness of the books, their seductive force, the "gross nonsense" most contain. Ignored are the many other works of the Western tradition that might reasonably have vied for the title "best book in the world." Style and pleasure, and some element of the romance not mentioned—its ability to generate enthusiasm bordering on obsession—blunt the purpose of a severe judge.

In contrast to the priest's waffling, the moral clarity of the niece and the housekeeper remains unclouded. They are merciless in their will to

torture and destroy all the old man's books. After the first day's judgments are issued, the housekeeper preempts further justice. She heaps all the yet-unsentenced books on the pyre and, skirting all judicial protocol, makes short work of them. We might think that the lower education, intelligence, or class standing of the housekeeper and the niece account for their intolerance. But no, in fact the infection of book lust is spread throughout this novel with no eye to class standing or educational level. Migrant laborers and innkeepers are smitten with romance, no less than gentlemen and ladies, licentiates and doctors.

The ambivalence of the priest and barber is shared by a yet more severe critic, the canon of Toledo whom they meet on the return from Don Quixote's second outing. This highly educated, well-read cleric introduces himself to Don Quixote, caged and carried home under the illusion of an enchantment, by saying, " 'I know more about books of chivalry than about Villalpando's Logic' " (1.47, p. 422). He condemns them in a long tirade ("very prejudicial to the commonwealth"; "all more or less the same"; "filled with monstrous absurdities"; "devoid of all art and sense"; "deserve to be banished from a Christian commonwealth")—at the end of which he sings praises for the literary potential of the form and confesses that he himself has attempted to write one, is proud of it, and has garnered much praise for the start, though he has put it aside as not appropriate for a man of his station. His own work, he claims, combines truth with fantasy, teaches at the same time as it delights—and so he rescues a form he condemns by its ability to please and instruct, but wants all works that don't function that way condemned and banished (1.47–48, pp. 424–27). Even in serious intellectuals, there is a bent toward the foolish and fantastic in this work, which can override or at least neutralize the critical sense: fantasy proves stable and enduring alongside a carping and disapproving reason. In this entire novel supposedly devoted to the criticism of chivalric romance, there are a mere three characters who are unequivocally opposed to that narrative form. They are far and away outnumbered by its fans and those who admire it, whether enthusiastically or reluctantly.

The book burning at Don Quixote's is a summing up of an ambivalence to a narrative form that from its first emergence is both praised and reviled—as we saw in an earlier chapter—sometimes by the same voice. For one, it is a maker of heroes and lovers and an instrument in the courtly education of the West; for another, it is a concoction so foolish only children could be taken in by its artifice.

This double valence suffuses Cervantes's novel: Don Quixote and Sancho are laughable characters, the embodiment of the foolishness generated by chivalric romance, but his misadventures in "reality" can never undermine his convictions, which he acts on with courage, and the vision of the world that informs those convictions is one in which courtesy, bravery, and a love that is passionate but not libidinous and love service that is fervent but not selfish is installed as the law of the universe for knights-errant. The result of this hybrid is a character who through all misadventures maintains heroic stature, a Galahad-like purity and chastity, charm, and an eloquence matched only by the most elegant and extravagant passages of chivalric romance.

The discussion among commentators on the novel whether Don Quixote is a comic or tragic or ideal figure seems to me reductive on all sides.[2] It is like asking whether the barber, priest, and canon of Toledo reject or defend books of chivalry. The culture they move in is saturated with knowledge of books of chivalry and its readers besotted with enthusiasm for them—however critical their open declarations. Romances are read with equal passion and intense absorption by rich and poor, educated aristocrats and country innkeepers. The fair Dorothea can step easily into the role of Princess Micomicona to trick Don Quixote to return to his village, because "she had read many books of chivalry, and knew the style in which afflicted maidens were accustomed to beg their boons of knights errant" (1.29, p. 251). The landlord in the inn where the company retires from their adventures in the Sierra Morena hears the priest claim that Don Quixote's madness is caused by excessive reading of romance, and he replies,

> I don't know how that can be, because I really think there's no better reading in the world. I have two or three of them here and some other writings. They've truly put life into me, and not only into me but into plenty of others. For at harvest time a lot of the reapers come in here in the mid-day heat. There's always one of them who can read, and he takes up one of those books. Then as many as thirty of us sit round him, and we enjoy listening so much that it saves us countless grey hairs. At least I can say for myself that when I hear about those furious, terrible blows the knights deal one another, I get the fancy to strike a few myself. And I could go on listening night and day. (1.32, p. 277)

When the barber suggests the innkeeper's books are ripe for burning, the latter responds that he would rather have one of his children burned. True, the innkeeper and the harvesters are ignorant workers, but the way to claiming that only the uneducated and ignorant could approve romances is already blocked by the aristocratic company with whom the day laborers share these sentiments.

The love of romance persists in this novel whose avowed purpose is to revile and ridicule it; book lust lurks in its every corner; few escape its infection, and those few who do are the bluntest and most foolish. I can't name another work where satire so evenly divides the task of ridiculing and affirming its object. *Don Quixote* does not yield to simple dichotomies like sanity and insanity, heroism and foolishness, the real and the ideal.

Erich Auerbach's chapter "The Enchanted Dulcinea," in *Mimesis*, argues essentially from the last mentioned dichotomy.[3] He identifies a reality from which Don Quixote's madness alienates him. It is the reality of Aldona Lorenzo (the "real" Dulcinea) and Maritornes. In this reality things retain their thingness and a certain proneness to fail in spite of any insistence, however stubborn, that they behave in ideal ways: windmill arms knock attacking knights silly; imperfectly tightened saddle girths slip sideways to deposit the most dignified knight in the mud; village maids smell of garlic and miss the leap onto their donkey's back. I take issue with Auerbach for his hypostasizing of "everyday reality" fixing it into a form as unyielding as Don Quixote's obsession: in seeing the village maids and not a peerless maiden, Don Quixote "sees nothing except the actual reality" (*Mimesis*, p. 338); it is a clash between Don Quixote's "illusion and an ordinary reality which contradicts it" (p. 339). This perspective is consistent with the overall orientation of Auerbach's work, focused on "representations of everyday life in which that life is treated seriously"; the scene of the three peasant girls, on which Auerbach's chapter focuses, presents them "in their true reality, their living everyday existence" (p. 342); "the persons and events of everyday life are constantly colliding with his madness, and they come out in stronger relief through the contrast" (p. 343). Don Quixote's idealism is admirable, but "not based on an understanding of actual conditions in this world. . . . It actually has no point of contact with reality; it expends itself in a vacuum" (p. 344). "The whole book is a comedy in which well-founded reality holds madness up to ridicule" (p. 347); "dying, he [Don Quixote] finds his way back into the order of the world" (p. 357).

It is hard to imagine a view that more decidedly puts to one side the charismatic aspects of the work and places them all in thrall to a reality unshakably grounded in observable everyday life. Departures from that reality that insist on redefining it are, so says Auerbach, held up to ridicule and become the subject of comedy, serving the overall "gaiety" ("Heiterkeit") that dominates the mood of the novel.

I hasten to add that Auerbach's reading of Cervantes's novel as a whole, of the character of Don Quixote, of his relation to Sancho Panza, of the humane intelligence and gentle courtesy that saturates the book and flows from the main character, is among the finest and most balanced readings of *Don Quixote* that I know. It is on the point of a reality fixed at the level of comic burlesque that a reading focused on charismatic narrative and charismatic effects must disagree.

There is a wholly different reality that is very far from comic and burlesque. It is a reality of romantic and heroic characters acting on motives of virtue and love, motives close to those that move Don Quixote. The narrative presents us, as reality, the story of a noble youth named Chrysostom, turned shepherd, who dies of love for the beautiful but cruel Marcela. The story received its prelude in the poetry and music of a talented goatherd named Antonio, who also suffers from unrequited love and sings his woes to the company of Don Quixote, Sancho, and his fellow goatherds. Marcela is so beautiful that scores of local youth fall in love with her. She escapes to the hills and joins the village shepherdesses, seeking refuge from male attention, only to have her army of suitors, the better to pursue her, turn shepherd as well, carving her name in the local beech trees. Marcela herself appears dramatically at the funeral of Chrysostom and delivers a speech, learned, eloquent, well composed, unhalting, with no intrusion of "realistic" stutterings and hesitations that might creep into a less fictionalized speech, defending herself against the charge of cruelty (*Don Quixote* 1.11–14, pp. 84–111).

A few chapters later comes the story of the handsome, talented, noble youth Cardenio, first seen leaping from rock to rock in the hills of the Sierra Morena, driven out of his mind by his love for Lucinda, a love frustrated because the villainous Don Ferdinand, once Cardenio's friend, lusted after her and forced her into an unwanted marriage. By a remarkable coincidence, which no mimetic realism could justify, Cardenio, Don Quixote, Sancho, the priest, and barber—immediately after hearing Cardenio's story—meet a beautiful maiden disguised as a boy and working as a shepherd in the same hills, the fair Dorothea. She is another of Don Ferdinand's

victims, a farmer's daughter who succumbed to seduction, now seeking consolation for her abandonment in the guise of a shepherd. Then follows a series of strange, remarkable, and totally incredible events at the inn to which they all repair, the same where many of the misadventures of book 1 occur. First a mysterious group of masked horsemen arrive, with them a beautiful young woman who turns out to be Lucinda, kidnapped by Don Ferdinand and accomplices from a nunnery where she had taken refuge from her pursuer. The four lovers, Cardenio, Lucinda, Dorothea, and Don Ferdinand, now unmasked, face each other in total confusion. Speeches are exchanged, eloquent and learned, flowing, delivered as trained orators and not as frightened, maddened lovers deliver them. Cardenio cleaves to Lucinda and claims her from her abductor. The abductor, his heart melted by the appeal to virtue and duty, repents, renounces Lucinda and accepts his marriage with Dorothea. All in the end are reconciled; the intertwined love stories have the happiest possible outcome.

The scene is not yet over when two more mysterious strangers arrive, a Spaniard, referred to as "the Captive," and a Moorish woman. He tells the story of his escape from captivity in Arab lands with the help of the beautiful Moor. His story is full of swashbuckling naval encounters with a cast of valorous captains and cruel Turks, soldiers who fight bravely and fiercely, gallant officers who die of grief at the loss of a battle or compose poetry on battles after bold escapes. In short, one of the episodes, narrated as part of the real reality, not the chivalric bunk, of the novel represents reality as heroic and exalted, and since they are scenes that Cervantes himself in part experienced and lived through, in part knew from report, they are closer than anything else in the novel to a particular historical reality.[4] Romance is injected into the Captive's tale via the Moorish woman, Zoraida, young, beautiful, and wealthy, who rescues him from prison and flees to Spain with him, motivated by love of the Virgin Mary to abandon her religion, her homeland, betray her father, and flee with a stranger, only to land in the same inn with Don Quixote and company. Along the route of this extraordinary narrative, it is revealed that the Captive had known and witnessed the bravery in battle of Don Ferdinand's brother.

Hardly is this "curious tale full of astonishing incidents" ended when yet another coach arrives at the inn, carrying a judge who turns out to be none other than the brother of the Captive. The reconciliation of the two brothers restores the Captive to prosperity and stability.

With a brief pause for sleep, the string of amazing incidents continues: a young, wealthy lord "dressed as a mule-lad" in love with the judge's daughter sings them awake. Another happy ending is in sight. In the meantime Don Quixote's mishaps continue: he hangs all night by his arm from a window of the inn; the barber reclaims his bowl, taken by Don Quixote as Mambrino's helmet, and so on. The comic world of imagined love and misadventure lives on in the background parallel to the foregrounded reality of romantic love and adventure. Its rich narrative brew is stirred up with a complete disregard for probability. It is a sequence of events out of a baroque opera, where one improbability can be heaped on the next to the audience's delight. The reader's penchant for measuring events against experienced reality is completely abandoned in favor of the treasure trove of redemptions, resolved conflicts, unraveled love knots, and happy endings.

The inn becomes an enchanted realm in the sense I've used that term in earlier chapters. The confluence of readers half or fully in the spell of chivalric romance is unequaled in the rest of the novel: apart from Don Quixote, we have the innkeeper himself, unlikely as that hardened character seems as a candidate for the softening effects of romance (Dorothea says to Cardenio: "Our host is not short of being a second Don Quixote" [1.32, p. 280]), Dorothea and Lucinda, the barber and priest, Maritornes, who herself is transformed into a princess in the imagination of Don Quixote. The inn is the venue for a positive marathon of romance narrating, both fictional and experienced (by the characters of the novel).[5] The works of the imagination performed in the inn (Maritornes transformed into a princess; wineskins into giants) are answered by moves from fantasy to reality (Princess Micomicoma becomes Dorothea; her persecutor, the giant Pandafilando of the Squinting Eye becomes Don Ferdinand), but the greater business of transformation is that worked on the lovers at the end of the episode: the string of operatic meetings, reconciliations, happy endings—in short, redemptions. The hills of the Sierra Morena are a safe zone for distressed lovers; the inn a place where transformation incubates and hatches: Don Ferdinand turns from villainous seducer to loyal husband and courteous gentleman; Cardenio rescues his reputation and his self-respect (he had accused himself of cowardice); the Captive is restored to his family, elevated to wealth and middle-class respectability, his attachment to Zoraida stabilized, her transformation from Muslim to Christian reaffirmed.

Recall now that the novel presents itself as a satirical rejection of chivalric romance; and try to reconcile its lurch into romance-as-narrative-reality

in terms of that enterprise. While the trappings, the costuming, the staging of the stories of amorous shepherds and shepherdesses, of heroic bravery, suffering, and love, separate them superficially from the genre of chivalric romance, the important point is that in their representation of experienced events they are nearly as far distant from "everyday reality" as the romance of Amadis.

We need to confront this narrative hyperreality with Auerbach's reading of the novel as "a comedy in which well-founded reality holds madness up to ridicule." Are Don Ferdinand and the Captive not part of "everyday reality" and "actual reality"? Are they, like Don Quixote's insanity, "not based on an understanding of actual conditions in this world"? We must ask above all if Don Quixote's visions actually "expend themselves in a vacuum" (Auerbach), or if on the contrary they are not in harmony with the romantic, heroic reality of the inn narratives. To repeat: there is a narrative reality far more exalted than the one Auerbach pegs as "the order of the world." The romance episodes are at least represented as part of that order, not an effluence of Don Quixote's fiction-deranged imagination.

One might object that what I've called the heroic and romance episodes are themselves literary fabrications, shaped from the conventions of pastoral romance, the result of Cervantes's wide reading and deep ransacking of his own earlier works. Then alongside these might be placed the episodes calling on the forms of the picaresque novel. The stories of Cardenio and Lucinda might be said to belong to the same reality as the "Tale of Foolish Curiosity," a narrative insert with no claim to unmediated participation in the "order of the world" of the novel. The fact that the Cardenio and Lucinda story and the Captive's tale are presented as the experienced not the fictionally mediated reality of the novel is relativized by the related "feel," the perceived texture of the aristocratic life both derive from. They are also related by their clear participation in a moralized or exemplificated world, in which narrative events and characterizations front for virtues (affirmed) and vices (rejected).

A consistent tendency of Auerbach's *Mimesis* is to conflate literary realism and reality, to see the order of the world of experience as comprehended in one single configuration of the represented world. But why do the comedic events Auerbach points to have any greater title to "reality" and the world order than the romance episodes? Everything that he assigns to the real is at least as contrived as the romance events. The "enchanted Dulcinea" episode belongs to a burlesque world. Virtually all the characters

and events that thwart Don Quixote's high-flung visions have the quality and texture of slapstick and malicious jokes. The world of the "real," in Auerbach's sense, has a consistent narrative dynamic in which the highest flights of fantasy are answered by the most humiliating and physically damaging of events, not because the latter are real, but because they thwart the ideal to comic effect. What is the quality of the real represented and what is its place in the order of the world when Don Quixote and Sancho Panza vomit on each other (1.18)? Or when Don Quixote hangs all night by his arm in extreme pain? Or is knocked off his horse by the swinging blade of a windmill? Or has his ribs kicked in and crushed, beaten, his jaw smashed and his mouth filled with blood, his whole body dipped in mud and manure? If we can take as a measure of the real and probable a doctor's prognosis for an ill-fed, skinny man in his midfifties, who suffers that sequence of mishaps and much more, his chances of survival, realistically speaking, would seem very slim. And yet his recoveries are quick, and catastrophes have no lasting effects. A peculiar, comedic version of the invulnerability of the questing knight is at work in the tribulations of Don Quixote. The representation of physical vicissitudes, among other things, is wholly unrealistic.

There is the "realism" of book 1, chapter 1, the beginning paragraphs of the novel describing the domestic life of Alonzo Quexana or Quixano, soon to morph into Don Quixote. The opening could be a few pages from a nineteenth-century realist novel:

> In a certain village in La Mancha, which I do not wish to name, there lived not long ago a gentleman—one of those who have always a lance in the rack, an ancient shield, a lean hack and a greyhound for coursing. His habitual diet consisted of a stew, more beef than mutton, of hash most nights, boiled bones on Saturdays, lentils on Fridays, and a young pigeon as a Sunday treat; and on this he spent three-quarters of his income. The rest of it went on a fine cloth doublet, velvet breeches and slippers for holidays, and a homespun suit of the best in which he decked himself on weekdays. His household consisted of a housekeeper of rather more than forty, a niece not yet twenty, and a lad for the field and market, who saddled his horse and wielded the pruning-hook.

Even this passage, the classic example of Cervantes's realism—with its sartorial and economic details, enumeration of diet and household duties,

more or less specific ages for each character—can be seen as "moralized," determined by its adversative role in a soon to be exemplificated landscape. The ordinariness of his life is there not because reality itself is humdrum but is contrived so as to heighten and justify the Don's departure from it. If the opening paragraph is as good as it gets, then the refuge of the chivalric romance is an understandable shelter and "sanity" not too high a price to pay for escape. How different this adventure-barren world is from that of the Captive, or for that matter, from the life of Miguel de Cervantes.

Finally, it is questionable to argue that the basic structure of ideas in *Don Quixote* is at work in the episode of the Don's meeting with the three village maidens. Don Quixote relates to the "real" romance world, that is, the world of Cardenio and Lucinda and others, in a way conceived by Cervantes to affirm the romance world and assert Don Quixote's role in it as a kind of mythical enabler of transformation. The episode of the amorous goatherd, for instance, the first in the pastoral mode, begins when Don Quixote and Sancho come upon a group of goatherds in the Sierra Morena, who courteously share their food with the two adventurers. The courteous mood, the pastoral scene, and the sight of acorns spread out on a sheepskin table inspire in Don Quixote a discourse on the lost golden age. Its primal cooperation of man and nature, its peacefulness, its innocent and untroubled practice of love and the erotic life are lost in the modern world, the age of iron: "in this detestable age of ours, no maiden is safe, even though she be hidden in the centre of some Cretan labyrinth; for even there . . . the plague of love gets in and brings them to ruin despite their seclusion" (1.11, p. 86). The passing of the age of gold, so says Don Quixote, is what made the institution of knight-errantry necessary. Its purpose, "to defend maidens, widows and orphans." Hardly has Don Quixote's speech, which Cervantes or the narrator dismisses as "purposeless," died away, when the goatherds introduce the amorous shepherd Antonio, who sings his sad love song. Then enter Cardenio, the bereft lover, then Dorothea, the unhappy shepherdess. It looks very much as if Don Quixote's "purposeless" discourse on the age of innocence introduces—we might say, calls into being, at the very least predicts or serves as prologue to—the sequence of pastoral episodes, in which betrayed lovers seek refuge in pastoral settings and costumes. Don Quixote also functions as the protector of maidens, not only in the contrived adventure of the fair Dorothea as Princess Micomicona, but in his avowed determination to help unravel the knots into which the various love relations are tied. He does not do it directly; the confusion and

conflict get resolved because some natural dynamic moves motives and events in the direction of duty, virtue, and a happy ending. But it is worthwhile taking seriously the words of Dorothea, now reconciled with her love, to Don Quixote, who is disappointed at finding the Princess Micomicona transformed into a mere mortal woman: "I believe, sir, that if it were not for you, I should never have succeeded in gaining the happiness I have" (1.37, p. 336). These words are paradigmatic for the receiver of enchantment speaking to its giver. They bear comparison to Sancho's statement that his attachment to Don Quixote has educated and elevated him. That effect is often to be felt in the novel, alongside the humiliations, the ridicule, the failures. Don Quixote radiates transforming force, though he is just a mediator of that force, the primary source of which is the chivalric romances. Though he is not really a chivalric knight, he is the epitome of the enchanted reader, transformed by the higher world of fiction and able in particular cases to transmit its force to the world of experience.

Charismatic "education" is at work. The gravitational pull of fantasy works its invisible effect. Don Quixote has a lucid understanding of it and affirms it. The hero of exaggerated virtue grips by participation and reforms the reader by imitation. He explains to Sancho his resolve to do penance in the Sierra Morena; it is an imitation of Amadis:

> When any painter wishes to win fame in his art, he endeavours to copy the pictures of the most excellent painters he knows. . . . So what any man who wants a reputation for prudence and patience must do, and does, is to imitate Ulysses, in whose person and labours Homer paints for us a lively picture of prudence and patience; just as Virgil shows us in the person of Aeneas the virtue of a dutiful son and the sagacity of a brave and skilful captain. They do not paint them or describe them as they were, but as they should have been, to serve as examples of their virtues for future generations. (1.25, p. 202)

Don Quixote refashions himself not "as he is" but "as he should be" and in doing so lives in the higher model of Amadis: "Amadis was the polestar, the morning star, the sun of all valiant knights and lovers, and all of us who ride beneath the banner of love and chivalry should imitate him." He tells the canon of Toledo the effects of romance on himself: "Since I became a knight errant I have been valiant, courteous, liberal, well-bred,

generous, polite, bold, gentle and patient" (1.50, p. 442). The exalting force
of charismatic fiction is at work throughout the novel. Chivalric romance
is its fictionalized form, Don Quixote is its living embodiment. He is the
fully enchanted reader.

Don Quixote as inspiring muse, a dynamic, even demiurgic force infus-
ing the world with courtesy, bravery and honor. It is a neglected aspect of
the novel. Just as he in some sense presides over the turn to an Arcadian
world by his speech to the goatherds, and over the return to happiness of
the lovers by his presence, the same process of verbal creation of reality is
or seems to be at work in the episode of the Captive's tale, framed signifi-
cantly by Don Quixote's eloquent discourse on the contest of arms and
learning. At supper with the three sets of lovers, Don Quixote begins a
speech, a propos of nothing, "moved by the same spirit that had moved his
long speech when he supped with the goatherds," arguing the superiority
of the calling of knight-errant over that of letters and learning.[6] He evokes
the circumstances of battle—courageous men boarding a hostile ship and
storming the enemy in the very teeth of cannon fire, another man rising up
to take his place immediately after the fall of the first, valor and honor
asserted in the face of death. With the soldier's life he contrasts the hard-
ships of study and the rewards of scholarship. He has in mind clearly the
career in the law—unheroic, posing no threat to lawyer and judge, and
richly rewarded—and the reason for privileging this career over other forms
of learning will be evident at the end of the Captive's tale.

No sooner has Don Quixote ended his discourse than the Captive tells
his life story, brimming over with brave captains, terrible pirate kings,
bold soldiers and sailors, including Don Ferdinand's brother and "a cer-
tain Spanish soldier called something de Saavedra." Then at the end of
his long story of combat, captivity, and romantic rescue, his—that is, the
Captive's—long-lost brother appears (the magic of the inn at work again),
of all professions, a judge. And so we have embodied in the two brothers
the professions of arms and letters, previewed in Don Quixote's lecture
on the subject and made explicit in Don Quixote's words of welcome to
the judge: "there is no place in the world so narrow and uncomfortable
that it does not allow room for arms and learning. Especially if arms and
letters bring beauty [the judge is traveling with his daughter] as their pilot
and guide" (1.42, p. 382).

So this gives us another fix on the "realities" of the novel and the struc-
tures within which they are set both against and in harmony with Don

Quixote's delusions: two discourses, two "realities" consequent upon them. Reality sometimes resists and sometimes yields to romantic ideals. The reality that resists is ordinary, everyday, packed with homely comic details (or loudmouthed and abusive—the cleric of the Duke's court and the Castilian who reviles Don Quixote, in book 2, chap. 62), that is, the "real" in the sense that is the focal point of Auerbach's study. The world as experienced by the characters is manifold and dynamic. Like a Proteus resisting arrest, it thwarts any attempt to stop it in place, force it to yield up its true self. The more it tends to "realism," the more the author has settled on a single face of a Protean thing. But the world as represented in *Don Quixote* is more complex than an "actual reality" constantly turning up the falseness of an imagined reality.

The romances of the Sierra Morena and the inn are evidently more than entertaining insertions, "interruptions," as William Entwistle calls them.[7] The romantic episodes are also narrative reality. They are high style. They involve high-born, noble, beautiful, amorous, eloquent characters, who regain a lost virtue and happiness in the inn. They resonate in many ways with the chivalric adventures of Don Quixote's books, omitting much of the fantastic and the exaggerated, but none or little of the improbability. They participate in a chain of "redemption narratives" of which Don Quixote himself is in some sense an inspiring spirit.

This perspective shows the variegated realities of *Don Quixote* as another assertion of the same ambiguous attitude toward the world of chivalric romance as the characters of the novel who are themselves readers of romance, the would-be book burners, their anger at chivalric romance softened by a weakness for the form they're raging against. The canon, priest, and barber, and all the others who mouth condemnation of romance, cling to it because "reality" itself operates on its laws and suffers the same low-level, romance-kindled mental fever that Don Quixote suffers at maximum heat. Of course, even the narrator, Cervantes, regularly dismisses Don Quixote's delusions as ridiculous nonsense, and Don Quixote on his deathbed does so decisively. But these dismissals also have the quality of the condemnations of romances in the book burning: openly condemning, inwardly yielding to some half-conscious, half-instinctual affection for the works, for their world where virtue, honor, innocence, and happiness are recoverable, and for the kind of actions and characters that "live" in them. The romance fever established throughout a long novel is not to be tempered by verbal condemnation. Though not specifically tied to the genre of chivalric

romance, it is ineradicable. *Don Quixote* affirms subtly the same thing it ridicules openly: the transforming power of romance.

It is important to stress that the force of romance had been present as an experienced phenomenon in Western culture in the centuries preceding *Don Quixote*. In fact, a survey of some of the eminent personages touched by that force suggests that Cervantes needed very little exaggeration to represent plausibly an entire civilization obsessed with romance and driven by ideals of chivalry to act in that mode and to compose literature in it.

Here is a short list of prominent historical figures who mitigated their scorn for romance by beguiled admiration. Queen Isabella of Spain, her grandson, Charles V, Francis I of France, and Louis XIV were admirers of chivalric romances. Ignatius of Loyola, founder of the Jesuit order, was likewise a reader of these "vain treatises." His conception of Christ appears to have been influenced by reading them, and it has been suggested that the Jesuit order is "knight-errantry" for God. Teresa of Avila read them secretly in her youth and was so absorbed into the chivalric world that "if I did not have a new book [to read], I did not feel that I could be happy." A sixteenth-century biographer of St. Teresa wrote that "she imbibed their language and style so well that, within a few months, she and her brother . . . composed a novel of chivalry full of adventure and imagination," though he adds that the devil made them do it.[8]

The prominent Spanish humanist Juan de Valdés complained that his ten years spent at court had led him to no pursuit more virtuous than reading chivalric romance. He judged *Amadis of Gaul, Palmerín*, and *Primaleón* as the best of their kind. The barber and the priest in *Don Quixote* agreed.

In the mid-sixteenth century a circle of French humanists in Paris seriously debated the value of romance. They show the same ambivalence to the form that Cervantes would represent in the canon of Toledo: they revile it while dabbling in it. Like the book burners at Don Quixote's, they condemn it roundly, but open all sorts of doors to its salvation, including their own translations and in some cases composition of romances, which of course they undertake—again like the canon of Toledo—by way of elevating the form to a level of humanistic respectability.[9]

This collection of intellectuals, kings, and mystics, torn between contempt and admiration for romance, gives a preview of the ambivalence to

romance that is the dominant in *Don Quixote*. It also confirms the ability of the romance form to soften critical judgment and make room in disciplined imaginations for tales of fantastic adventure. Extravagant fantasy can entrap and seize the imagination, diminish the critical faculty, form obsessions. As lucid a mind as Samuel Johnson was vulnerable to its effects. James Boswell wrote in his biography that Johnson was "immoderately fond of reading romances of chivalry" all his life. He attributed "to these extravagant fictions that unsettled turn of mind that prevented his ever fixing in any profession"[10]—two centuries after the appearance of *Don Quixote*. The fact that seduction, obsession, and derangement lurk at the dark fringes of courtly enculturation at least affirms romance's grip on the imagination.

Another set of sources shows the seductive force of romance as an experienced reality, not a literary conceit or a schoolmaster's temerity. The reading of *Amadis* and similar romances among the Spanish adventurers in the New World, richly documented by Irving Leonard, shows the patterns of chivalric romance translated into the actions of avid readers. Here again the signature of romance: valor and foolishness. A famous captain of Charles V, Don Fernando de Avalos, Duke of Alba (d. 1583), performed extravagant feats of valor, which others related to his constant reading of chivalric novels in his youth. These books supposedly brought forth "the noble ardor and desire for glory" for which he became known. A common soldier fighting in the army of Portugal in India charged into the enemy with suicidal fury, having been goaded on by his comrades to believe in the knights of romance and imitate their deeds. He emerged from combat as a respected fighter, though he entered a dupe. Irving Leonard's study gives many other examples of romance imprinting chivalric values and forms of behavior on the imagination and will of kings and common soldiers. In the course of the sixteenth century both the church and the monarch issued edicts forbidding the printing, selling, possessing, and reading of books of chivalry in both Spain and the New World. The prohibitions were futile. The appetite for romance and the market in books it generated overrode any threat of law breaking.[11]

Finally, the insanity of Don Quixote as a result of excessive reading resonated broadly with the various forms of reading pathology that became a standard element of medical studies and guides to health in the seventeenth century. The age of Cervantes experienced, throughout Europe, enchantment by the book less as therapy, more as a disease with the double

effect of weakening and exalting the sufferer. This is a big topic for the age of the baroque. We can only touch briefly on three areas outside of imaginative literature that register the reality of madness caused by reading: medical theory, clinical observation, and casual observations of learned madmen.[12]

The dark side of reading registered in the literature and philosophy of medicine. The connection of reading with melancholy and madness was a given of psychopathology at least since Marsiglio Ficino's *On the Threefold Life*. It went back as far as the Pseudo-Aristotelian "Problemata."[13] Excessive thought and reading stimulated the black bile, or *melancholia*, which produced an imbalance of the four humors. An excess of melancholy had effects ranging from mild depression to derangement. But reading-induced insanity was a special brand of derangement. Madness by literature provided the generic name (one among many) for melancholy and madness: *morbus litteratorum*. The victims of "scholars' illness" in the narrower sense suffered derangement, possibly also physical paralysis, but all its symptoms indicated a higher intelligence, a form of genius, a mental elevation closely associated with an excess of black bile. Melancholy became a badge of genius, worn, like the melancholy Jaques in *As You Like It*, as a show of intellectual superiority and higher wisdom. It is not too much to say that the age was obsessed with the peculiar connection of madness and genius. The characters in Cervantes's novel who are puzzled by the apparent wisdom and intellectual sharpness of Don Quixote alongside of his obsession needed only consult the "technical literature" on madness, its causes, symptoms, and cures, to find how consistent this combination was with the pathology of "scholar's illness." Perhaps the best known to English-speaking readers is Robert Burton's *Anatomy of Melancholy* (1621). This ponderous tome has a long section on "Love of Learning or overmuch Study, With a Digression of the Misery of Scholars, and why the Muses are Melancholy" (part 1, sect. 2, memb. 3, subsect. 15) and another section on education as a cause (1.2.4.2). The seventeenth century was the heyday of the melancholy man of letters. Jacob Boehme and John Donne were only two of many famous cases. Hardly a man of letters worth his salt in the seventeenth century did not suffer from melancholy, or pretend to.[14]

The derangement caused by reading has the feel of a fictional idea and a whimsical fantasy, that is, a literary phenomenon. But an extensive clinical literature on scholars' illness in the sixteenth and seventeenth centuries belies this impression.[15] It is unlikely that a phenomenon that produced

doctoral theses from clinical observations existed only in the imagination, individual or collective, of the age.[16] Observation and analysis of a case history was a requirement of a medical dissertation, though of course diagnosis can be guided by received presuppositions.

And so the seventeenth century produced not only one of the greatest novels in the West based on the spellbinding and obsessive effects of reading, it also produced many medical pathographies on the subject. The emergence of insanity as disorder, sickness, disease, is not adequately explained by the demonizing of the irrational in the age of reason.[17] The strain of insanity I'm looking at is not demonized. It has stature that derives from that strange mixture of the sublime, the ridiculous, and the pathological that also characterizes chivalric romance: the cause (or one prominent cause) and the symptoms play in the same key.

The madman-from-excessive-reading was not perceived by contemporaries as the tragic wreckage of a human life, but as a person of special talent having succumbed to the dangers of his intellectual preoccupations. The illness enabled a higher vision that could look like a form of prophecy. The learned madman was never regarded with the sublime awe of, say, the mad King Lear or the suicidal Ophelia. Just the opposite: madness was a form of comedy; the antics of the insane were entertainment, best known via the visits to the madhouse, available for the price of a ticket at the famous London institution Bedlam, to mention only one venue. The entertainment consisted in the sane visitors entering into the delusions of the inmates, humoring them, acting within the phantasms of the mad so as to provoke and sustain their fantastic narratives, much as the Duke and Duchess of *Don Quixote* book 2 entertain themselves by humoring the delusions of Don Quixote, which inspire them, as they would a fan following; their staging of dramas in which Don Quixote and Sancho Panza play the major roles is a kind of slash fiction. The fans are the playwrights, directors, and stage managers; the chivalric world is played out as an entertaining drama, and Don Quixote and Sancho are guarantors of the authenticity of the theatrical spectacle.

It is futile in the late sixteenth and seventeenth centuries to look for a uniform condemnation of fiction-induced madness. The odd combination of ridicule and pathos with which the age perceived scholars' malady was always—even in the medical literature—mixed with a sense of the sublime exaltation experienced by the madman as a product of his suffering, an exaltation in which truths were available to the insane to which the sane

had no access. How should realism gain a decisive victory over fantasy in an age of grand illusion, an age where life felt like a dream, where metaphysical "truth" lost its moorings and floated in an ocean of contention (Reformation and Counter-Reformation), where political stability seemed more a lost illusion than an attainable reality (Spanish Armada, Thirty Years' War)?

From Plato to the present (*Harry Potter*), readers in the West have approached fantasy with an ambivalent attitude. An aggrandizing art, one that magnifies its subject into the heroic or the fantastic is potentially a dangerous thing. Freudian psychology had a brief look into the hidden fetishism of reading. Freud noted the libidinous character indicated in the trope of "eating words"—your own and the author's, of "voracious"reading, of "devouring" the book. His students pressed the consequences fearlessly. Otto Fenichel, a student of Freud, in an article called "Scoptophilic Instinct and Identification," associates reading with other acts of gazing which can tend to a condition of fixation and fascination mediated by the eye. "In the unconscious," writes Fenichel, "to look at an object may mean . . . to devour the object . . . , to grow like it (be forced to imitate it)." Seeing becomes "active behavior by means of which one enters into the object seen. . . . All primitive perception is a taking part in what is perceived."[18] Reading is his primary example of this kind of radical participation. He might have taken Paolo and Francesca as a clinical study.

Fenichel's view assimilates the perception of fictional worlds to the perception of the real world. A whole range of charismatic experiences not normally associated with reading falls into place as its parallel: imitation of fashion, admiration of political figures and movie stars, falling in love with another person, sexual arousal either in reality or via pornography—of course along with spellbound absorption into narrated or represented worlds.[19] In Fenichel's view, the psychology of perception does not distinguish, at least from the point of view of "entering into the object seen." Georges Poulet's essay "Phenomenology of Reading," cited in an earlier chapter, might be a clinical case for Fenichel's claims. He gives some lyrical descriptions of the "spell" cast by the book, with which the present writer can identify, even if they have the character more of autobiographical than critical comments: "When I read as I ought, i.e., without mental reservation . . . my comprehension becomes intuitive and any feeling proposed to me is immediately assumed by me." The state of being "gripped," he claims,

amounts to "the possession of myself by another": "When I am absorbed in reading, a second self takes over, a self which thinks and feels for me"; "The work lives its own life within me."[20] The agent of these experiences has to appear to the one who experiences them as magical and supernatural, their result a form of enchantment.

In the twentieth century the idea of the transformation of the self through narrative developed from early Freudian extravaganzas[21] into the more restrained paths of cognitive and developmental psychology, narrative theory of the self and narrative therapy (see below, Chapter 13). One of its prominent formulators calls on the figure of Don Quixote as a paradigm of the effect: "The act of involved reading, for you and for me no less than for Don Quixote, results in an involvement in the constructed effects of reading—the creation of imaginary people, fictive events, and fanciful landscapes. In the act of reading, a transfiguration of the reader occurs."[22] Theodore Sarbin consistently argued a parallel between reading and hypnosis, a model in which the enthralled reader is as vulnerable to the suggestions of the book as the hypnotic subject to those of the hypnotist.

In the chapter on courtly romance we looked at its educating force. At issue in *Don Quixote* is its power to enchant. Perhaps no art form has brought the susceptibility of humans to seduction more clearly into focus than romance. The world of chivalric narrative is an ideal one, but the ideals of chivalry strained on beyond the bounds of either the decorous or the heroic, in contrast to the solemn nobility of Homer. Since its beginnings in Chrétien de Troyes, the form had its double aspect: heroic hyperbole tipping over into irony, amorous sentiment at the outer boundaries of the plausible. Intelligent readers despised the form without escaping its spellbinding effect. Europe since the Middle Ages addressed courtly epic with the double gesture "Burn them all! But save most of them!"

Don Quixote is a reflection on charismatic effects in literature. "Criticism of chivalric literature" or "rejection of the charismatic effects of literature" are judgments that do not do justice to the complexities of the novel. Rather *Don Quixote* is an anatomizing of charisma in fiction. The magic curtain that masks off a fictional world and its hypnotized admirer from view is opened to an audience, within the fiction, who observe and judge the character thus enchanted, and that divided world opened a second time to another audience altogether outside the fiction, the reader of *Don Quixote.*

While the long disquisitions between Don Quixote and Sancho and other characters on the question of what is real are in the foreground and in fact take up much narrative space, while the only rational position is, Don Quixote is insane, the world he lives in is a figment—he has been absorbed into a grossly false world, swallowed up by participation and imitation— still, the irresistible gravitational pull of chivalric fantasy remains as a powerful reality exercising its force at the same time as it is superficially dismissed. No book burning or mental purging avails against it.

The literature and history of book burning[23] would help confirm the double life of fantasy I've suggested as a dominant in *Don Quixote*. Similar forces are arrayed against books in general (not just fiction and fantasy) in Ray Bradbury's *Fahrenheit 451*, where books are altogether forbidden and possessing them is severely punished. The result is not their extirpation but the breeding of a new society where men and women make themselves into books ("How do you do. I'm *David Copperfield* by Charles Dickens" and so on). In the film version by François Truffaut the first book discovered and burned by the troop of arsonist firemen is Cervantes's *Don Quixote*.

9

Goethe's *Faust* and the Limits of the Imagination

[The Demonic] seemed to be at home only in the realm of the impossible and dismissed the possible with contempt.
—Goethe, *Dichtung und Wahrheit*

On his way through the phantasmagorical landscape of the "Classical Wal-purgisnacht" to fetch Helen of Troy out of the underworld in Goethe's *Faust Part 2,* act 2 ("At the Lower Peneios"), Faust hitches a ride on the back of the centaur Chiron. They have an informative conversation, Faust asking questions like a tourist in time, Chiron answering with sententious superiority and cynical flippancy. Half man, half horse, the mentor of great men rehearses the list of heroes he tutored and praises the beauty of Hercules, whereupon Faust asks him about the beauty of women, segueing into his request to take him to Helen. Chiron responds in chopped syntax, which gives his galloping haste a linguistic counterpart: "What! . . . Woman's beauty means little. Too often it's stiff as a statue. The only being I can praise is one who beams bright good humor and lust for life. Mere beauty is self-satisfied; it's grace and charm that make her irresistible" (7399–7404).[1] He adds, as if to oblige Faust: ". . . like Helen, when I carried her on my back." Faust starts: "You carried her?" Chiron: "Yes, on this back." Then he tells Faust, whose agitation grows with each word, how he once rescued Helen from kidnappers.

Faust's quest for Helen of Troy is hard to characterize in conventional terms. His impossible plan is to revive her from the dead in order to satisfy

the love he conceived for her in their first "meeting." In a magic trick performed earlier (*Faust, Part 2,* act 1, ("Hall of the Knights," lines 6479ff.) before the emperor's court, he had conjured her ghost from the underworld. But the conjurer himself was stunned, literally knocked out by her beauty and the force of her presence, ghostly though it was. Now he has entered the world of classical antiquity to revive her. To underscore Helen's relative freedom from time and fate, Faust recalls a precedent for her revival from the dead: Thetis, the mother of Achilles, arranged a rendezvous of her dead son with Helen, also dead and gone to the underworld. Both revived, reclaimed their bodies, and entered the upper world long enough to gratify their long ungratified desire; they successfully break the ironbound law of human nature—as though the mortality of desire might vary with the combined glory of its agent and object—then return to the dark realm. Faust: "What a rare delight: love defies fate." He is drawn by the wild improbability of two dead lovers overcoming death to consummate a love they couldn't consummate in life. The suggestion is that the fulfillment of love is greatest when reality resists it; there's nothing heroic about loving within the bounds of normal human limitations. Anyone at all can love when circumstances don't hinder them. It takes the immense resources of the greatest hero and the most beautiful woman to realize the impossible. Faust: "And should I not be able to bring her peerless body back to life? My desire is strong enough to force it. . . . Now my imagination, my whole being is captivated" (7438ff.). Unstated is the vaulting hubris the parallel implies: "*If Achilles could do it, why can't I?*"

Chiron diagnoses Faust's condition as madness. Fortunately, the horseman is about to pay his yearly visit to Manto, sibyl, prophetess, guide to the underworld and warden of its entrance, the daughter of Aesculapius, skilled in healing. She will cure Faust of his obsession, says Chiron.

> FAUST. I don't want to be cured. My imagination is charged. Cure
> me and I'd be as vulgar as all the rest.
> MANTO. Who's this?
> CHIRON. The night of ill-repute swirled and tossed him out here.
> He's completely mad. Helen—he wants to get Helen, and hasn't
> a clue how and where to begin. Aesculapian cure—none better.

But rather than administer medicine or psychiatric care, Manto cheers him on, replying to Chiron, "I love a man who desires the impossible." She

sends him off to the underworld with the admonition not to bungle it, like Orpheus, his predecessor in this kind of enterprise (cf. 7399–7494).

There is a breathtaking arrogance, at least boldness, in the conviction that if desire is strong enough it can bend the laws of death. And while Orpheus's motives were more noble (he's in despair at losing his wife, while Faust is driven by desire for a beautiful woman), Faust's quest makes Orpheus's look paltry. Orpheus desired a woman recently alive; Faust goes back three thousand years. Both of them fail ultimately (Faust comes closer than Orpheus); no human skill and no magic overcomes death. And both failed quests are channeled into art: Orpheus, music; Faust, poetry (but in a way that is more obscure and in need of interpretation than Orphic song). So we have again that protoform of charismatic art: longing for the beloved wife or lover or master, who is dead and gone, the strong urge to resurrect, which can satisfy itself ultimately only in art, however close it comes to what passes for reality in the two legends.

The Quality of Reality

But that brief sketch does not come to terms with the breathtaking intensi-fication of experience, the quests and resurrections that must be faced and accomplished before this love affair with a ghost can be consummated. Faust has to journey to the realm of the "Mothers," spirits who "form and reform" (6287), who, as well as generating all natural forms, tend the shades of the dead in some realm deep beneath the underworld; he has to obtain the release of Helen by using a magic key. That is not enough. The ghost of Helen conjured up at the emperor's court in act 1 does not inter-face with Faust's world; he reaches for her and she disappears in an explo-sion. That means that Faust has to gain entry to the ancient world where she can live again and be physically available.

What is the quality of the reality into which he resurrects Helen and has a brief moment of Arcadian bliss with her? The scene plays in a revived ancient world with its myths alive and its nature spirits all speak-ing and acting as though Hesiod and Ovid had described a reality that existed somewhere and that still exists, unchanged and unchangeable, in its own parallel universe, and the guidance of a test-tube man in search of his own reality (Homunculus), with Faust's dream of Leda and the swan (Helen's begetting) as roadmap, who can gain entry for questers

from the eighteenth—make that, sixteenth century. The three companions (Mephisto, Homunculus—still in his test tube—and the sleeping Faust) fly through the air and land in the Greece of ancient myth.

Brief though their appearances are, Chiron and Manto are miniatures of a much greater opposition of reason and fantasy. The macrocosm of which they are a faint but harmonious echo, is the entire *Faust Part 2* in opposition to a fading European rationalism and at the same time to a dawning realism. The drama represents poetic fantasy affirmed on a scale that surpasses anything contemporary and stands up well against Dante's *Divine Comedy* and Milton's *Paradise Lost*. While Chiron retains some dignity as teacher of heroes, his scoffing places him in the same category in a taxonomy of philosophical positions as the old scholar at the emperor's court in act 1 of *Faust Part 2*. Along with other courtiers and courtesans this pedant observes the phantom of Helen of Troy conjured by Faust to entertain the emperor. His response is to avert his gaze because

> I see her clearly, but I'll admit openly:
> It is doubtful that she is the true one.
> Presence seduces us to extravagance.
> I'll rely on books.
> There it says, she pleased all
> The graybeards of Greece.
> It fits perfectly, it seems to me.
> I'm not young, and yet she pleases me.
> (6533–40)

He does not deny the reality of the phantom; he just wants to authenticate it by the means in which he places his faith, written books (though he argues also from the libido: "*She pleases me, old though I am*"). The reproach of lying, directed at the fantastic (Homer, chivalric romance), has shriveled to pettifogging source citing and consulting the relevant secondary literature on the subject. The primary prodigy/fantasy-in-itself is available, but dismissed as an "extravagance" caused by "presence." Absence is more comfortable for a man of paper and ink; distance and abstraction favor analysis. Better to read about an irresistible woman than meet her in the flesh, in which form she is an offense to the reasoning powers of a pedant. For Chiron Faust's pursuit of "the impossible" is a form of madness. One might expect a figure who is half horse, half man to have more

tolerance for the fantastic, or at least a measure of self-criticism. But the phantasm skeptical of fantasy left a nice irony in the text. (Goethe had planned early on to give Chiron the line, "I love a man who desires the impossible.")[2]

Manto's comment gives a stamp of affirmation to Faust's quest through a fantasy world for a woman long dead; the resistance of myriad impossibilities matters little. The representative of imagination need not recognize boundaries and limits. The quester himself valorizes his mission by his belief in the resurrecting power of desire and by a snobbish commitment to visionary quests ("Cure me and I'd be as vulgar as all the rest.") Manto's term, "the impossible," seems pale as a description of the disregard of the empirical, the leaps of fantasy, the casual spiting of natural law built into the operating system of this hyperreal world.

The constellation, Faust–Chiron–Manto, is paradigmatic for some central ideas in *Faust* and in Goethe's thought and writing generally: the quester seeks beauty in its highest form; the rationalist impedes; some mysterious force urges the quester on against reason.

Beauty and Art

Helen is beauty and the ancient world personified. To illuminate the relevance of this episode for charismatic art, we should start by looking at some of Goethe's ideas on aesthetics, formed in his classical period and nurtured into his old age. Some of the basic ideas: art functions as a vital element of a cosmic system in which art and nature have complementary functions. Nature constantly develops an inestimably huge variety of forms in such a way as to magnify and intensify fundamental forms into higher ones, which develop toward perfection by the inescapable law of organic evolution. The highest creation of Nature is the beautiful human form. But that form, like all others Nature creates, is unsustainable—another inescapable law: created things wither and die. To make the level of perfection sustainable requires the artist. The artist develops himself to the point where he can produce an artwork correspondingly lofty, but above nature, an "ideal reality." Its effect: the work of art *"raises man above his limits* and *deifies* him for the present moment, which enfolds the past and the future."[3]

The beholder functions within this process as an integral part. Immersed in the work of art, the beholder is raised up to the level of ideal

reality and transformed, made godlike. Beauty is the quality most closely allied with divinity and grandeur. It is diminished if not paired with vitality and charm.

Goethe's ideas on education through art crystallize in the phrase "a higher existence." Unquestionably he thought of his own works as, among many other things—but prominent among them—instruments of an education that raises the level of existence of its beneficiaries (more on this later). Wolfgang Schadewaldt sums up the idea of the beautiful in Goethe: "In every niche and corner of Goethe's works one finds references to the effect of the beautiful: it intensifies and elevates existence, it condenses and solidifies it, strengthens its inner moorings, in fact lends reality to a living being in the true sense."[4] Helen of Troy, as Goethe represented her, is the embodiment of this ability of beauty to transform the existence of the beholder, worshipper, or lover. That is the effect that Faust feels in his brief idyll with Helen.

Art and Illusion

It seems clear that Goethe was also willing to narrow the gap generally posited between reality and art: the better a work of art, the more it approximates nature. That is not a statement about mimesis. It means that the work of art approaches the ontological condition native to life and natural forms, hence loses or diminishes its character as a mediated form, a representation. Art is not artificial, concocted by someone who just "thought it up," but rather an element of a cosmic arrangement for the preservation and use of beauty. The classical statues that Goethe admired on his Italian journey appeared to him over time to have become works of nature. He waxes hymnic in developing the thought: "These high works of art are at the same time the highest works of nature, brought forth by men in accord with true and natural laws. All that is arbitrary and mannered collapses. Here is pure necessity, here is God."[5]

It requires some softening and destabilizing of the concept "reality" to think our way into this conception of poems and statues as "realities."[6] It may be useful to distinguish two concepts of reality by etymologizing the Latin/English/Romance term "real" in comparison with German "wirklich." The "real" is rooted in things, Latin *res*, its adjective *realis*. "*Wirklichkeit*" has as its verbal determinant the effect that things and persons

make on us ("*Wirk*ung" = effect). A reality weighed and determined by the weight of effects that objects, persons, and art make on those who see and experience them opens a much broader scale for the classifying of reality than the "real," empirical, thing-bound concept. If reality is measured by effects, then the greater the effect, the more real its cause.

Helen's Epiphany

When we turn back to the text of *Faust, Part 2*, and try to understand this tangle of enigmas in the terms just set forth, we run into some interesting resonances, but also into some big problems.

The ancient world was persuaded that a Helen of Troy had actually existed, but it was not at all sure of her ontological stability. A legend has it that the real Helen sat out the Trojan War in Egypt, and what Paris abducted was a simulacrum.[7] Even without this legend, that is, assuming a real Helen really taken by Paris and really present in Troy, it is possible to think the Trojan War an absurd enterprise. Its absurdity is raised to several powers if Paris kidnapped a shade. Mephistopheles, disguised as Phorkyas, raises this point in his conversation with Helen:

> MEPHISTO (*as* PHORKYAS). Rumor has it that you appeared as a doubled image, sighted in Troy and in Egypt at the same time.

Goethe's Helen is so uncertain of the stability of her existence that she can't deny it and even finds some psychological truth in the fantastic claim:

> HELEN. Don't blur the madness of a sullied imagination altogether. Even now I don't know which I am.
> PHORKYAS. The rumor also has it that Achilles lusted for you and joined you from out of the empty realm of shadows, gratifying his earlier love for you against every resolve of fate.
> HELEN. The ghost I'd become coupled with Achilles the ghost. It was a dream; the words say it all. I'm fading away and becoming a ghost even to myself.
>
> (8872–81)

Of course, one can expect some loss of the sense of reality from a creature fetched blinking and yawning out of three thousand years of death. The

chorus recognizes that it is a crisis of the moment, that she is about to fade back into the beyond. They call to Phorkyas: "Stop this talk! Let the queen's soul, on the verge of slipping back, firm up, let this figure of all figures that the sun ever shone on, let her stabilize" (8903–8).

But there is a problem of charisma and perception behind the immediate crisis of a return of the dead to life. When Faust first saw the shade of Helen, an illusion even in the fiction of the drama, he insisted it was real; having fetched her from the realm of the mothers into "reality," he imagines that his successful quest means a real Helen: "Was it for nothing that I've returned? Isn't this key still in my hand? [The magic key that secured Helen's release from 'the Mothers.'] It led me through the terrors, the surge and surf of the realms of loneliness, here to firm ground. Here I'll set my foot! Here are realities! From here I'll mount my duels with spirits, here I'll prepare the great double kingdom. She was distant by infinities; now she could hardly be closer. I've saved her and she's doubly mine. . . . One look at her and you can't live without her" (6549–59). If Helen underestimates her reality in the next act, in the passage just cited Faust overestimates it beyond measure. Not only does he take her, but the whole realm of "here" and "firm ground," as substantially real. His thoughts soar on into the impossible; it's the vision of a discoverer of a new continent setting foot on firm ground after a long voyage of discovery and founding a new kingdom: a "great double kingdom," where presumably magic lantern images will interact with the same texture of reality as flesh and blood humans.[8] Rescue her and she will be "doubly" his, the shadow will have body and life and yet remain a shade. The extent of Faust's delusion could not be more dramatically underscored than the following event shows: no sooner has he reached for her than she fades away, an explosion ends the scene and all the conjured spirits vanish. Faust remains for much of the following scene (act 2, scene 1) "paralyzed" by the sight or the touch or the loss of Helen (Mephisto: Anyone paralyzed by Helen is slow to recover his senses. [6568–69]). In his sleep Faust dreams the rape of Leda by the swan—the conception of Helen—and so in a sense dreams her back into life.

A purposeful destabilizing of the concepts "reality" and "illusion" is at work here. The basic conception of the Helen scenes thematizes that intermediate realm between real and illusion, which is a very real experience of the viewer or reader spellbound by art. There is a psychological "double kingdom" where the illusion takes on the quality of reality so persuasively that the beholder is entranced. That is the basic experience of

Faust in the Helen episodes. That experience that we identified as funda-
mental to charismatic art, or ritual, is very close to what Goethe described
as the force of beauty in elevating reality: "Art . . . stimulates the eye to
gratify it; it challenges the spirit to strengthen it. . . . In this way imagination
and reality intensify each other mutually until at last they reach the highest
goal: they come to the aid of religion and expose to the sight of worshipping
mankind the god whose nod shakes the heavens."[9] "Reality" clearly is
permeable and elastic; it stretches and grows; it rises like dough, and the
leavening is art. The imagination takes it in and refashions, heightens,
intensifies reality; reality corrects imagination, and in the turning of this
aesthetic circle, both players rise to the level where imagination reveals the
divine. Ontology is permeated by aesthetics and rises to something like an
ontological proof of the existence of god, via beauty ("that, than which
nothing more beautiful can be thought, is god"). Goethe has in mind pretty
clearly an Olympian god. But no matter, the startling claim is that beauty
alters reality and ultimately enables the vision of God. If the work of art is
beautiful enough, it must be real; if it is more beautiful yet, it reveals God.

Reality, it is clear, is a pretty threadbare thing in itself ("die gemeine
Wirklichkeit," vulgar or common). Reality needs an aesthetic education to
realize its higher destiny. Goethe reflected frequently on the docile character
of "reality," especially in relation to the figure of Helen and Faust's quest
for her. She and her child Euphorion are "half realities."[10] They can flourish
only within the magical boundaries of the castle.

But Goethe is perfectly aware that the Faust who tried to grasp Helen
in act 1 is himself in the grips of a delusion: the shade of Helen as conjured
at the emperor's court is a phantom. His blather of "firm ground," "plant
his feet for the struggle with spirits," "here are realities!"—are misjudg-
ments that explode along with the specter who inspired them. The illusion-
ary is not really real. And yet Goethe is reluctant to deny the revived Helen
reality. So, which is it? Is the conjuring of act 1 only preparatory to that of
act 3? And is Faust's failure in act 1 preparatory to success in act 3? The
Helen of act 3 does not share the purely illusionary quality of the phantom
of act 1. Goethe hedges the question: she is genuinely real for a short time,
or she is half real. He compared her once to trees he had planted in his
garden: "This work [he means the figure of Helen], a creation of many
years, seems to me at the moment as remarkable as the trees in my garden.
Though they are not as old as this poetic concept, they have grown to
such a height that something real, which one has caused oneself, appears as

something miraculous, incredible, beyond what can be experienced" (letter to Knebel, November 14, 1827).

Helen of Troy is for Goethe also a symbol of Greek antiquity as a whole in its meaning for the present. What makes Helen real in Goethe's mind is, at least in part, her Hellenism. His friend Riemer recorded in his diary an observation of Goethe: "The Ancient is sober, modest, tempered, the Modern entirely unbridled, intoxicated. The Ancient asserts only an idealized real, an objective thing depicted with grandeur (style) and taste; the Romantic an unreal, impossible thing, to which fantasy lends only an illusory appearance of the real. The Ancient is plastic, true and objective [reell]; the Romantic deceptive like the images of a magic lantern."[11]

Goethe as "realist" is an evasive figure. That he values the real and associates it with ancient art and literature is evident. Still, the reality of Phidias's statues is something very different from that of living trees. The illusory can never be real, though it may feel like it to someone in its spell. But it does or can have effects more real than reality. Those effects are shown in the outcome of the Arcadian idyll of act 3 ("Shady Grove"). Faust and Helen have fallen in love. In the previous scene ("Castle, Inner Courtyard") Faust courted Helen, now revived, real, and full-bodied. The courtship has more of wit and rhetorical persuasion than romance, and Helen's yielding more of calculated self-interest than love, but they make the signs of love "before the eyes of the public," in a way, the lines imply, that their majesties but not private persons can indulge. Some kind of ritualized royal foreplay seems indicated. However they get there, they are in love and retire to an Arcadian realm near Sparta, where "pleasure is hereditary" and "everyone is immortal, content and healthy"; Faust is uncertain whether the denizens are gods or mortals (9550–57). He and Helen make love in a grotto and conceive a child, who springs from Helen's womb and grows quickly to boyhood—a few instants separate conception from birth and birth from puberty. The child, Euphorion, is ungovernable. He hops about, the earth acting as a springboard. He disappears into a mountain fissure, only to emerge in splendid robes, carrying a lyre. A blaze of golden light rises up from his head, a "flame of overpowering intellect." His bearing and gestures proclaim "a future master of all beauty, through whose body eternal melodies flow" (9619–27). After he abducts and presumably rapes a young girl from the chorus, he springs higher and higher into the mountains, and while his parents, whose anxiety swells to horror, warn him against climbing too high, the chorus cheers him on: "Let sacred poetry

climb heavenward!" (9863–64). At the summit Euphorion jumps off—and falls to his death. The stage direction: "He leaps into the air, his robes hold him up for an instant, light radiates from his head, a ray of light follows his plunge. . . . His corpse vanishes at once, the aureole rises like a comet into the sky, the dress, mantle and lyre remain on the ground" (9900). His voice, now bodiless, calls to Helen: "Mother, don't leave me alone in this dark realm!" (9905–6). Faust holds her, but she also fades. He is left holding only her dress and her veil.

The scene is the highpoint of a drama of the questing imagination, its pursuit of perfect beauty and its partial fulfillment in poetry.

Fantasy had gripped Faust in act 1 (Helen's ghost), he pursued it, made it real, at least half real. The fantasy bore fruit. But the vanishing of Euphorion and Helen, their outer garments signaling the loss of the living core, would seem like a symbol of futility. Manto's weakness for lovers of the Impossible seems fatally ill-conceived. Finding reality in lost perfection is an enterprise like bringing a dead person back to life. The union of classical beauty and romantic passion produces a highly volatile product that is smashed when it touches the firm ground of reality. The relation of powerful desire to a lost object it longs for is not like that of sperm to egg, nor is it like that of sun and water to seed. Longing evokes; it does not produce anything. We dream what it evokes—beauty and poetry—but we can't have it. But the dream itself seems part of life, an obligation of existence. It is one of those goals where failure does not thwart the impulse, but the effects remain as something positive and, if not permanent, at least long-lasting.

Goethe is at pains to rescue something, quite a lot actually, from the apparent tragedy. Phorkyas/Mephisto is made, oddly, into the voice of this message. He says to Faust, holding the now empty garments of Helen:

It is no longer the goddess—you've lost her—
But it is godlike. Make use of this high,
Invaluable gift and raise yourself up.
It will carry you swiftly over all that is vulgar
Up into the ethereal realm, as long as you can last.
(*Helen's garments dissolve into clouds, surround Faust, raise him aloft,
 and float off with him*)

 (9949–54 and stage direction)

So the unreal object of intense longing realized is available to the quester—given Faustian ambition and satanic help—but only for a short time. The beauty of the ancient past cannot ever be recovered and reproduced fully and permanently, but it can "raise up" the one who receives it.

The Present and the Exquisite Moment

Faust and Helen sit on their thrones in the "Castle, Inner Courtyard" scene, "surrounded by rich, fantastic buildings of the Middle Ages." They play a game with language as they sit on the throne. Of all the wonders that astonish the freshly revived Helen, the first she asks about is the lilting, rhyming way of speaking she has just heard from the tower watchman Lynkeus; "strange and friendly," the words seem to cozy up to one another. Hardly is one word out, another arrives to caress the first. Faust proceeds to teach her how to rhyme, something the classical world did not do. He speaks lines, finishes before the rhyme word, and has her complete the line (I yield here to Stuart Atkins's good translation):

> HELEN. Tell me then how to speak so beautifully.
> FAUST. It's simple: let the words well from your heart.
> And when your soul is filled with yearning's flame,
> you look around and ask
> HELEN. who feels the same.
> FAUST. There is no past or future in an hour like this,
> the present moment only
> HELEN. is our bliss.
> [FAUST. Nun schaut der Geist nicht vorwärts, nicht zurück,
> Die Gegenwart allein—
> HELENA. ist unser Glück.]
> (9377–83)

These lines have been interpreted and set in a historical context in an essay by Pierre Hadot.[12] Here is Hadot's shrewd reading of its role in the Helen/Faust scene:

> Helen becomes "modernized," if one may say so; as she adopts rhyme, the symbol of modern interiority, she has doubts, and

reflects upon her destiny. At the same time, Faust becomes "antiquated": he speaks as a man of antiquity, when he urges Helen to concentrate on the present moment, and not to lose it in hesitant reflection on the past and the future. As Goethe said in a letter to Zelter [October 19, 1829], this was the characteristic feature of ancient life and art: to know how to live in the present, and to know what he called "the healthiness of the moment." In antiquity, says Goethe, the instant was "pregnant"; in other words, filled with meaning, but it was also lived in all its reality and the fullness of its richness, sufficient unto itself. We no longer know how to live in the present, continues Goethe. . . . We no longer know—as the Greeks did—how to act in the present, and upon the present. Indeed, if Faust speaks to Helen as a man of the ancient world, it is precisely because the presence of Helen—that is, the presence of ancient beauty—reveals to him what presence itself is: the presence of the world, "That splendid feeling of the present" (*Herrliches Gefühl der Gegenwart*) as Goethe wrote in the *East-West Divan*. . . . Following after humble Gretchen, it is ancient, noble Helen who reveals to him the splendor of being—that is, of the present instant—and teaches him to say yes to the world and to himself. (pp. 220–21)

The idea is prominent in Goethe's writings, as Hadot shows. Hadot gives precedents in Stoic and Epicurean philosophy. Both directions in ancient philosophy "posit as an axiom that happiness can only be found in the present, that one instant of happiness is equivalent to an eternity of happiness" (p. 222). John Dryden embroidered on a few lines from Horace (*Odes* book 3, nr. 3.29), and Tony Richardson and John Osborne picked up the first four of Dryden's lines to end the film *Tom Jones* (1963), and so gave longevity to this remnant of Epicurean philosophy:

Happy the man and happy he alone,
He who can call today his own,
He who, secure within can say,
Tomorrow do thy worst, for I have lived today.[13]
Be fair or foul or rain or shine,
The joys I have possessed, in spite of fate, are mine.
Not heaven itself upon the past has power,
But what has been, has been, and I have had my hour.

Given this sentiment it is possible to see in the wish for longevity a life-denying impulse. To want to live long you have to recognize the present moment as a threat and make yourself secure from it. While the impulse for longevity can be productive, it cannot produce happiness. It is a timorous evasion of the immersion in the present, which is at the same time the immersion in existence. Hadot quotes a remarkable passage from Marcus Aurelius: " 'I say to the universe: "I love along with you.' " We have here a profound feeling of participation and identification; of belonging to a whole which transcends our individual limits" (p. 230). Goethe also gave powerful expression to this feeling.

It is possible to see in this ancient sentiment shoring against eternity in a culture that has no belief in an afterlife. The Christian belief in the redemption would seem to create huge—indeed, infinite—spaces of potential future happiness. Christians do not need happiness in the moment; they have it in eternity. They might have good reason to scoff at the contrived optimism of "an instant of happiness equals an eternity of happiness," as an act of temporal imperialism that co-opts what it does not own. Also, Christianity, in its ascetic traditions, does not say yes to the world or to existence, and therefore does not deify something as world- and existence-bound as the present moment. The neglect of the present in the modern world that Goethe decried might be laid at the door of Christian conceptions of time as the scruffy stepchild of eternity.

It would be easy to find a Goethean paganism in his assigning the glorification of the present to the ancient world, the neglect of the moment to the modern. But in fact Goethe is closer to something like a theology of the present moment than any of the pagan sources Hadot cites. The glorification of the exquisitely lived moment harmonizes easily with his idea that all living things are symbols of the eternal. The present moment is not in place of an afterlife; it predicts one. In a conversation with Goethe, Johann Peter Eckermann (Goethe's secretary and companion in his later years, author of *Conversations with Goethe*) commented that his life in Weimar dissolved his (i.e., Eckermann's) earlier tendency to reflection and theory and made him appreciate the present moment more. Goethe's response: "Every circumstance, in fact every moment is of infinite value. It is the representative of an eternity" (November 10, 1823).[14] It would intensify our relationship to the present considerably if we imagined that the quality of the present moment would return as the quality of the eternity we are destined to experience in life after death, that a moment of boredom

condemns us to an eternity of boredom, a moment of treachery to an after-
life of treachery. If that is a good reading of Goethe, then there is an ethic
to associate with the glorification of the present: we are shaping eternity by
making the present moment to our liking. This is far from an alienation of
the present from the eternal. Linking the two as foretaste and fulfillment
on the contrary resolves the division of existence into transcendence and
the here and now. It reconciles physics and metaphysics, nature and God.
Goethe's hymn-like poem "Prooemion" ("Prologue" or "Beginning") links
the immediate with the eternal by this logic:

> In the name of the Self-created one,
> Of Him whose mission through eternity is creation,
> In the name of Him who creates faith,
> Trust, love, benefaction and strength,
> In the name of Him who, however often named,
> Always kept his essence secret:
> All that the ear can hear, the eye can see
> Reveals familiar things, His likeness,
> And the highest fire-flight of your mind
> Finds fulfillment in resemblance and image.
> It draws you on, it lures you happily,
> And wherever you go the path is pleasant, the place is sweet.
> You no longer count the moments or calculate the time,
> And every step is infinity.

A characteristic Goethean idea is at work here: eternity is in the present
moment as infinity is in a few inches, as divinity is in the plant and its vein
structure, as revelation is in the blue sky, as profundity is in the granite,
and theory in the phenomena. Its relevance for this study is in its implica-
tions for the surface of things, of events, of narratives, of statues. It lends
profundity to the surface. It is not dense with nothing metaphysical lurking
behind it, as in Homer. Homer's Odysseus was the master of the present
moment, the supreme negotiator of the *kairos*. He possessed the wisdom of
immediacy, hence mastery of the passing instant. In Goethe, the wisdom of
immediacy is a promise of a pleasant stay in eternity.

This idea offers us an understanding of the Helen episode as more than
a dramatizing of the emptiness of her resurrection and of Faust's quest for
the impossible. Helen began and ended the scene as a shade. But between

rebirth and redeath, she lived luminously. The moment experienced as bliss abolishes past and present. It makes the fact of her return to the underworld irrelevant. She is immortal in the moment. In the exquisite moment bliss and oblivion coincide. The moment is creative, creating, lived with the intensity of orgasm.

"Presence" and the Irresistible Person

The German word *Gegenwart* has the double meaning "present" and "presence." The experience of the blissful instant coincides with the highest heightening (*Steigerung*, Goethe's word) of the physical presence of the players, and that coincidence bears significantly on the conceptual: the intensified personality lives out the perfected moment of time.

Helen's arrival and reception in act 3 ("Castle, Inner Courtyard") has a baroque, operatic character.[15] Apart from the choreographed entrance of a troop of elegantly pacing youths who bring carpets, pillows, and a tentlike, cloudlike enclosure, there is the introduction of Faust. He appears at the top of a flight of stairs "dressed in the court garb of a medieval knight and descends the stairs slowly and decorously." The leader of the chorus is in awe: "Perhaps the gods have lent him, as they often do, for a brief moment, an astonishing form, a sublime grace, a love-inspiring presence which will soon fade. If instead this [presence] is his own, then all that he undertakes will succeed, be it in battle or in the smaller war with the most beautiful women. He is truly to be preferred to many others, whom I have also seen with my own eyes and admired greatly. I see the prince approach with slow and dignified, respect-inspiring gait" (9182–91). She is referring to the Homeric gods' service to their favorites of heightening the presence by showering them with beauty and charm. It is the art by which Athena had transformed Telemachus and Odysseus several times, and Aphrodite Aeneas (see Chapter 3). Faust appears to the chorus leader as though he had been the beneficiary of a divine makeover.

The presence of Helen is equally exalted. A prominent idea of the Helen scenes is her magical effect. It was anticipated by Goethe's description of the Greek artist Polygnotus's painting of the fall of Troy. He evokes a scene of dreadful destruction, the bodies of the war victims strewn at the feet of Helen enthroned, and he marvels at her immunity to guilt and blame:

All crimes committed against her had the most tragic results; all that she committed was expunged by her presence. . . . She charms old and young alike even while she brings destruction down on them, she disarms the vengeful husband, and she who was the cause of a destructive war now appears as the brightest prize of the victors, and, elevated above piles of corpses and captives, she is enthroned at the pinnacle of her effect ("Wirkung"). All is forgiven and forgotten, for she has returned. The living man sees the living woman again and rejoices in the highest earthly good, the appearance of a perfectly beautiful form.[16]

Faust's first gesture to Helen as he receives her in act 3 highlights her stunning presence. He appoints Helen the judge of the tower watchman Lynkeus, on trial because he had neglected his watchman's duty to gawk at Helen as she arrived. But since it is a moment of threatened warfare, the punishment for his neglect is death. Helen can forgive him or send him to his execution. His defense (or rather explanation—he is so taken with Helen he would be glad to die at her hands): her stunning beauty made him forget everything else; the world of his duties was like a deep and dark dream; she, like the rising sun; he was disoriented, lost his sense of time and place, as in the presence of a goddess; he, who has the eyes of a lynx (hence his name), blinded by her beauty, had eyes only for her (9218–45). Helen spares him. Lynkeus describes the charismatic effects of her presence:

> The entire army is soothed and tamed,
> All their swords are blunt and lamed.
> In the presence of this magnificent figure
> The sun itself turns weak and cold,
> The splendor of this face
> Voids everything, nullifies everything.

<div align="right">(9350–55)</div>

A large-scale deprivation of individual agency that happens in the enchanted state: they are all so rapt and transported out of themselves as to forget even the most urgent duties. Charismatic effects intensify on into the fabulous: her beauty blunts swords, pacifies armies (though she is the cause of the Trojan War), and cancels out everything other than herself. No object, goal, intention can exist other than Helen's face, no striving other

than devotion to her. With this enchantment still vibrating throughout the court, the rhyming lesson follows, at the highpoint of which the exquisite moment is evoked (9382).

The magical presence of all three major players in this scene and the following is the dominant in their description. Euphorion seems to combine presence and the present in the meteoric growth spurt from birth to puberty in a matter of seconds ("from the mother's womb into manhood" [9599]). He emerges from the mountain fissure clothed in glory. Perhaps he has clothed himself in treasures buried in the depths of the earth, Phorkyas surmises. Like a little Apollo he holds a golden lyre, a radiant light rises around his head, perhaps a gold crown, perhaps a "flame of overpowering intellect," the astonished viewer can *see* "eternal melodies," which flow through his arms and legs and become visible music in his motions and gestures (9616–27). His magical radiance separates from his head after he dies and vanishes, the "aureole" rising heavenward like a comet.

All of this charismatic glory is a distillation into physical presence of the present moment. The eternal asserts itself in the momentary and the passing like an epiphany. We can add one other element to the inversion of Christian conceptions of paradise, redemption, and afterlife: the exquisite moment is the moment of life most concentrated, vitality at its highest intensity. Helen is "the vital principle" (*das Lebendige*).[17]

In an earlier chapter I extended the idea of "the heroic" to a culture based on charisma. Charismatic culture is heroic, but not in the military sense, or not only. It also means action rather than reflection, presence rather than representation, the glorifying of the lived moment, the *kairos*, and of the elegant human response to it—not art.

In this sense the Helen episodes of *Faust* try to recapture a heroic world. The grandeur resides in personal splendor and temporal bliss. To a certain extent however we can call Goethe's revivification of Helen's world and its marriage to that of Faust "sentimental." It is driven by loss; its fullness and possession of perfect beauty are an artificial restoration of the past, however real the lived moment; Faust's "powerful longing" is in part at least nostalgia, and no matter how many resuscitated phantoms love men who desire the Impossible, it is still impossible.

In Chapter 5 I described a historical moment in the late eleventh, early twelfth century, when charisma was vanishing as a dominant mode of behaving (supported by a system of education) and was passing over into the realm of art and fiction. The earlier phase glorifies the living embodiment of

charisma, the later, its representation in art. The later period was a restorative phase when artists and poets worked to rescue and preserve—in texts, images, and statues—real and present charisma which is passing out of existence, as the disciples of Socrates and Christ strove to hold firm the physical and spiritual presence of the dead master. This dynamic is at work in the Helen episodes: what Helen represents reverberates in Euphorion's music. The only real form of long-term revival of lost beauty is art.

It follows that there is a kind of art that aims at intensifying representation by translating the experience of the redeeming moment into art. One bit of testimony from Goethe will have to serve to firm up that claim, a conversation with Eckermann (November 16, 1823) about Goethe's poem "Marienbad Elegy." It was written in the immediate aftershock of his falling in love with Ulrike von Levetzow (she was nineteen, he was sixty-three at the time) during a stay in Marienbad. He proposed marriage. She, or her mother, turned him down. He was devastated. Eckermann finds the emotions in the poem stronger than in other poems. Goethe: "You see the product of an extremely passionate mood. . . . While I was captivated, I would not have given it up for the world, and now nothing could induce me to return to it." It isn't like your other poems, says Eckermann. Goethe: "I put my chips on the present moment, just as one would bet a large sum of money on a single card, and I tried without exaggeration to raise it [the feeling of the present] to the highest possible intensity."

The Two Helens

The legend of the double Helen has a relevance to our topic beyond the mention it receives in Goethe's play. The belief in a doubled Helen is too common to be an idiosyncratic motif. Why should the ancient world have posited a doubled Helen of Troy? It may be that Helen's innocence had to be rescued as an icon of a certain cultural ideal.[18] It is also possible to tease out of the double-Helen motif an aesthetic problem. Helen reduplicated is an act of mimesis:[19] the original is real, the copy is a work of imitation. If Paris abducted a lifelike imitation of the real Helen, then the Trojan War itself becomes, on the one hand, senseless, and on the other, a subject of aesthetic response. Paris is taken in by a beautiful copy. He accepts the copy for the original, the illusion for the real. He is enchanted by the appearance, not the embodiment, of beauty. In this case the Trojan War would be an

example of charismatic seduction having a horrendous outcome. Helen the simulacrum is the grandest deception, practiced on the largest audience with the worst consequences. Greeks and Trojans alike are lured into that intermediate realm of enchantment where illusion merges with reality.

Goethe did not make much of the doubling of Helen in itself. He was, however, clearly interested in its effects on the doubled character. He highlighted the disorientation of Helen, of which the phantom other is only a single instance. The more general cause is her celebrity, the iconic stature that her beauty imposed on her. When Phorkyas asked whether it was true that the Trojans and Greeks had fought out a senseless war over her simulacrum, Goethe's Helen could not answer the question: "Even now I don't know which I am." Asked about her postmortem coupling with Achilles, she replied, "The ghost [*Idol*] I'd become coupled with Achilles the ghost [*Idol*]. It was a dream; the words say it all. I'm fading away and becoming a ghost [*Idol*] even to myself" (8879–81). A few lines earlier, still in the fog of her revival, she had felt the terrifying memories of the Trojan War and the shades of the dead pulling her back to the underworld, but could not locate the images ontologically: "Is this a real memory or a mad deception that takes hold of me? Was I all that? Am I it still? Will I be it in the future, the dream and the nightmare of those destroyers of cities?" (8838–40). These cries resonate less with Hellenic tradition than with the loss of self experienced by other living idols or simply living beings whose identities are made or become an object of negotiation. Goethe wanted to pose loss of self as an effect of embodying "perfect beauty." Helen "voids and nullifies everything"—herself included. She is forced to live as a human and a symbol at the same time. Her admirers cast her in the role of absolute beauty, and she becomes trapped in the vast distances that separate the human condition from symbolic—or, rather, iconic—status. To be an idol is to become a phantom. The double meaning of the Greek word *eidôlon* lucidly illustrates the loss of reality of the living icon. It is a charismatic effect. The effect of worship and adoration is profoundly disorienting, first for the idol. She comes to live in a world that is part fiction. Life becomes the staging of that scenario on which she and her audience have come to agree. It is a well-known syndrome of kings and queens, who live as though set on the stage, and whose life is a role playing that interferes with any sense of authentic existence. The courtiers around the queen likewise are sucked into the staged pageants of court life and royal identity, forced to play their

parts. They recur at their peril to a genuine identity. Stephen Greenblatt famously analyzed Thomas More's staged scenarios "at the table of the great": "One consequence of life lived as histrionic improvisation is that the category of the real merges with that of the fictive; the historical [Thomas] More is a narrative fiction. To make a part of one's own, to live one's life as a character thrust into a play . . . forever aware of one's own unreality—such was More's condition." Every encounter requires preparing the face of one's own fiction and an appropriately altered identity. The self fades to a shadow and shades on toward extinction: "There is behind these shadowy selves still another, darker shadow: the dream of a cancellation of identity itself, an end to all improvisation."[20] Movie stars and fans live within the same constellation of idol and worshippers. They are accordingly also subject to the syndrome. The adored person has to agree to participate in the mythmaking process as a condition of adulation, in some cases even becomes its subject, has no more power to control the process than the followers. Myths, legends, and miracle stories accrete around the idolized figure. If the idol's life does not supply true ones, then fictions have to be invented. True or not, the person thrust into the status of idol becomes a living fiction.

In the case of Helen of Troy and any woman or man of extraordinary beauty, their own skin subjects them to idolatry. "I no longer know who I am" states a deeply resonant crisis.[21] "Identity up for negotiation," "transmuting and transforming of the self," the "temporary absorption of the individual identity by another"[22]—these may be taken to formulate the basic psychological problem faced by both the charisma bearer and his or her admirers.

Goethe's Helen suffers the erosion of the self that peculiarly threatens the living idol. That is certainly Goethe's intention in stressing her crisis of identity and having her faint to end the hectoring questioning of Phorkyas: "I'm fading away, turning into a ghost [*Idol*] of myself. [*She sinks into the arms of the chorus.*]" (8881). If Goethe's Helen represents a good interpretation of the psychology of charisma, then the myth of Helen of Troy's two selves seems like a brilliant response to its attendant psychological crisis. Fabricate a ghost self and send it out to playact life and suffer all its tribulations, while you sit comfortably in Egypt as a private citizen. No psychologist could have formed a better defense against the assault on her identity posed by her beauty and the divisions in the life of an idol.

Nature, the Enchanted Realm

Goethe's Faust does not sell his soul for knowledge. He has plenty, more than enough of that. He is not driven by "the drive for understanding."[23] "Lust for knowledge" describes the Faust of the legend, the puppet play, and Christopher Marlowe, though the German word *Erkenntnis* is broad enough to include a kind of understanding beyond mere study and learning. In a summary of the play written late in life Goethe describes Faust as a man "discontent and impatient within the ordinary limits of earthly life, who regards the highest level of knowledge and the enjoyment of the most desirable possessions as inadequate to fulfill his longings to any degree whatsoever."[24] What Faust wants excludes intellectual knowledge and understanding. "Drive for knowledge" is embodied in the pedant Wagner: "True, I know a lot, but I'd like to know everything" (601).

Faust wants participation, not understanding, and to get that, he has to escape the suffocating world of learning and knowledge. The tragedy of part 1 opens with Faust as an old man, wearied by the pedantries of a life of learning, shallow or profound, trapped in culture and striving for nature and experience. Faust's study, in which the early scenes are set, has the quality of the grave, or of a museum. It is a "world of moths" (659), a desiccated realm of pure rationality, where learning shrivels human beings into scraps of curled paper. He wants out: "Oh! if only I could walk in your light [he's talking to the moon] on the mountaintops, fly with spirits around mountain caves, weave about in meadows in your glow, freed of all the soot of learning, bathe myself clean in your dew!" (392–97). But he turns back to his study, crammed with books, papers, experimental apparatus, a corpse or two, human and animal, the bric-a-brac of conventional learning. It is not just his study that's confining; the whole world he lives in is: the bourgeois narrowness, the vulgarity, the philistinism.

What Faust wants is life. His everyday world is a form of death. He wants "living nature." The nature he sees and experiences is not reality; it is a mask over real reality, a paralyzed, disenchanted wasteland, which offers no way into living nature. And yet living nature is everywhere around him; life suffuses the everyday world to the point of saturation, but no one who has acclimatized to the quotidian world can see and feel it, perhaps at most sense its presence. The world of the everyday is filled, packed with unperceived mysteries. Faust knows it: "The way to the spirit world is open. It's your mind that is closed; your heart that is dead" (443–44). And "Mysterious still

in the full light of day, nature holds its veil tight. No levers and wrenches will force out what she doesn't reveal" (672–75). Reality in *Faust* has a double structure: the everyday and the mysteries that pervade it unseen. Since we don't see or feel those mysteries, we think nature is dead, an empirical, dull affair to be forced open with levers, wrenches, and drills, but for the man who senses its richness, tragically stifling and suicidally dispiriting. And all along everything is alive and inhabited by spirits, pretty much indifferent to the short-sighted beings trapped in the world of habit.

The threshold is just the opening of the eyes. But how to cross it? how to break through? Conjure spirits? It doesn't work; all he conjures is a spectacle, not reality. Suicide? A few remaining traces of his religion and a sentimental, maybe aesthetic attachment to the Easter drama pull him back into life. His final option: a pact with the devil. Original as Goethe's vision of nature and the way into it, this is the world of romance. In Homer's *Odyssey* there is no division into humdrum and enchanted realm: the whole world is enchanted. It is all magical design and gods are present at every act of humans, spirits live in every tree and river. In the Christian West the enchanted realm becomes something like the Christian heaven, shut to all but the redeemed. Parzival alone can enter the Grail realm; only Tristan can find the cave of lovers. Access is reserved to an elect few who can enter the realm of adventure. In *Faust* the price of entry has gone sky high. No force available to ordinary men gets him in; he has tried all the licit and half licit ways, and they have failed. And so in a bargain where his whole existence and moral character are at risk, and in full cognizance of a God in heaven who is his supporter and wishes him well in this desperate enterprise—without lifting a finger to guide him[25]—he sells his soul.

Fantasy and Allegory

Mephisto's service rescues him from entrapment in the immanent. Now he has life and access to living nature, heightened by appearing to him in its "real" guise. He sings one of the great hymns of the play to the Earth Spirit. Scorned prior to the pact with the devil, Faust is now heaped with its favors:

Sublime spirit, you gave me, gave me all
That I asked for. Not for nothing
Did you turn your face to me in the fire.[26]

You gave me glorious nature as my kingdom,
The strength to feel it and to enjoy it,
Not as a cold wonder-struck visitor,
You grant me the vision that sees into the depths of her breast,
As into the heart of a friend.
You lead the dance of living beings past me
And teach me to know my brothers
In the silent bush, in air and water.

.

Mysterious, profound wonders open to my gaze.

(3217–34

This is a nature beyond any ever dreamed up. Hyperrealism borders on phantasmagoria.[27]

The grotesqueries of the Witches' Kitchen and Walpurgisnacht in *Faust, Part 1*, are outbid by the fantastic elements of part 2. Plausibility is stretched beyond the breaking point, or, rather, is totally scorned, as in the chorus of bugs, beetles, lice, and grasshoppers, which intone a welcoming hymn to Mephisto, in excellent German, at the beginning of act 2, singing about how much they had missed their old master in the long time given them to settle into his coat (6592–6603). It would be juvenile nonsense if we had not already entered an agreement with the imagined world to suspend skepticism. Faust wants access to the mysteries of nature and gets it. That is precisely the enchantment of *Faust, Part 2,* that it seems to remove the veil that separates us from "living nature," and so we ride for free through a world to which the entry fee was the main character's soul. We hear nature and its creatures speak in many forms. Why not singing insects?

The "Classical Walpurgisnacht," which follows that scene, is not a staged event, like a Halloween costume party. Rather it is the classical world revived with all its mythological creatures living and its mythological dynamics functioning as if in the primal time when myths were real, the living model that Hesiod and Ovid imperfectly copied reinstated to life. The scene "At the Lower Peneios" opens with a speech by the river, rousing the things and creatures that live in it:

Up and about now, you reed whisperings!
Breathe gently, all you brotherhood of pipes,
Rustle, gentle willow fronds . . .

Faust hears the voice:

> If my ears don't deceive me, I must take it
> That a voice like a human's rings out behind
> The low hedge of these branches, these plants.
> The waves seem like idle chatter,
> The breezes like teasing banter.
>
> (7249–62)

Nymphs, satyrs, centaurs, sphinxes live, act, and talk. This is not the language of allegories in baroque interludes. It is not allegory at all. It is the final dream of the naturalist, that the things of nature express and explain themselves in language readily accessible to us; and the final dream of the semanticist, deconstructionist, or any captive in the prison house of language, that the separation of human language from its objects is magically removed. Nor is it a realization of the "book of nature," because even that idea presupposes the translation of nature into writing, in which mediating form it can be read and interpreted. This is on the contrary immediate communication of the being of nature itself, Nature's self-revelation in language.

It is a fantastical take on Goethe's idea of the "primal phenomenon." An *Urphänomen* is a thing into which nature has planted a fundamental law and function, from which other things like it derive their nature. The magnet is an *Urphänomenon*; so is the "primal plant." There is nothing to interpret behind a primal phenomenon, no abstraction behind the concrete thing. We cannot explain it; the only appropriate reaction is astonishment, as if we had seen a human being perfectly normal and real and then discovered that it is a god, indistinguishable from a human: We can comprehend nothing higher than that everything factual is already theory. The blue of the sky reveals to us the basic law of color theory. One need not search for anything behind phenomena; they themselves are theory.[28]

This is a radical affirmation of the visible surface of nature. It answers and contradicts a metaphysical approach to science.[29] The deepest truths that nature has to reveal are there in the trees, reeds, and rivers themselves. Just as they stand there, in their ontological givenness, they are, to borrow a phrase from Mephisto, "plausible miracles" (9579). Poetry might be able to convey those truths approximately; but a prosaic science will only make

nature appear either dead or absurd. Nature is appearance and truth, illu-
sion and reality at the same time:

> In studying nature
> Always regard one thing as everything;
> Nothing is within, nothing without;
> For the interior is the surface.
> So, quickly take hold of
> The holy visible mystery.
> Rejoice in this true illusion [*des wahren Scheins*][30]

This conception of nature expresses a fundamental feature of a charismatic
world: the profundity of the surface. The world of *Faust, Part 2*, is not
allegorical; all those creatures named rivers, spirits, and so on do not stand
for something; they are the thing itself. True, the creatures of this classical
world call themselves at one point "allegories,"[31] but the mere term does
not dissolve them into baroque abstractions. Allegory is present in the work
not as a favored mode, but rather as a historical holdover, like a once-
welcomed guest who sneaks in uninvited through the back door. Helena is
beauty because she is beautiful; Euphorion is poetry because he sings and
inspires poetry. Neither of them nor anything else in the fantasy world are
what they are because they stand for it. If the feeling persists that the figures
stand for something, it is because allegory is present in *Faust* the way the
grandfather is present in the grandchildren. He does not set the terms of
being, but there he is; you see him in the eyes of the child.

The surface of the world through which Faust rides on Chiron's back is
layered, in the sense in which Dürer's self-portrait is layered (see Chapter 7
and Figure 30). The portrait does not mean or suggest or symbolize Christ.
Christ is right there on the surface; he just shares that space in a union with
Albrecht Dürer. *Faust, Part 2*, acts 2 and 3, has the same impenetrability of
the surface as Homer's work, although the play of ideas is richer (and that
possibly weakens Goethe's work as charismatic art—too intellectual).

This world teems with "true illusions." The author's imagination keeps
bubbling and boiling over, an obscene fertility is at work spewing out the
plenitude of things never seen before, which we are invited to grab hold of
as visible and palpable mysteries. Things nature probably never dreamed of
happen (at least as far as we know, but who are we?), things beyond our
imaginations and beyond nature's. For instance, at the end of act 3 after

Helen and Euphorion return to the underworld, the chorus is left stranded in the living world. A staging problem to be settled by an "Exit chorus"? No, much too ordinary. They decide that they like the light of day too much to return to the underworld: "True, we aren't persons any more . . . but we'll never return to Hades. Eternally living nature claims us spirits and we claim it." Like abandoned orphans they cleave to a new parent. They metamorphose into trees, rivers, and grapevines. And if the viewer/reader stopped to question this peculiar process, the questioning would be overwhelmed by a torrent of verse so stunningly lyrical and original, we are captivated by it as by a lizard's writhing tail, while the large impossibility once attached to it slips away from scrutiny:

> Part of the Chorus.
> We in the whisperquiver, the rustleswaying of these thousand
> boughs,
> Goad our flirtatious way rootupwards, lure gently the sap of life
> Into the sprigs; soon to burst into a riot of leaves and blossoms,
> We coax the floating flutterseeds loose to airy flourishing.
>
> <div align="right">(9992–95)</div>

> [Wir in dieser tausend Äste Flüsterzittern, Säuselschweben
> Reizen tändelnd, locken leise wurzelauf des Lebens Quellen
> Nach den Zweigen; bald mit Blättern, bald mit Blüten überschwen-
> glich
> Zieren wir die Flatterhaare frei zu luftigem Gedeihn.]

The neologisms *Flüsterzittern* and *Säuselschweben* are language adequate to a primal world. The poet is at work here as though he had discovered the Ur-poem, which like the Urpflanze holds the key to the infinite production of new forms—new words, new images—yet undreamed of by nature or poetry.

Goethe imagined nature envying him his possession of the primal plant, because with it he would outshine nature herself in the production of new and completely plausible, natural plant forms. We might say the same of the fantasy world of acts 2 and 3. It is a serious mistake to regard its reality as that of a dream, as unreal, even as an apocalyptic vision of another world. This nature is nature viewed with its veil removed. All its mysteries (revealed already earlier with the veil in place) step forward, introduce and

explain themselves. Certainly the move from experienceable nature to poetry as in *Faust, Part 2*, brought with it a whole army of implausibilities, and most levelheaded individuals not caught up in the spell of the work or in Goethe's vision of nature might react with a steady shaking of the head. But as is the case with the sublime, reasonings about plausibility tend to be drowned out and overridden by grandeur of conception, brilliance of vision and of language.

Dynamics

The human drama of Faust, grand as it is, is framed by an even grander one. The "Prologue in Heaven" opens with a brilliant sunrise and rhapsodic hymns by the angels Raphael, Gabriel, and Michael glorifying creation, which is "magnificent, as on the day it was made." Mephistopheles, hanging out in the court of heaven like a courtier, or ambassador from an opposing court, finds the human condition, "as always, thoroughly bad." "The Lord," who, we can feel fairly assured, takes little individual interest in our affairs, singles out Faust as a good servant, bets with Mephisto on his loyalty, and gives him leave to pursue the wager by seducing Faust however he can. The cosmic drama gains resonance and depth by its layering with the book of Job.

The immensity of the drama framed in this way is answered by the sublime heights of its outcome: Faust's soul welcomed into heaven at the end of *Faust Part 2*. This frame takes us far beyond the magnification of the hero we saw in courtly romance, even though it shares central elements: the electedness of the hero, the quest/striving, the enchanted realm where the fantastic becomes natural, the hero engaged in struggle with fantastic forces in the mode of "adventure," the redemption of the hero in spite of serious failings, the loved woman as the redeeming force, a motif that developed, in however broken a line, from courtly romance to Dante's *Divine Comedy* to *Faust*. The contest with fantastic forces links Faust also with Homer's Odysseus. That gives a quick glance over some of the shared elements, though we could spend much time parsing the differences among these works.

The Faust figure therefore creates magnetism in many ways as do the heroes of other romance forms: close alliances and dire conflicts with supernatural forces, a nearly superhuman ability to overcome them and

succeed. The element I want to linger over is the defiance of God, or the gods.

In earlier chapters I tried to cement the claim that charismatic representation tends to affirm a heightened and idealized view of humanity. It might not be too much to say that that is its purpose. This functioning registers most strongly in the relations of heroes with the gods or with God. In an earlier chapter we discussed Odysseus's sacrifice of immortality in favor of his wife, his family, his kingdom—and saw in this priority a sublime affirmation of humanity, which a reasonable hero could prefer to divinity. The opposition of the divine and human conditions takes a different form in Christianity, and as must be the case in monotheism, the force that a God can bring to bear against a human is intensified when divine power is concentrated in a single being. And so when the hero out-and-out defies God, more is at stake.

Faust has pretensions to divinity, at least titanism, without any authorization. But he cannot attain to godlike knowledge or godlike status. That is the core of his frustration in the opening scene: "Am I a god? I feel so lit!" (439).

> EARTH SPIRIT. You match the spirit that you grasp,
> Not me.
> FAUST (*collapses*). Not you?
> Whom then?
> I'm the image of God!
>
> <div align="center">(512–16)</div>

> FAUST. I'm not the equal of the gods! It rends me deeply;
> I'm like the worm burrowing through dirt.
>
> <div align="center">(652–53)</div>

Faust senses his godlike nature, knows intimately "the god within me" (1566), but the limits on his penetration of nature and its secrets refute the intimation. Everything he tries in the opening scenes aims at maintaining his titanic self-conception. He conjures the spirits to prove that he is their equal; failing that, he finds the alternate route in suicide, the only way open to him to prove that "the dignity of man does not shrink from the height of gods" (712–13). But the final insight of the scenes before the devil's pact is that escape from the human and flight to the ether are not what will

satisfy Faust—but rather life, of which his stifling intellectual world has robbed him. The heights are closed to him, but the depths are a backdoor to divinity. If godlikeness is available to Goethe's titan, then not through study, conjuring, or suicide, but only through the world with the devil leading the way.

One result of Faust's defiance of God, which continues nearly to the final moments of the play, is that his charisma is intensified. The aging Faust, with death just around the corner, reverts to Promethean scorn of gods:

> I know the earth's round well enough,
> The view to the beyond is closed to us;
> The man's a fool who looks blinking heavenward,
> And dreams up beings like himself above the clouds!
> Let him stand firm here and look around.
> The world speaks to a resourceful man.
> What need to wander off into eternity!
>
> (11441–47)

Risking his soul with Mephistopheles makes him titanic. Deep sin and rejection of God is a way to redemption, and that way works to affirm the human. The dynamic at work here, as in Odysseus and Parzival, is rising above or outside of divinity, sacrificing or risking the favor of God, to affirm humanity.

The narrative dynamics of Faust are immense; they make those of Odysseus seem minor and those of Parzival middling. Having sold his soul, he is nonetheless forgiven and redeemed, cheats the devil, and is escorted by the soul of Margarete and hosts of the redeemed, angels, paters, doctors, and boys-died-young, directly into heaven. How he has earned this special grace is vague, but formulated in the lines of the angelic chorus, "We can redeem the man who never ceases striving" (11936–37). The intercession of Margarete, like that of Beatrice for Dante, had a hand in this spectacular rescue.

In short many of the elements that we have identified as rousing participation and imitation are at work in *Faust*, their intensity turned up to the highest setting observed so far.

Goethe the Educator

Goethe cast his work, along with all of his activity as writer and thinker in his later days, as a grand educational project. He writes to C. J. L. Iken thanking him for a letter full of praise for the planned Helen episode of *Faust*. It is time, he writes, to end the passionate conflict between classics and romantics, clearly the central point of Helen's union with Faust: "What is most urgent is that we educate ourselves; it doesn't matter from which source, so long as we need not fear the distorting influence of false models" (September 27, 1827). Goethe's later works as education, his preoccupation with Johann Joachim Winckelmann and the art of classical antiquity as curriculum—this project frames his later life. While I know no comment to the effect that he regarded himself as "the educator of Germany," it is fairly clear that education was one of his main goals, that he sought, in his works and his own presence, to pose a "positive model." This goal is summarized in his attitude toward the "elevating" power of art, in the exuberant optimism, stress on happiness, health, and healthy thought and writing he set against romantic sickness, in the positive attitude toward the world that he regularly expressed, sometimes in statements bubbling over with optimism and affirmation, like this passage from his essay on Winckelmann:

> When the healthy nature of man functions as an organic unity, when he feels himself in the world as a great, beautiful, dignified and valuable entity, when a harmonious contentment affords him a pure, unencumbered pleasure—then the universe, if it were capable of sensing itself, would shriek with delight at having reached its goal and find itself standing, astonished, at the highpoint of its own becoming and being. Otherwise what is the sense of all the lavish panoply of suns and planets and moons, of stars and milky ways, comets and sunspots, of worlds formed and forming, if it does not give some human an unconscious moment of happiness? ("Winckelmann," p. 22)

His disgust at romanticism (see especially the letter to Zelter of June 18, 1831) was only mildly altered to include his admiration of Byron. But he

could still issue a sharp criticism of Byron's negativism and a defense of "good and joyous" poetry:

> His endless oppositional and disapproving attitudes were ruinous to even his excellent works. Not only that the poet's personal discontents are evident to the reader, but also, that all oppositional activity militates toward the negative, and the negative is nothing. If I call what is bad bad, what does it accomplish? But if I call the good bad, it does much damage. To have a true influence one must never find fault, pay no attention to things perverse, but always do only what is good. What is important is not to tear down but to build something in which humanity can feel a pure joy. (Eckermann, *Conversations*, February 24, 1825)

Undoubtedly there is an unstated remorse in this attitude: a sense that he himself had generated or helped generate romanticism and had to stem the flood tide toward the negative and eccentric that his own works, *Werther*, *Faust, Part 1*, and some of his early lyrics ("Prometheus") had loosed.

Walter Benjamin cast a side-glance at Goethe himself when he directed some lines of mixed praise to Eckermann. Having called his *Conversations with Goethe* "one of the finest prose works of the nineteenth century," Benjamin continued: "What fascinated Goethe about Eckermann, perhaps more than anything else, was the latter's unrestrained attachment to the positive—a quality never found in superior minds and which is rare even in lesser men. Goethe never had any real relationship with criticism in the narrower sense."[32] Benjamin's harsh judgment confers superiority solely on the mind of the critic and intellectual, and that limitation excludes from "superior minds" the modality of Goethe's "attachment to the positive."

But what speaks out of Goethe's defense of the good, the positive, health, joy, and happiness[33] is not the voice of the critical intellectual, but that of the educator. "Lesser men" may often fulfill the role of educator, at least in comparison to the likes of Walter Benjamin, Adorno, Heidegger, Wittgenstein. It is not surprising that a resounding statement of "attachment to the positive" in Goethe comes in the context of pedagogy. It is in the section of *Wilhelm Meister's Journeyman Years* called the "Pedagogic Province." The elder who guides Wilhelm through the province and sets forth its pedagogic bases explains that much of the regimentation aims at

cultivating "reverence" (*Ehrfurcht*), which comes in four different catego-
ries: reverence for what is above us, what is below us, what is equal with
us, and reverence for oneself. Wilhelm takes this principle to be opposed
to negative thought and action: "'I understand!' Wilhelm answered; 'the
mass of men are so caught up in ill-will because they are only comfortable
in the element of ill-wishing and ill-speaking. Whoever delivers himself
over to these forces will soon be indifferent to God, contemptuous toward
the world, vicious toward his own kind, while the true genuine, indispensi-
ble self-conception destroys itself in ignorance and pretense.'"[34] While
Goethe is not referring to a habit of critical thought, but rather to an uncrit-
ically negative attitude, bad-mouthing and fault-finding, the lesson, which
Wilhelm ardently affirms, is appropriate to the education of young people.
"Criticism," whether it derives from precision of thought or from ill will,
has no place in the pedagogic province.

It is also worth noting that the imitation of models is prominent in the
pedagogy of the "province": "There is a peculiarity of human nature which
makes a precise judgment [of the individual's stage of development] rather
difficult. It is the spirit of imitation, the inclination to adapt oneself to
another. It is rare indeed that a pupil hits on something with no precedent.
Mostly they choose something well known, something they see before
them. . . . They adapt themselves to this one or that one, and in this way
more general attitudes and convictions take shape; we discover in what
directions each one inclines, which model he rises to" (bk. 2, chap. 2, p.
432). "Pedagogy" is about the development of the self, of character and
personality. That is very different from the development of critical judg-
ment. The distinction is clear from many relevant passages in Goethe but
worth mentioning since Benjamin's comments ("unrestrained attachment
to the positive—a quality never found in superior minds, rare even in lesser
men") so clearly exclude Goethe from the ranks of "superior minds."

In confronting Benjamin's comment with Goethe's own "unrestrained
attachment to the positive"—arrived at comparatively late in life—we face
again the two opposed cognitive modes, enigma and revelation (see Chap-
ter 3). Both are deeply irrational. The enigma is tragic and intellectually
engaging, its puzzles provoke analysis and illumination; revelation is cogni-
tive optimism, untestable and defensible only by some kind of faith, ordi-
narily at odds with the probing intellect. Charisma is an ally of revelation.
There is no necessary connection between mental acumen and charisma.

Current and recent experience teaches that the intellectual level of charismatic figures can sink very low indeed. The denial of the intellectual is often attractive to disciples of a charismatic teacher (Christ chose simpletons to confound the wisdom of the world).

Goethe would be fast to recognize the distinction between the intelligence peculiar to the intellectual, and the force, charm, and exemplarity of a charismatic person. He gave a close description of a charismatic personality in defining what he called "the Demonic."[35] As a force in nature it manifests itself, for instance, in earthquakes and natural disasters. It is like a third force of morality alongside Good and Evil. He shows the Demonic as at least partly Faustian in the passage quoted at the beginning of this chapter: "It seemed to be at home only in the realm of the Impossible and dismissed the Possible with contempt." He mentions the main character of his early play *Egmont* as an embodiment: "I gave him a boundless lust for life, an infinite confidence in himself, the talent of drawing all to him and so also the favor of the people." The Demonic is strangest when embodied in a living person. It "constitutes a force that is not exactly opposed to a moral world order, but that crosses it like warp and woof":

> But it is most terrifying when it appears as a predominant quality in some person. . . . [Such people] are not always the most distinguished, either in mind or talents, they seldom possess a humane goodness; but they radiate an immense strength, and they exercise an incredible influence on all creatures, even the elements, and who can say how far such an influence might reach. All the combined powers of morality avail nothing against them; useless that the more intelligent among men try to unmask them as deceived or deceivers, the mass is drawn to them.

The description anticipates Adolf Hitler. Goethe would certainly have seen a fair amount of this quality in Napoleon. But nothing in the quality confines it to diabolical, terrifying, or world-shaking purposes. "Demonic" means "enspirited by a 'daimon,'" some spirit and personal genius that raises the being of the demonic character outside of the commonplace. It can be as benign as Socrates's "daimon" or as malignant as those exorcised by Christ. Inject an "attachment to the positive," to health, optimism, and happiness, and a demonic character turns into a charismatic teacher.

Goethe the educator is a role inscribed not only in his works, but in his person, in a way so direct as to remind us of the charismatic teacher from antiquity and the Middle Ages who was, in his own person, the curriculum. Ebullient after meeting Goethe for the first time, Eckermann gushed, "What all will I learn in his presence this winter! . . . merely through my proximity to him . . . even when he isn't saying something of note. His person by itself, his mere presence seems to me to educate, even when he says nothing" (September 18, 1823). Besides cultivating it in his own person, Goethe was also keenly attuned to the force and quality of personal presence; he claimed to value it above talent: "In general, the personal character of the writer accounts for his influence on the public, not the arts of his talent. Napoleon said of Corneille: 'If he were alive I would make him a prince'—and he didn't read him. He read Racine, but didn't say it of him. For that reason Lafontaine stands in such high regard with the French, not for his poetic merit but for the greatness of his character as shown in his writings" (Eckermann, *Conversations,* March 30, 1824). This priority may account in part for the gross misjudgments Goethe rendered on some of his contemporaries, Jean Paul, Kleist, and Hölderlin. In rejecting their writings he was rejecting the person more than the poetry. But he was willing to advocate a flawed work if charismatic qualities were available in it. He said of the confused early works of Winckelmann, "One learns nothing when reading him, but one *becomes* something" (Eckermann, February 16, 1827).

While he may well have warmed to the idea that he himself was the lesson, he also regarded much of the activity of his mature life as pedagogy. The entire sprawling corpus of the novel *Wilhelm Meister* is embraced by the idea of education. It moves from a humanistic idea of individual development, formation of the ego and self-fashioning in the *Apprenticeship* to a more limited conception of education in the *Journeyman Years,* where the didactic purpose can take on the character of a fictionalized tract ("The Pedagogic Province") propagating a radically anti-Rousseauean education close to military regimentation. Goethe apparently envisioned a pedagogic activity for Faust's soul in heaven; he sent him back to his teaching career. At least he has the chorus of redeemed boys (children who died young) sing in the final scene,

We were taken early
From the choirs of the living.

But this man has studied.
He will teach us.
 (12080–83)

Thomas Mann cited this passage in his essay "Goethe and Tolstoy." His exuberant commentary on Goethe as educator:

> Ever more distinctly the idea of the personal development of the self through adventure in [*Wilhelm Meister's*] *Apprentice Years* transforms into the idea of social education [*Erziehung*]. It funnels completely into the social and political in the *Journeyman Years*. . . . Anyone who has ever loved himself in the sense that he regarded his own ego as a cultural duty and striven to fulfill that duty, anyone who has ever been that egocentric, will also ultimately have been led to pedagogic activity in the real world, the role of leader of youth and shaper of men in all its happiness and dignity. The moment of the insight into this role, when it occurs at the height of life, is the highest moment in the life of a productive person. . . . It will not occur to the poor autobiographer whose energies are exhausted in the cultivation of his own garden . . . that he "can teach anything to improve and transform mankind" [quoting *Faust*, 372–73]. Nonetheless, the day will come when, incredulous with amazement, he will realize that in learning, he has also taught; that he shaped, educated, and led young people by means of the lofty, eros-filled and community-shaping cultural medium of language. . . . This insight will dominate his existence from this point on; the pleasure in writing and representation will far surpass all common human happiness derived from love and family, just as the life of the mind in general surpasses the sensual-individualistic life in dignity, beauty and grandeur.[36]

Goethe's didactic bent is a strange development of a major intellectual figure. The didactic has to be associated at least in part with what Benjamin called "an attachment to the positive," though in this capacity it cannot be "a quality never found in superior minds." Certainly those works in which Goethe developed intentionally a kind of exemplarity seem among his stiffest and least compelling as poetry, drama, or fiction: "Hermann und Dorothea" or *Wilhelm Meister's Journeyman Years*. His major works have

decidedly not a didactic purpose in the straightforward sense of the exemplarity that this study has concentrated on. *Werther* and *Elective Affinities* turn on psychological and social problems; the destinies of their characters pose enigmas and tragic dilemmas, not models that invite imitation and participation as does Wilhelm Meister. Far from educating and shaping youth, they confront the reader with a tragic fatedness. They cannot be equated with the kind of work Goethe called for in insisting on the good, the true, and the beautiful, or the true and the beautiful approached via the useful.

The inconsistencies of *Faust, Part 2,* show us a Goethe caught between the complexities of existence and Goethe the educator, convinced of the value of ancient beauty for his culture, of his task in teaching that beauty to his countrymen, and of his obligation as educator more generally—to provide "good models," elevate his countrymen, show them divinity, shun the negative and perverse, and proclaim the good. In Goethe the pedagogic parts company with psychological realism. The imagination can move "from the useful to the true to the beautiful" when attached to a pedagogic goal (that phrase is from the "Pedagogic Province" of *William Meister's Journeyman Years*). The idea that man is a demigod is useful—as pedagogy; the idea that the beauty of the past can be revived is useful—as pedagogy; the idea that the imagination has no limits is useful—as pedagogy; the idea that the impossible is possible is useful—as pedagogy. There is the gray zone of the "effect" (*Wirkung*) into which the realist in him can retreat when resolving the impossibilities of the love affair of Faust and Helen. But *Faust* was above all others the work of fiction in which magic, the impossible, the ideal, and the imaginary were to bend back the limits that hedge them, and so it is also a work where realism and idealism, psychology and pedagogy occupy the same space, all their dissonances unresolved. But even in the world of practical experience Goethe wanted to affirm striving beyond the possible. He made a curious comment to Friedrich von Müller that shows him holding firm to his belief in the possibility of the impossible, strangely in this case, in the context of popular magic. Müller and friends had witnessed the performance of a mountebank in a public market. They brought it up in conversation and got this comment from Goethe: "In order to make the impossible possible, one must only set to work on it with restless striving. Last year in Dornburg I saw an Indian stick a knife several feet long into his throat. It had required several years of daily practice."[37] A minor and eccentric if spectacular accomplishment, it's true, but the echo

of Faust's "restless striving" and the more remarkable "one must *only* . . ." are worth pointing out. In a more elevated context, he also took Napoleon as the facilitator of the impossible: "To anyone who served under Napoleon and shook the world along with him, nothing will seem impossible" (Eckermann, February 29, 1824). He recognizes the illusionary character of magic and conjuring, including charismatic effects, but also their force. He recognizes that he cannot bring the dead back to life in reality, but admires the act of the imagination that makes it seem to have happened, as Manto loves the man who desires the impossible and Faust despises the vulgarity of the cure and return of a "charged imagination" to mere reality.

Goethe's influence was such that Wilhelm von Humboldt could claim that he re-formed reality: "In him reality gave up its shape, only to receive a new one from the hand of the creative imagination."[38] At the end of World War II a distinguished German historian could seriously suggest "Goethe Sunday Schools" as a source of moral regeneration for Germany.[39] But his influence was decidedly mixed. In the negative, it ranged to the diabolical. The same man who wanted writers to "pay no attention to things perverse, but always do only what is good" had created Werther, an unstable character, who commits suicide when he proves unable to win the love of another man's wife. His Faust seduced a village maid, provided the drugs that killed her mother, killed her brother in a duel, got Gretchen pregnant, waltzed around the world with Mephistopheles, to whom he has sold his soul, while Gretchen is left to give birth to and drown her baby, go insane in prison, and die by beheading at the sentence of a court, probably the kind of court in which Geheimrat Goethe would later support the death sentence for an unwed mother who kills her child.[40] Faust, having left Gretchen to her fate, wakes up on the day after her death fresh, free of guilt, sensitive to the splendor of the day and the transcendent meaning of the rainbow, ready to proceed with further adventures under the guidance of Mephistopheles.

The overarching outrage is the pact with the devil and Faust's ultimate redemption, earned by unremitting striving. These elements of his work and others like them were also active in Goethe's reshaping of reality. The morbidity of romanticism was at least helped along by the influence of Goethe. His vision of Faust redeemed by striving and of impossibilities overcome by longing created a category of the privileged genius, which bore fruit in Rimbaud, Baudelaire, and Verlaine and gave impetus to a trend that associated genius with criminality. His *Werther* and *Torquato Tasso*

had helped associate art and sickness, a trend that peaked in European neoromanticism of the *fin de siècle*. The reach of these trends is evident in the fierce and passionate resistance to them by Fyodor Dostoevsky. His *Crime and Punishment* and *Brothers Karamazov* aim directly at exposing and deflating the cult of the privileged genius.

Early on Goethe's near contemporaries were sensitive to the questionable side of this crushingly powerful model. Madame de Staël wrote, in her treatise on Germany, full of admiration for Goethe and of misgivings on Faust, "Faust arouses our astonishment, but the impression it leaves in our soul is by no means a pleasant one. . . . Faust is definitely not a good model. It may be significant as a work of intellectual frenzy or as testimony to the rebellion against excessive reason. In any case it would be preferable if such creations were not repeated. But I must say that when a genius like Goethe throws off all restrictions, then the wealth of ideas is so great that it overflows on all sides and leaves the limits of art in shambles."[41] A journalist, Ferdinand Gustav Kühne, in his essay "Faust und kein Ende" (something like, "Faust—he won't go away!"), called for a parody and satyr play of Faust: "Faust perches like a lump of lead on German shoulders. He nestles in their hearts and infects their blood. We sit and write poems and blather about the destiny we carry in our soul; we chew it up and swallow; it comes up; we chew and swallow again, and as often as we do, we can never digest ourselves."[42] Goethe's call for positive works and artists who represent the good, true, and the beautiful was vehement, but too late. The direction of culture in Europe followed much more closely the ethical trends of Goethe's storm and stress period. Germany was set on a path to "inwardness," which isolated the artist by setting him above society, left him dangerously indifferent to politics, and condemned a German popular culture, any German popular culture, to vulgarity and banality.

In high culture the devil's pact did not go over well as a means to higher knowledge and redemption. Balzac's novels take up central ideas of Faust and turn them toward catastrophic ends. Others have noted the elements that link Mephisto and Faust to Jacques Collin and Lucien de Rubempré, Gretchen to Esther Gobseck.[43] Lucien in effect sells his soul to Jacques Collin in return for literary success and entry into Parisian high society. He is led on by "the eternal feminine" in the figure of Esther. And the arrangement leads to her wretched death and his suicide. The Mephistophelean Jacques Collin, however, ends his days as a high-placed civil servant. Balzac created a Faustian truth seeker in *The Quest of the Absolute*. Like Faust he

is drawn into the world of scientific experimentation, driven by an unquenchable hunger for secrets of nature. It drives him to insanity and his family to ruin. The master artist Frenhofer in *The Unknown Masterpiece* is obsessed with creating a work of art that transcends the boundaries of art and makes a woman come to life on the canvas. When he unveils the masterpiece on which he has worked for years, the culmination of his artistic life, the canvas is covered only with formless smears of paint, a faint suggestion of a woman's foot at the bottom, and it goes up in smoke and flames along with the master and all his works as soon as it is exposed. The final Faustian wisdom of Balzac is that the impossible is impossible, no matter how powerful the longing that drives the quest; the unattainable is unattainable, no matter how strong the desire; and the artist's imagination is not God, a god, or a demigod, however much it wants to be; its limits are met when it tries to elbow reality aside and replace it with imagined worlds. The one who constantly strives can easily wind up broke, imprisoned, insane, and hanging from his own necktie.

The most trenchant criticism of the Faust figure as a model of German identity came from Thomas Mann (writing twenty years after his essay "Goethe and Tolstoy"). Mann wrote his novel *Doktor Faustus* (1947) out of the deep bitterness and pessimism into which World War II had plunged him. As many had done before him, he makes Faust into a representative figure of Germany and the Germans, but here he presses all the implications of the flirtation with the diabolical.[44] His novel dramatizes German culture since Goethe as a pact with the devil. The culture Goethe introduced leads in a straight line and with a stringent logic to Hitler; the pact with the devil accounts for its greatness (as it does for the greatness of Adrian Leverkühn), and it is complicit in what looked at the time he wrote like the total destruction of Germany—thus Mann's wholesale condemnation of German culture since the eighteenth century.

There are many Goethes ("universality," a term common in his commemoration), but the one at work in *Faust* created an intellectual rebel, advocate of the titanic creative genius, the author of "Prometheus," the titan who created and cultivated a mankind greater than the wretched race of slaves and sniveling worshippers the gods or God made to pamper their egos. His Faust cursed the entire world order and "smashed" it to rebuild it "in his breast," shocking even the chorus of ghosts who witnessed his ranting (see lines 1583–1627). The dynamic genius who dances with the devil, sleeps with Helen of Troy, and floats into heaven had more power to

enchant than the pleasant, rather passive middle-class Wilhelm Meister who ends his career as an ordinary medical assistant.

Recall that charisma and the sublime override judgment. Oddly, the voice of sobriety, the only character who advocates reasoned judgment in the entire drama, is Mephisto, who sticks the blood-signed contract in his pocket and smirks (to himself; Faust is offstage), "Go right ahead, despise reason and knowledge, the highest powers of mankind, take strength from illusion and magic shows by the lord of lies—then I've got you for certain!" (1851–55). It is good to exit the spell of Faust's allure and ask, what has his redemptive "striving" accomplished? In part 1, a trail of tragedy and ruin; in the central moment of part 2, the union of Faust and Helen whose offspring fades like a mirage. What remains of that greatest of conjurations is some promise of future poetry and individual, inner improvement. Besides great adventures of the imagination and land reclamation, what remains behind of Faust's striving is very little. Even the settlements he builds by the end of part 2, while they provide housing for many, also spell the death of the old couple who refuses to move out of their cottage so that Faust can have an attractive view. Their death by fire is the drama in the foreground of Faust's socially beneficial project.

Redemptive striving is not fulfilled in any practical, real accomplishments. It is all inward, adventures and accomplishments of the imagination. The rest is high-risk tourism. Max Kommerell pointed this out: "His enterprise is immense by itself. That suffices. . . . His doings are great, not his deed."[45] *Faust* ends in immensity of person, little else. So the rescue of Faust's soul at the end of the play seems like an incomprehensible and mysterious act of grace. The man who translated the opening of the Gospel of John, "In the beginning was the deed," might have expected worse.

The play leaves us with a tremendously charismatic figure who affirms striving to whatever ends it leads, the quest of the impossible no matter how futile, and the exercise of the imagination pushing against boundaries it can never cross. He can fill readers with desire and ambition but not with purpose.

For all its ambiguities the elements of Goethe's *Faust* virtually crowd up to us and offer themselves as central exhibits in a typology of charismatic representation: the great figure, his rise, the catastrophe followed by a second rise and ultimate redemption, a breakthrough from the everyday to life experienced as an unfolding revelation moving toward a redemptive end, the adventure of the hero questing in a world of fantasy, the abandoning of

any commitment to mimetic/realistic representation, the hero whose character and destiny draw others in, numb their critical sense, absorb them into the heightened contours of his elevated being. And the element of the sublime ("grand conceptions," "enthusiastic passions") powerfully at work to inspire wonder and amazement, to overwhelm readers and transport them out of themselves, the sublime with its dual capacities: to "develop our natures to some degree of grandeur" and to strike terror into our souls. And finally, we can add to the typology of this experience: the devotee of Faust—let's say, the collective devotee as he develops over two centuries—who backs out of the spell the character weaves and shakes his head in alarm at all that he has consented to in the course of his enchantment.

10

The Statue Changes Rilke's Life

In those gods in human shape the effort of man to copy that divine
model through which artists had realized the law of perfection,
unattainable but imperious, found its purpose and its happiness.
—Werner Jaeger, *Paideia*

Rainer Maria Rilke's poem "Archaic Torso of Apollo" is a defining "myth"
of charismatic art exercising a transforming effect. Here is the poem in the
original:

Wir kannten nicht sein unerhörtes Haupt,
darin die Augenäpfel reiften. Aber
sein Torso glüht noch wie ein Kandelaber,
in dem sein Schauen, nur zurückgeschraubt,

sich hält und glänzt. Sonst könnte nicht der Bug
der Brust dich blenden, und im leisen Drehen
der Lenden könnte nicht ein Lächeln gehen
zu jener Mitte, die die Zeugung trug.

Sonst stünde dieser Stein entstellt und kurz
unter der Schultern durchsichtigem Sturz
und flimmerte nicht so wie Raubtierfelle;

und bräche nicht aus allen seinen Rändern
aus wie ein Stern: denn da ist keine Stelle,
die dich nicht sieht. Du mußt dein Leben ändern.

The German is dense, relies on subtle wordplays, and defies translation. I will paraphrase and weave in some commentary.

The poet is situated in no place discernible, no museum or gallery, looking at an ancient statue of Apollo. The indefinable space, far from other works and other viewers, allows undisturbed communication between the two. The poet posits a kind of ideal placement of sculpture in a void. He had admired Auguste Rodin's proposal to mount his statue *The Citizens of Calais* on a two-story tower built in the ocean not far from Calais, where its self-enclosed completeness would be better admired than amid the distractions of a city square. (The proposal was turned down by the city of Calais.)[1] The reader's sense of the statue of Apollo existing together with a single viewer in a void may echo this urge to isolation to make the experience of an artwork individual and private. The only location is the implied space between the object and the viewer.

The statue is mutilated, the head broken off, only the torso remains. He views it at first with the comfortable sense of stability and autonomy that the reifying of art tends to create in the general viewer, or perhaps with Rilke's sense of art's isolation from reality, its encapsulation in a "magic circle" that permits no entry and no communication:[2] the marble god is a *thing* from a distant time, safely confined to a realm outside the real, to be admired, and, being already owned and exhibited, like a zoo animal, it presents itself to the first glance as "domesticated"; it provides the viewer an unthreatening and pleasant "free play of the imagination and understanding."

But this sense of autonomy and stable separation of life and art is gradually disturbed. He becomes aware of a force the statue emits, something like a consciousness aimed at him, the viewer. He feels like he is being watched. And far from enjoying art disinterestedly in a Kantian mode circumscribed by taste, imagination, judgment, and understanding, he finds himself engaged in something like a power struggle with the statue. It is a gazing contest, and the statue is watching him more powerfully than he is watching it. It may have no head, but it has eyes everywhere else, or seems to. Vision sits in its chest, its shoulders, and loins, penetrates its every curve and contour, and gaze radiates like a powerful light from the surface of this eyeless polyops. The body sees, so intensely that it glows like a bright, shimmering brace of candles. If it were not filled with light and vision, the poet asks himself, how could the breast dazzle you so and how could the gentle curves of the thigh send a smile toward that place of convergence

where conception happens ("jene Mitte, die die Zeugung trägt")? And how could this transparent stone shine and flash, how could light like a star break from its every contour?

This light crescendo ends with the cryptic final line and a half of the poem:

> For there is no point
> that does not see you. You must change your life.

> [Denn da ist keine Stelle,
> die dich nicht sieht. Du mußt dein Leben ändern.]

The work of art has the force of a strong human presence, and it exercises a fatherlike authoritarian influence over the weaker living presence, whose sense of the impassable barrier between reality and art is eroded in the course of their meeting. It's not clear who is saying "You must change," the one who issues or the one who receives the command. The statue has tapped into an inner state of the poet that he himself has not yet recognized. It forces whatever malaise it finds there into consciousness. Rilke capitulates to its silent authority the way a guilty person might confess in the mere presence of a daunting judge, or the way a Catholic might be overcome by unconfessed guilt just at the sight of a priest and a confessional: "*Don't say anything. You don't need to. I know what you want!*"

The body of the archaic torso "implies" the head; it sees though it has no eyes. It fixes him in its eyeless gaze, which sees more powerfully—the way blind poets and prophets see more powerfully than the seeing—and draws him into the orbit of its greater, semidivine authority. (Its authority over the observer, assuming it is Rilke, may well be greater than over others, since it is Apollo, god of Rilke's art.) In the same way charismatic art implies a missing human presence reestablished in an artificial/artistic medium. The statue's missing head symbolizes lost or hidden presence sublimated and operating through the work of art.

The source of charismatic force in the statue is its body. It is godlike and charisma-filled, not an object on the same level of existence as the man. It is made by an artist's hand and seen by an artist's vision, but it is also far from mimetic art. It has luminous physicality and sexuality (a smile in the thighs!), and, the end of the poem tells us, it also has will and authority. It overwhelms the viewer, the way the sudden, unexpected presence of the

king close by and face-to-face would confuse and overwhelm a subject. It also overcomes the critical sense that insists on the barrier between art and life. Rilke is alone with the statue and nothing "happens" in the realm of the statue. What happens is the struggle that plays itself out in the space between the two contestants and its result. The commandment "You must . . . !" ushers from a voice more imperious even than Jehovah's, whose divine modal auxiliary is mild: "Du sollst . . ."/ "You ought to . . ."/"Thou shalt . . ."

Experiencing the Charisma

Walter Benjamin's comments on "aura," often referred to in earlier chapters, help illuminate the force that flows between the viewer and the statue. Benjamin might describe what happens here by saying that Rilke "experiences the aura" of the statue. Benjamin's comments on aura in his Baudelaire essay set the experience of aura—of things or artworks—in terms that fit this poem strikingly: "To experience the aura of a thing means, to invest it with the ability to look back at you."[3] The exchanged gaze has psychological power. Benjamin placed the experience in the context of "things" that a viewer "invests" with the power to look back. The viewer's act of investing makes it a wholly subjective experience, and while "things" gather up the subjective associations of those who perceive them (relics, petites madeleines), Benjamin's leap into the mystical and mystifying happens with the idea that what is invested is the "power to look back," as if the object gained eyesight from that with which the viewer invests it.

The eyesight of Rilke's statue is different, however. Its effect is the combination of qualities specific to the thing itself and associations projected onto it. The statue combines the effects of aura and charisma. It is not a distant mountain (Benjamin), a crudely modeled block of wood (like the Madonna of Rocamadour) or a cookie (Proust), but an exquisitely shaped body whose truncation intensifies its physicality and multiplies its force. At the same time it is the body of the god of Rilke's art, an association that has meaning for the poet but is little beyond a historical curiosity for the casual observer. Also, the statue has in itself a quality that Rilke will describe in his Rodin monograph as "life" (see below). It is stuffed to overflowing with that quality. It has so much of it that the functions of the head don't require the head itself. The reserve supply of thought, vision, sense, hearing

in the body, the overflow from a lost head, is so great that those things ooze from every point on its surface and are perceived by the viewer prepared to see it. What would its effect be if it actually exercised the force of vision and the authority of person through its head. The gods show kindness and mercy to humans by throttling down their divine brilliance and warn them against viewing their full-powered divinity, too great for mortals to bear (Zeus and Semele). The statue nonetheless sees without eyes. Sight is distributed throughout an eyeless body. So Benjamin's definition doesn't apply exactly to a situation where the object isn't "invested" by the subject with vision, but rather possesses it by the fanciful physiology just described.

The experience of the statue is through and through charismatic. As I said earlier: there is no charisma without physical presence. The statue has it so intensely that it needs neither head, legs, nor arms to be physically superior to the ordinary observer. The experience of the statue is a parallel to what the icon worshipper experiences when communing with an icon. The psychology of visual reciprocity lifting the beholder into a realm where higher beings live, rescue, issue commands, is at work in both cases. When the worshipper looks at an icon, convinced that the image is a living vessel of the revived saint, then the occupied icon can look back at him. In the case of icons the agency of the work of art is activated by the theology of the image: of course the object looks back; Christ or the Virgin Mary lives in it. But that, too, like Benjamin's "the object looks back," is a metaphor or a metaphysical trope, helpful for getting us into the psychology of the event, but not into its ontology. As the efficacy of icons depends on beliefs of the viewer, as the ability of objects to stare back depends on a psychological willingness or need in the viewer to vivify the object, so also the ability of a statue to glow, see, and issue commands depends on the psychic state of the observer. It is easy, and on the surface rational, to deny that there are any real effects at all, just some self-enclosed event in a psyche triggered by its own subjective need: pictures don't work miracles and statues don't see and glow. Not everyone reacts as Rilke does to Greek statues, and that encourages us to think we are dealing with poetic fancy.

The Agency of Art

Is there some kind of agency really, ontologically at work in the statue? If our parallel to the statue is the living human, we can still dismiss the experience

as purely subjective. A person can act out of intention; a statue cannot. The effects of personal charisma can also be seen as results of intention on the part of the agent/actor: a politician gives a carefully rehearsed speech, prepared by voice and gesture training, combed over by speech writers, and he enchants his audience because he wants to. A statue or picture cannot act in the same way. Some nonliving objects have the ability to exercise agency without intentionality, for instance the action of a chemical "agent." Pour sulfuric acid on a hundred human hands and it will have presumably the same effect on each. There we have agency, a consistent physical action and predictable effects, without intentionality. Chemical compounds "behave" according to internal laws that operate free of anything that we could regard as volition: sodium "attracts" chloride powerfully enough to "alienate" partners in weaker relationships into which it might have entered. Goethe explored this idea of agency beyond personal will in *Elective Affinities*. A love relationship dissolves a marriage; the forces that drive the "realignment" of partners are mysterious and beyond the grasp or control of the actors—or would be were it not for the intervention of another force adverse to the "elective affinities," but just as mysterious and beyond personal agency. A detailed analysis of Goethe's novel might help understand the problem of the agency of art; I can shorten the discussion and illuminate the ontology of statue charisma by reducing the problem to sexual attraction. One person radiates it and another is enchanted by it. The force radiated has real power, however subjectively perceived. It can radically influence the behavior of the person under its spell, can deprive that person of reason and judgment, can subject him or her to the will of another. Also, while there is a strong subjective element in sexual attraction, it is a real experience, whereas works of art that see and icons that really live and perform miracles are imagined experiences. Sexual attraction also does not depend on intentionality. A man can claim that a woman exerts it on him, and the woman denies that she's exerting anything on him; she dismisses his claim as a lie, a threat, a form of harassment. The one experiencing enchantment can enjoy the agent of it without any cooperation of the enchanter ("If I love you, what business is it of yours?"). Another beholder can find the same woman repulsive. There are broad lines of consensus on what constitutes sexual attractiveness in a man or woman—physical characteristics, personality, intelligence, power, and so on—but broad variation from those patterns. It is not predictable, largely subjective, and yet undeniably effective.

Classical Greek art aims at distilling the qualities that form that highly variable consensus: a certain harmonious proportion of parts of the body,

the shape of the torso, breasts and legs, facial features, the posture suggesting motion and life, projecting grace. The enchanting force of the human body thus represented is a real experience, available to any viewer—not a fictional response to art. David Freedberg's chapter "Arousal by Image" is strictly about sexual arousal, an interesting parallel to charismatic effects.[4] But just a parallel. The agency of Rilke's statue also is *like* the agency of sexual attraction. But if we can let that parallel stand, then we've come a long way to accepting the real character of the experience Rilke describes within a poetic trope.

The improbability of the statue's life force is determined in the perceptions of the reader in part by the cultural status of museum-kept art. If we allow biography to confuse the self-encapsulated nature of the statue, we can imagine Rilke in the Louvre (where he no doubt got his inspiration for the poem). That placement secures it largely from participation with the viewer. In that setting it is an object, a thing with no life in it, ingeniously carved. The genius is that of the artist, so the museum visitor imagines, not that of the thing. The museum lowers the quality of communication between art object and viewer; it turns down the current of charismatic effects. Museum art is put there for study, and visitors accept the artworks on those artificial terms. The museum encases its holdings in a mantle of empirical thought: to understand this work of art, to locate it in the history of art, to analyze its composition and the ideas conveyed by the artist—so says a casually accepted popular mind-set—is to enjoy it. The aesthetics of Kant and Schiller prepare us for a gradual moral transformation as a result of an aesthetic education; it requires detachment and the ability and will to extract virtue from the visible—thus the logic of Kantian aesthetics. The museum no more encourages a surrender of the will to the work of art than it encourages, say, stripping naked in imitation of the Apollo Belvedere. Seeing the eyes of the headless statue staring at him powerfully and imperiously suggests something closer to derangement in the viewer.[5] At least for Kant the absorption of the viewer by the work and the abandonment of will to art have to appear like a loss of rational control. It is, however, a common response, if not of the connoisseur to art, of the simple worshipper to an icon.

Transformation

"Archaic Torso" moves through various transformations. First, of the viewer's vision: the statue changes from an art object to a gloriole-radiating god

who sends inaudible but perceptible messages. The agon of a viewer who begins as an autonomous subject first dazzled (*blenden*) then seduced (the curving thighs smile toward the genitals—a precious image internalizing erotic double gendering and punctuated by the poem's single internal rhyme, *blenden—Lenden*), then made the object of an overpowering visual force (every place on the surface sees you), finally taken command of ("Du mußt . . ."), establishes a hierarchy of greater and lesser presence, and the greater force of the statue absorbs the will of the lesser being. The statue assumes the somatic force of the living body of a god. In Rilke's contest with the statue something big is at stake, something having to do with the present condition of the viewer: he discovers his inadequacy. He is inferior, insufficient, weak, ugly, miserable. We are free to imagine him riddled with faults and failures to which he tacitly confesses. The statue shames and humbles him. This is a common way of describing the response to a powerful work: the text is more powerful than its reader; the image is so grand as to diminish the viewer—and of a worshipper to his or her god. I discuss this agonal effect in the next chapter.

"Du mußt" is Rilke's capitulation to a greater presence. The statue exercises the tyranny of ancient perfection, very much like the Greek statues Werner Jaeger referred to as "gods in human shape" who impose a model and set by their lapidary presence an endpoint to the human effort to realize "the law of perfection, unattainable but imperious."

Hypermimesis implies the real existence of a supernatural world. It crystallizes in a real object, and if it is possible to see transcendence in the immanent thing, then the thing confirms the existence of a transcendent world, just as, if you accept the divinity of Christ—a living man of flesh—it would be absurd not to accept also the higher existence of divinity itself. If the viewer will only give up his own will and capitulate to the higher force confronting him, the grandeur of that higher world is available to him.

The Messianic Poet Rescues Culture

Rilke and his generation wanted to imagine art and poetry powerful and exercising grandiose effects. This glorification of art was in large part a response to the fear of the decline of their civilization, in part a rescuing impulse, turning to Western tradition—classical art, for instance—as a

reproach to a civilization that was selling its soul to technology, progress, and capitalism.

This broad trend in intellectual culture in Europe had its origins in romanticism. But one of the most powerful influences pressing this idea of contemporary wretchedness and lost artistic grandeur was Jacob Burckhardt's *The Civilization of the Renaissance in Italy* (1860). Burckhardt's recreation of Renaissance culture evoked a world freed from the sterility of medieval modes of thought, which had held human will and creativity captive for centuries. One result of the liberation of the individual in Renaissance Italy was the flourishing of the greatest period of art the West had known since antiquity. Burckhardt's vision of the Renaissance offered his contemporaries and the following generations a model of the resurrection of culture out of decadence, which was, fatally as it turned out, joined to the exercise of violence and arbitrariness in governing. Burckhardt also formulated a widespread malaise of a dispirited generation, the sense that they had experienced the extinction of human greatness. In an essay entitled "Historical Greatness," he made the comment, much quoted later: "Greatness is—what we do not have."[6]

Burckhardt found an enthusiastic disciple in his younger colleague at the University of Basel Friedrich Nietzsche. There is much of Burckhardt's *Civilization of the Renaissance* in Nietzsche's early work *The Birth of Tragedy from the Spirit of Music* (1872). Both works evoke heroic ages (ancient Greece, Nietzsche; Renaissance Italy, Burckhardt) and represent them with the power of myth to a contemporary world that both authors regarded as sterile, convention-bound, spiritless, and lacking greatness. Nietzsche's view of classical art was a drastic revaluation of ideas essentially determined by Enlightenment ideas and the works of Johann Joachim Winckelmann. Nietzsche did not abandon or contradict those influences, but he deepened them by defining the art of Apollonian culture (sculpture, epic poetry, the Olympic world as represented in Homer) against a more dynamic, vitalist Dionysian strain. The result is an extravagant and dazzling view of the messianic cultural mission of classical art and sculpture, nurtured and manipulated into greatness, so to speak, by a hidden agenda of nature. Apollonian art exists as a counterbalance to Dionysian wisdom, the high point of which is the insight into the fundamental horror of existence. Dionysian pessimism induces loathing and nausea, paralyzes the person who sees it, makes him incapable of any action. At most he might manage suicide. It negates existence. Everything in life seems terrifying or absurd.

In the middle of this crisis of Dionysian wisdom the rescuer appears: "In this moment of the greatest peril of the will, there approaches an enchantress, a savior wise in cures: Art. Only art is capable of reshaping those thoughts of horror and loathing into visions that make it possible to continue to live. These are: the Sublime, by which art tames horror, and the Comical, by which art cures the nausea of absurdity."[7] The beautiful vision of an Olympian realm, the Homeric world, the statues of the classical period: these great creations of Apollonian art exist not to give pleasure and waken the understanding—but rather to lure back into existence a people especially endangered by their deeper knowledge of the real nature of existence behind the veil of the everyday. Apollonian art is a grand illusion but one of those illusions powerful enough to dissolve their own illusory character and lift the viewer into a "heightened" world that makes redemption, vitality, greatness, seem attainable. The grandiose illusion is one created by nature (or what Nietzsche calls "the genius of the world") to accomplish a goal beyond aesthetic virtuosity: to affirm life and rescue a type of wise man threatened by existential despair. This bold conception of the purpose of art makes it into a savior, a guardian against despair and death.

The thought of messianic art is in the air at the turn of the century. The poets of the European *fin de siècle* looked for alternate realms of value and transcendence to substitute for the collapsing world of Western philosophy, religion, metaphysics, a world unable to sustain the spiritual coherence that had survived for centuries in the West. Resurrection and renewal through art and vital cultures of the past was a thought that commended itself to William Butler Yeats, T. S. Eliot, Rilke, and others. Yeats returned to Celtic origins and spiritism; Eliot sought renewal in the world of ancient fertility cults opened up by Frazer's *The Golden Bough*—and ultimately in Catholicism.

Rilke was familiar with Nietzsche's ideas, and he undoubtedly saw the "event" represented in "Archaic Torso of Apollo" as an example of redemption through Apollonian influence, even if he would part company decisively with Nietzsche on the question of "beauty" and "illusion."

George the Redeemer

An age in need of redemption, religious or cultural, is vulnerable to charismatic figures. It will nurture desires for greatness that border at the fringes

on messianic expectations. Such expectations seemed to many, in Germany at least, to be fulfilled in the figure of Stefan George.[8] A lengthy description by Edgar Salin, a disciple of Stefan George, of his first contacts with the German poet, will convey this aspect of the cultural atmosphere at the turn of the century:[9] "He who has breathed the flaming air of *living poetry* for the first time will never forget the moment in which his heart, warmed by new fevers, beat faster, *a mighty storm blew* through his inner world, *realms yet undreamed of opened before him*, then the narrowness of the sanctuary seized him, until perhaps finally a flood of tears brought him back to his new self." After this vague outpouring, Salin goes on to explain its object: as a young student he was walking in Heidelberg one day in 1913, when suddenly the sullen crowd of students around him comes to attention and opens its ranks to let a single person pass, who moved as though winged and floating.

> The observer stood rigidly as though some spell rooted him to the spot. *A breeze from a higher world* had touched him. He no longer knew what had happened, hardly aware where he was. Had that been a human who strode thus through the crowd? But he was different from all humans. There was an unself-conscious majesty and a lightly wielded power around him, so that *next to him all the pedestrians seemed like mere empty forms and soulless shadows. Was it a god* who had parted the crowd and hastened on winged feet to other shores? . . . In his hand whirred a small, thin walking stick—was it the staff of Mercury? And that countenance, which the observer could only vaguely recall: its features were sculpted and the pallor of his cheeks strengthened the impression of some alien, *statuelike, godlike* presence. And his eyes? Suddenly the observer realized: it had been a beam of these eyes, sent to him with the speed of lightning, that had held him spellbound, had penetrated to the innermost region of his soul. After a fleeting smile he strode on. Then the realization arose: if this was a human being, then it could only be—Stefan George.

This operatically staged scene breathes (to use Salin's term) the air of stylized sanctity, of ancient religious rituals in the perfumed, balletic style of Pre-Raphaelite art. We don't need to ask whether the crowd actually did part on that fateful day, having been seized by some mass presentiment of

greatness approaching. But the awed reverence of the young enthusiast
Salin is at least clear. The scene continues: he follows, hoping to catch
another glimpse of George. He observes how light seemed to rise up from
his body, but is abashed when, their eyes meeting again, George seems to
frown faintly. Again he is rooted to the spot, "frightened, confused, and
blissfully happy."

The "master" appears at an evening discussion group at the house of
Friedrich Gundolf. Salin is present. Salin again employs the artifice of a
religious ritual, or at least religious experience, to stage George's appear-
ance. It is an entrance befitting the apostles receiving an unexpected visit
from the risen Christ: the room is dimly lit by a single oil lamp, and "inau-
dibly the door opened behind us and closed again. Only *a gentle breathing*
assured us that we were no longer alone in the room with Gundolf. We
turned, very slowly and fearfully. Before us stood Stefan George." It is an
entrance scene from an overdirected movie. The main figure does not
epiphanize at once. We have only his breathing (the *Atem* and *Hauch* and
Wehen that regularly announce and emanate from George's spiritlike com-
ing and going in Salin's memoir); we see the disciples in the grip of an
anticipation too great to gratify itself by mere reality, too intimidating to
confront in its heightened state. In worshipful awe they embolden them-
selves to turn and face the master.

It is a poetry evening. The young men proceed to read their work.
George criticizes the readings. This intensifies the shock of a private conver-
sation with the master: George himself will comment on their poems. But
a distraction lets them sink back relieved into a dark corner of the room:
"Once out of the line of fire, we had . . . the opportunity to let the powerful
excitement subside and to observe the poet whom we timidly worshipped
and timidly feared." In the half-lit room they observe that he is of normal
height, something that escaped them upon their meeting in the street,
where his figure "so exceeded all human scale." His figure seems, Proteus-
like, to vary from delicate and graceful to "peasant density, taking strength
from the earth beneath him." In a later meeting the timid disciples stand
by and observe while the master and one of his older admirers discuss
Hölderlin. It happens that there is a bust of Julius Caesar on the table that
separates them from George. George raises his head slightly and, lo and
behold! the two profiles, George's and Caesar's, are aligned: "The inescap-
able magic of this image, along with our knowledge that they shared the
same birthday, impelled us to compare the two." They find remarkable

resemblances and are led to the insight of the relatedness of the man of poetry and the man of action. But "the *power of life*" puts Caesar in the shadows, and they continue a minute survey of George's physiognomy, then summarize: "[his whole appearance] was flooded by that quintessence of *grace and dignity*, for which the word *charis* irresistibly imposed itself on us." Such "irresistible" moments are common in the meetings with George, since Salin is at pains to suggest, by breezes and breathings and blowing winds, that higher forces waft into the human realm, in the way that the gods interfere invisibly or disguised in the Homeric world, to bring forth the words, gestures, and actions in that magically charged space "Around Stefan George" (the title of Salin's memoir).

The book goes on in a tone of cultic adulation so overdrawn that one asks first, is this a parody? The young Thomas Mann had encountered George a few years earlier in Munich, smelled the same incense burning around the high priest, his acolytes, and worshippers, and wrote a biting and hilarious parody of the whole scene ("At the Home of the Prophet" [Beim Propheten]). Mann's story also exposes how susceptible cultic self-surrender to a powerful "master" might be to fanatical ideas of world domination, which were not far away on the horizon of German history.

George picked his devotees with good taste and judgment. Many of them became accomplished poets and scholars. Edgar Salin had a distinguished career as an economic historian, sociologist, humanist, and public man, in charge of the Basel office of labor disputes for a number of years. He served a term as rector (i.e., president) of the University of Basel. This sober public man was powerfully under the spell of the master and spoke a widely shared language of discipleship. His book on George appeared in 1948, was well-received, and had a second edition in 1954—that is, he maintained his reverence for "the master" many years after these formative meetings. It may be difficult for an American in the early twenty-first century to take the animal earnestness and slavish worshipfulness of these passages seriously, but they are at least a genuine record of the atmosphere in the George cult observed by an otherwise levelheaded intellectual and public man. But it also suggests to the post–World War II reader a susceptibility in Germans that made many of them willing followers of Hitler.

Putting aside all mantic and romantic nonsense in Salin's prayer book to George's memory, his description is a wonderfully vivid example of relationships in the cult of a charismatic leader.[10] "Life" here also is a recurring motif. George appeared as the life-giver of German poetry at the end of the

dreary and disenchanted late nineteenth century, Salin notes. George seemed to offer "deeper, broader, and more exclusive penetration into the poetry of the Germans—the living image of the living poet seemed like a magic wand calling all poetry to life." The statue of Caesar fades from their attention because the "power of life" evident in the poet upstages the Roman general and emperor. The "living statue" (i.e., George himself) is compared with the stone artifact (Caesar) to the advantage of the former. And George is himself "living poetry."

The presence of the master also evokes other worlds, past worlds, gods, and spirits. Myths and great Romans offer comparisons commensurate with the "more than human" presence Salin sees. He magnifies George into the titanic: he comes from a "higher world"; he is like Hermes/Mercury or the giant Antaeus (he gets his strength from contact with the earth). The ancient Greek vocabulary of beauty and grace has to supply the word (*charis*) to describe a figure who lives in the twilight between the past and the present; the vocabulary of the contemporary world cannot supply them. The hieratic atmosphere around George also emerges clearly from the "breaths," "breezes," and "winds." "Had it been a human?" "Was it a god?" "If this was a human, then only . . ." His chiseled face rouses "the impression of some alien, statuelike, godlike presence." Charismatic light surrounds his person: "a beam of these eyes, sent to him with the speed of lightning, that had held him spellbound"; "a light seemed to beam from him."

The passages quoted here, and many others in Salin's work, give an anatomy of authority relations within a charismatic cult. They also show how the cult figure works on the imagination of his devotees, an essential element of such cults: the image of the master is a project on which they are at work. The project opens a realm of fictions and images and poetry and representations, called forth by the charismatic figure, cultivated by both master and disciples. Stories accrete around him. His every word and gesture are the stuff of fabulation. His life becomes a narrative affirming the visions of the followers. "Realms yet undreamed of" open before the disciple, as they did before Salin at the first look at George. The disciple, Salin, is drawn out of the world of everyday experience into the higher world in which the "master" lives. He dreams the dreams of the master, is deaf to criticism, resists with aggression any attempt to lessen or undermine the idol, and longs to live in that world himself. It is a condition in which the mind is under a spell and capable of an uncritical awe that extends to

selfless devotion and beyond, to self-sacrifice. In the political realm such
unthinking devotion is useful to a demagogue and dangerous to the subject.
In the presence of the king, or of the messianic ruler, the follower would
gladly sacrifice his life to maintain that of the king (the spell cast by the tsar
on Nicholas Rostov).

The spellbinding effect of charisma is directly related to love. The rever-
ence for the ruler/teacher/star/whatever is a kind of love in which the
adored one can do no wrong, is a higher being. The language of gods and
goddesses is again at hand, also the sense of destiny and predestination.
Salin felt a sense of electedness in his first encounter with George. The
master's glance inexplicably singles him out from the crowd. Again the
comparison with romance suggests itself. There is something of the star-
crossed lovers in that recognizing glance. The master sees by prophetic
vision a quality in the devotee that is destined to bind them together. The
recognition troubles, frightens, and exhilarates the devotee. The mysterious
election is answered by the marvelous recognition. As if he had never seen
him, Salin can exclaim, "if this was a human being, then it could only
be—Stefan George."

George embodies renewal. The death of poetry and of the imagination
seemed imminent. George appears in order to revive them. Such dreams
and expectations are a normal part of cult experience. The charismatic
awakens extravagant hopes in the devotee, visions of happiness, heroism,
divinity, the restoration of the spirit, and the realization of fantasies. The
charismatic and his followers create and share a world in which the bound-
aries of reality become unclear. Reality and illusion, genuinely spellbinding
personal qualities and fraud, become difficult to separate. Dreams appear
realizable, the deepest hopes and desires appear attainable. Greatness—
"what we do not have"—is restored to us in Stefan George. He rescues the
entire sterile present from disenchantment.

This is the vision of one of George's most gifted disciples, Friedrich
Gundolf. Gundolf wrote a monograph on George in 1920, which sees all of
Western artistic, intellectual, and spiritual history—imminently threatened—
rescued from extinction, fulfilled and redeemed in George.[11] The opening
chapter is titled "The Age and the Task." The age has been abandoned by
the gods, lacks a spiritual church, any form of "public magic," and all
sense of mystery. The unity and coherence of being that the ancient world
knew "would be lost forever, either a stage we are glad to have passed or
a receding dream we mourn to have lost—if it were not again renewed by

the physical presence of Stefan George" (p. 25). George's meaning and role in history is that "he alone is on the level of the eternal human, as opposed to the modernist "humanity." Stefan George is important by virtue of a form of being that would be lost or legendary without him. All by himself he maintains the living tie to a primal world of essence. . . . Only George has the living will and human essence most recently incarnate in Goethe and Napoleon" (pp. 22–23). George does what Burckhardt and Nietzsche had evoked in their historical visions: he prods the present world to rediscover a lost perfection.

While George's person and character—George the "total man"—are in the foreground of Gundolf's prose hymns, he sees George's real task as the rebirth of the German language and of poetic culture (p. 1). Poetry was the magic force of transformation. The program of George and his circle was "the restructuring of life through poetry."[12]

It is an exorbitant vision of a world gone to the dogs rehumanized by a single personality, transformed and reenchanted by his poetry. The George circle was not alone in propagating it. A group of poets around Hugo von Hofmannsthal founded the journal *Hesperus* during World War I. Its task was "nothing more nor less than the rescue and security of the whole coming generation."[13]

Rilke and Rodin

The poem "Archaic Torso of Apollo" (written in 1908) is far from a direct reflection on the messianic totalitarianism of redeeming art of the George circle. But it resonates clearly with some of the notions of transformation through the art of antiquity: a luminous god or godlike figure invested with *charis* communicates mysteriously with his devotee, dissolves the boundaries between illusion and reality, weakens the devotee's resistance and will, exercises a sexual-like magnetism, turns imperious, and gains a measure of control over the life of the beguiled and bewitched adherent. Something remains in the Rilke poem of visions of redemptive, miraculously healing art.

Like the followers of George, Rilke also looked for messianic culture heroes. His first was the Russian novelist and religious prophet Tolstoy; the second, the sculptor Auguste Rodin. The latter is to Rilke what George was to Salin and Gundolf—with big differences I'll stress later.

Rilke came to Paris in 1900 with a commission from a publisher to write a monograph on Rodin.[14] The stay, which lasted with interruptions until 1908, meant both a major shift in Rilke's poetry and a deterioration of Rilke's personal life, racked by marital problems, penury, and existential misery.

He studied Rodin, came to know him, hung out in his studio, wrote his monograph, and eventually became his inofficial private secretary.

Rodin's art is for Rilke the answer to the great intellectual curse of his own time and his own life: all conflicts happen in the realm of "the invisible." They do not find external shape. They have no surface, "no things, no houses, no exterior" (*Auguste Rodin*, p. 240). The present is cluttered with thought, encumbered with reflection; all ideas and sense impressions are internal and, if not formless, then having the contours and substance of smoke in the wind or of form shrouded in fog. But the art of sculpture turns inwardness outward, gives it "a firm handhold and a nobility deriving from its mere existence, not its meaning" (p. 149). The resurrection from vagueness that Rilke experienced through Rodin's influence is evident everywhere in the Rodin essays and in his letters from the period 1902–8. The loss of structure and coherence of the current generation is overcome by Rodin's art, which develops in the course of his life into "a force that has not existed since antiquity" (p. 240); the darkness of inwardness is exchanged for things that glow as if from the light of "a new solar system."[15]

Rilke formulated Rodin's great discovery and breakthrough in the antinomy, fiercely asserted, of conventional form versus "life." In the paradigm shift that Rodin represents, "Life" becomes the central idea:

All the received concepts of sculpture had become worthless for him. Pose, group, composition no longer existed. The only thing that existed was a countless multitude of living surfaces, only life existed. And the means of expression he had discovered for himself went straight for this life. Now his task was to master it and its plenitude. Rodin seized the life that was everywhere, wherever he looked. He grasped it in its most inconspicuous sites, observed it, stalked it. He lay in wait for it at the bridges where it hesitated, where it ran he caught up to it, and in every nook and cranny he found it equally great, equally mighty and rapturous. There was no part of the body insignificant or minor: it was alive. The life in faces

[is] like the faces of clocks, easily read, easily related to time. Set in
bodies it was more diffused, greater, more mysterious and more
eternal. (*Auguste Rodin*, p. 151)

This is for Rilke the remarkable achievement of Rodin: the injection and
compression of life into every surface, fold, and corner of his statues. The
arms have life when they embrace; but embrace is no longer restricted to
arms or sight to eyes in Rodin's works, but as if that which empowers arms
and eyes were too immense in the Rodinian armature, or as if the vision
were too big for a single set of organs to contain, its vital function erupted
from its source and spread throughout the whole body. The body need not
fear amputation of the instruments of embrace or, amputated, loss of the
force of grip; no lack of hands and arms diminished the body's capacity to
embrace and hold; blindness of the eyes did not hinder vision from seeing
through other surfaces of the body. If tears and weeping were the subject,
then he learned from Rodin of a weeping "that was ubiquitous, spread over
the whole man, and tears that seeped from every pore" (p. 152). Rodin's
The First Man showed forth life equally distributed throughout every point
on his body. If the figure bespoke the pain of a primal awakening, then this
emotion was written on the tiniest part of the body: "each surface was a
mouth, speaking, in its own way, the same pain. The most critical eye could
discover no place on this body that was less living, less definitive and clear"
(p. 160). He found a similar justification of the armless statues of Rodin.
They forfeited arms "in order to become all arm," like a man who gives up
his drinking cup in order to drink from the stream (p. 163).

Rodin's triumph is the overcoming of metaphysics, the renunciation of
ideas and allegories, in the return to radical vitalism of form and affirma-
tion of the statue's surface as the site of the maximum concentration of
"life." This comes to Rilke as a great simplification, not as Schillerian
"naïveté" or Nietzschean vitalism, but rather as a return to a reality prior
to all ideas, a reality not yet incorporated into the "interpreted world."

The ancient world had known this will to form and the priority of
surface vitality over meaning and allegory. Greek sculpture realized the apo-
theosis of the exterior. But that will had lain in incubation for two thousand
years and in its long fallow spell had gathered up an immense new energy,
which it was Rodin's task to discover and make visible. Rodin clearly was
for Rilke what Wagner had been for Nietzsche, the great rescuing artist in

whom the titanic creativity of the ancients is reborn. Rilke finds in Rodin a release from stagnation and sterility into a new vitality. It is a vision of redeeming art comparable to that of Salin and Gundolf for whom George's poetry revitalized an exhausted culture. In both cases the transformation of cultural barrenness into vitality becomes a reality. Art overcomes cultural stagnation.

The Poet in a Cage

Some suggestion of a broadly transforming force of art, that is, a force exerting itself on the culture at large, might be read out of the poem "Archaic Torso of Apollo." But the reading is not consistent with Rilke's tendency to regard poetry as existing ideally in neoromantic isolation of the aesthetic, moving in a closed circle without any relation to history and society. The transforming effect in "Archaic Torso" is radically individual-ized, restricted to an elite cult of poetry encompassing the god of poetry and his devotee. The belief community evoked consists of Rilke and Apollo. Instead of a world-conquering—at least a Western-world-conquering—vision of redeeming art militant and prophetic, the poem encapsulates Rilke's own experience of the release from spiritual sterility through the sculpture of Rodin. "Archaic Torso" conveys the reordering, not of culture and certainly not of mankind, but of a poetic gift run off the tracks.

Rilke experienced long dry spells in his creative life. He wrote out of inspiration and, like many poets who rely on the muse, he found himself abandoned over long stretches.[16] One of these dry spells set in around 1900 and returned periodically during his stay in Paris. The wretchedness, filth, and suffering he experienced every day in Paris caused physical nausea and existential loathing, expressed in his novel *The Notebooks of Malte Laurids Brigge*. These irritations were aggravated by marital problems, too little money, and doubt in his calling as a poet. He sought recovery through a new preoccupation with the visual and the objective, that is, objects, includ-ing sculpture. His fear of creative sterility registers in one of his most famous poems, "The Panther" (1902). The panther pacing endlessly in his cage is a fierce vitality stifled. The "great will" that seems to guide the animal in his "dance of strength" is numbed—or to put it in a term that connects the panther with the poet, an-aesthetized. The "dance of power around a center point" continues endlessly and absurdly in its demarcated

course. Now and then the curtain of the eye opens, an image enters, courses through his body, only to die in his heart. The death of image-consciousness in the panther is tied to the numbing of the great will governing the power dance.

Rilke projected his own crisis onto the caged animal. The images enter the eye only to die in the heart; they generate nothing, inspire nothing. The heart is as numbed as the vision, which "no longer grasps anything"; instinct dies out—a desperate situation for a poet or artist, whatever it is for a panther—an image of intellectual sterility and the death of the imagination. Graceful motion becomes empty ritual when repeated without the governing center. The ordering power is there, but silent, anesthetized.

In a long letter to Lou-Andreas Salomé written in the summer of 1903, Rilke expressed the personal crisis that had him strung out between the creative impotence of "Panther" and the renewing force of "Apollo." He unpacks his enthusiasm for Rodin at great length, opposes the "thing"-ness of Rodin's work to that which he superseded, the abstraction of beauty and illusion and the illusion of beauty, and exclaims, "The appearance of his things is a matter of indifference to him [Rodin], so powerfully does he experience their *being*, their reality, their total release from imprecision." The force of Rodin's work is the "silent and surging realization of the wish to exist." His own creative force, by contrast, is weak and ungoverned: "I still lack the discipline, the ability and compulsion to work that I've longed for for years. Is it strength I lack? Is my will weak? Is it the dream in me that thwarts any action? The days pass and now and then I hear life passing. And still nothing has happened, still there's nothing real around me, and I divide myself again and again and flow off in all directions." He had known intuitively, long before he met Rodin, that the sculptor was "infinitely exemplary, the model" for a life governed by work, and he comes away from the encounter with Rodin with a great simplification and a new will to work: "I will pull myself together out of all distractions. . . . Only things speak to me, Rodin's things, the things on Gothic cathedrals, the things from the ancient world—all things that are perfect things. They pointed my way to the archetypal model, the restless, vital world, seen simply and without any interpretations as the source of things. I'm beginning to see in a new way."[17] "The Panther" evokes a crisis of creativity; "Archaic Torso of Apollo" conjures its healing. Rilke's personal crisis is consistent with that of his generation:[18] in his own understanding of the crisis and its resolution, a consciousness that had lost itself in metaphysics and abstractions is

brought back to "being," to "life," to "existence," and to "reality" by the curing encounter with the great will to visible form that Rodin represented. "Archaic Torso" is the revivification of the governing will through the vision of "living" art and of the commandment of renewal it imposes with a will far greater than that of the poet.

11

Grand Illusions: Classic American Cinema

"Cheek to Cheek" is one of the most famous, most quoted sequences in the films of Fred Astaire and Ginger Rogers. It is set in the context of a moral problem for Dale Tremont (Ginger Rogers) in the movie *Top Hat* (1935). She met persistent suitor Jerry Travers (Fred Astaire) in England. He flirted, he ignored her repeated snubs and attempts to get him off her back—the standard opening relationship in Astaire-Rogers movies. Gradually he wears her down, charms her. They dance in an outdoor pavilion in a rainstorm to "Isn't This a Lovely Day," and she is won over. But before the romance can develop she discovers, or thinks she discovers, that Jerry is married to her best friend Madge (Helen Broderick). Dale is outraged at what looks like a shameless flirtation. Madge's husband is actually Horace Hardwick, Jerry's producer and impresario (Edward Everett Horton). The mistaken identity causes turmoil. After the events in London, Jerry, Dale, and Madge, meet in a lavish grand hotel and nightclub in Venice where Madge hopes to make a match between Dale and Jerry. Dale has to assume that Madge is pushing her own husband on her and encouraging an adulterous affair. But of course, she's not; she just wants her two friends to connect.

This fragile error stays in place for about half of the movie. When Jerry joins Dale and Madge in the nightclub, Madge is winking, nodding, and gesturing to get Dale to flirt with Jerry. They dance. Madge prods Dale to get closer, to seduce and snag him. Dale is confused. She draws back, narrows her eyes in moral disapproval or uncertainty, looks again to Madge—more winks and nods. Then her perplexity melts for a moment:

DALE (*to Jerry*).: Well, if Madge doesn't care, I certainly don't.
 JERRY (*not sure what she means*). Neither do I. All is know is that
 it's [*he starts singing*]

Heaven, I'm in heaven,
and my heart beats so that I can hardly speak,
and I seem to find the happiness I seek,
when we're out together dancing cheek to cheek . . .

And so the whole number is marked by Dale's acquiescence in what she
takes to be an affair with a married man, urged on her by his wife, what
looks like the beginnings of a ménage à trois.

They move away from the crowded dance floor while he sings and out
onto a veranda with marble floor and a balustrade opening onto a garden.
The singing is over, now begins a grand, sweeping dance of tremendous
grace and sophistication across the veranda. It is formal and elegant, Fred
in his evening clothes, Ginger in a white full-length dress hung with thick
overlapping curtains of white ostrich feathers. The vaudeville-like tapping
(as in "Isn't This a Lovely Day") gives way to a dance that is all gliding and
floating. Dale is entranced. She gazes at him, smiles, is lost in the bliss of
the moment. The barriers to romance are forgotten or put aside. Then the
dance ends. Dale rests against the balustrade, breathing hard, coming down
from her entranced state. A long, amorous stare at Jerry. Then she looks
away. The false reality returns. Her smile fades. Her face flickers with emo-
tion: consent to the wickedness of the moment wars with decency. It's her
friend's husband; she (Dale) loves him, but he must be a scoundrel, and
her friend—his wife—a conniving pander. Dale has to overcome either
homespun virtue or aristocratic decorum to consent—and she does: "Well,
if it's okay with Madge, it's okay with me." But that surrender lasts only as
long as the dance.

The mistaken identity drives her into the arms of her suave but ridicu-
lous Italian suitor, the dress designer Alberto Beddini (Erik Rhodes). She
marries him on the spot, sacrificing herself to escape the illicit attractions
of Jerry.

Eventually the error is unmade, not by a logical plot development, but
only by the sense that the trick has gone on long enough. Jerry realizes
what's happened: "She must have taken me for Horace the whole time."

All is set right. The moral problems evaporate, and that includes the quicky marriage to Alberto, annulled because the priest who married them was really Horace's clever butler (Eric Blore), pretending to be a priest in order to insure that the marriage is not valid.

The Astaire-Rogers movies like to veer toward the problematic, then slip back into innocence. In *Shall We Dance* (1937), Peter (Fred Astaire) and Linda (Ginger Rogers) sit on a lawn in Central Park and have a conversation of which a passing cop overhears only the following snatch:

LINDA. Peter, you've got to marry me.
PETER. Why, Linda, this is so sudden.
LINDA If we get married now I could start divorce proceedings in
 the morning.
[*Cop saunters by, overhears their talk.*]
PETER, Well I . . . I don't know.
LINDA. You got me into all this. The very least you can do is marry
 me.
[*Cop shows shock and outrage.*]
PETER. It wasn't my fault any more than yours.
LINDA. All right, it's my fault. But you've just got to marry me.
[*Cop shows he's heard enough; it's time to step in.*]
PETER. I'd like to think it over.
LINDA. But why? There's nothing to think over.
PETER. All right. [*Cop smiles, relieved.*] But where can we get a
 license? Everyone in New York knows us now.
COP [*as he saunters on his way*]. Why don't you try New Jersey?

So in this scene, the policeman is jerked around, as is the Ginger Rogers character is in *Top Hat*. It is part of the formula to play on morally precarious situations that only appear so.[1] Here the cop is invited to think that Astaire's character got her pregnant and he's trying to squirm out of his obligation, then that she seduced him and is trying to sucker him into marriage. Finally—just a misunderstanding: they are good, upright people trying to get out of a tough situation not of their own making. Immorality was appearance; decency troubled by minor problems, the reality.

The safety net of innocence is always there to catch them, while the audience gasps or at least chuckles at their *salto mortale* into the forbidden. The policeman in the scene just quoted is the very embodiment of the

movie censor board and fictionalized enforcer of the censorship guidelines introduced in 1930 known as the Hays Code. Astaire and Rogers play games with him; they provoke his moral indignation, then retreat to the safe ground of innocence: *just joking, officer, just a misunderstanding; that isn't what we meant at all.* In *Shall We Dance* the warden of morality is Eric Blore, here a hotel manager shocked at the possibility that he might have given adjoining suites to a couple (Astaire-Rogers) who is not married. It's true that they aren't married, but they wouldn't dream of sleeping together, so his anxieties are aimed at nonexistent immorality, like those of the policeman.

The world of Astaire-Rogers movies is dry-cleaned and pressed. Three things have been sponged out of it: fault, harm, and threat. They can only enter the scene via misunderstandings. The conflicts of romance, love, courtship happen risk-free. Even the stuff of mortal conflict turns into light comedy. Fred Astaire lies down on the bed in the bridal suite where Alberto Beddini awaits his bride on their wedding night in *Top Hat,* a howling challenge to Alberto's masculinity. The response of the bridegroom, deeply insulted, is fluffy bluster and comic gesticulations with a sword. No one takes serious offense, shows or feels resentment. When bandleader Ricardo Romero (Georges Metaxa) refuses to play music for Lucky Garnett (Astaire) and Penny Carrol (Rogers) to dance in the 1936 film *Swing Time* (Romero is in love with Penny and announces his intentions to marry her), Lucky does not push, punch, or insult him. He heads for the casino, wins enough money to buy Romero's contract from the owner in a card draw. Suddenly he's Romero's boss, and he orders him to play, but does it in a gentlemanly way that rouses no evident anger in the bested suitor.

The most serious subjects turn light. Guy Holden (Fred Astaire) proposes marriage to Mimi Glossop (Ginger Rogers) in *The Gay Divorcee* (1934):

GUY. What would you like—Cointreau? Benedictine? Marriage?
MIMI. What was that last thing?
GUY. Marriage.
MIMI. Do you always propose marriage so casually?

No emotion is strong, no event overwhelms. Love happens without sex, desire without passion, anger without violence, revenge without harm; the resentments are lightweight and the grudges resolvable. This is an entirely

Apollonian world. There is nothing primal or primitive in it. The veneer of civilized gentility is never broken. The classic Astaire-Rogers movies operate in a "reality" that is hermetically sealed from threat. No rend or tear opens the fabric of being to let in a darker reality, one with betrayal, cruelty, transgression, and suffering. The walls are made of clouds and the floor of air. Gravity itself hardly exists, or it enters an agreement with Astaire and Rogers to release them from the heaviness that weighs down the bodies and legs of normal mortals.

Fred Astaire is the perfect hero in this world. His face is soft, rubbery, and boyish, mischievous without malice, aristocratic and clownish at the same time. It shows no extremes. A Fred Astaire turned violent or even angry is unimaginable. The world of the movie appears to have flowed out from his character, talent, and physiognomy. His lightness and impish playfulness infuse all the relations, the habitus of individuals, the entire social construct, even the scenery. The Venice scenes in *Top Hat*, the architecture of the hotel, the white gondolas, seem made from clouds and light. The producers could not have thought, *"We have the story, we have the music and the production design. Now whom can we find to play the main characters?"* Just the opposite: *"We have Fred Astaire. Now what world can we create that accommodates all that he is?"* The answers all flow from him.[2]

How can such a quintessence of fluff survive, receive Oscar nominations, and be voted among *Time* magazine's top one hundred films of all times (*Swing Time*)?[3]

Beneath the spritelike weightlessness of his characters there is a rock-hard consistency. Fred Astaire is the same character in all his movies from the thirties. It is a good example of the star syndrome in which the composed life of the star becomes that of his characters rather than vice versa. The tap and ballroom dancer from Omaha, Nebraska, becomes the epitome of American aristocratic behavior, and the elegant dance is the chief means of expressing aristocratic self-control. There is a close coordination of the controlled emotions and the controlled motions of the body. The dance studio in which Penny Carrol teaches dancing in *Swing Time* has a plaque in front with the motto

Gordon Dance Academy
To know how to dance is to know how to control yourself.

A faint shadow falls from classical orator's and European courtier's education onto this claim: through dance comes *sophrosyne*, self-control which

filters from the body to the soul, and from soul to body. Perfect control of the motions of the body can only result from perfect control of the inner world, the motions and emotions of the soul. Of this art Fred Astaire is a master no less than Cicero's orator or Castiglione's courtier. All passions are held in the check of the golden mean. During the romantic dances he rolls his eyes upward in lukewarm ecstasy. His eyebrows rise in gentle, completely manageable longing. The motto of the Gordon Dance Academy shows the world around Astaire as a projection of Astaire. But it also shows that the uniform decorousness of the world of these films is a result of control, not of sterile, milquetoasty acquiescence in any and all points of conflict.

The complaint that that control is cheaply bought in a world stripped of masculine toughness cannot arise, because the seemingly lightweight victories are undergirded by a magical invulnerability and the imperturbable cheer by unshakable confidence. Lucky Garnett might be backed up by invisible gods and spirits. He hasn't a penny to his name when *Swing Time* opens. He's wearing formal clothing because the dancing troupe he stars in has just finished a number. But he has to go to New York, loses every cent in a bet (one rigged against him; all things being equal, he doesn't lose), and so he hops onto the open car of a freight train in his cutaway coat, striped pants, spats, and top hat. So he's broke in the big city, but dressed to the teeth. This is no sad sack and little tramp. He is "lucky," and his luck is such that he wins every bet. He has a lucky quarter, and it never fails him. He even wins a jackpot in a cigarette dispensing machine that at first swallows his money. One bang with the fist, and nickels, quarters, and cigarettes rain from the opening just in the moment when he had lost his last cent. The two couples of the movie—Pop and Mabel (Victor Moore and Helen Broderick) are the sidekicks of Lucky and Penny. All four are unemployed, but shortly into the story they are dressed to the hilt, living in a grand hotel/apartment, and driving a four-door convertible. It's a charmed life. "Luck" is an inalienable quality of "Lucky," a character trait and a talent like dancing, one of those qualities like charm, authority, sex appeal, various talents that are given as gifts (*charismata*) to elect individuals. He is like Odysseus rising in the assuredness of his success, in the sweep of his rise from bottom to top, and in the mildly magical, god-sponsored spell, disguised by the light comic atmosphere, that gives him mastery of other men, roulette tables, and his own legs. The "Fred Astaire" character gives the movies not just appeal but a subterranean charge that pulls the

viewer into identification—the more broke and the more down-and-out the viewer is, the stronger that pull.

But at least as powerful is the charge placed on music and dance. Those elements give both substance and artistic unity to the films. They also flow, more obviously than the sets and the characters, from the talents of Fred Astaire. His every move is a work of art, infused with a grace beyond what is attainable to ordinary mortals. Even simple actions like putting on his tie, brushing off his pants seem choreographed. There is less division between dance and normal motion in Astaire than Rogers. She walks like a mortal; his walk is a tempered dance.

Dance and music are the most elemental supports of charismatic art. They have gotten little commentary in this book so far because they rely less on representation than do literature, painting, and plastic art.[4] But they add powerfully to the mimetic impulse that character and story generate: I react to Fred Astaire's dances with twitching muscles and nerves, driven by the urge to repeat his movements and accompanied by the conviction that I can do it; it looks so effortless—always followed just as quickly by the realization that I can't come close. Dance as an art forces us to throw the concept of mimesis as verisimilitude overboard. There can be no loyal rendering of ordinary reality in dance. Everything is hyperreality: love and longing, sadness, tragedy, are "hyped." These emotions have no natural rhythm, only an interpreted one, emotion translated into motion, given an ideality more graceful and a passion more convulsive than anything observable in everyday life. Likewise music of all the arts has the greatest power to seize the emotions and give them a sensuous counterpart in the world outside the performer. Both of these arts take the viewer into their world and make that of the viewer dissolve. I forget that I can't dance, and I become a passenger, along for the ride with one of the best dancers in the world; our bodies seem linked, their motions as if coordinated by lines of magnetism. I dance in him and through him; what he does becomes my performance—to see is to do. True, the actual execution stops short of my body and limbs, but the electrical signals that course from brain to nerves are just as real as if I were Fred Astaire or his partner. Governing my organs of perception, he takes charge also of the part of the mental process that generates action, even if the process is short-circuited prior to the disappointing moment where the body betrays its inability to dance as well as the mind. But prior to that point and beyond, the moviegoer experiences the sensation of dancing with and like Fred Astaire. The music likewise

loses any character of artifice, which it has in abundance for those not under its spell. For the enchanted it seems to have become part of nature. We don't question that the dance in the country pavilion in *Top Hat* isn't possible because there's no band to play, no radio to broadcast the music. The music is just there the same way the rain and the thunder are, and likewise it seems perfectly natural, at least acceptable on the terms set by this fictional world, that characters in the film begin to sing when no normal person living in the real world would. Irving Berlin, Jerome Kern, George Gershwin are absorbed into the reality of the film no less than Fred Astaire, invisible presences "hyping" that of the characters and the world represented.

The editing in Astaire-Rogers dance scenes is so unobtrusive and uninvasive as to leave unimpaired the perception that this is reality, not illusion. The dance is grandeur and romance experienced as if it were reality. The trivial artifice of the plotline does not weigh heavily against the sublime reality of the dance.

The music and dance in these films is the one mildly Dionysian element. Lines from "The Continental" (*Gay Divorcee*):

> Beautiful music, dangerous rhythm . . .
> There's a rhythm in your heart and soul,
> A rhythm that you can't control . . .

The dance as seduction is unsettlingly realized in *Carefree* (1938), where Astaire is a psychoanalyst, Rogers his patient, committed to his care by a man who wants to marry her (Ralph Bellamy) but can't get her to consent. His ego-blinders point him to the conclusion that she needs psychiatric care to help overcome her reluctance to marry him. She wakes up from a dream in love with her analyst, Astaire; the love is generated by a dream dance scene. In a remarkable sequence, later, not her dream, Astaire hypnotizes her. The point is to turn her off of himself and on to Bellamy, but hypnosis and seduction merge in the dance. The sequence represents visually the hypnotic quality I've tried to express in the previous paragraphs: one person performs motions not by his own will and talent, but by the hypnotic force of another. *Carefree* has some untypically dark elements— screwball comedy meets psychological drama; it veers in the direction of Hitchcock's *Spellbound* (1945). Clearly the producers of *Carefree* were

stretching the formula of the earlier films. The love attraction and courtship routine takes on the aspect of psychic control and power relationships.

The lines "Beautiful music, dangerous rhythm . . ." are the Dionysian counterbalance to the pure Apollonianism of "To know how to dance is to know how to control yourself." Dance is an instrument of seduction ("courtship rituals," one viewer called them).[5] In *The Gay Divorcee*, Rogers resists Astaire's advances because she takes him for a gigolo, or just because she finds him annoying. Then they dance to "Night and Day." She resists, and resistance and pursuit become the dominant of the choreography, followed by Rogers's yielding. She is won over, but briefly. As in "Cheek to Cheek" the enchantment lasts as long as the dance. The quick passage from resistance to the coordinated dance movements is beguiling for the viewer; the act of seduction on the screen repeats on the viewer's inner screen where the dance is perceived and co-performed. The dynamics of that unconscious insight snatch us from difficult courtship to ritualized intercourse, another quality of the Astaire-Rogers mystique. The dance numbers are chaste and deeply erotic at the same time. The stuff of sexual fantasies could be shown to the League for Moral Purity (if there were such a league) without ruffling feathers. Romantic dance is the ideal skirting of the Hays Code, the perfect medium for the erotic in films from the thirties to the fifties and beyond—deeply suggestive but not offensive.

Gene Kelly was fond of dream sequences to imagine the pursuit of a woman who evades him in reality (*An American in Paris, Singin' in the Rain*). In dance the rituals of sex and the act itself can be transmuted and played out as public performance. The dance scene onboard ship in *Gentlemen Prefer Blondes* (1953) nearly goes over the edge in its suggestiveness: Jane Russell dances out her admiration of the three-quarters-naked bodies of the men on the American Olympic team.

American "Classical" Movies

What do "classic" and "classical" mean? Goethe tried to understand ancient Greek sculpture in these terms. He wrote in his *Italian Journey* that classical sculpture is that which remains after time has sifted out everything mediocre. The winners in the competition staged by Time assimilate to "Nature."

The classical work of art may become nature in Goethe's sense, but in the sense of hypermimesis, it expands nature. Oscar Wilde was close to this view in his essay "The Decay of Lying": "What Art really reveals to us is Nature's lack of design, her curious crudities, her extraordinary monotony, her absolutely unfinished condition." Let's replace "Nature" with "Reality," and urge that a classical work of art magnifies reality, orders it through design, polishes its crudities, and completes it, relieving it from its "unfinished" condition. The tyranny of "reality" is greater at present than what Wilde and the romantics called "nature." Our conception of reality tends toward the lowest setting of human motives, instincts, and values. When a movie or work of literature hits that mark plausibly, we tend to say, *"yes, well, that's reality,"* a remark that no classical work of art or literature can provoke.

The truth value of what is perceived as "reality" is completely relative in relation to the truth value of an aggrandizing vision of the same "reality." In Michelangelo Antonioni's *Blow-Up* (1966) the fashion photographer hero (David Hemmings) becomes obsessed with a "fact," or set of facts, revealed, at least suggested, to him by some random shots from his camera. It seems to have captured a murder. He pursues the facts obsessively, and the closer he approaches, the more the truth recedes. Understandably—he lives his life in the hyperreality of fashion photography; his work is the construction of charismatic images. The man who has made his living concocting glamorous, sexy photographs to seduce consumers, finds himself drawn into the realm of the real and factual, only to be deceived, misled, and left with the world of grand illusion as his only acceptable reality. In the last scene of the movie he passes a troupe of mimes playing tennis without a ball in a public park. Their imaginary ball is evoked by the motions of their imaginary rackets and their positioning to get to it. Their nonball flies over the fence; the players watch it and point to where it supposedly landed. He reaches down, picks it up, and throws it back over the fence—even though it doesn't exist.

The scene is, for one thing, a nice expression of the entry into a belief community, but centrally, of the tension set between fact as reality and imagination as reality. The latter wins the day, at least has the last word. In *Blow-Up*, imagination reclaims one of its devotees who had strayed into empiricism. The acts of the imagination are real and attainable, as long as the truth seeker becomes a player in an imaginary game. Gratification through illusion is more accessible than the factual truth of events in the

sense that the police detective and positivist historian want them. The final gesture of throwing the nonexistent ball affirms illusion, the option that remains after the discrediting or loss of the real and factual as a way to the truth.

Define reality as the complete lack of illusion, and reality disappears, at least shrinks and fades, gets reduced to the bare level it occupies prior to "enlargement." The imagination also shrivels when confined to the desiccating effect of illusion-freed reality. In *Hard Times* Dickens dramatized the diminution of the world and of the individual stripped of all imaginative "fancy." He showed the degeneracy of the myth-deprived characters and reality's "wolfish turn" that devours the captors of fancy and administrators of fact. Art has to be present and active in life in order to limit the diminishing effects of critical reason.

"Classic" art creates tensions between the viewer and the art object by being evidently superior to the viewer at the same time as it appears deceptively natural. That is the sense in which it expands the natural and the real. It sets norms that appear attainable, just well above what ordinary human beings can experience. There is nothing about the aesthetic qualities of the Apollo Belvedere that a living human being with the necessary natural gifts, and with the will, time, and discipline, could not attain. But most don't, and so the classic work shows possibilities that appear superhuman and yet are attainable, and a world that appears far above what is available in experienceable reality, but not completely impossible. The classic rewrites nature to affirm the superhuman human.

Alongside nature and the real—which constantly generate everyday life, reality, minor conflicts, trivial irritations, and lukewarm pleasures—there is another force generating desire. Fantasy and the imagination produce characters, behaviors, destinies, and accomplishments beyond our grasp, which we therefore want to reach. It activates narcissism by thwarting it, by telling you that the you you see in the mirror is ordinary and uninteresting, but the potential you you see in the museum or the movie house is fascinating and is the person you ought to be.

The Astaire-Rogers dances are "classic" in several senses: each move seems necessary and "correct." It is the way it had to be. Change anything and it diminishes the quality of the dance. I know no norm of dance movement (it may be that experts do), and yet there seems to be one that could be inferred from Astaire-Rogers dances. I know the dance is perfect, and I don't know anything about dance. Its perfection is there in plain sight, a

Figure 38. *Swing Time:* Rogers hangs her head. (Photo: Carolyn Hammersly)

"primal phenomenon" in Goethe's sense. Its essential and profound mean-
ing is on the surface, palpable in the viewer's spontaneous physical and
emotional response. You can interpret and analyze the dance, but the naive,
immediate reaction is already fully informed of its finished, perfected qual-
ity. That quality suggests that the viewer is witnessing an archetype, an ideal
form, that can then reproduce itself in others who imitate it, but which is,
as it stands in itself, just right.

The movements, gestures, and positions seem not just to represent,
but to *be* a certain mood and feeling. Sadness and thwarted love sit like
physical objects in the bodies of Rogers and Astaire in "Never Gonna
Dance" at the end of *Swing Time.* No one, feeling melancholy, hangs her
head to the side, against the languid arc of the body, and touches her
shoulder with her chin as Ginger Rogers does in that number (Figure 38).
And yet I recognize it as exactly appropriate to a woman who has just
agreed to marry a man she doesn't love while dancing with the man she
does love. Position and movement, station and motion rouse in the view-
er's mind the vision of melancholy—not merely natural, but—grandly
expressed and "grandly fitting" in the movements of the body. The

ancient world had the term *megaloprepeia*, its root meaning, "grandly appropriate," its rhetorical sense, "magnificent," "sublime." What good is natural grief in this supernatural world? It is just an annoying disturbance without aesthetic appeal. The Astaire-Rogers world shows forth hyper-grief, sadness raised to a higher power, maintaining the law of decorum that infuses the film and at the same time making sorrow and loss into a work of art.

Finally, the Astaire-Rogers dances are hypermimetic. Rhythmic movements of the body that are more graceful and charming than any movement observable in experienced reality, seem natural, unrehearsed, spontaneous, are made to appear like part of everyday life. They make the impression that dance is a mode into which Astaire and Rogers can enter with as little reflection as it takes me to get out of the chair, leave the house, and walk somewhere. Never, under any circumstances, could I dance gracefully down to the bus stop, but Fred Astaire can do it and make it seem not just natural to him, but part of a natural order in which he lives. And since the viewer knows better, knows that he himself is trapped in a reality where the human body and limbs move by cruder laws, he also sees a realm in which perfect rhythm and grace are the law by which its happy citizens live. Perfect grace becomes a norm of motion.

Dance can never be mimetic in the sense of "imitation of nature." It always heightens. Even low elements, clumsiness, cruelty, and violence, are raised up by the mode of performance. Exquisite dance numbers in the film *West Side Story* (1961) choreograph gang fights and murders; one of the most unforgettable numbers dances out the return of a frenzied gang to self-control. Extreme emotional states are an invitation for the interpretive dancer to go over the top. Gene Kelly does it all the time. He sentimental-izes his desire for Cyd Charisse in the dream sequence of *Singin' in the Rain*. His gestures of longing seem governed by the overdramatized emotionality of silent film. His routine in the dance number "Singin' in the Rain" from that movie lives from boyish, affected indifference to conventional behavior ("*What do I care if it rains; I'm in love and I gotta dance to show it; I'm glad to get soaked; it shows how far outside of trivial concerns my life has moved*"). Gene Kelly in love and dancing it out in dream realms feels like self-satirizing, rehearsed ritualized gestures of love. The viewer thinks, "*Now there's going to be a dance number.*" That doesn't happen with Rogers and Astaire. The dance is a seamless part of the films' reality. Dance seems a spontaneous and natural reaction to the given situation, as if they

were making, for the first time and unrehearsed, exactly the right moves given the crisis or joy of the moment. Astaire is classical; Kelly, mannerist.

Music, dance, and the talents of Astaire and Rogers give unity and charismatic force to the whole. Take away those elements and the stories would melt away like cotton candy in the rain. But building on those elements it creates magic. In all the artifice of the Astaire-Rogers movies, the music and dance are real, irreducible elements. At the same time they are what creates or helps create the higher world in which enchantment can occur; they may not make the world of air and light completely plausible, but they erode our disbelief. To call them fluff and artifice would be to mistake their genuine force. The undeniable truth and aesthetic force of dance is the talent on which the whole setting and narrative are based, their hyperreality a plausible elevation of represented reality, consistent with the exaltation of motion that the dancing of Astaire and Rogers projects with the force of an undeniable fact. If they can dance like that, then reality can be like this: fabulous surroundings, witty and wise characters, romance, happiness, a world where money is not a problem, neither is anything else; in short, the enchanted realm.

That hyperreal world creates fascination, draws the viewer into the life of the film, and effaces the contours of his or her real life. It makes the viewer think, feel, and experience as Fred and Ginger do. We are absorbed into the life of the film and welcome the release from our own. Nietzsche described this merging of viewer with dancer: "In song and dance man expresses himself as a member of a higher communal nature. . . . He feels himself as god, now he himself strides forth as enraptured and uplifted as he saw the gods stride forth in dreams. Man is no longer an artist, he has become a work of art."[6]

Happy Movies–Hard Times

During the heyday of Rogers and Astaire films, the outside world was the very opposite of the world of the movies. It was struggling with the Great Depression; it witnessed the rise of Nazism and felt the threat of another world war just a few decades after the most lethal war of human history. In 1935 the unemployment rate in the United States varied between 20 and 25 percent. If you didn't have a job, you were in deep trouble; if you had one, you feared losing it. So when Penny Carrol is fired from her job in the

Gordon Dance Academy in *Swing Time,* it played on anxieties everyone in the audience shared in the year of the movie's release (1936). Her boss fires her ("You're fired, that's final. Now get out"—nearly the same words with which Cecilia is fired from her waitress job in *The Purple Rose of Cairo*) because she can't teach Fred Astaire, who has posed as an awkward amateur to get closer to Penny, how to dance ("No one could teach you how to dance in a hundred years"). It is the setup for the dynamics of "enter abject, exit exalted," at work in Penny's mind. To rescue her job Lucky sheds his disguise and becomes "Fred Astaire," showing off his sudden virtuosity to Penny's awestruck employer, the studio director, as the results of her teaching. She is rescued from unemployment by fabulous dancing skills, someone else's. His rescue of her occurs with the same sense of miracle and unreality as would some supernatural intercession, as if some goddess had made over the man who could not learn to dance in a hundred years into the world's greatest dancer. It appears to the employer as if Penny has transformed Lucky by her brilliant teaching from a stumbling bumbler to a master of the dance, and to Penny as if some inexplicable surge of talent had saved her. Lucky's rise from klutz to virtuoso is sensational. He sheds his mortal gravity to rescue Penny; he acts as a benevolent, supernatural force protecting the jobs of its beneficiaries, elevating them to the heights of society and the entertainment world. A threatened existence rescued by the dance, all good things restored by optimism, sophistication, song and dance, to a world stripped of them: that is the contribution of the Astaire-Rogers movies to national recovery in the grim thirties. The agenda hidden in the idealizing fabric of the movies is made explicit in the song, "Pick Yourself Up," sung by Penny with Lucky sitting on the ground. He tripped over his own feet trying out his first dance steps with Penny as his instructor in the scene just described. Penny sings encouragement to him:

> Nothing's impossible I have found,
> so when my chin is on the ground
> I pick myself up, dust myself off, and start all over again.
> Don't lose your confidence, if you slip,
> be grateful for a pleasant trip,
> And pick yourself up, dust yourself off, and start all over again.
> Work like a soul inspired,
> till the battle of the day is won,
> You may be sick and tired,

but you'll be a man, my son.
Will you remember the famous men,
who had to fall to rise again,
So take a deep breath, pick yourself up, dust yourself off, and start
 all over again.

The enormous success of the Astaire-Rogers films depended not only on
the talent of the stars, but also on the tension set up between charismatic
heroes and dispirited audience.

The division into two realms—Olympian bliss, godlike grace, and
human suffering and stumbling: it repeats the romantic division of Hölder-
lin's poem "Hyperion's Ode to Destiny."

You stride along up there in the realm of light
Where all ground is soft, you happy spirits!
Sparkling breezes sent by the gods
Caress you lightly,
As the fingers of the artist
Stroke the sacred strings.

No fate troubles the immortals.
They draw breath like the sleeping babe.
Genius blooms eternal in them,
Its tender bud sheltered
In virginal blossoms,
And their radiant eyes
Gaze in silent, changeless clarity.

But our lot is—
No place to rest.
Humans suffer,
They faint, they stumble
Blindly from one
Instant to the next,
Like water tossed
From crag to crag,
Downward into
Endless uncertainty.

A division as stark as that is a dominant element of movies of the thirties, those that do not acknowledge and deal with misery, like Astaire-Rogers, and those that do. The film industry in the wake of the Depression was in part mobilized to manufacture narratives of hope and renewal. The desperate circumstances of Depression-era America were the immediate need that generated charismatic heroes, heroines, and films and hastened the rise of a "star system." In the films that responded to that need, the American cinema found the power of combining charisma and charismatic representation with narratives of redemption and renewal.

The American popular film of the thirties is the epitome of what this book is about, charismatic art in full bloom in a medium peculiarly suited to its character.[7] That is not a qualitative judgment setting Fred Astaire and Ginger Rogers equal to Homer and Albrecht Dürer, but rather it states the obvious truth that in the Hollywood classic film we can observe charismatic art as an experience of our own culture and see its impact on an audience at more or less first hand, something we cannot do for Homer or Dürer.

Western Art Declines, Cinema Rises

The American cinema developed as a popular medium, devoted to pleasing a broad audience. This set it apart from the European cinema by and large, which conceived film narrative as an instrument of the interpretation and, largely, the criticism and unmasking of culture, not its magnification. European cinema throughout most of the twentieth century continued European traditions of literary narrative based on the cult of the great artist.[8] The American cinema is based on the cult of the great star. The European cinema lived from the grand vision of great individual directors.

Representative art in the West experienced a revolution in the twenties and thirties. In painting and sculpture we can characterize the trend most broadly as the rejection of representation. This sea change in artistic style is of course seen variously by various viewers. Cubism, abstract expressionism, and primitivism were seen as moves to a new and pure art, freed of the tyranny of realism, freed of the ties to particular persons, places, historical moments, systems of value, the move to an "art of painting in which only aesthetic elements seem to be present," a movement that supplied "the aesthetic evidence that in art feeling and thought are prior to the represented world."[9] José Ortega y Gasset, at the opposite extreme, attacked

modernist trends as "the dehumanization of art."[10] Franz Kafka gave a sweet, sad, and devastating parable of the demise of Western art in his short story "A Hunger Artist," where a once great and popular virtuoso of the art of starvation gradually loses his audience and rescues his self-esteem by the thought of his independent artistic integrity and the incomprehension of a vulgar, sensation-seeking public.

Whatever construction the trend away from realistic representation invited, it seemed to several generations that classical Western art as it had developed since the Renaissance was at an end.[11] At the same time a new art loomed that seemed to replace the artist with a mechanical instrument of reproduction, the camera.

The period of sweeping transition in art was bound to provoke sweeping explanations. The most cited and probably the most intellectually exciting master narrative of the trend is Walter Benjamin's essay "The Work of Art in the Age of Its Technological Reproducibility."[12] Benjamin identifies a transformation of consciousness in the move from classical art to photography and cinema. Prior to mechanical reproducibility, the work of art is characterized by "authenticity" and "aura." The mode of reception—even of wholly secularized art—is "the cult." But given mechanical reproduction, art experiences "the decay" and the "withering of its aura." The reproducible work of art can only emerge and gain legitimacy at the cost of "a tremendous shattering of tradition," which undermines the authority and authenticity of art. The advent of photography and cinema signals the loss of the cultic admiration of art. The "real presence" of the canvas that actually received the brushstrokes of Leonardo or Renoir, that sat in their studios as the glory of Renaissance Florence or of nineteenth-century Paris accreted around it and clung to the authentic and irreproducible canvas like a ghost to its grave, inexpressibly present but unapproachable, mysteriously tucked into its materiality, near and yet distant, sensible and yet impalpable, is lost in mechanical reproduction. Replace the unique work of art with a xeroxed copy, a photographic copy, a digitalized copy, and the collection of images and colors remains, diminished however precise the reproduction, bared of its accumulation of ghosts. For Benjamin essentially "auratic" art is finished in the twentieth century. What passes as art beyond that watershed is something poorer, more dangerous, more available to fascist manipulation and capitalist exploitation. Benjamin sets out bravely to theorize the managing of a new art, but with the clear sense that not much good is going to come compared with what has passed.[13] The lens of the camera

reduces the subject of imitation to an aura-free, science-experiment kind of object, Benjamin believes. Whereas the artist had his analogue in the magician, the camera's analogue is the surgeon. The latter lays bare, dissects, analyzes, investigates a raw reality; and at the same time it filters out any trace of artistic imagination, magnification, or glorification. For Benjamin the camera is the Mr. Gradgrind of representation.

Benjamin thought that the circumstances of filming must have a deadening effect on the movie actor's performance. The idea of an integrated, seamless performance, where an actor projects his transformed self into the character and sustains the transformation for three hours, where Hamlet remains in character from acts 1 through 5, is lost and replaced with individual shots repeated in up to twenty or thirty takes, then interrupted for the shooting of an entirely different scene, then finally edited together in a laboratory in the absence of actor and public. Gone and artificially replaced is the integrity of the performance.

Most remarkable in Benjamin's critique of film, for me, is what he did not observe. Even by the late 1920s it was obvious that movies would be received in the mode of the cult, a cult more fervid and widespread than anything the artists of Europe had envisioned from the Renaissance to the twentieth century. It was obvious also what a powerful force cinema was for progressive change, revolution (Eisenstein), for reactionary sentiments (D. W. Griffith), or for national mythologies (Abel Gance, Leni Riefenstahl). The star system had emerged, and the historically unique relationship of living star to movie role, the source of so much fan adulation and movie magic, was in full force. The year 1939, an *annus mirabilis* of the American cinema, was also the year of Benjamin's third and final revision on "The Work of Art."

Benjamin took note of the "star system," but considered it another means by which the producers of film manipulate the public: "Film responds to the shriveling of the aura by artificially building up the 'personality' outside the studio. The cult of the movie star, fostered by the money of the film industry, preserves that magic of the personality which has long been no more than the putrid magic of its own commodity character" (p. 261). Film history shows how wrong Benjamin was in this assessment. The aura of film and of the star as represented in film is more powerful and more available to cultlike followings than that of a medium so museum-bound and encumbered by connoisseurship as mimetic

painting. For Benjamin the cinema is commodified art, produced for mass consumption, dangerously vulnerable to ideology, its apparatus and production modalities vulgarizing, its results the draining of aura and the stultifying of an already undereducated mass audience.

Benjamin's comments on film read now like the grumpy pessimism of a conservative resisting a new medium. His predictions were not prophetic: the bond between cinema and science, which Benjamin saw as inevitable, linked by the technological character of both, has no part in art cinema and very little in entertainment cinema. Nor does the aestheticizing of politics lead inevitably to war, though this prediction might have seemed sensible when Benjamin wrote, confirmed in Leni Riefenstahl's *Triumph of the Will* (1935). In his negative judgment of the cinema, Benjamin shows the elitist character of his views on aura. The worshippers of film simply didn't worship in the same church with the devotees of Botticelli and Raphael. The former were the masses, and the taste of the masses was vulgar and uninformed. Mass appeal excluded film from the realm of the auratic.

Benjamin and the Frankfurt School helped move the development of German cinema in the decades after World War II in the direction of avant-gardism. The rejection of popular culture as complicit in a "culture industry" maintained a division that had plagued Germany since the nineteenth century and joined Marxist sentiments to artistic and intellectual elitism: low culture was vulgar; high culture, the only realm worthy of artists and intellectuals. If the cinema is not art, then there's no need to pay any attention to it. One result was that artists and intellectuals were not available to change the cinema under fascism into a progressive medium.[14]

Another result of the tyranny of reactionary avant-gardism in German cinema was that the medium remained in the orbit of the genius cult. It produced the bitter, morose, violent films of the "new German cinema" and lionized a character like Rainer Werner Fassbinder. In the same period Italy, France, England, and the United States developed a stunning repertoire of great films with both popular and intellectual appeal.

Benjamin, Horkheimer, and Adorno could not have misread the character of film, filmmaking, the star system more completely. They could only view them as an extension of business: since the capital and means of production were in the hands of the studios, the studio owners could further deceive a mass, undereducated public by inflating the value of a worthless product.

Culture Industry and Star System

The history of the star system underscores how one-sided the Marxist criticism is. The studios early on saw stars as a threat to profit, not its source. If stars became popular, their price would go up. Therefore the early studios refused to give out the names of the actors in their films. Carl Laemmle broke through this monopoly and facilitated the creation of the cult of the movie star by the opposite tack: he publicized the star, created a persona around him or her that heightened the actor's performance in the film. The success of his studio showed that the future of narrative film lay in the cultivation, not the repression, of the public's passionate desire for stars. Of course, that change meant that the star actor could command much higher pay, and that was the source of the resistance to glorifying popular actors on the part of the early studio bosses. The star system could not have developed if the producers alone had called the shots. Its success was only possible once the producers gave up their stranglehold on star identity and conceded the predominant relationship of viewer to star. Obviously, once the primacy of the star dominated the artistry and economics of film, the producers appropriated the system, backed by an awesomely effective journalistic support system.[15]

But what about cinematic art and the *auteur* film, the core of the European cinema? Film art in America seemed to have no artist. American films presented themselves as team products; the job of the team is to dream up the stories that they can tell about a given star—or a remarkable character like Florenz Ziegfeld, William Randolph Hearst, Lou Gehrig, and others. Either develop charismatic worlds to accommodate charismatic movie stars or develop the fables incarnate in "fabulous" people.[16] All of the production team was there in order to shape a product around a star. It was hard to locate the artist. An occasional director could rise to the level of *auteur*, but even that was stretching a concept that had meaning in Europe but not in America. John Ford, Howard Hawks, Michael Curtiz, and John Huston were strong directors, but artists? The American film through the fifties is much more a vehicle for stars than for great compositions of genius directors. Of course there were great visionary artists, like D. W. Griffith, Charlie Chaplin, and Orson Welles. But the history of "geniuses" in Hollywood is by and large a sad one. Often the career of a director turned fatally downward once he gained artistic freedom based on a grand, virtuoso success. That happened to Orson Welles, Stanley Kubrick, Francis Ford Coppola,

Michael Cimino. The phenomenon of the director-auteur who can sustain productivity over an entire career is rare indeed in America. Perhaps Alfred Hitchcock is the only one in the history of the American cinema, though I would add Woody Allen, who through hits and misses has sustained a remarkable creative accomplishment from his first to his latest films.

While the role of the artist was spread out across the whole production staff, the art was still there. It had to be. An artless, aura-free cinematic work like the one Benjamin theorized would have been sterile, unable to attract either educated intellectuals with taste and judgment or a mass audience with none. The *art* of the film worked in a way critics of the medium had not envisioned or experienced previously. With painting, the mystery was the artist's genius. With photography, it is the genius of the subject.[17] Therefore film arranges itself around the person, place, or story. For the American cinema, the work of art had to coalesce around the actor; that was its mystery. When you had someone with immense talent like Charlie Chaplin or Fred Astaire, that role is easy and obvious. The work of the director, cinematographer, artistic director is to interpret him or her and create a world in which the screen actor's talent comes to life in narrative. It's different with actors like Gary Cooper, Greta Garbo, Humphrey Bogart, Marilyn Monroe, Tony Curtis. They are not actors in the traditional sense of stage acting. Seen through the eye of the lens, they are a physical presence first, and a speaking, acting persona second. The camera reacts positively to them; the camera likes them; the camera longs for them, and they come out on film, given good direction, the right lighting, makeup, and costume, with their physical qualities magnified and imbued with soul, or at least, with personality. The great film actor has the potential to become, just as he stands there—walking, smiling, looking soulful—a work of art in himself. It is up to the studio magnates to see to it that the desires of the camera get satisfied.[18]

There is something incarnate in a star that makes him or her suited to perform before the camera; but there is much that has to be constructed. I heard a commencement lecture by Katharine Hepburn at Bryn Mawr College some years ago. She talked about becoming famous and had an impressive description of growing into her role as a star. She said that at some point she began to construct a character that she and everyone else called "Katharine Hepburn." It was a composite of her screen roles, of fans' expectations, of an image worked on by the studio and journalists, and there was even some admixture of what she still called "herself," Katharine

Hepburn without quotation marks. Every morning she would climb into her "Katharine Hepburn" persona, put on her "Katharine Hepburn" mask, and every evening both came off again. As time passed she had more and more trouble getting out of the costume and removing the mask. Finally it came to dominate her; it paid no attention when she wanted to return to herself. Then she just decided to live in it. She became "Katharine Hepburn." The "star machine" may have provided the backup system to facilitate that change, but it did not produce "Katharine Hepburn" by the art of voice coaches, hairdressers, and makeup. Something irreducible in Katharine Hepburn rose into a role that no one else could have played.

The Star: Living Fiction

Another unprecedented element of the cinema, incomparable with painting, fiction, drama: the star is alive after the release of the film. The actor gets the film narrative projected onto him or her by the fans. In literature the fiction exists entirely in the mind of the author, or in some past history or myth. If the models for the characters are living, the author will deny them for fear of lawsuits. An author's or painter's models are seldom tested for their congruence with their fictional role or their painted likeness. At least the broad public cannot go checking the model against the portrait. In the movies, however, the movie star appears as a live human being before a public that has seen him or her as a fiction. The public wants (or at least, from the thirties to the eighties or so, wanted) the congruence between star and role, and the studio bosses in the thirties fed that appetite. They made the stars over, groomed them, fed and dressed them, taught them how to walk and talk.[19] The star system required that the star be fashioned on both sides of the shoot. To make the living persona congruent with the film persona, Katharine Hepburn had to become "Katharine Hepburn." In the culture of film, the living actor becomes a form of fiction.

The appetite of the public for stars whose lives were heightened no less than their roles was immense. The studios could project "stars" into cosmic realms and not lose fan adulation: they are goddesses, immortals. But far from alienating the actor from the public, the distance of the star from the viewer and the public's feeling of being hopelessly ordinary while the star was unreachable stimulated desire and the appetite for more of the same.

In an interesting study of women's reactions to female stars Jackie Stacey found that the distance between the spectator and her ideal "seems to produce a kind of longing which offers fantasies of transformed identities."[20] The fan can remake and transform herself by absorption into the film character or into the life of the star—at least she wants that. The fan lives in a dreary reality; the star in an enchanted realm. This Manichaean separation multiplies the fan's desire to participate in that higher world. As in the popular admiration of chivalric fictions the sense of identification and modeling could border on the fanatical, so also with film glamour and the fans' desire to possess it, to live in the world of the star.

The phenomenon of the movie star cannot be judged by standards traditional to Western art.[21] Rather it is at the same time unprecedented and a reversion to the phase in art where the human body and the physical presence were its medium. We have returned after a long route to living art. Katharine Hepburn relates to "Katharine Hepburn" as the untattooed Maori to the tattooed, as the everyday, ritual-free, unmasked tribesman relates to the masked tribesman dancing and performing ritual dramas. A big difference is, of course, the transference of the star onto film. The work of art does not remain limited to the living body; it makes its broad impact projected as light and shadow in motion onto a screen. But the point of comparison remains: the living film star, like the tattooed Maori, is in herself a walking drama of psychological stimuli and cultural signs.

The movie, injected with the charisma of the star, had a claim to the illusion of life much more persuasive than that of easel painting or literature. It is worth noting that the film industry from the outset understood itself as putting life into film. The earliest major American studios were "Biograph" and "Vitagraph." Both inscribed the claim of "writing life" into their corporate identity. A whole industry of representation shed the strictures of Western traditions (Benjamin felt, correctly, a "great shattering of tradition" in progress), and *reverted* to body art, personality art, the self as art. The cinema is a medium that unites visual with tactile experience, and while you can't touch the persons and objects projected, cinematic vision activates sensual response more directly than any other medium.[22] It made possible the extraordinary states in which the fan falls in love with the star, writes the star love letters in earnest acceptance of the coinciding of the star's life and film roles, submits to the star's body and soul, stalks the star, experiences a passion no less genuine than any generated by a real as opposed to a half-fictional person.

Glamour and Magic

The quality of screen acting had something primitive about it. An elemental somatic force beamed from a movie star. Alexander Walker captures that quality in describing what movies do to stars and fans: "The cinema multiplied their images, altered their personalities, projected their uniqueness and forced filmgoers to participate in the collective experience in a way that had much in common with tribal worship, myth and primitive magic."[23] The inescapable metaphor is "magic." That field of meaning is tucked into the etymology of "glamour." Connected in medieval usage with "grammar" (by a logic not important here), it means a magic spell, or an alluring charm that compels love, longing, or simply the wish to be like or possess the glamorous object or person. The Fox studio created an exotic false biography for Theda Bara in 1915, and the publicity preceded the release of the film it was meant to hawk. Walker characterizes the publicity pitch: "Born in Egypt, child of a sheik and a princess, weaned on serpents' blood, given in mystic marriage to the Sphinx, fought over by nomadic tribesmen, clairvoyant and insatiably lustful: the emphasis was put heavily on her supernatural powers since Fox cast her in a role in the film *A Fool There Was* (1915) which entirely consisted of her mesmerising and then ruining a succession of besotted lovers."[24] The imagination at work here was more that of Barnum and Bailey than Metro-Goldwyn-Mayer. She is something like a sideshow freak, exotic and dangerous, tinny and transparently false. But the magic and the compulsion by charm was the raw stuff of later female star images.

In pursuing the metaphor of screen magic as a real effect of charismatic art, there is the danger of losing one's bearings in the enthusiasms of its observers. John Lahr, longtime drama critic for the *New Yorker* magazine, wrote an essay on film glamour, which straddles the line between personal enthusiasm and objective reporting. Film glamour embodies in individual stars the movies' dream of a happy ending. "Glamour is the glorious moment continued and absorbed into personality," Lahr quotes the director Mike Nichols, "In that sense it's in defiance of time and death."[25] So we meet the "glorious moment" again: bliss condensed into an instant where "one moment of happiness is an eternity of happiness." It is peculiarly situated in charismatic art, which wants force, power, compulsion, happiness compressed into a single moment or a single image. But Mike Nichols's comment is that that effect is "absorbed into personality." The film

star is the exquisite moment embodied; the star's personality is mystically charged with the power to transmit that happiness that—we might think, while in its spell—stretches into eternity.

The sense that happiness is available through meditative gazing on the face of an extraordinary, godlike person suffuses viewer expectations of Hollywood films, at least in the era of high glamour. John Lahr writes, "The glamorous, we come to realize, are built for worship, and what we get in exchange for our adulation is a stage-managed sense of blessing and authority. Perfectly made, potently endowed, they offer us the illusion of a world beyond harm. . . . At their dashing best, in their moment, the kings and queens of the movies define our moment. Their history becomes our history. We read about them, we talk about them, we listen to them, we even dream about them.[26] How did they arrive unbidden? Why did they stay in our imagination?" Lahr quotes the fashion photographer Richard Avedon: "Glamour is the belief in the possibility of salvation through magic."[27] Glamour redeems the stars from their ordinariness. It co-opts religious terminology to convey its extraordinary effect—not just "halo" but "goddess," "god," "divine," "immortal," "immaculate," "sublime." The movies are "a redemption" from everyday life. The messiah of this redemption is the star. This language of magic, mysticism, and religious effect is constantly at hand in the writings, not just of wide-eyed fans, clearly, but those who have experienced and worked with glamour at first hand. A typical comment of Norman Mailer on Marilyn Monroe: "One has to speak of transcendence. . . . It was a habit as much as a miracle, yet a mystical habit not amenable to reason."[28]

But glamorous stars are also perfectly real, just so grand that they are outside what for the rest of us is the sphere of the normal and everyday, the sphere of habit. Glamour photographer George Hurrell said that the glamour of the stars of the thirties was not an illusion. "You could feel an atmosphere to it. . . . You felt inspired when someone like Dietrich or Crawford walked into the room." Hurrell described "the entrance" of the glamorous star, quite different from that of the plain star (Hurrell's distinction): "When they came through the door—they'd *arrive* somehow. They didn't just walk in the door . . . you know, saying, 'Hello, how are you?' They'd *arrive*. They'd develop that thing. . . . I never saw anything like it. . . . It was as if they had internal trumpets that blew for them just as the door opens."[29] Lahr quotes director Billy Wilder: "[The star had to be] the absolutely exceptional person, not the ordinary somebody, . . . They had to

appear as a super-person at all times. They looked as if they were thought up by a magnificent painter or sculptor." And Mike Nichols: "Glamour is bringing art to life, using the principles of art."[30]

The movies created an Olympian realm for these gods and goddesses and gave the moviegoer access to a world of sublime emotions, heroic actions, supernaturally beautiful, supernaturally manly and virtuous—or evil—characters. It also made the experiences of happiness, goodness, invulnerability, redemption, available to the paying public on a broad scale. The movie world could at least be seen and represented as a source of vital spiritual nourishments, salvation, and redemption, as Richard Avedon put it, through movie magic.

The movie industry invented its own mechanisms of charisma and charismatic representation. But in doing so it was at the same time renewing modes far more archaic. Lahr's term "voodoo" speaks to that theme. The lowest level of superstitious magic can be sensed as present in the compulsive force of stardom (*"As he does, so I'll do; as she thinks and speaks, so I'll speak and think"*). But also that primal myth of representation and the dream of the artist and art-lover that art can become life, that Pygmalion's statue can turn from stone to flesh, is revived in the experience of the charismatic world in film and in the discourse of movie glamour: "Glamour is bringing art to life, using the principles of art—stylization, emphasis and deëmphasis of certain aspects of the surface," Mike Nichols continues (Lahr, "Voodoo").

Walter Benjamin's master narrative of the development of the work of art in the age of technical reproducibility needs to be revised to encompass the magical view of classical cinema (he saw magic in traditional art, surgery in movies). By the time Benjamin wrote, traditional Western art had lost the ability to create masterpieces and administer charisma; the movies had gained it.

Transforming the Fan

The catastrophe of the Great Depression expanded the range of concerns of the movie industry; it added, alongside gangster films, romantic and screwball comedies, sometimes joined to those genres, themes that would contribute to the psychic cure of the nation: happiness, success, the need

for hard work, and the reassurance that no depression can get the better of you if you maintain your confidence. While the movies played on the longing for wealth, a glamorous, at least comfortable life, and admiration for an American aristocracy, they also insistently satirized the greed and frivolities of the wealthy and sophisticated (*Animal Crackers*; *American Madness*;*You Can't Take It With You*; *My Man Godfrey*; *Mr. Deeds Goes to Town*; *Meet John Doe*; *It Happened One Night*).

By the early thirties the immense power of the movies to shape values, fashions, behavior, and commercial trends was evident.[31] That insight brought down on the movies a system of censorship.[32] The marketing practices that grew up around them also generated powerful criticism of the industry as a tool of capitalism. But also in respect to products spun off of movies, the commercial aspect rides along on impulses which are part of the psychology of charismatic experience. The wish to keep the characters and paraphernalia of the movies close at hand is related to the urge to continue living in the world of the movie. But more important for our topic is the question, what impact the movies had on the psyche of individual fans. The impact was immense. The whole range of charismatic responses emerges from studies of that impact.[33] The transformation of identity is a felt or desired effect: "In marketing the star the studios understood that the real connection between performer and audience occurred when the fan took on, in the dream space of the movie theater, the star's intangible qualities of personality and style."[34] The profit motive was served when the participation of the viewer was most intense, when the willingness to break through the spell and brush aside the movie as fluff was minimized. The illusion had to have persuasive power, had to override the critical sense and shape a character and a world that invited the viewer to leave his or her own ordinary world behind and live in a world of heroism, glamour, and romance. Film commercialism is a by-product of film's salvific effects. Those effects weigh more than the motives of moviemakers and the aesthetic judgment of critics or theorists who see that art as an ax to shatter and reform the public's consciousness and not a magical incantation to heighten it. Nietzsche saw clearly how the purveyor of illusion par excellence, the Apollonian artist, serves purposes he or she doesn't understand. He compares the life-saving function of illusion to the tricks nature plays to sustain life: Apollonian art always relies on "powerful misleading delusions and pleasurable illusions. . . . [Homeric 'naïveté' was] the kind of

illusion that nature often uses to realize her intentions. The true goal is concealed by a hallucinatory image: we stretch out our hands toward the latter and nature achieves the former by deceiving us."[35]

"Redemption" and "salvation" figure prominently in the vocabulary of film effects borrowed from religion. The next two chapters will talk about redemption through the movies often enough that it's worthwhile dwelling on the term as psychological experience, not a frothy metaphor. If we are to take Richard Avedon's comments seriously, then millions of people believed in the possibility of "salvation through magic." The vision of Astaire and Rogers dancing is available as an image of perfection in motion, beauty and romance. Significant images get stored in the memory of the viewer (Lahr: "Why did they stay in our imagination?") and are available to rescue and revive the viewer in extremis. It is like the process Dickens described in the passage from *Hard Times* quoted at the beginning of this book: "The dreams of childhood—its airy fables; its graceful, beautiful, humane, impossible adornments of the world beyond: so good to be believed in once, so good to be remembered when outgrown, for then the least among them rises to the stature of a great Charity in the heart, suffering little children to come into the midst of it." The products of the dream factory also have the capacity to generate this space of grandeur and generosity in the heart of the moviegoer. The reactions to those visionary images can be far different from "suffering the little children" (by which I believe Dickens means something like maintaining in adulthood an innocence governed by the law of love). They depend entirely on the individual viewer. Artists, film critics, and scholars comfortable in well-paying jobs will not find forgiveness for the fluff, inanity, or sentimentality of film glamour. Some will experience elevation in the shortest of terms and dismiss film glamour as phony nonsense fabricated for the sake of making money. Others will want to buy the clothes and imitate the sophistication of the actors. Others yet will experience the kind of elevation I've referred to throughout as "redemption"; they retain the film's vision, be it banal or sublime, as a map out of their own world and into the enchanted world of the movie. If the need of the viewer is great enough, that inner path stays open as a refuge from despair and suicide.

No one goes to the movies the way they might go to Lourdes, hoping for miracles. But the movies gave viewers again and again the experience of the miraculous, transported them into unattainable realms: love, death, danger, romance—and allowed them to overcome these dangers, or rather,

to appropriate a vision of dangers overcome and romance experienced, and tuck it into their soul in the form of desire and emulation. The feeling that life could be happy—that you could give and inspire love and respect, that you could live a life of grandeur and greatness, that you are invulnerable, indestructible—was available every night at the corner movie theater. The greater the public's poverty of spirit or of purse, the more powerful was the effect of that illusory experience. The grander the illusion, the greater the tendency to accept it as temporary reality and psychological shelter, to want to continue life in that illusion after the screen darkened.

Happiness is what human striving aims for ultimately. The hope that happiness is attainable is what sustains ambition, desire, and any striving for any goal.[36] The legitimacy of the pursuit of happiness is written into the American Declaration of Independence. It does not matter whether or not we or the movie public understand what happiness is and what kind of "seduction" is at work when we are drawn into the pursuit of a goal that recedes one step beyond our reach every time we advance one step toward it. "Happiness is that which we would attain if our deepest longings (of the moment) were satisfied,"[37] and it nearly always remains in that grammatical mode of condition contrary to fact, always pursued, fleetingly attained.

The Hollywood film industry discovered in the thirties its ability to create the sensation of not just moving closer to happiness, but attaining it through complicity in a model of a narrative world whose internal logic guarantees an ultimate return to happiness, presents barriers to that goal as manageable and people who resist it as either evil or ripe for conversion. A whole range of films dispensed doses of *eudaimonia* to a needy public.

The industry discovered its own pharmacological purpose by following the money. There was commercial value in giving the public what it needed and wanted. Hollywood was a drug dealer and doctor of the soul. It gave happiness in small doses.

Walter Benjamin identified the connection between happiness and the idea of redemption in his essay on the concept of history: "The idea of happiness is indissolubly bound up with the idea of redemption. . . . There is a secret agreement between past generations and the present one. . . . Like every generation that preceded us, we have been endowed with a *weak* messianic power."[38] Benjamin, in the footsteps of Proust, sought happiness in its resurrection into the present. But this same sacramental form, or one very close to it, is at work in a mass medium able to purvey the experience of happiness in the skin of the great or the talented or the beautiful.

"Increase of being," however short lived, strengthens and magnifies the one who experiences it.

The Agon in the Movie House

At the same time as grand illusion and charismatic worlds pump up the viewer, they set him or her up for disillusionment. A charismatic work of art creates an agonal relationship with the viewer, no less than a charismatic person does. The viewer enters into a contest with the work of art. Rilke's "Archaic Torso of Apollo" is the paradigm of this agon. It is a contest in which something big is at stake, something having to do with the present condition of the viewer; he suffers the reverse of "growth in being" by discovering his inadequacy. The greater presence can be a threat to the weaker. He is inferior, insufficient, weak, ugly, miserable. The statue or the star shames and humbles him. In *Singin' in the Rain* an unnamed fan in the audience of a movie within the movie (*The Royal Rascal*), watching a beautiful blonde superstar play a French aristocrat, sighs, "She's so refined I think I'll kill myself." What René Girard called "mimetic desire" is at work. Any possession, condition, or talent beyond that which the observer possesses is charged with tensions; what one person has and another lacks creates desire in the have-not and casts the have in the role of model.[39] A character in Sam Shepard's play *Angel City*, a satire on the movie industry, frames her life in terms of desire for the life on the screen:

> MISS SCOONS [*a sexy woman working for a movie mogul*]. I look at
> the screen and I am the screen. I don't know who I am. I look
> at the movie and I am the movie. I am the star. I am the star in
> the movie. For days I am the star and I'm not me. I'm me being
> the star. I look at my life when I come down. I hate my life not
> being a movie. I hate my life not being a star. I hate being myself
> in my life which isn't a movie and never will be. I hate . . . having
> to live in this body which isn't a star's body and all the time
> knowing that stars exist. . . . That there are people living in
> dreams which are the same dreams I'm dreaming but never
> living.[40]

The agon between art or charismatic personality and viewer is a close relative of a contest that goes on in the charismatic person between the ego

and its expression or counterpart in art. One of the going explanations of Marilyn Monroe's suicide is that she lacked the inner strength to live within the image she—in collusion with her fans and her studio—had created for herself. It is plausible that the agon of the star played a part in her death. She lost the exhausting contest with a "Marilyn Monroe" constructed bigger than life and so as to suck the life out of the weaker character that she herself happened to be.

Here are some instances of this agonal effect cited in earlier chapters, represented both in real relations and fictional ones.

- Hildebert's Rome poem: the gods look "awe-struck on divinities sculpted and wish themselves the equals of those sembled forms." The gods recognize that nature could not, even its finest handiwork (themselves), "make gods as fair of face as man created images of gods." And, most humbling, their statues improve their models, are more divine than they. Men would do better to worship the statues than the gods.
- Gorky on Tolstoy: "[Tolstoy] would come out looking rather small, and immediately every one around him would become smaller than he."[41]
- Oscar Wilde on Balzac: "A steady course of Balzac reduces our living friends to shadows, and our acquaintances to the shadows of shades. His characters . . . dominate us."
- Rilke capitulated to the power of the statue ("Archaic Torso").
- Edgar Salin on Stefan George: "Next to him all the pedestrians seemed like mere empty forms and soulless shadows."
- Helen of Troy experiences loss of self, both in ancient tradition and in Goethe's *Faust Part 2*. The role imposed on her by the gods and her own beauty crushes the mere human being she is and makes a "phantom" existence and a simulacrum a psychological necessity.

It would be shortsighted to privilege either threat or elevation as an effect of idol worship, to say "charisma is a dangerous and destructive quality" or "charisma is a quality that affirms, exalts, and educates." All charismatic relationships are negotiated individually between the charisma-bearer and the admirer. Superhuman models can elevate their devotees; they can also crush them.

The relation of movie glamour to fans is a single instant of the greater relation of charisma-bearer to adherents. It is a particular constellation with circumstances peculiar to cinema, but it is a parallel with the charismatic relationship of tribal ritual to its beneficiaries. As such, the relationship of charisma-bearer (living or fictional) to devotees is one of the fundamental relationships in human society generally, like the relationships of parents to children, teachers to students, priest to congregation, political leader to adherents.

12

Lost Illusions: American Neorealism
and Hitchcock's *Vertigo*

BRIGID O'SHAUGHNESSY. I love you!
SAM SPADE. I don't care who loves who. I won't play the sap
for you.
—*The Maltese Falcon* (1941)

JOE GILLIS. You're Norma Desmond. You used to be in silent
pictures. You used to be big.
NORMA DESMOND. I am big. It's the pictures that got small.
—*Sunset Boulevard* (1950)

The movies did not exactly get smaller in the period 1939–1960, but they
got less glamorous, and the glamour that remained was either trivialized,
stripped of mystery, or inflated to pomposity. The cinema in one of its
major postwar trends veered away from big, charismatic representation. It
worked on an agenda of deflating it, bursting the illusions about glamour
and a happy, wealthy world of witty aristocrats that the thirties wanted and
needed. The films turned against the phenomena of glamour and personal
charisma and sought to expose them as dangerous, deceitful, an escape
from reality. The death of grand illusions is not just an event from the end
of the late thirties on; it is a prominent theme of American movies.

At the same time, a nostalgia for lost grandeur answered the hard-nosed
realist vision of a world liberated from illusion. But both of those positions
confirmed the passing of the age of grand illusion.

This crux of film history registers in some of the biggest films from the late thirties and forties, not because they reflect directly on trends in the cinema, but because their narratives are perched, like the creative energies of the film industry, between two worlds, one where glamour, wealth, success, stability, and happiness were conjured and believed in like presences at a séance; another where that kind of seduction was exposed as a foolish and dangerous hallucination.

Gone with the Wind (1939) sits exactly on that crest: it looks back to a world of elegance built on airy foundations and about to collapse—the Old South—and forward to a harsher world where life and competition have become brutal and a new world has to be built on ruins. It has two kinds of heroes: one, the slave-owning plantation masters and Southern gentlemen who think that chivalry, fine manners, and aristocratic values can prevail against Yankee cannons; the other, the hard-bitten, clear-seeing, self-serving realist Rhett Butler. The former live in dreams and illusions and predicate their lives on them; the latter serves himself, not hindered by any ideals or feather-light Southern moral values. Scarlett O'Hara stands between the two: she clings to a false romantic illusion, however hard-nosed her relation to men and business otherwise. She ruins her marriage to Rhett Butler by her love of a world that no longer exists, pinned onto a man (Ashley Wilkes) who is a pathetic shell of that world and its values; she loves the aura of the Old South in him, but it turns into a ghost in the course of the story. The final moments of the movie show her throwing over the illusion too late ("I've loved something that didn't really exist"), while Rhett heads in the opposite direction, seeking some partial restoration of the lost culture by returning to Charleston (to "see if there's something of charm and grace left in the world").

The Wizard of Oz (1939) runs a close second as a send-up of grand illusion, here in the genre of musical comedy.[1] The major part of the film still plays in the operatic (at least comic-operatic) mode of hypermimesis, but it is a dream, embraced by a dreary reality, the black-and-white world of Kansas, ultimately preferred to Technicolor fantasy via the flat-as-Kansas wisdom "There's no place like home." The wizard of the dream world, on whom Dorothy and her companions had pinned their hopes, turns out to be a charlatan who has adduced cultic adulation in the people of Oz by projecting a hyperreal image of himself in smoke and flames through the Ozian version of cinematic special effects. The charismatic magician reveals himself as a blatant phony—a parable for movie history, 1930–1950. The

three companions (film fans, in the meaning of the parable) hope for miraculous transformations from the wizard (movies), and, indeed, he ministers to their psychic needs, but only with some tinny substitute for brain, heart, and courage:

> WIZARD. Why anybody can have a brain. That's a very mediocre commodity. . . . Back where I come from we have universities, seats of great learning, where men go to become great thinkers . . . and with no more brains than you have. But they have one thing you haven't got: a diploma. Therefore by virtue of the power vested in me by the Universitatis Committeeatum e pluribus unum, I hereby confer upon you the honorary degree of Th.D.
>
> SCARECROW. Th.D.?
>
> WIZARD. That's Doctor of Thinkology.
>
> [*Followed by a demonstration of brilliant thinking by the Scarecrow.*]

Charismatic frauds peddling hyperinflated illusions can do nothing for those who come to them as petitioners, nothing that they can't do by their own character and will (Dorothy and her companions already proved themselves in the quest for the witch's broomstick). The symbols conferred on them—Th.D. degree, ticking, heart-shaped clock, and hero medal—are cheap, empty reminders of acts of real heroism that didn't depend on any supernatural force.

These two films mirror America and its relations to the movies in the period 1930–1950. Behind it a lost champagne-bubble world of wit, gaiety, and hardships overcome; facing it a world of war, crime, burst ideals, disillusionment, hard-bitten, black-and-white neorealism.

Preston Sturges mounted a brittle rebellion against the trend in *Sullivan's Travels* (1941), where a Hollywood director of fluffy comedies, Sullivan (Joel McCrea), wants to drop escapism and get reality in his movies:

> SULLIVAN. This picture . . . shows we're awake and not ducking our head in the sand like a bunch of ostriches. I want this picture to be a commentary on modern conditions, stark realism, the problems that confront the common man. . . . I want to hold a mirror up to life . . . a true canvas of the suffering of humanity . . .

PRODUCER. How about a nice musical?

SULLIVAN. How can you talk about musicals at a time like this, with
the world committing suicide, with corpses piling up in the
streets, with grim death gargling at you from every corner, with
people slaughtered like sheep?

PRODUCER. Maybe they'd like to forget that.

To get authenticity into his next film (to be titled "O Brother, Where Art
Thou?"), Sullivan decides he has to experience poverty. He lands in a prison
labor camp, gets beat up, brutalized, put in isolation. While serving a six-
year sentence, from which he sees no escape, he and the other prisoners
once watch a Mickey Mouse cartoon. This pack of desperate losers are
hysterical with laughter (along with the congregation of a black church that
has opened its doors to the prisoners). Sullivan joins in. He is a changed
man. He realizes the redemptive force of comedy. Restored to his stature as
glamour director, he drops the "O Brother, Where Art Thou?" project and
returns to light comedy.

The message is that Hollywood films redeem reality by rising out of it,
not reproducing it. It provides a good statement on the tides of cultural
history around 1941—by opposing them. Mickey Mouse gives a momen-
tary shot of humanity to a group of men brutalized by reality.

A hunger for "reality" was prominent among the energies that drove
film production,[2] and to some extent American culture generally, from
about 1939 on. The gangster thriller and film noir fed that appetite—the
need to see things as they are by cutting through illusion and confronting
false appearances.

The film noir comes in many variants, but one of its most durable
formulas is this: a beautiful woman practices her allure on a man, manipu-
lates him to cover her crimes, or to get rich, or to get rid of her husband,
and the man either resists her glamouring and penetrates her dangerous
web of deceit, or succumbs to it, or escapes it in spite of being taken in by
her. The essence of the film noir is the opaque nature of female charm. The
woman is beautiful, irresistible, but always mysterious, her motives always
concealed. But she hardly needs to conceal them and can still wrap men
around her finger. If the man is strong, hard-boiled, incorruptible, like
Humphrey Bogart in *The Maltese Falcon* (1941), *The Big Sleep* (1946), and
Dead Reckoning (1947), then he is immune to her mystery. Or he may be a

softy and roustabout, available for adventure and susceptible to the danger-
ous female. Orson Welles in *The Lady from Shanghai* (1947) gets wrapped
in the illusions of the seductress, but comes through it unscathed when the
glamorous-appearing world of hate and evil, multiplied into a thousand
images of itself in the hall of mirrors scene, destroys itself.

Alongside film noir there is also the gangster film where the tough guy
still nurtures illusions of innocence. He pins them onto a young woman,
whom he had idealized. She betrays them. Then he is freed to do desperate
things in his disillusionment, more to commit suicide than to gain freedom
(*High Sierra*, 1941; *Brute Force*, 1947). The hard-bitten cynicism of this
formula is unrelieved by any redeeming elements, and that is clearly seen
as "realism."[3]

One of Alfred Hitchcock's ventures into, or at least near, film noir is
Vertigo (1958).[4] It lacks the look and the emotional tone of film noir, but
turns on the formula of the mysterious seductive female, the insidious plot,
and the detective drawn into it. It gives psychological depth to the experience
of deception by glamour and rises well above the hard-headed banalities of
the genre. *Vertigo* reworks, with great psychological complexity, the theme of
seduction by illusion and restates the rejection of big illusion rooted in Amer-
ican neorealism. But the romanticism of *Vertigo* is so intense that it generates
a nostalgia for what is lost in the rejection of an enchanting illusion.

Two Epiphanies

Epiphany in film, as in religion, is the sudden appearance of a character
who seems to have walked in from another world. I mentioned earlier the
appearance of Harry Lime (Orson Welles) in *The Third Man*. In *Vertigo* the
Kim Novak character(s) have two such moments.

The first epiphany: Madeleine Elster (Kim Novak) appears to ex-detective
John "Scottie" Ferguson (James Stewart) in Ernie's restaurant in San Fran-
cisco. She is sublime and ravishing, she seems to float rather than walk
along the path that leads from her table to the place where she pauses,
supposedly to wait for her husband—actually to display herself to Scottie.
We see her ethereal beauty, her otherworldliness, in her magnificent profile
(Figure 39). We hear it in the music. We also see it in Scottie's face. As
Madeleine both waits for "her" husband and puts her magical presence on
display, a light comes up on the background, the restaurant's plush dark

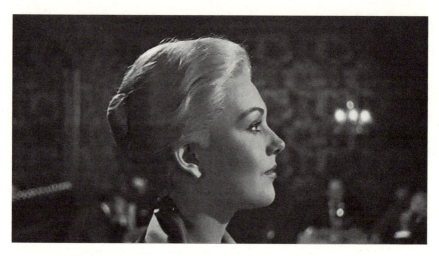

Figure 39. *Vertigo*: Madeleine at Ernie's. (Photo: Carolyn Hammersly)

red Victorian wallpaper. It creates a brief gloriole effect, Madeleine's profile heightened and raised out of the ordinary by the halo of light surrounding her. Scottie blinks and looks down and away, as if to avoid detection, but also with an admission of awe, as if to say, *"I don't want her to be this beautiful. I don't want to believe in her."* We see him starting to fall in love with "Madeleine" and buying into the story that she is possessed by an ancestor, that a dead woman from the past is now coming to life in her and trying to kill her. *"If this woman is this beautiful, anything could be true"*— that is something like the logic which shows in the tense, suppressed emotion in his face and which takes him in.

The second epiphany: Judy is putting the finishing touches on her hairdo so that she will look in every way like the supposedly dead Madeleine Elster. Scottie has made this shopgirl from Salina, Kansas, into a perfect copy of the Madeleine who fell to her death from the tower of the San Juan Bautista mission. But her emergence from the bathroom in the Empire Hotel suggests a resurrection, a return from the dead. Judy steps out slowly. She's bathed in a green-white light, more intense and stranger than the subtle halo of the first epiphany. It forms a mandorla that surrounds her and sets her off in an unreal realm within the reality of the hotel room. The light is so intense, her image so overexposed, that her contours almost fade into her surroundings (Figure 40). For the first moment she's a ghost, in a

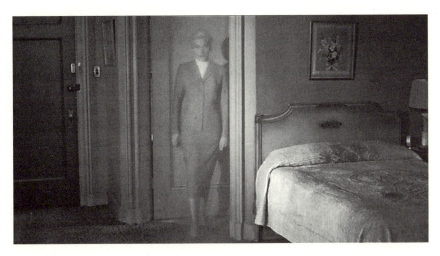

Figure 40. *Vertigo:* Judy, made over, epiphanizes at the Empire Hotel. (Photo: Carolyn Hammersly)

state between the living and the dead. Then she steps forward out of the fog of obscuring and illuminating light. A ghost is made flesh; a real woman emerges from among the dead.[5] Scottie has been fidgeting restlessly while he waits, the same tenseness in his face as at Ernie's, now heightened. As Judy approaches, he swallows with emotion, the nervous anticipation gives way to a blissful smile, his eyes widen, tears well. He's ecstatic. The camera zooms in on Scottie, moderately fast, to a three-quarter close-up, the heightened visual excitement answered by the swelling music. Scottie cranes his head as if he had to make room in his throat for the vision that's flooding in on him. He now has Madeleine. He has brought her back from the dead. She lives again in Judy.

Once we get initiated into the intricacies of the plot we know that "Madeleine" and Judy are the same person, just Judy. She was Gavin Elster's accomplice in a murder plot. She was pretending to be Elster's wife, so that he could murder the real Madeleine Elster and inherit her money. So "Madeleine's" epiphanies were both false. Both suck Scottie into big illusions: that she is a goddess;[6] that she is a dead lover reborn. The camera is a partner in the conspiracy. It keeps any hint of the deception hidden until Judy's flashback three-quarters of the way through the film. We are Scottie; we see what he sees.[7]

What he experiences is enchantment, glamouring, wizardry, seduction, the construction of an alluring woman that calls on techniques of charismatic representation we have seen in other contexts. The dynamics of the plot are powerful: passionately loved woman dies, lover finds a bad copy of her, bad copy gradually transformed by the obsessive artistry of the bereft lover into the archetype, and in the green glamourings of the Empire Hotel, the transformation is complete; Madeleine was dead; now she's alive. Miracles happen, to Judy/Madeleine, as to Christian saints. The light effects are there to shore up the sacred, at least supernatural, character of the resurrection.

The Dead Inhabit the Living

But the real witchcraft is in the story of the dead Carlotta Valdes returning to inhabit the living Madeleine. Carlotta Valdes was the real Madeleine Elster's real grandmother. Abandoned in her youth by her wealthy lover, whose child she had born, Carlotta went mad and committed suicide. Now she has returned from the dead and is gradually moving into the body and soul of "Madeleine," driving her to repeat the suicide of Carlotta. So runs the fake scenario arranged by Elster and played by Judy.

That story is the invention of Gavin Elster, and it's a good yarn. It plays on some of the favorite motifs of the romantic or late romantic imagination: the past is alive in the present and can be evoked by objects, persons, places, smells. Proust says, "Each face we love is a mirror of the past." And Walter Benjamin: "The past carries with it a secret index by which it is referred to redemption. Doesn't a breath of air that pervaded earlier days caress us as well? In the voices that we hear, isn't there an echo of now silent ones?" Those alive at present, the Benjamin passage continues, are obligated by a virtual contract to recapture the past and are "endowed with a weak messianic power" to enable the recovery.[8] That is, we are the savior of the past; we redeem it from its only partially dead state, the limbo in which it floats inexpressibly around us and wafts by in living persons and moods, rises up out of saints' bones, French pastry, and mysterious women. Gavin Elster's conspiracy exploits this worldview, injects the past into the present, turns it into a case of demonic possession, and foists onto Scottie the role of exorcist.

The highly auratic setting of San Francisco is made to participate in this logic: for Elster, the city's alluring past ("I should like to have lived then [in the nineteenth century]: color, excitement, power, freedom") is still alive but "fading fast"; he describes pseudo-Madeleine looking entranced at a monument in Golden Gate Park, "you know, the Portals of the Past"; she passes her finger along the time line on the cross section of the ancient redwood and stops in the mid-nineteenth century, "Here I was born, there I died." In other words, the conspirators plant hermeneutic signals in the cityscape and the landscape, saying to Scottie, in effect, *Look how we read the present: its surface is charged with the past, and the past is still available. It's not that dry realm of history and fiction a man like you, Scottie, cares nothing about, but rather a Proustian world, where the past haunts the present in its very materiality, and objects—buildings, trees, cars, women, streets, painted portraits, even the walls of hotel rooms—can open to discharge the past that they contain.*

Proust called one of the characters in *In Search of Lost Time*, M. de Borodino, a "living reliquary," because his imperial ancestors peered out through the eyes of the living descendant.[9] *Vertigo* beckons us into the same alluring logic; we can call Judy the "living reliquiary" of Madeleine. I said in an earlier chapter that charismatic art needs the suggestion of a living force present in the person or the world depicted, a force that is "both human and superhuman, natural and supernatural at the same time. . . . If the viewer does not come away with a sense of astonishment or, at the minimum, awe, the charismatic work has not made its effect." Astonishment is the emotional trauma that overwhelms the viewer's critical sense, as Rilke is dazzled or "blinded" by the vision of light breaking from the torso of Apollo, as the Olympic gods are awestruck at their own "amazing" images in Hildebert's Rome poem. This sense of transport overcomes the rationalism that insists the work of art is illusion, not vision. Charismatic images take their authority from the suggestion of a supernatural force alive and at work in the living being.

That describes Madeleine/Carlotta's effect on Scottie. Madeleine contains the past, she glows with it, it radiates from her like an aureole. It is a case of double identity, where the hidden occupant magnifies the host, raises her up into the realm, here, of the supernatural. That doubling of identity is a favorite effect of Hitchcock: one person lives in another. Uncle Charlie and young Charlie share one existence in *Shadow of a Doubt* (1943). They merge into one another, and the danger of Uncle Charlie's madness

infecting young Charlie is real. In *Psycho* (1960) Mrs. Bates lives on in her son, and here she eventually takes over, or at least the son capitulates to her. A comparable agon is fought out in *Rebecca* (1940), where the dead Rebecca is, or seems, still present in Manderley, working a demonic effect on the second Mrs. de Winter (Joan Fontaine), who takes her place or tries to. She also is urged by the overpowering model of Rebecca (the mad Mrs. Danvers speaking for Rebecca) to throw herself down to her death, and that is supposedly the same act the dead Carlotta is urging on "Madeleine." In Carlotta, a strong presence is supposedly absorbing the weaker presence—"Madeleine"—as Rebecca threatened to absorb and destroy the second Mrs. de Winter. Carlotta is dead; she is "preserved" only in her portrait, but also in some vague sense inhabits the body of "Madeleine." Madeleine allows herself to be transformed into Carlotta. She also resists and is partly aware that "absorption" means death. But the film posits a spell, experienced in a trancelike state ("Madeleine" standing at the edge of San Francisco Bay; "Madeleine" among the redwoods; "Madeleine" sitting in the horse-drawn buggy in the stable) in which the living embodier gets drawn into the consciousness of the dead spirit, and loses her own.

Vertigo and Other Diseases

Of course, in this case the relationship and the effects are raw fabrication. There's a perfectly good explanation for Carlotta's presence in Madeleine—it's faked—and for Madeleine's in Judy—they are the same person.

Why does Scottie succumb to this hoax? It's a clever deception, but also so full of improbabilities that a man like Scottie, in possession of his faculties, should have penetrated it. He was a detective, idealistic and successful, before vertigo set in. His job required precisely the clarity of vision that cuts through lies and fabrications—the stuff from which criminals regularly weave their tales of innocence. That quality is not only in the job description, so to speak, it's also on the line of descent, in film tradition, from Sam Spade and other movie detectives. When Elster first pitches the story of Carlotta's return from the past to him, he reacts with appropriate scorn:

> ELSTER. Scottie, do you believe that someone out of the past, someone dead, can enter and take possession of a living being?
> SCOTTIE. [*Emphatically*] No.

ELSTER. If I told you that I believed this has happened to my wife, what would you say?

SCOTTIE. Well, I'd say, take her to the nearest psychiatrist, or psychologist, or neurologist, or psychoan— . . . or maybe just a plain family doctor. I'd have him check on you, too.

ELSTER. . . . It sounds idiotic, I know. And you're still the hard-headed Scot, aren't you? Always were.

Scottie offers to find him a good detective firm. Elster: "I want you." Scottie: "Look, this isn't my line." What an understatement! The "hard-headed Scot" ought to be immune to threats from beyond the grave; the irrational has to appear absurd, insane, or idiotic to the clear-eyed crime-stopper, elements of a conspiracy to deceive. And, of course, again, there is film noir tradition. By that criterion, he ought also to be a hard-boiled dominator of women with incorruptible judgment and critical sense. But Scottie is no Sam Spade or Philip Marlowe. He has next to no experience with women, knows only the comparatively ordinary Midge (Barbara Bel Geddes), a buddy, not a lover. He doesn't court her or flirt with her. Sex is far from their minds. The closest they come to it is the inane exchange about what a brassiere is (Scottie: "What's this doo-hickey?" Midge: "You know about those things. You're a big boy now"). It turns out that they were engaged once, and Midge broke it off. Scottie is still available, "I'm still available. Available Ferguson." So there is still some of the innocent good boy of his Frank Capra movies in this James Stewart role. He is way out of his depth dealing with Elster and Madeleine. Romantic and psychological complexities are definitely not "his line."

But Scottie's inexperience and a certain naïveté were not enough by themselves to make him swallow Elster's story—they had not gotten him into trouble until that point. The real transformation of Scottie comes through the trauma of his brush with death and his fellow policeman's succumbing to it. He loses his grip.

"Grip" is a visual theme of the opening scene. The first thing the viewer sees after the titles is a solid horizontal iron bar dominating the screen. We have no clue why the movie opens with this odd, unidentified object in the foreground—in shallow focus, the blur of the San Francisco skyline behind it. Our first clue is that a strong hand reaches up and grabs it with force. The other hand follows. Then the camera backs up to reveal the bar as the top rung in a steel ladder. The focus deepens, we see the cityscape in the

background. A fleeing crook climbs up the ladder and heads across the roof. Scottie and partner are in hot pursuit. Scottie misses the jump across two buildings, skids off the edge of the roof, and grabs the gutter drain, which all but rips out of place, leaving him hanging ten stories above the ground. The firmness of the crook's grasp is answered by the precariousness of Scottie's. And "grasp" is clearly meant in a broader sense than just holding firm to a pipe. Scottie's whole grip on reality is weakened by the experience. Hanging from the gutter drain he discovers that he has vertigo, or contracts it at that moment ("Boy, what a moment to find out I had it!").

What is vertigo? What does it mean for the movie? Fear of heights, fear of falling. It is the dizziness made visible in the spinning whorls and eye-grids of the opening titles and of Scottie's nightmare, and made audible in the pulsing swirls of the musical score. It is a disorientation of the mind, which skips out of its normal orbit and wanders exorbitant, like Scottie, whose main activity after retirement is "wandering." The vertigo sufferer has his emotional world overturned. He feels fear he had not known before; he looks into the irrational and its most frightening manifestation, death. Scottie's nightmare fear is falling into the grave, which is far deeper than six feet or even ten stories. Carlotta's grave is the entrance to that "dark hall" "Madeleine" wanders through in her dreams on the way to suicide. Vertigo is what connects Scottie with the realm of the dead. Scottie plummets into the grave in his dream, but it is also a descent into the past. It is Carlotta's grave that drags him in. His fall will be a century or so deep. The grave is the real "portal of the past."

A man whose "line" it is to investigate, to detect, to penetrate lies, has his mind opened to obsessive love that presents itself in a fantastic, supernatural story. These things were "not in his line" until vertigo set in. Vertigo sets him up for Elster's plan. He is now vulnerable to spells, hypnosis, the dulling of the critical faculty and the hypertrophy of emotion: fear, guilt, desire, imagination. Those swirling eye-grids are not only dizzying, they are hypnotic, and they suck at the viewer, like the irrational compulsion that might urge you to jump when you stand at the edge of a cliff or a high building. They are drawing the viewer into the world of the movie, as Scottie is drawn into the enchanted world of "Madeleine" where the past can live again and the dead reenter the living.

A great bit of camera work marks one step (beyond the erotic-mystical vision in Ernie's) in his gradual entrapment. Scottie is standing in the museum watching "Madeleine," who sits staring in trancelike rigidity at

the portrait of Carlotta. He stations himself behind her and two point-of-view shots show his eyes as they wander from the bouquet on the bench next to "Madeleine" to the identical bouquet that Carlotta holds in the portrait; again, from the swirling bun into which "Madeleine" has tied her hair to the identical swirl in Carlotta's hair. The camera literally weaves the real and the painted objects together: the past and the present are there, at hand, together on proximate surfaces; the living woman is woven into the dead woman, and the weaving also weaves a spell on Scottie. His unpracticed imagination expands to take in the merged identity of the two women.

The incident in the McKittrick Hotel, Carlotta's old house, and "Madeleine's" mysterious disappearance help cinch the knot. The story of the historical Carlotta is confirmed by the folk historian in the Argosy bookstore, Pop Leibel. The further details are supplied by Gavin Elster. So Carlotta's story is "true," and "Madeleine's" possession by Carlotta seems confirmed by history—at least Scottie swallows it.

There is a pathology of Scottie's development that connects fear and guilt with love and desire—as a form of sickness. Elster knows his old college mate is vulnerable, sickened with vertigo; and the story of Carlotta is like a secondary disease that develops out of the first. The progress of the disease takes Scottie from skeptical detective and regular guy who wouldn't know what to do if he found Donna Reed naked in the bushes (the embodiment of "health")—through fear and guilt to love and desire, to psychoanalysis. He enters "Madeleine's" mind, as we enter Kim Novak's eye in the image of the opening titles. The turn inward, the descent into the mind, ultimately leads to the traumatic emptying of the mind (mental breakdown).

Scottie the Psychoanalyst

He might still resist a belief in ghosts and spirit possession, but having fished "Madeleine" out of the San Francisco Bay, he is hopelessly in love with her. Love never prevented Sam Spade ("I don't care who loves who; I won't play the sap for you") or Philip Marlowe from squeezing the truth out of lying females they were in love with. But Scottie has other ballast, noted above. He is far from Rip Murdock's manifesto, "I don't trust anybody, especially women!" (Humphrey Bogart in *Dead Reckoning*). Scottie has made the leap out of reality and into romance. He has lost his ability

to penetrate show and illusion. He is "transported." He now participates in "Madeleine's" world. He accommodates the reality of her spirit possession with the one remaining scrap of rational understanding: possession by Carlotta is "real" in the sense of a mental disorder. He himself has been wrenched out of the realm of reality and the practice of empirical thinking by looking into the face of death. Why not Madeleine? Both are sick, both need a cure. He is no longer a detective but a psychoanalyst in love with his patient.

Scottie believes in "Madeleine's" possession by Carlotta, in the way that the analyst believes in the patient's neurotic symptoms. He drives "Madeleine" to San Juan Bautista, Carlotta's hometown, convinced that a cure lies in the return to the past: "I'm going to take you down to that mission and when you see it you'll remember when you saw it before, and it'll finish your dream, it'll destroy it, I promise you."

Scottie wants to cure her without realizing, in the fog of romance, that he is the one who is sick and living in a dream, hypnotized and spellbound. Without any experience in psychoanalysis or understanding of neuroses, he is convinced that the cure lies in a return to the past. Confronting childhood trauma, seeing its origins, loosening the mental knots that formed neuroses, unraveling them by exposing things forced out of the subconscious and into the conscious mind—this romanticized Freudian therapy was an effective, dramatic plot element of Hitchcock films linking *Spellbound*, *Vertigo*, and *Marnie*. Both John Ballantine (Gregory Peck in *Spellbound*) and Marnie (Tippi Hedren) are cured by the return to the neurosis-generating trauma. But the cure of "Madeleine" fails. She dies, or at least appears to, in the fall from the tower.

Scottie's own malady now moves from fear of heights to a doubled burden of guilt to a complete nervous breakdown, followed by obsession and compulsive behavior. He sees Madeleine in every trace of her, works at imagining her back into life, quests after a lost love. And so once again he is set up, made vulnerable for the reappearance of "Madeleine" in the form of Judy. Scottie thinks the untying of his own knotted complexes depends on a return to their place of origin: "There's one final thing I have to do, and then I'll be free of the past. . . . I have to go back into the past once more, just once more. . . . I need you Judy. I need you to be Madeleine for a while. And when it's done, we'll both be free." One of the ironies is that Scottie's return to the mission church, the climb up the tower, confrontation with his vertigo, does in fact cure him of his fear. So Hitchcock's faith

in the repetition of past trauma as neurosis medicine remains strong, at least as a narrative device.

George Bailey Meets Dionysus

So, we have to understand the transformation of Scottie's character as a move from a completely, naively rational life with all the attendant denial of the senses, to the irrational: the senses, desire, guilt, fear, death, the imagination, stories, and histories. In the character Scottie, Mr. Deeds and George Bailey meet Dionysus; they absorb what Nietzsche called the "wisdom of Silenus" ("The best thing for you is never to have been born; the next best, to die as soon as possible"). Like the wisdom seeker who sees into the deepest causes and motives of existence in Nietzsche's *Birth of Tragedy*, his ability to think and act are crippled. Suicide has to look like a good alternative to his empty life. But then, as in the rescue of Nietzsche's Dionysian pessimist, art and the realm of the beautiful present themselves as the force that can lure him back into existence.

Gavin Elster's Star System

Scottie emerges on the other side of his nervous breakdown as—an artist. Sickness, derangement, and the artist—together again at last. Their union has a long history. Scottie cannot accept the loss of Madeleine. Judy is not Madeleine, but she is a copy stripped of charisma, a reminder, a petite Madeleine, so to speak, able to evoke the memory of the lost one. Pygmalion-Scottie goes to work, reduplicating the work of the real master sculptor,j Gavin Elster:

> SCOTTIE. You were the copy, you were the counterfeit, weren't you? . . . You played the wife very well, didn't you Judy? He made you over, didn't he? He made you over just like I made you over, only better. Not only the clothes and the hair, but the looks and the manner and the words. And those beautiful phony trances. . . . And then what did he do? Did he train you? Did he rehearse you? Did he tell you exactly what to do, what to say? You were a very apt pupil too, weren't you? . . .
> JUDY. I let you change me because I loved you.

Others have noted that Elster's remake of Judy is what a movie director does. The bit of dialogue just quoted, taken out of its context (Scottie is dragging Judy up the tower for the last time), could describe a director at work on the living material of the actress being remodeled into a dramatic figure and a star. Scottie as "director" is spared a lot of work because of Elster's efforts. But what was crass deception for Elster is an Orphic quest for Scottie, a descent to the underworld, to redeem the lost love. Like Eurydice, Madeleine is not exactly dead, being still alive in Judy. Both appear resurrectable to their mourning lovers. Scottie works obsessively, true artist that he has become, to reconstruct the original in the surrogate and carve the beautiful Madeleine out of the rough matter of Judy.[10] A primal and aboriginal aspect of art agitates the surface of the "revival" scenes from far within: the artist as one who restores the dead to life.[11] He is in the grip of a half-insane obsession, like Jacob's hoping to recreate the (supposedly) dead Joseph in Thomas Mann's *Joseph and His Brothers* (see Chapter 2 above). Scottie and Jacob follow the logic of the bereaved in the Orphic moment: the lost love is not attainable in reality; he cannot bring her back from the realm of the dead. He becomes an artist to restore the beloved to life. Scottie doesn't get as far as the shattering discovery of the mourner that an artificial surrogate (i.e., made of clay, stone, paint, or prose) is his only resort. He has a living surrogate.

The disease in its second stage reaches its critical point when Judy, transformed into Madeleine, steps out of her green gloriole in the Empire Hotel (see Figure 40). His last shred of empiricism is overridden, replaced by ecstasy at the mystic vision of Madeleine resurrected, the Orphic quest completed in a work of living art. His clear judgment is replaced with a vision of the reincarnated beloved. The initiate into this mystery cult is all shivery bliss. He kisses her with the magic kiss that breathes the breath of life into the effigy—not with the passion of sexual desire, but of the resurrection.

Again the camera sees with Scottie. It circles around the couple as they kiss, and—another miracle: the wall of the hotel room opens to show the stable and arcades of the mission at San Juan Bautista. The past lives again, in his arms and in the once firm walls of reality, now a passageway into history for this spellbound dupe. The mysteries with which Gavin Elster baited his hook offer themselves to Scottie in this moment of consummation—a dead woman epiphanizes in a woman at hand, and the walls themselves open to let in the past they contain, as impossible and as mystical an event as the heavens opening in some revelation of a hidden god.

Carlotta's Necklace and the Withering of Aura

Somewhere in his mind Scottie must have sensed, in the lead-up to this paralysis of his character and theft of his mind, that he was abandoning good old Yankee good sense and Scottish hard-headedness for romantic nonsense. That awareness might account for his oversensitive reaction to Midge's caricature of Carlotta's portrait. Midge, still living in her Frank Capra world, naive and jovial, paints her own face on Carlotta's body.

Scottie: "No, Midge. It's not funny."

Why not? It has approximately the effect of the Bruce Dern face on the crucified Christ in *Hannah and Her Sisters* or Marilyn Monroe in the place of Christ in the kitsch pop-art parody of Da Vinci's *The Last Supper*. To Midge and any viewer not affected by the religious devotion to the cult image, it's not a bad joke. But Scottie is on his way to cult membership; he has had his mind and character stolen, replaced with a dizzying intoxication, and he doesn't want to be reminded of the time when reason—and that means also the acceptance of irony and parody—were his way of thinking. There is also something of the genre wiring of charisma and caricature at work in his reaction: they are fundamentally mutually repellent. Scottie has become a connoisseur and devotee of charismatic art. The loved woman is present in the painting, and the maiming of her portrait disgusts him. By now he is absorbed into Carlotta's elevated, "romantic" world, and Midge's intrusion into it lowers it.

Carlotta's necklace breaks the spell that holds Scottie. As soon as Scottie sees it, he is cured. As he drags Judy up the tower stairs, he changes from third person ("Madeleine made it this far") to second ("*You* went on"). Judy starts. She knows the deception is over.

Scottie: "The necklace, Madeleine. That was the slip. I remembered the necklace." Then he looks down through the stairwell—which has telescoped each time previous—and it's stable.

A powerful charge is placed on things and places in this movie: Ernie's restaurant, the flower bouquet and necklace, the gray suit, the green Jaguar. The world of *Vertigo* overflows with Proustian talismans. Scottie's obsession registers in his shocked recognition of Madeleine in things still charged with her aura after her death. Her invisible presence is a ghost in each of them. A lady in gray walks out of Madeleine's apartment building, goes to the green Jaguar. Scottie's aggressive reaction when he realizes it's not Madeleine: "Where did you get this car?!" as if the dead woman were so

present that her property rights need protection, or as if the answer might lead him back to her.

Of course, the real aura-bearer is Judy herself. She is not just the "reliquiary" of Madeleine, she is a full-body relic, a living effigy.

Carlotta's necklace has the role of disenchanting. It breaks the spell when Scottie sees it around Judy's neck (Figure 41). It takes its place among various objects in Hitchcock's movies heavy with plot development and the power to indict: Guy Haines's lighter (*Strangers on a Train*), the wedding ring of one of Uncle Charlie's victims (*Shadow of a Doubt*), Bob Rusk's tie pin (*Frenzy*). Carlotta's necklace reverses Cary Grant's erotic entrapment with Grace Kelly in *To Catch a Thief*:

> JOHN ROBY (Grant). You know as well as I do that that necklace is
> a fake.
> FRANCIE STEVENS (Kelly). Well I'm not.

And turns it into: "That necklace is genuine. Therefore you must be a fake." Scottie sobers up immediately. It is the Scarlett O'Hara moment, when Scottie, like Scarlett, can say, "I loved something that did not exist." The besotted lover is gone, the resurrection and the light that the revived Madeleine seemed wither and fade to what they were: criminal deception.

Judy is still Judy, however. Nothing has changed. She exudes the same sexual attraction; she still has the Madeleine remake on her person. (She says, significantly, as Scottie pulls her over to kiss her in the Empire Hotel just before the revelation of the necklace, "Too late, I've got my face on.")[12] But that's just what she has lost, or is about to lose, the face that she had put on. Here is the definition of "aura" I proposed earlier: that quality that *the crystallization of things lost or hidden, the sudden apparition of the reassembled past*, seems to confer on the evoking object, that which rises up in the mind of the beholder from the scar of Odysseus, the petite madeleine dipped in tea, or the jawbone of an eloquent saint, we can call "aura." And let's add, for *Vertigo*, Madeleine's necklace.

Aura is an invisible presence that assembles itself in the mind of the beholder, the catalyst for which is an object (or person, place, sensation, or smell) onto which the beholder has projected associations. Petites madeleines dipped in tea transmit the lost world of his youth to Marcel Proust. Likewise the necklace radiates the story of Carlotta, her ghost, the demonic possession of Madeleine. Scottie's recognition of the necklace on Judy's

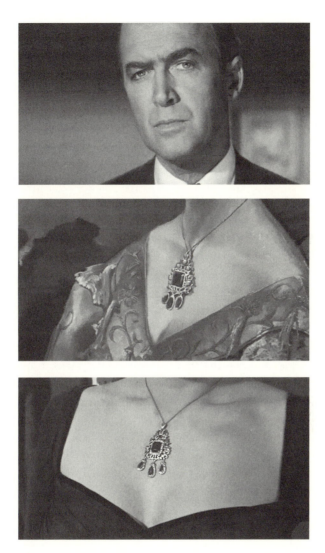

Figure 41. *Vertigo: from top*, Scottie sees the necklace; the necklace in Carlotta's portrait; on Judy's neck. (Photo: Carolyn Hammersly)

neck reverses the act of "experiencing the aura" of a thing. The whole auratic world that Scottie had swallowed hook, line, and sinker is present in the necklace, but its recurrence on Judy's neck exposes that world as a sham. The reconstructed Madeleine deflates like a punctured tire. Like a frog prince in reverse, she reverts to a vulgar shopgirl and paid swindler. The necklace sobers him up, for the moment, totally, though it does not cure all of his romantic compulsions. The drama of recognition and reversal is great, not just because of the dynamics of the plot reversal, but because it works on the mechanism of aura destroyed. Aura is as vulnerable and volatile as grand illusions and charisma, since it relies on stories, legends, complexes of beliefs, whose habitation in a physical presence is unstable and in this case vulnerable to debunking.

Scottie Meets Zampano

The last words Scottie speaks to Judy in the bell tower are "It's too late. There's no bringing her back." Then they kiss passionately. The double gesture (first reject her, then kiss her) makes it at least conceivable that he might after all walk down the stairs with Judy and make a new life, work things out, carefully plan the concealment of her crime, create a life together on the basis of a cover-up. Scottie is in love with her or with Madeleine in her, and he had already once managed to resurrect her in her. She is in love with him. That's more than Mark Rutledge and Marnie have as they conspire to fabricate Marnie's innocence and create a lie that makes their married life at least viable. But the ending in *Vertigo* cuts off this possibility. Judy staggers back when she sees the figure in black and falls to her death.

The final shot is resonant, complex, ambiguous, and deeply engaged in the movie's basic idea. Scottie steps slowly out onto the ledge of the bell tower (Figure 42). No railing prevents him from following Judy and falling to his death. But the slowness of his steps—he could have lurched after her in a desperate grab—speaks clearly: it's over, Judy is dead, the disease is gone. He can balance on high places and look down without fear of falling. Then Scottie raises his arms slightly, the slow-motion version of a gesture a falling man might make in trying to stabilize himself during the fall. Throughout the movie the image of a falling man splayed in just this position recurs (Figure 43).[13] That position becomes the emblem and visual

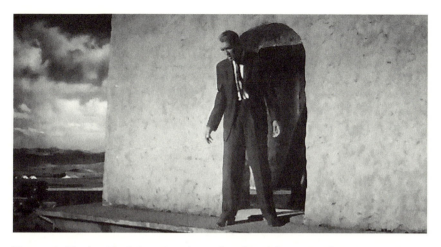

Figure 42. *Vertigo:* Final shot: Scottie on the edge. (Photo: Carolyn Hammersly)

marker of the falling figure, of loss of solid ground, of imminent death. Since Scottie is neither falling nor dying, why does the movie end with this shot?

Consider Scottie's position: now Madeleine and Judy are both lost irretrievably; the vertigo is cured; so is his obsession; and the crazy illogic that persuaded this soft-boiled detective that the dead can live again is erased. He is once more a successful crime-stopper. He has solved the murder of Madeleine Elster and brought Elster's co-conspirator to an inofficial justice. He could even go back to work. Pursuing Elster might give him something to live for. One could think out a future for Scottie, perhaps with Midge. But just as easily one can comprehend how empty and futile that future would be. We don't need to spell it out. He has won his freedom from vertigo and grand deceptions—and the final image asks if there could be anything more absurd and useless than that freedom.

The world of Carlotta, Madeleine, and Judy was rich, full of life, vitality, emotion, Scottie had a deep relation with another human being—so far as we know, the only one in his life. That may have been a grand illusion and a scurrilous deception—but it gave meaning, intensity, human depth, and intimacy to this life of sterile rationality.

So *Vertigo* speaks the language of disillusionment, of skepticism toward fabricated glamour and scenarios of the dead ancestors alive in the living, toward charismatic stars and charismatic deceptions. It shows the realm of

Figure 43. *Vertigo: top*, Dream faller; *bottom*, Scottie on the edge. (Photo: Carolyn Hammersly)

enchantment as a dangerous place. A man's life is ruined for getting absorbed into it. The process of charismatic assimilation turns vampiristic. The Frank Capra hero in the world of grand illusion, used to taking rationality and lawfulness for granted, is an easy mark. Anyone who enters that realm without clearheaded cynical skepticism (and perhaps the crass anti-feminism of a Sam Spade and Philip Marlowe) is headed for trouble. But it also argues, in the emotional momentum of the entire movie and in the darkly suggestive final shot, that Scottie's life is barren once its mysteries are penetrated and exposed and its actors eliminated. Some element of his life is swept away that can never be replaced by the desiccated pleasures of a profession and a girlfriend. *Vertigo* both rejects illusion and shows the poverty of life when it is lost.[14] Romantic illusion is a psychological need as powerful as the hunger for reality. The two live in a reciprocal relationship with each other that guarantees their constant presence in varying mixtures and excludes any final triumph of "the real" over dream, illusion, desire. The relationship of mutual dependency of dream and reality relativizes the truth claims of critical reason over against those of the imagination.

Grand illusion accordingly is something other than self-delusion. Imagine, by contrast to Scottie's love of Madeleine and his pursuit of the dead woman beyond the grave, the barrenness in the everyday lives of those hard-boiled detectives whom no romantic dream can touch.[15] Their hard edge is a kind of inhumanity. Their mastery of women is asexual dominance, the activating of a master-slave relationship. The level of humanity in the successful film noir hero is represented in the view of women expounded by Rip Murdock (Humphrey Bogart) to Mrs. Chandler (Lizabeth Scott) to shut her up in *Dead Reckoning*, which amounts to, women talk too much. It would be good if he could reduce her to fit in his hand. When he needs her, he could take her out of his pocket, restore her to normal size, then shrink her and put her back in his pocket.

The final image in *Vertigo* suggests an affirmation of illusion beyond the attainment of the "real." Fellini ended *La Strada* (1954) with a visual statement based on this same logic, the emptiness of the life lived without illusion. The last scene in that film has the same kind of moral complexity as the last shot of *Vertigo*. Zampano (Anthony Quinn), a circus strong man and brute, has drunk himself into a stupor, got into a fight, kicks over garbage cans, then wanders out onto the beach and washes his face in the ocean. Kneeling in the sand, he is suddenly seized with fear and a kind of horror, his strong man's chest begins to shake with voiceless sobbing, he

Figure 44. *La Strada*: Final shot, Zampano on the beach. (Photo: Carolyn Hammersly)

looks up into a mottled night sky with some kind of wonder in his face (Figure 44). The camera pulls back and climbs, leaving Zampano small and writhing. Gelsomina's song comes up on the soundtrack.

He has been shaken—an emotion we cannot imagine him capable of—by the news that his old assistant and traveling companion, Gelsomina (Giulietta Masina), died insane. Zampano is the cause of her insanity (though she was borderline mentally retarded to begin with). He killed "the fool" (Richard Basehart), the one person Gelsomina had come to respect, possibly to love, and threw his body into a ravine while Gelsomina watched. Gelsomina, an angelic innocent and a kind of secular holy fool, can't deal with it, and loses her mind. He abandons her and finds out about her death years later. Something happens to him on the beach, some thought comes to him—one of the only ones he's ever had. Like Scottie, he looks into some abyss. Probably the murky thought that shakes him is, what Gelsomina was and what it means that she's dead. Some moment of guilt and bereavement softens his animal brain, some dull awareness of the gentleness and good-ness that she embodied offers him a contrast to the despised, drunken bully,

carnival fake, and beast, penitent and self-pitying, that he is. It is an August-inian moment. The man who has lived his life moved by only physical needs has slumped in the course of his life gradually into misery. At the point of maximum wretchedness he realizes that the evil in his life (and if he reflected, in life generally) is not caused by agents outside himself (the devil, all the people who envy him, who don't understand him), but by the absence of God.[16] Gelsomina is the missing occupant of that empty space in *La Strada*, and Zampano's horror powerfully affirms the value of what he has lost. Both Zampano's and Scottie's prostrate, capitulating postures in the end of their respective films figure men who have battled their way to a life without illusions to find how horrible or empty existence is without them.

The hard-line neorealist cinema of the postwar years, Italian and American, overcame the fluff of the thirties grand illusions, but not altogether. It kept casting Rhett Butler's backward glance toward a richer period of "grace and charm." Glamour, romance, and a vision of a happy world continued in romantic comedies (like *Romance on the High Seas*, 1948) and musical com-edies; the sophistication of the thirties musical turned into the sentimental-ity of the fifties (Rodgers and Hammerstein). The world of high glamour lived on via the many remakes of thirties movies from the fifties on. And it lived on in the nostalgia of movies like *Singin' in the Rain*, *Radio Days*, and *The Purple Rose of Cairo*, a nostalgia for the good old days when the movies and entertainment were "big." Fortunately the two (high glamour and new realism) did not annihilate each other, as Norma Desmond ("big movies," the past, glamour) shoots Joe Gillis (B-movies, mediocre, trivial, desperate for creative inspiration), shortly before going completely insane. *Sunset Boulevard* is an allegory of the destructive struggle of two eras of the movies with each other. Gillis hopes to live off Desmond. He's scornful of her big, overswollen ego and her big overswollen movie ideas. But he'll scavenge off her leavings. In this dark agon of classic against postclassic Hollywood, the greater existence snuffs out the life of the smaller, shortly before expiring itself.

 Vertigo—whatever else it is—is a comment on the development of American films from the thirties through the fifties. The false world of glamour and mystery produced and directed by Elster and play-acted by Judy is the classic Hollywood film of the thirties. The world of Scottie, the detective, and Midge, the smart, snappy, cute-as-a-button female buddy

and sexless romantic interest, is postclassical ordinariness, the fifties of Doris Day and Rock Hudson. "Madeleine" relates to Judy and Midge as Greta Garbo and Marlene Dietrich relate to Doris Day and Debbie Reynolds. Scottie penetrates the falsehood of mysterious, obsessive, spellbinding romance and ends up dully aware that his life once was "big" and now it's gotten "small."

13

Woody Allen: Allan Felix's Glasses and Cecilia's Smile

Sometimes the illusions work better than the medicine.
—Woody Allen, *You Will Meet a Tall Dark Stranger*

New York City must breed charisma, awareness of it, fear of it, desire for it. It cultivates and admires the big ego and the brassy personality in a way that sets it apart from Los Angeles, the other city of the big ego, but whose self-conception is more frail than the New Yorker's, undercut by the secret conviction that big personality is flash not brass, glitz, phoniness, and hollow show.

Three New York writers in the later twentieth century show a special awareness of charisma and charismatic effects, reflect on them, embed them in the operating systems of their works: Norman Mailer, Tom Wolfe, and Woody Allen. I quoted Mailer's studies of Muhammad Ali and Marilyn Monroe in earlier chapters. Wolfe's *The Right Stuff* posits mysterious forces innately present in extraordinary characters—more than strength and certainly more than virtue, inexpressibly at work sifting those with it from those without it. His novels *The Bonfire of the Vanities* and *A Man in Full* narrate tragic-pathetic failures of charismatic personalities. Woody Allen is the real theorist of charisma. He is a good informant, not because he produces charismatic art, but because he reflects on it, because his characters respond to it and long for it, because it dominates, stunts, transforms, exalts, and rescues their lives.

Allan Felix's Glasses

I'll focus on two images from his films. The first is the opening of *Play It Again, Sam* (1972).[1] The film starts inside another film. We're watching the airport scene at the end of *Casablanca*: the plane to Lisbon and freedom sits on the runway. A car drives up, Rick, Ilsa, and Victor Laszlo get out. While Laszlo sees to the luggage, Rick gives Ilsa the shattering news that she will be going to Lisbon with her husband, not with him. "As Time Goes By" comes up on the sound track, violins, not Sam and his piano. Gradually the frame of the screen shrinks, the camera backs away; we see the screen images framed by the proscenium of a movie theater, shadowy heads get in the way of the screen, and we realize that we're watching moviegoers watching the movie. As Ilsa asks, "But what about us?" and Rick answers, "We'll always have Paris," the camera cuts to Allan Felix (Woody Allen), close-up, watching the scene. His mouth drops open slowly in the course of the exchange. He's awestruck by the romance, by Rick's noble, it-is-a-far-far-better-thing-I-do gesture, awestruck by the beauty of the woman Rick gives up to save her marriage and her husband's life ("You're passing up a real tomata so you won't hurt another guy," Bogart will say to Allan later in *Play It Again*). We see the images on the screen dimly flickering across the surface of Allan Felix's eyeglasses, as though the movie were playing both outside the spectator and on his surface (Figure 45).

There is our first image: Bogart and Bergman in one of the most romantic and melodramatic moments of movie drama jumbled into the light dancing on Allan Felix's glasses. As the scene from *Casablanca* continues and the credits to *Play It Again, Sam* roll, Allan Felix falls into the role of Bogart, repeating the words of the dialogue, which he clearly knows by heart, mimicking Bogart's facial expressions.

Much commentary on the film sees the opening juxtaposition of Allan and Bogart in terms of the escape into fantasy of a man unable to live in the real world, "a watcher, not a doer." But this approach makes it hard to come to terms with the ending.

Play It Again also ends at an airport. A plane (anachronistically for 1972, it has propellers) waits on the tarmac, and Allan explains to Linda (Diane Keaton) why she must not leave her husband to stay with him. No repeat of the surrendering female Ilsa, condescended to by her worshippers in *Casablanca*, Linda interrupts to tell him she's already decided to stay with her husband. She has found out through loving Allan that she also

Figure 45. *Play It Again, Sam*: Allan Felix's glasses. (Photo: Carolyn Hammersly)

loves Dick, and she is afraid that if she spent any more time with her new lover, she would love him too deeply to be able to stay with her husband. The first noble gesture is reserved for the woman. Allan answers with another noble gesture: quoting Rick, he tells her to forget him.

> ALLAN. If that plane leaves the ground and you're not on it, you'll regret it. Maybe not today, maybe not tomorrow, but soon, and for the rest of your life.
> LINDA. That's beautiful.
> ALLAN. It's from *Casablanca*. I waited my *whole life* to say it.

Her husband walks up. Allan tells the lie parallel to Rick's to firm up the shaken marriage ties: she didn't really love him, she rejected his advances, she loves her husband too much to fall for another man. The motor of the plane engine starts portentously, the monumental reaction shots from Linda to Allan to Dick, again, cribbed from *Casablanca*. The couple walks to the plane. Linda strains to look back at Allan, like Ilsa at Rick. Allan watches them move toward the plane, and another figure steps out of the fog to join him. It is Humphrey Bogart (Jerry Lacy).

> BOGART. That was great. You've really developed yourself a little style.

Figure 46. *Play It Again, Sam*: Bogart salutes Allan. (Photo: Carolyn Hammersly)

ALLAN. Yeah. I do have a certain amount of style, don't I?

BOGART. Well, I guess you won't be needing me anymore. There's nothing I can tell you now that you don't already know.

ALLAN. I guess that's so. I guess the secret's not being you, it's being me. Of course, you're not too tall and kind of ugly. But, what the hell, I guess I'm short enough and ugly enough to succeed on my own.

Allan turns and walks away. Bogart watches him, salutes jauntily (Figure 46), and gives his Ilsa toast with World War II–officer debonairness, "Here's lookin' at you, kid." Allan leaves Bogart in the fog and walks into the lights of the airport; the music surges, "As Time Goes By." The end credits roll.

Bogart the Charismatic Master

This early film is a drama of maturing, a coming-of-age film, only an older age than conventional in that genre. Allan Felix has changed. He has developed "a certain amount of style," but also character and ethical action. His mentor and teacher Bogart has led him through a process of "education,"

and Allan has grown into the role, maybe not of the tough guy, but of the noble, romantic hero.

Of course, the development is worm-eaten with a schlemiel's self-consciousness. What he gains in strength and heat of expression by quoting Bogart, he loses in his puerile self-commentary, "I've waited my whole life to say it." But the outcome of the movie is clear: Allan emerges a stronger character at the end, shaped in the narrative lines and character conception of Bogart. Old neuroses are overcome. The act of courageous renunciation is itself healing, liberating, the threshold to maturity. Woody Allen has envisioned the final scene as the shedding of a dependency on a stronger model, Bogart: "You won't be needing me anymore. There's nothing I can tell you now that you don't already know." Allan Felix now has appropriated "the secret"—"being me." He has become himself. He walks away with the sense of entering a bigger existence than the pathetic one he has shed. Whether he will remain "himself" is not so clear. The fog through which he exits leaves the question open. Reversing the positions—Bogart walks off into fog, Allan salutes and says, "Here's looking at you"—would have implied that the charismatic phantom returns to the unreal world from which he came, leaving Allan Felix in a real world of romantic happiness. It doesn't matter. The circle from the Casablanca airport, 1942, to the San Francisco airport, 1972, speaks clearly. What happened once in the life of great screen heroes happens now in the life of reformed schmuck, Allan Felix.

The image of Bogart and Ilsa's farewell scene on Allan Felix's eyeglasses is rich and powerfully suggestive. We are watching an act, not just of perception, but of internalizing. This is the Woody Allen version of the eye as entry into the mind. It is the organ that both sees and is visible; it perceives and reveals at the same time; it is the door to the inner world. Kim Novak's eye, staring unblinking and unnervingly at the viewer during the credits of *Vertigo* is our entry into a world of twisting and twirling spirals, disorienting inner-ear operations, which throw us out of balance along with the main character, Scottie. Or the opposite: the horror of a dead person's eye viewed close-up and the realization that the inner world is no longer functioning; the life behind the eye is gone: Janet Leigh in the last shot of the shower scene in *Psycho* (1960) or Anjelica Huston, whose character was recently murdered in *Crimes and Misdemeanors* (1989).[2]

In the glare on Allan Felix's glasses, we watch Bogart being inscribed into the personality of Allan. Bogart appears in two personations in *Play It Again*, as the Rick of *Casablanca* and as the phantom tutor who pops up in

Allan's apartment and once in a supermarket. His position as live-in mentor extends the image on the glasses into the narrative. He is projected out of Allan's mind, as the projector projects him onto the screen and into Allan's eyes.

We can describe Allan's transformation with language developed in earlier chapters: the devotee makes himself over in the image of a charismatic model. It is another realization of Seneca's advice to Lucilius: "Cherish some man of high character, and keep him ever before your eyes, living as if he were watching you, and ordering all your actions as if he beheld them"[3] Seneca was talking about living models. Thomasin, the theorist of court life (see Chapter 6), urged fictional models: Gawain, Tristan, Yvain. Don Quixote was sucked so powerfully into the fictional model that he could not get out, or, rather, with an unshakable resolve, he opted for life in the fictional realm and refashioned his existence to comply with the laws of that realm. The greater ego absorbs little ones, sometimes disorienting and diminishing them ("She's so refined, I think I'll kill myself"), sometimes lifting them up and refashioning them for a bigger existence, magically producing "increase of being." Commentary on *Play It Again* tends to see the Bogart–Allan Felix relationship as the weak, sick, star infatuation of a loser, an imaginative way of reframing the impossibility of an authentic existence for Allan.

Character, Soft and Hard

Sam Girgus's and Sander H. Lee's readings of Allan Felix assume that Allan is, already at the beginning of the movie, whatever he is going to become, fixed into his schmuck character without hope of redemption, and any moves toward stability and self-assurance have to be inauthentic. They reduce the importance of Bogart in *Play It Again* and reverse the value placed on his model. They assume that movie-induced transformations are flights into inauthenticity and that assimilating to a stronger role-model is a sign of instability.[4]

The opposite idea of character, and I believe the one that operates in this and other Woody Allen films of transformation, has it that art and literature can change and "enlarge" a person by charismatic effects like those exercised by forceful personalities in reality. The skeptical attitude is

represented in the film also. Linda says, everyone's insecure. Allan answers: "You know who's not insecure? Bogart."

> LINDA. But, Allan, that's not real life. You set too high a standard.
> ALLAN. Well, if you're gonna identify, who am I gonna pick? My rabbi? I mean, Bogart's a perfect image.
> LINDA. You don't have to pick anybody. You're you. I know that you can't believe that.

But the thrust of the film shows up the straightforward "You're you" as a simplification. Allan is not stable enough to be himself when the film begins; he is when it ends. There is a sensible resistance on the part of a stable, mature person to the idea that it is useful and healthy to let yourself be absorbed into an ideal/idealized personality, real or fictional. In an earlier chapter I cited Emerson's take on "greatness" and "excellence" in representative figures (see Chapter 1). It is for Emerson a redemptive force. The replicating force of "greatness" in a single person redeems the mass from its mediocrity and insignificance and raises individuals and nations up to the level of the great man—an extravagant take on charismatic fashioning, and the seemingly opposed take in Emerson's better known essay "Self-Reliance" does not contradict it. Self-reliance is a stage in development beyond reliance on a model, great or not, and that is the stage reached by Allan Felix at the end of the movie.

The idea that fictional greatness can also exalt readers was of no interest to Emerson. Recent theories of cognitive and developmental psychology have claimed the importance of the "narrative construction of the self."[5] Identity gets fashioned via narratives. The process of writing a life narrative is by now entrenched in the practice of therapy in cognitive psychology. Individuals construct their identity by "writing" their own narratives, and they derive a sense of who they are from fictional narrative, their own and others. Theodore Sarbin calls this appropriation of identity from fiction the "Quixotic principle."[6]

The pathetic screwball immaturity and instability of Allan Felix make him a candidate for exaltation by Bogart. He is in the grips of the Quixotic principle. Only Bogart, instead of remaining in fiction, turns up in Allan's apartment to give him on-site help in writing a life narrative.

Play It Again, Sam is a reflection on maturing under the influence of mentor figures. It seems that falling in love with Linda heals some inner

paralysis of Allan. He can make a manly confession to Dick and rearrange their lives according to the new state of affairs: "That's what people like that do," he tells Linda. He is now "people like that," he is "mature," at least the script has Linda declaring his maturity in the dialogue on the morning after their fling. They are riding up a hill in a cable car and have the following exchange:

> ALLAN. I think as long as we handle this in a mature way, as long as
> I'm mature about it, and you're mature about it and both of us
> are mature, we'll achieve a certain maturation that guaranteed
> maturiosity.
> LINDA. Yes, well, you're mature, Allan, and very wise.
> ALLAN. Yes, well, I think the key to wiseness is maturiositude.

The inanity of the exchange makes clear that Groucho Marx and Bob Hope are in Allan's/Allen's psyche to stay, even while Bogart gains command of some of it. But that does not intrude on the evident telos of the movie—rising to maturity through Bogart imitation and ultimately to independence. Bogart takes leave of his pupil with the words, "I guess you don't need me anymore." This is not "abandoning" Bogart any more than the liberation of a young man from an older mentor in an initiation rite means abandoning the one who has disciplined and formed him.

The Exquisite Moment

The rise to maturity is one end toward which the narrative tends. Another is life. Allan Felix is not alive, at least in the sense I have used the word so far in this book: radiant inwardly and outwardly with a life-affirming energy, a certain kind of force concentrated on the skin, so to speak, possessing the surface luminosity that proclaims the character, as the tattooing of the Maori proclaims ineradicable Maoriness; a sense of living and being alive as the sudden, immediate coalescence of the positive forces in one's being—love, compassion, courage, admiration. That moment happens in the replay of the airport scene at the end of *Play It Again*. It is the luminous moment. It represents another crossing of boundaries, a breakthrough of sorts, but not into an otherworld realm, as in courtly romance or Faust, but into

"self-reliance," a moment that can authenticate the rest of his life and govern the rest of his action.

Woody Allen has a keen sense of the exquisitely lived moment. It is part and parcel of his sense of charisma of person. He captured the experience in one of the most moving and atmospheric scenes of any of his movies, Sandy Bates's recollection of the instant pregnant with life in *Stardust Memories* (1980). Ironically it comes in his own posthumous reflection. Sandy (Woody Allen) supposedly has been shot to death. Actually he has only fainted and is lying in a hospital emergency room fantasizing that he is dead, that he is receiving a prize posthumously and making his acceptance speech:

> SANDY. Just a little while back, just before I died in fact, I was lying on the operating table, and I was searching to try to find something to hang on to, you know, 'cause when you're dying, life suddenly does become very authentic. And, and I was searching for something to give my life meaning, and, and a memory flashed through my mind. It was one of those great spring days, a Sunday. [*Music plays: Louis Armstrong, "Stardust."*] And you knew summer would be coming soon. And I remember that morning Dorrie and I had gone for a walk in the park. And we came back to the apartment. We were just sort of sitting around, and I put on a record of Louis Armstrong, which was music that I grew up loving. It was very, very pretty. And I happened to glance over, and I saw Dorrie sitting there. And I remember thinking to myself how terrific she was, and how much I loved her, and, I don't know, I guess it was the combination of everything, the sound of that music and the breeze and how beautiful Dorrie looked to me. And for one brief moment everything just seemed to come together perfectly, and I felt happy, almost indestructible in a way. That's funny, that simple little moment of contact moved me in a very, very profound way.

The single moment of happiness that justifies his life and gives him the sense of immortality flows from the face of his lover, caught at a significant instant (Figure 47). It turns that instant into eternity. It makes him "indestructible." It is an "exquisite moment," as Pierre Hadot described it and I discussed it in an earlier chapter.

Figure 47. *Stardust Memories*: Dorrie's smile. (Photo: Carolyn Hammersly)

Woody Allen's most pathetic characters can find some fragment of redemption frozen into a single perfect moment. In *Anything Else* (2003), miserable writer Jerry Falk (Jason Biggs), unhappy in love, makes love with his girlfriend Amanda (Christina Ricci), who has just returned from a fling with another man, and says in voice-over: "We made love that night. It was wonderful. If only certain moments in life could last, just stay frozen, like some old vase." They kiss; the frame freezes. The character's world is horrible, full of degradation and guilt and other things that destroy lives. What makes the characters indestructible is not anything metaphysical, gods or religion, but perfection condensed into a moment. At least that moment gives them the vision of life beautifully and happily lived. It creates in those characters what Dickens called "a great Charity in the heart" in the passage from *Hard Times* that provided the epigraph to this book: "The dreams of childhood—its airy fables; its graceful, beautiful, humane, impossible adornments of the world beyond: so good to be believed in once, so good to be remembered when outgrown, for then the least among them rises to the stature of a great Charity in the heart, suffering little children to come

into the midst of it." The "Charity" is a sheltered space in the mind where, by a kind of alchemy, the remains of fairy tales and children's fables and experiences get transformed into forces of salvation. The working of the "great Charity" in the psychic life of an individual is like the working of a brain implant on a body attacked by some degenerative nerve disease. The implant is not visible, not noticeable to the patient, but it issues a secretion, repeated over time, that retards the crippling of the body. The Charity-implant generates its secretions from "grace, humanity, beauty." Our reading of Woody Allen suggests an adult supplement to that list from Dickens: "love" ("music that I grew up loving"; "I remember thinking to myself . . . how much I loved her")—the word preserves the more profound meaning of "charity," *caritas*, alongside its more ordinary one, a welfare institution. Grace, humanity, beauty, and love may appear as "impossible adornments of the world," but in Dickens's reading, they are not deception and opiate to conceal or cloud a realistic vision of the world, but rather a psychological stabilizing force, an internal gyroscope that holds those under its influence to notions of humanity and compassion. They are what Ebenezer Scrooge lacked; he had to replenish an impoverished supply of childhood memories by his return to the past.

Let's call this invisibly working force of renewal "the Rosebud effect." It is a transforming—at least, sustaining—effect of things seen, read, and experienced in youth. With his dying breath, Charles Foster Kane (Orson Welles) in *Citizen Kane* (1941) utters the word "Rosebud," which turns out to be the name of a sled he owned in his youth prior to becoming a rich young genius. A newspaper reporter's search for the meaning of the great man's last word sets the film in motion and ends it. What Rosebud meant to him is left to the viewer to reconstruct, but its occurrence in his dying moment places its importance to Kane throughout his life beyond doubt. The film's unwillingness to articulate a meaning of the image (and the total subjectivity of "Rosebud"-type objects) registers in the failure of the newspaper's search. None of the film's characters ever discovers what "Rosebud" means, only the viewer of the film, who learns at least what the word refers to when in the last minutes of the film the camera wanders randomly over the acres of cultural detritus left behind by Kane and comes to rest on the sled named Rosebud, as it is being fed into the fire. That connection also illuminates the image of the glass paperweight globe containing a snowy landscape, which falls from Kane's hand and bursts open in the moment of his death. The meaning for Kane of that prelapsarian world of snow, sleds,

and a loving mother remains personal and subjective. It may mean escape and a dream of an unattainable, lost innocence. But it is reasonable to assume that it is a force that remains alive in Kane throughout his life, distinguishes him from other, less visionary, more conventional men. Since Kane had used the sled as a weapon against the big-city banker who takes him away from the world of his youth, it works also as an instrument of rebellion, and its memory, however vaguely maintained (it's an implant), supplies the force that drives the rogue newspaperman and reforming politician to keep attacking the banker and people like him.

The passage from Dickens's *Hard Times* quoted above is a good comment on the Rosebud effect: the dreams and "airy fables" of childhood, "its graceful, beautiful, humane, impossible adornments of the world beyond," which create "a great Charity in the heart," once made the child believe the world is better than it is, and they still work in adult life to minimize the effects of selfishness, cruelty, spiritual sterility, toward which Charles Foster Kane's life inevitably steers. They form an incorruptible inner core, not easily accessible, given its highly corruptible casing. It is not necessary to *believe in* the "world beyond" ("once believed in . . . outgrown") in order to experience its redemptive effect, only to remember it; not even to remember it, just to keep it stored in the "involuntary memory."

Hard Times is about the desiccating effect on the soul of fact-saturated, fantasy-deprived education. Far from producing a model Englishman or woman, its result is a kind of disease of the soul produced by deprivation of a vital nourishment.

Woody Allen has this much in common with Dickens, Proust, and Fellini at least: youth and a state of innocence serve them as a kind of treasure chamber to which they turn for inner renewal. The entire vast reminiscence of *In Search of Lost Time* is driven by the urge to recover the lost state of childhood happiness. Federico Fellini's *8½* (1963), of which *Stardust Memories* is a reworking, is about a film director who has run out of inspiration and bogged down in the middle of a blockbuster project that he can't continue and can't abandon. The knot in the artist's mind in the present is loosened by a return to the past. He reminisces; he adjusts reality; he dips the past in a Proustian magic elixir. The blocked director, Guido (Marcello Mastroianni), watches a magic show, is asked to think of something, anything, and the magician will write it out on a blackboard by reading it in his mind. He thinks the words "ASA NISI MASA," duly scribbled by the

magician, who says, "I don't know what it means." Then without transition, the narrative flashes back to a scene in Guido's early youth: In his mother's house the children were bathed in wine once each year. It was believed to make them strong and healthy. We see his mother wrapping the five-year-old Guido in a white towel, and the whole scene is shot in whitewashed rooms, Guido and his mother dressed in white. As she carries him, dandling and cuddling him, to the bath she prattles with a beatific smile, "sweetest boy, sweetest boy in the world." Bathed and dried, Guido sits in the darkened bedroom with other children, and his older cousin tells him to look at the portrait of an ancestor on the wall and speak the magic words, "asa nisi masa; asa nisi masa." They will make the man in the portrait direct his eyes "to where the treasure is hidden." For the grown man and artist Guido, the magic word that opens treasure chambers is his rediscovered youth. The film ends with Guido's creative force restored, and the genie of restoration is the little boy Guido who marches offstage leading a parade of clowns—a dance of the "dreams and airy fables of childhood," which have just dramatically exercised their curative power in the present.

Woody Allen's exquisite moments and redeeming experiences are a lifeline for drowning characters. Like Sandy Bates who searches for "something to hang on to" in that especially authentic moment just before he dies, the possessor of the inner Charity heads, in crisis, for the refuge of past enchantments.

Zelig's Reverse Elitism

Allan Felix's development to maturity depends on surface change catalyzed by a powerful character. It is the obverse of Woody Allen's awareness of "hard" character and its charismatic force; the susceptibility of the soft character to the influence of a strong personality. The predominance of the imagination in any given character activates the imitative impulse in response to an admired model. That means that he incurs the risk run by weak or unshaped characters that the authority of the greater model overwhelms them. Woody Allen's *Zelig* (1983) plays on this effect by positing a character who has absolutely no resistance to the personal force fields of the people around him. Zelig becomes everyone he encounters, not by slow, self-conscious shaping, but by a complete capitulation and magical adaptation to the force field of the person facing him. The comedy is that

it does not require force or charisma in the giver. So weak is Zelig's resistance to the basic human equipment (i.e., not charisma, greatness, or excellence) that everyone becomes an overpowering presence forcing him to transform himself. He adapts perfectly to his environment: he hobnobs with presidents, socialites, and baseball players as their equal. He realizes that ideal of transforming himself altogether into his "teachers." In the presence of a fat man he thickens. Garry Wills said of Ronald Reagan's charismatic effect, "He is the opposite of a chameleon: environments adapt themselves to him."[7] Reagan is the reverse of Zelig, whose emblem is the chameleon: he adapts to every environment. But the movie also confirms the principal of personal magnetism and charismatic force shaping individuals— ex negativo. Transforming force is everywhere, in every cabdriver, and one weak character is drawn into whatever force field he enters, and is transformed promiscuously. His changes respond to the simple urge to be safe and to be liked—not to heroism or greatness. But this quintessence of weakness ends in "self-reliance" ("Kids, you have to be yourself," his message to the children of America), even heroism. After departure from the United States in scandal and a heroic escape from Nazi Germany, he is welcomed back to America in a ticker-tape parade through New York in an open convertible. The mayor awards him "the medal of valor." Irving Howe sums up Zelig's cultural significance in an interview that opens the movie: "All the things our culture values were there—heroism, will . . ." And Saul Bellow at the end: "What allowed him to perform this great feat was his ability to transform himself. Therefore, his sickness was the root of his salvation. . . . It was his very disorder that made a hero out of him." The same can be said of Allan Felix, and, of course, of Woody Allen. His disorders made a major film artist of him.

Cecilia's Smile

At the end of *The Purple Rose of Cairo* the main character, Cecilia (Mia Farrow), sits in a movie theater watching Fred Astaire and Ginger Rogers in *Top Hat* ("Cheek to Cheek"). She wipes tears from her eyes. She has good reason to cry. It's the Great Depression. She has lost her job. She has left her husband. She has been deceived and abandoned by a glamorous young movie actor who declared his love and promised to take her with him to Hollywood. Because of that promise she left both her husband and

Figure 48. *The Purple Rose of Cairo*: Cecilia's smile. (Photo: Carolyn Hammersly)

her fictional lover, Tom Baxter, who had stepped down from the movie screen and left "Purple Rose of Cairo" (the movie within the movie) in order to experience real life with Cecilia. She has nothing left, no home, no income, no man. Her best option is the river or the gas pipe or sleeping pills, which she probably can't afford. Everything that could rescue her for life is cut away.

She looks up at the movie. "Cheek to Cheek" plays; Astaire and Rogers dance with the grace and beauty of gods, and very gradually—the single close-up shot of Cecilia lasts, with clips from *Top Hat* intercut, about one and a half minutes—she begins to smile. Cecilia's smile is the second image I want to focus on (Figure 48).

The answer to the central questions the movie poses is delivered in a single polyvalent image. As as at the end of *Match Point* (2005), the existence of a character is threatened, and the final image offers not an answer but a reaction to the situation of the moment. Neither Cecilia's smile nor the grim, lost, introverted look of Chris Wilton (Jonathan Rhys Meyers) that ends *Match Point* gives unambiguous answers to the question the movie poses. (How should a man react, having murdered his pregnant mistress, when his unloved but wealthy wife presents him with their new baby?) Chris's glazed look offers no "meaning" behind its opaque surface. It is a pregnant moment that does not signal what it will give birth to.

Why does Cecilia smile? Is she, once again, deluded, seduced by movie glamour and glitz? Will she walk out of the movie (like Allan in the beginning of *Play It Again, Sam*) disillusioned and head for the river?[8] Or she is strengthened and reclaimed for life? Is she Emma Bovary or Nora Helmer?

The Movie as Redeemer

While Cecilia's smile does not preclude either possibility, the stronger reading is, the smile means redemption. Parallel scenes in other Woody Allen films and others he borrowed to make this one argue that the movie rescues her for life.

Mickey Sachs (the Woody Allen character in *Hannah and Her Sisters*, 1986) thinks he has cancer, then finds out that he doesn't. But he has looked into the face of death and it creates an existential crisis. How can he live given the inevitability of death? He has this exchange with his colleague, Gail (Julie Kavner):

MICKEY. Do you realize what a thread we're hanging by?
GAIL. Mickey, you're off the hook. You should be celebrating.
MICKEY. Can you understand how meaningless everything is? Everything, I'm talking about—our lives, the show, the whole world—meaningless.

He tries religion, philosophy. Nothing works. Finally he gets a gun, puts it to his forehead, pulls the trigger—and misses. He goes out to calm down and pull himself together for a second try, walks around, goes into a movie house and watches the end of *Duck Soup*. He comes out reconciled with existence—saved by the Marx Brothers. The movie ends with Mickey happily married to a reformed Holly (Dianne Wiest, Hannah's self-pitying, cocaine-addicted sister). In the last line of the movie Holly announces to Mickey, medically certified as incapable of making babies, that she's pregnant. So, not only his despair, but ultimately his sterility is miraculously overcome. Mickey's prospects for redemption and renewal were better than Cecilia's, since he was a successful producer, surrounded by family and admiring friends. But his despair is at Cecilia's level, perhaps even lower—she never got the gun to her head—and the ability of the movies to leverage a lost character back into existence asserts itself in both scenes.

Figure 49. *Stardust Memories*: The empty screen. (Photo: Carolyn Hammersly)

The end of *Stardust Memories* takes us the same route. Sandy Bates declares life horrible and meaningless. As he lies dead in the hospital emergency room (but it's a delusion), a nurse talks to the camera, chomping into an apple: "It's a shame. Poor fool. He's dead. And he never really found out the meaning of life." His analyst blames his "faulty denial mechanism" for giving him too clear a view of reality: "In the end his inability to push away the awful facts of being in the world rendered his life meaningless." That despair finds two answers in the film: the exquisite moment with Dorrie and the movie's final shot. The award ceremony honoring Sandy Bates is over; the theater is emptying out. The public and the characters from the film file out. The camera continues to look at the theater, its empty seats, the screen empty of images, surrounded by a wreath of lights. Sandy Bates walks in slowly, picks up the pair of dark glasses he's left on a chair, puts them on and leaves, but turns back to take a long look at the empty screen (Figure 49).

In significant moments in his movies Woody Allen calls on symbolic gazing, a technique he learned from Federico Fellini, who had used it masterfully to comment on characters and events by evoking, not stating or signaling meaning, not playing out resolutions in dialogue or action: the village idiot's gaze at the stolen angel in *I Vitelloni*, Gelsomina's spellbound look at the retarded boy, and Zampano's at the sky, in *La Strada*; Marcello's

Figure 50. *La Dolce Vita:* Final shot, the "Umbrian Angel." (Photo: Carolyn Hammersly)

at the sea monster, then at the angelic young girl, Paola (Valeria Ciangot-tini), in the last moments of *La Dolce Vita* (Figure 50). They see something that speaks to the grounding of their existence, though what that is remains a mystery, a set of suggestions bundled into the images. Sandy Bates's long gaze at the empty screen has the same kind of evocative power as those moments. The screen empty, wiped clean of images, and virginally white: it's not the emptiness of a meaningless existence, but rather the fecundity of a creative one. It's an image like the poet watching the page that hasn't yet received the writing, or the sculptor looking at the block of marble not yet touched by the chisel and hammer. Then he turns and leaves, and we watch the empty theater while "Easy to Love" plays on the sound track. The movie screen is what ultimately gives life to a character threatened by an "excess of reality" and a senseless quest for "meaning." The ending of *Stardust Memories* says essentially what the ending of *Purple Rose* says. Sandy's gaze equals Cecilia's smile; both gaze at the screen, empty and filled; both find in the screen the ability to continue living.

Woody Allen cribbed the last scene of *Purple Rose* from the ending of Fellini's *Nights of Cabiria* (1957). The lovable prostitute Cabiria (Giulietta Masina) has descended through various levels of disillusion and despair. At

Figure 51. *Nights of Cabiria*: Cabiria saved. (Photo: Carolyn Hammersly)

the final rung, she is horrendously deceived by a confidence man who pretends to be in love with her in spite of her career as a whore. He's about to grab her purse, stufffed with lire—she has sold her cinder-block house, since they're supposedly eloping—push her over a cliff and disappear, but loses courage. He just snatches the purse and runs off. She is left with nothing, no savings, no house, no man, no career, no life. But a troop of young people surround her on the country road, singing and dancing, and the movie ends with Cabiria slowly won over by the mirth and life of the group. Her eyes fill with tears, she smiles and nods at the young people, to her left, to her right, and then, straight into the camera, to the audience, assuring us that she's back in life (Figure 51).

For Fellini innocence exercises the force that movie strength, romance, and glamour exercise in Woody Allen's films. The young, muselike girl in *La Dolce Vita* (1960), sweet as "an Umbrian angel," fills the screen in the last shot of the movie. While she can't rescue the dissolute reporter Marcello (Marcello Mastroianni) from his descent, her angelic, wistfully smiling face (see Figure 50) is the image that ends the film, as Marcello and a troop of debauched revelers, separated from her by a river, stumble off into dissipation.

Figure 52. *8½*: Final shot, young Guido and the empty circus ring. (Photo: Carolyn Hammersly)

And, one final Fellini image of redemption through innocence picked up by Woody Allen: the little boy Guido, leading the clowns in the dance of life that ends *8½*. The last shot of that movie (Figure 52) shows a circus ring surrounded by lights, a stage where all the actors have exited, like the bare screen at the end of *Stardust Memories*.

What the dancing, singing teenagers gave Cabiria, the dancing and sing-ing Fred and Ginger give Cecilia. The gift—the beauty, glamour, the *charis* of the scene—offers her a moment of happiness into which her real misery cannot penetrate. For how long, with what end result, is not so important as the immediate effect: the moment of enchantment in the extreme of despair opens a way to survival. Time stops and the realities of her life are suspended. Proust gives a crystalline description of such a moment: "I was enclosed in the present. . . . I was glued to the sensation of the moment with no extension beyond its limits. . . . The most serious matters . . . relapsed into insignificance. . . . My immediate sensation, thanks to its extraordinary intensity, to the joy that its slightest modifications, its mere continuity, provoked, alone had any importance for me. . . . Inebriation brings about for an hour or two a state of subjective idealism. . . . Every-thing . . . exists only as a function of our sublime self."[9]

Cecilia's smile shows this compression of all her life into the moment; she owns it; nothing disturbing can intrude; it speaks only to "her sublime self" and shuts out her deceived and suicidal self. She experiences assumption into the higher reality of *Top Hat*, an illusion inside the greater illusion that sustains all of cinema, the deception of the eye that allows it to see a succession of still-framed images, twenty-four per second, as an unflickering progress from one to the next, magically merged by the overarching illusion of continuous progress. Cecilia's smile, of course, registers an escape into the refuge of this double deception; but it also shows how the "mere entertainment" and "escapism" of the film supply a desperate need of the viewer who enters the cinema as a patient. It affirms the movie's potential to heal, if not to cure. Just as we accept the appearance of continuous action as the given of the film medium (and what sense would it make to claim, "*Yes, but the reality is, still photos in frames; the viewer is being deceived!*"?), we can also accept as a given of charismatic illusions their "inebriating" effect and their potential to create a state of "subjective idealism."

Top Hat encloses Cecilia in one of those "illusions" so big and so far superior to the "reality" of the viewing subject that they take on redemptive force. The parallel to other figures in Woody Allen movies rescued from despair by the *charis* of the film suggests that at least that same rescuing force is at work in this luminous moment in the Jewel Theater. Allan Felix, Mickey Sachs, and Cecilia enter a higher world just as they hit bottom. Cecilia experiences the real presence of the glamorous Tom Baxter behind the surface events of the movie of which she's a character, *Purple Rose*. She enters into the world of the movie within the movie, "Purple Rose," and experiences a beautiful fiction as reality.

Like the experience of the worshipper who believes in the real presence of God or of a saint behind or within the surface of the icon, immersion in the other, higher world and its beautiful, ideal, perfect, and perfectly happy beings draws the viewer back into life not because it is their world and their reality, but because it is so much better. The vision at least has the capacity to produce catharsis and transformation. What is cleansed is, at the minimum, the will to abandon life.[10] Cecilia's sense of degradation and rejection has to be cured, or she can't live on. She is lured back to existence by a persuasive representation of happiness, love, a good life, and creatures whose motion links the here and now with a world where humans are godlike and life is bliss. Seeing them in their world, she thinks the healing

thought, better than medicine: "*If the world can produce such moments, if people can dance and love like that—then I can live.*" It does not matter that the represented world is not real; what matters is the outcome: "*Then I can live.*" Illusions can have this healing effect in the worlds represented by Woody Allen more than psychoanalysts.

Cecilia's experience comes close to reiterating Nietzsche's extravagant and dazzling claim of the purpose of Apollonian art in *The Birth of Tragedy*. Recall that the benefits of art are greatest when the individual is threatened by the terrifying insight into what life is and what the "spirit of the world" has in mind for human destiny. This knowledge induces loathing, nausea, and paralysis. The person who has it is incapable of any action other than suicide. Everything in life appears horrifying or absurd. The wisdom of Silenus now makes good sense: "The best thing for you is never to have been born; the next best, to die as soon as possible." But in the middle of this crisis the rescuer appears. "In this moment of the greatest peril of the will, there approaches an enchantress, a savior wise in cures: Art. Only art is capable of reshaping those thoughts of horror and loathing into visions that make it possible to continue to live" (chap. 7). The beautiful Greek vision of an Olympian realm, the Homeric world, the statues of the classical period: these creations of Apollonian art exist not to give pleasure and stimulate understanding—comparatively shallow and pleasure-driven goals—but rather to lure back into life a people especially endangered by their deeper knowledge of the real nature of existence behind the veil of the everyday. Art is illusory, to be sure, but the illusion is one created by nature to accomplish a goal beyond aesthetic virtuosity. Nature has a hidden agenda: trick us into living and reproducing. The bait and lure is art. Art affirms life, says Nietzsche, so that living creatures will not lose the will to survive and multiply.

The Purple Rose of Cairo brings the purpose of charismatic art into sharp focus. The illusion powerful enough to dissolve its own illusory character and lift the viewer into a "heightened" world brings redemption by promising happiness, suggesting immortality and invulnerability, by injecting the equivalent of "Rosebud" into the nervous system and sensorium of the needy or susceptible recipient. Since its gifts are what humans want most, they are the greatest lure to participate in the charismatic world. Once deceived and disillusioned because she abandoned Tom Baxter (the movie character) and gave in to the seduction of Gil Shepherd (the actor who plays Tom), Cecilia is lifted a second time into the higher world by *Top Hat*.

In an earlier chapter I talked about the mechanisms by which charismatic art breaks down the resistance to illusion: the supernatural, the fabulous, the fantastic, beauty, charm, and grace beyond what is observable in life, the sublime style, the dynamics of narrative. Once the critical, rational sense is disabled, once the viewer accepts illusion as the presence of a higher world, it becomes possible to live in the work of art and refashion life in imitation of that higher model. It creates a psychological state in the viewer in which the supernatural qualities of the hero can come to life in the reader or viewer.

In *The Purple Rose of Cairo* Cecilia has no resistance to romantic illusions. All critical sense is overridden by need. She needs a "heightened" world as refuge from the real. What need could be met by reasoned judgment? It would only hold her captive in a reality that is crushing her. The only rescue that reason offers Cecilia is suicide—the wisdom of Silenus: "*If you can stay alive seeing the world as you now do, you must not understand it. If you understand it, you must want to die.*"

You give yourself to illusion as to a lover: the need is great, the desire is strong, the promise is immense. The danger of seduction is great in the same degree. In Cecilia's case, the need is so great that no fear of seduction remains. That leaves her defenseless, and she succumbs to the real actor manipulating her in order to rescue his own career. In an odd turnabout there is stability in the world of illusion. The world of the movie within the movie ("Purple Rose of Cairo") is perfect—genuinely, not illusively preferable to the real. It is one of those enchanted realms available after the "breakthrough," like the realm of adventure in chivalric romance, like the post-devil-pact world of Faust, like Oz and Narnia. As in *Faust* the world of the real is deadly; the other realm filled with blessings. Kansas is dreary but Oz promises adventure, the heroic life, and the breakthrough into a genuine identity. In the higher world of "Purple Rose" people dress and live beautifully and face decisions like whether to vacation in Paris, Tangiers, or Morocco, whether to use the large bubbles or the ass's milk for their bath. Cecilia drinks in perfection, romance, gaiety, freedom from cares on her "night on the town" spent in the nightclubs of Manhattan. Those pleasures get her through her last crisis.[11]

CONCLUSION

This book has pointed to some aspects of art viewed through the lens of charisma, aura, hypermimesis, the sublime. "Showing" and "pointing" are techniques more deeply complicit with my approach than what the ordinary usage of those words indicates. As mediating acts they are very different from interpreting. A reader cannot interpret and at the same time participate in the life of a work of literature. Interpretation is to the work of art what surgery is to the body—of course a valuable and important procedure, often salutary, sometimes enhancing, sometimes endangering the life of the patient, always invasive. Interpretation sets the work of art parallel to the patient etherized on the operating table, makes it into an organism functioning by a chemistry peculiar to its individual body. (It's no accident that "anatomy of" and "anatomize" became critical terms.) The trained expert interpreter who understands the complex inner workings of the patient is the mediator of understanding. This model accordingly establishes an authority relationship of interpreter to text analogous to that of surgeon to human body. As the doctor explicates the passive patient in the anatomy lesson, the interpreter teases out meaning from the body of the text; the work itself is something complex and difficult, its meaning esoteric but explicable, and so, explanation and its end effect, understanding, develop a mystique like that of the psychoanalyst and the cure, the guru and enlightenment.

The surgeon-and-patient model does not work when the point is the effect of art. To ask about the patient's influence on the surgeon makes no sense. Falling under the spell of those on whom he operates, submitting to their authority, or falling in love with them, would not promise a good outcome. The subject of an operation radiates no influences; it is anaesthetized. A reversal of the relationship would have to take place before that question made any sense. The power of images, the agency of art and the charisma of literature pose questions that insist on that reversal. The work

of art itself is the guru and teacher, the immediate source of irrational, potentially enthralling emotional influences. The person who points to and shows those influences is one among others participating in a kind of fan culture. His or her privileged status as trained expert is revoked, or at least much lowered. No one who had not experienced the charisma of art would proclaim it; and confessing sympathies with fans and readers of the works discussed makes it difficult to claim an objective, disengaged posture as critic and commentator. The potential for slackening of critical sense in the commentator engaged in this way mirrors the loss of critical sense endemic to enchanted fans and readers.

That points to a criticism that looms before my mind's eye in concluding this book—also to one of my regrets for things left undone. I imagine it (the criticism) taking more or less this form: "*The author of* Enchantment *avoided the most glaring example of charismatic representation in the twentieth century—alongside Hollywood movies: fascist art. Big, overinflated, hypermimetic statues and buildings, stultifying, mesmerizing movies that show a single will triumphant over whole nations, demonstrate the danger of linking charisma and art. Charismatic art is (also) demagoguery by other means, and the author of* Enchantment, *having smoked his aesthetic opium, has his eye on worlds of heroism and happy endings. What is in essence seduction he turns into education—a formula for anaesthetizing reason and critical judgment.*"

It is true that my awareness of charismatic art as an instrument of political and commercial seduction was on the margins of these chapters (the demonic side of charisma came up in the chapter on *Faust*), and fascist art is a prominent example of the type. I excluded a more detailed discussion because in fact my own tastes and interests, my own form of fan worship led me to a very different set of works. However, *Enchantment* is far from an uncritical advocacy of charismatic art and of a critical position allied with "vitalism." I don't think that it runs a risk of blinding its readers to a hidden agenda of mental kidnapping posing as an educating, affirming art. A chapter on Arno Breker and Leni Riefenstahl would not change any claims made about charismatic art; it would underscore them. A dictator's conviction that charismatic representation in sculpture and film enhances his persona and furthers his political goals is a dramatic confirmation of the power of charisma in art.

With less reluctance I decided against a chapter on fashion photography, a hypermimetic art form premised on the conviction of advertisers

that aggrandizing art can rouse the consumer's desire for the world repre-
sented, for the people who live in it, and for the trappings they wear, hold,
and possess. The businesses that create advertising art do something no
artist or critic does: conduct empirical testing of the effects of their art. And
on the basis of that testing, they pay large sums of money in return for
representations peculiarly suited to fascinate consumers. The underlying
aesthetic principles are not much different from those governing the hyper-
mimetic representations that were the subject of this book. Chapters on
fashion photography and Nazi art would have underscored the argument
of *Enchantment* more boldly than studies limited to the traditional creators
and consumers of art, literature, and film. Advertisers and fascist dictators
have a very different kind of authority than professors of comparative liter-
ature. The former have more at stake; their investments in charismatic
art argue for its real effectiveness as a manipulator of opinion, taste, and
conviction—as a medium of enchantment. The latter have only aesthetic
experience, love of literature, and broad reading, and those are much more
easy to contest as the grounding of an argument for the effectiveness of
charismatic art than wealth and power.

What this book aims at in large part is to show the transforming force
of participation in the life of works of art, to show the dynamics by which
the viewer or reader is drawn into a kind of art and literature especially
fashioned to stimulate participation. The focus was the impact of art as
something immediate and unmediated, the response to art that precedes
reflection, the emotionally sensed stimulus of charisma, unseen and yet
perceptible at first glance and seizing the reader immediately with a force
like love at first sight. In fact first sight is the real entry point of charisma,
since the critical judgment that would dismiss as imaginative folly some-
thing so irrational is not yet alert and at its post. This storming of the
mind, or the subversive skirting of rational judgment, wakens in the viewer
sympathies modeled on those experienced by the main character of an epic
or novel, makes the viewer's sympathies compatible with those of the hero
and weaves the two together.

What constitutes charismatic art in its fullest form is the cooperation of
charisma and aura. The self-portrait of Albrecht Dürer discussed in Chapter
7 is a remarkable piece of hyperrealist representation: an artist paints him-
self as a man with great power to arrest and captivate the viewer's gaze—a
power greater than his actual physiognomic gifts would seem to have pos-
sessed—with whom some viewer might even fall in love. That captivation

might be the response of someone who had no conception of Jesus Christ, no knowledge of the conventional gesture of the "savior of the world" quoted in the position of the subject's hand, no idea of the "imitation of Christ." Another stage of the arrest and capture of the viewer kicks in when the layering of the portrait becomes evident. Jesus Christ lives in Albrecht Dürer. That realization intensifies wonder at the figure; miracle is added to charisma. Once Christ is recognized in Dürer, the person of the artist becomes the medium of a second incarnation. When that apprehension dawns, the soft, gentle eyes of the portrait say more than when we regarded them as just belonging to a remarkable individual. The impact is multiplied by all that the Christian viewer associates with a loving, forgiving, merciful God-man. The self-represented charismatic persona of Dürer co-opts the aura of Christ.

Aura is in that sense an embracing category that includes the metaphysics of art. Any true believer is free to infer the mystery of the incarnation from the Dürer self-portrait, or even from the messianic role of Chrétien de Troyes's Lancelot or of Terry Malloy in *On the Waterfront*. The efficacy of things suggested or stated in art depends on the belief systems within which they are represented and viewed and the emotional engagement of the viewer in those beliefs. Seen as an element in the working of charisma, metaphysics of art is aura mythologized. It is one means at the disposal of an artist to suggest depth in his subject, one further source of big illusion.

And so enchantment is a state that has much in common with faith. Both urge the reality of things beyond everyday life. (Only faith insists on the reality of things unseen; if charisma is not seen, it doesn't exist.) Both promise transformation and a kind of redemption. All mediated vision happens through a glass darkly. For the faithful the dark mirror may obscure, but it is also a guarantor of the other kind of vision, face-to-face. But Christian metaphysics offers the artist, emancipated from the second commandment, the opportunity to enchant through visible mysteries, to intensify the faith of the belief community and to engage non-Christians in participation in those mysteries.

Charismatic effect in art depends to a great extent on the preparation of the viewer or reader to perceive it, on his or her vulnerability to its power to enchant. The same is true of the charisma of John F. Kennedy, Greta Garbo, Ronald Reagan, Adolf Hitler, and Billy Graham. The charismatic figure is a focal point. He or she gathers the force of suggested qualities and gathers bundled promises, promises of great things, beyond any hope of

attaining or experiencing on our own: this individual is our conduit, our channeler, and our muse; she or he stimulates the imagination; in his spell we become artists, and the work of art we produce in our imagination is the charismatic figure; we think out the fables, the stories, and the destinies she or he implies.

When we live and our imagination thrives in the presence of charisma, everything we think and feel is good, positive, affirming; the only possible take on the world and the human condition is optimism. Exhilarated, we are lifted up into the charismatic world and want it never to vanish, always to go on conferring its benefits. Stripped of illusion, enchantment feels like deception.

Readings of charisma in art and literature are about the life on the surface of a work of art: its allure for the listener, viewer or reader, its ability to make fans of an audience, lift them into its world and hold them there, to suggest depths, either hidden or visible or slipped in by ambiguity. Those perceptions are always exclusive and cult-like. Tattooing is just patterns on skin for the westerner. For the Marquesan Islander in the pre-colonial period, the tattooed surface of the body teemed with things hard to describe to the noninitiate; the ink marks were a second life visible on the skin of the living tribesman. For an outsider to see the life of the work of art requires an interview with the recipient or at a greater distance, an anthropological and psychological study of the recipient. The charisma of Adolf Hitler will remain incomprehensible to anyone who just looks at the portraits of this ill-endowed demagogue. His initial success as a leader of the Germans is a mystery hidden in the despair, and in other deeper levels, of the German psyche in the 1920s and 1930s.

My interests for many years have focused on education as transformation. An earlier book studied that process in medieval education (I've used some of the material and ideas in Chapter 5).[1] Art, literature, and film are some of the catalyzing forces, along with the living presence of a charismatic teacher. This topic may be more relevant than fascist subversion in a cultural climate that reduces education to the transfer of knowledge, and where education through art, music, and literature is an endangered element of school curriculums. Charismatic education—that is, transformation of the viewer or reader through immersion in the work of art—was

not just a topic of these chapters, but rather a constant of varying audibility, their basso continuo.

The power of art to educate by transforming has guided my choice of texts for the most part. Transformation is a term like "enchantment" and "charisma." It describes a process of change that can be experienced and verified, but it shades over via popular usages into magic and superstition. Transformation becomes observable and verifiable especially when it relates to young people. Change and development are physical and mental experiences of youth, empirical givens of the human condition, not fictional or mythical events. Transformation has to be seen and represented to young people as an attainable goal. In education of the young transformation is development in its managed and administered form. *"You must develop into . . ."* whatever the predicate of that sentence might be: a good person, a great artist, a president. That imperative moves the child toward transformation. The pedagogue, parent or teacher, who strips a child's education of the stuff of enchantment and reduces the message to *"You must develop into an engineer, or a stock broker, or an auto mechanic"* allies himself with the "utilitarian economists, skeletons of school-masters, and commissioners of facts" (Dickens, *Hard Times*), reduces the process of development to fact-gathering and helps transform them into members of the workforce. A child educated to nothing more than engineering and business lacks the subconscious support system of the imagination, at least has not had it awakened by education. What Charles Foster Kane had in Rosebud, they do not have, and their reality is much reduced for it.

Transformation is, for children, myth experienced in one's own person. Myth and fairy tale are probably the earliest versions of charismatic forms wedding development to transformation, urging goals of development beyond membership in the workforce. Charismatic art nurtures what Dickens called the "romance in the soul." Myth, fairy tale, and fantasy awaken that romance: the frog prince who is transformed by a kiss, the beast by the love of beauty, the weakling, soft-minded third-born who rescues the country after the older siblings fail. These fantastic transformations model circumstances that the child needs to believe in as in some way realizable, in some way a close relative of his or her own development into an adult. They give the child strength, courage, and knowledge necessary to negotiate troubles of all kinds. Bruno Bettelheim's book *The Uses of Enchantment* spells out the "knowledge" children learn from fairy tales.[2] I agree with Bettelheim on many points, especially the absorption of the reader into the

tale by identification with the hero and the transfusion of values. The earliest awakening of the imagination is the moment when enchantment puts affirmation of self in place and enables the conviction—strong, hidden, or unquestioned enough to resist any improbability—of the value of one's self, of a large destiny, of order in the world, of the attainability of happiness, love, control, power and invulnerability.

When the phase of enchantment through fairy tales passes and its results move to some sub-memory holding place, the process continues in the heroic story, where supernatural metamorphoses happen as real events: the nerdy journalist Clark Kent is really a supernaturally powerful being from another planet who rescues the city from criminals; Luke Skywalker sheds his farm boy persona to become a great Jedi knight, and, the Force flowing through him, destroys the death star and rescues the rebel alliance; an introverted computer geek is called to become "Neo, the one," to save the enslaved real world from an evil conspiracy of machines.

The romance in the soul is the charisma-implant that, undetected, drips confidence from the youth's sub-memory of an enchanted world. While he learns the school curriculum, this other form of education is proof, or at least refuge, against fears, troubles, bullies, and his own inadequacies. Educators, parents, or teachers, ignore this form of education and the role of art in it to their and their students' peril. The "wolfish turn" Dickens predicted is a world reduced to Darwinian struggle and an individual who relates to that world solely through ruthlessness and self-interest.

By contrast, in the adult world metamorphosis has become a dream of redemption, not a destiny unfolding. Aspiration gives way to need. In this world where the avoidance or cure of psychic wounds looms larger than aspirations, the worlds represented in charismatic art have more a healing than an educating purpose. Charismatic art plays to one of the deepest desires of humans trapped in the everyday and singing their "De profundis," or rather "De quotidianis." (Recall the text of that Psalm: "Oh lord—or whoever—artist, athlete, hero, politician, psychoanalyst, rock musician, movie director, movie star, or the waitress in the café—oh, rescue us from the ordinary!") The silent commandment that charismatic art issues is no longer that of the teacher, "*You must become . . .*" but that of Rilke's Apollo: "*You must change your life.*" The need that draws people like Cecilia (*Purple Rose of Cairo*) to the movies is not just entertainment, a few hours of oblivion, but also the urgent need to believe in the reality of a higher world, one that is immanent and inhabitable. And behind that

urge, the belief that adaptation to that higher world, transformation and redemption, are somehow available. If the world can be plausibly represented as it is in this movie or that book, then it is possible to get out of the grinding despair of the everyday, to change. This is the urge that leads the patient to the psychoanalyst, the destabilized, deceived, and dispossessed to the demagogue, the poor in spirit to the preacher, and the consumer to products made to appear salvific.

The alternative that charismatic art offers is "life." There is some human condition available, better, more vibrant, more vital than the present one. The magnified version of life in the movie gives exaltation to the viewer. Whatever "life" means and however many different end effects resonate in the word, it is what the makers of charismatic art name as the quality of their work that satisfies them, and it is what readers and viewers want. If the work lifts them into that condition, gives them momentarily qualities of people who appear to embody them permanently, and if the experience translates into an affirmation of life, then the charisma of art is at work and at its most intense leaves the reader, as she or he finishes and puts it aside, with the exclamation of King Shahryar at the end of *Thousand and One Nights*: "How my soul is changed and joyful, it beats with an appetite for life!"

NOTES

Introduction

1. Aristotle, *Poetics*, trans. Stephen Halliwell, in *Aristotle: Poetics; Longinus: On the Sublime; Demetrius: On Style*, Loeb Classical Library 199 (Cambridge, Mass.: Harvard University Press, 1995; repr. with corrections, 1999), p. 33 (2.1448a).

2. Here and throughout I will use art to designate, on the one hand, the various forms of creative representation and, on the other, "art" in the narrower sense, painting and plastic representation.

3. *Peri hypsous* was written in Greek, probably in the first century A.D. The ascription to a certain Longinus is uncertain, and even if it were not, no one knows who this Longinus was. The tract is unfinished and was largely unknown. No one cites it from late antiquity until the sixteenth century. It came into its own only in the eighteenth century.

4. Longinus, *On the Sublime,* trans. W. H. Fyfe, rev. Donald Russell, in *Aristotle: Poetics; Longinus: On the Sublime; Demetrius: On Style*, Loeb Classical Library 199 (Cambridge, Mass.: Harvard University Press, 1995; repr. with corrections, 1999), p. 225 (11.15).

5. See Claus Uhlig, "Auerbach's 'Hidden' (?) Theory of History," in *Literary History and the Challenge of Philology*, ed. Seth Lerer (Stanford, Calif.: Stanford University Press, 1996), pp. 36–49, esp. 38–40.

6. Criticisms of "realism" and "the real" by Fredric Jameson, "The Existence of Italy," in his *Signatures of the Visible* (New York: Routledge, 1992), pp. 155–229; and Slavoj Zizek, *Looking Awry: An Introduction to Jacques Lacan Through Popular Culture* (Cambridge, Mass.: MIT Press, 1991), pp. 1–47.

7. See my essays "Charismatic Body—Charismatic Text," *Exemplaria* 9 (1997): 117–37; and "Aura and Charisma," *Eadem utraque Europa* 2 (2006): 125–54 (a revised version appeared in *New German Critique* 114 (2011), 17–34: "Aura and Charisma: Two Useful Concepts in Critical Theory"). See also the work of Raphael Falco, *Charismatic Authority in Early Modern English Tragedy* (Baltimore: Johns Hopkins University Press, 2000), and his earlier article "Charisma and Tragedy: An Introduction," *Theory, Culture and Society* 16 (1999): 71–98. His focus is reading tragedy through the perspective of Max Weber's ideas of charismatic leadership and its demise, not on an aesthetic of charisma. Eva Horn has edited a special volume of the journal *New German Critique*

on the topic "Narrating Charisma." See also her studies "Arbeit am Charisma: Macht und Affekt in Joachim Fests und Ian Kershaws Hitler-Biographien," *Tel Aviver Jahrbuch für deutsche Geschichte* 38 (2010): 47–62; "Vom Portrait des Königs zum Antlitz des Führers: Die Struktur des modernen Herrscherbildes," *Das erzählende und das erzählte Bild*, ed. Alexander Honold and Ralf Simon (Munich: Fink, 2010). Two books of high if peripheral interest for my project are Bonnie MacLachlan's *The Age of Grace: Charis in Early Greek Poetry* (Princeton, N.J.: Princeton University Press, 1993) and Eckart Goebel's *Charis und Charisma: Grazie und Gewalt von Winckelmann bis Heidegger* (Berlin: Kadmos, 2006), which has little to do with charisma, though he places it in a significant relationship with *charis*, as does, from an earlier historical perspective, Martino Rossi Monti, *Il cielo in terra: La grazia fra teologia ed estetica* (Turin: Utet, 2008).

8. See my introduction to the volume *Magnificence and the Sublime in Medieval Aesthetics: Art, Architecture, Music and Literature* (New York: Palgrave Macmillan, 2010).

9. Longinus, *On the Sublime*, p. 163 (1.4).

10. W. J. T. Mitchell, *What Do Pictures Want? The Lives and Loves of Images* (Chicago: University of Chicago Press, 2006); an earlier version of the title essay, "What Do Pictures *Really* Want?" *October* 77 (Summer 1996): 71–82; David Freedberg, *The Power of Images: Studies in the History and Theory of Response* (Chicago: University of Chicago Press, 1989); and Alfred Gell, *Art and Agency: An Anthropological Theory* (Oxford: Oxford University Press, 1998); see also his essay "The Technology of Enchantment and the Enchantment of Technology," in *Anthropology, Art and Aesthetics*, ed. Jeremy Coote and Anthony Shelton (Oxford: Oxford University Press, 1992), pp. 40–63.

11. See Freedberg, *Power of Images*, pp. 429–36, on academic resistance to the study of emotional response to art.

12. Weber's comments on charismatic leadership, spread widely through his *Wirtschaft und Gesellschaft*, are conveniently collected in Max Weber, *On Charisma and Institution Building: Selected Papers*, ed. S. N. Eisenstadt (Chicago: University of Chicago Press, 1968). There is a line of thinking in sociology that develops from Weber's studies of charisma, which denies the reality of charisma in the contemporary world, claiming it was most real when embodied in its "pure forms" (as identified by Weber): the shaman, the prophet, the berserk. The charismatic leader or ruler embodies an unstable form of it. With the growing "disenchantment" of the world, it is gradually hollowed out and emptied of true charismatic force lodged in an individual; contemporary culture manufactures it, banalizes it, and reduces it to celebrity. The classic statement of this position is by Edward Shils, *Center and Periphery: Essays in Macrosociology* (Chicago: University of Chicago Press, 1975), "Charisma," 127–34, and "Charisma, Order and Status," 256–75; also "Charisma," in *International Encyclopedia of the Social Sciences*, ed. David L. Sills (New York: Macmillan, 1968), 2:386–90. For a recent voice, see Stephen Turner, "Charisma Reconsidered," *Journal of Classical Sociology* 3 (2003): 5–26. For an extreme statement, see Philip Rieff, *Charisma: The Gift of*

Grace and How It Has Been Taken Away from Us (New York: Pantheon, 2007). Rieff calls his first chapter "Spray-on Charisma." Its condition in the modern world, he argues, has the substance of hairspray and deodorant.

13. See the commentaries of Shils; Karl Loewenstein, *Max Weber's Political Ideas in the Perspective of Our Time,* trans. Richard Winston and Clara Winston (Amherst: University of Massachusetts Press, 1968); Harry Liebersohn, *Fate and Utopia in German Sociology, 1870–1923* (Cambridge, Mass.: MIT Press, 1988); Charles Lindholm, *Charisma* (Cambridge, Mass.: Blackwell, 1990). See also the various studies in *Charisma, History, and Social Structure,* ed. Ronald M. Glassman and William H. Swatos, Jr. (New York: Greenwood Press, 1986).

14. See Joseph Bensman and Michael Givant, "Charisma and Modernity: The Use and Abuse of a Concept," in Glassman and Swatos, *Charisma, History, and Social Structure,* 27–56; also Weber and Loewenstein.

15. Lisa Jardine, *Erasmus, Man of Letters: The Construction of Charisma in Print* (Princeton, N.J.: Princeton University Press, 1993).

16. Joseph Roach, *It* (Ann Arbor: University of Michigan Press, 2007).

17. Ibid., p. 7: "For many religious thinkers, from the biblical prophets and apostles to modern theologians, It was expressed by the word *charisma,* a special gift vouchsafed by God, a grace or favor, which sociologist Max Weber then condensed into a principle of powerfully inspirational leadership or authority."

18. This approach is allied with a current trend in critical thought to get "beyond metaphysics and hermeneutics." See Hans-Ulrich Gumbrecht, *Production of Presence: What Meaning Cannot Convey* (Stanford, Calif.: Stanford University Press, 2004).

19. The language of magic is regularly at hand to study the effect of charismatic performance and star quality. Roach reverts to it unapologetically, or rather sees "It-effects" as related to a variety of forms of magic, to illustrate which he cites James Frazer's studies of primitive magic in *The Golden Bough*. See the essay by John Lahr, longtime drama critic of the *New Yorker* magazine, "The Voodoo of Glamour," *New Yorker,* March 21, 1994, pp. 113–22, and my discussion of it in Chapter 11.

20. Alfred Gell has inspired work that is closely related to mine. When this book was in its final stage, I came across the collection of essays *Art's Agency and Art History,* ed. Robin Osborne and Jeremy Tanner (Malden, Mass.: Blackwell, 2007). I am glad to find in these essays agreement on some of my basic ideas and material I might have drawn on more abundantly. Gell, who died young, wrote two works of particlular interest for my topic: *Art and Agency* and "The Technology of Enchantment and the Enchantment of Technology," cited above, note 9.

21. Michael Taussig, *Mimesis and Alterity: A Particular History of the Senses* (New York: Routledge, 1993), p. 16.

Chapter 1. Charisma and Art

1. Max Weber, *On Charisma and Institution Building: Selected Papers,* ed. S. N. Eisenstadt (Chicago: University of Chicago Press, 1968), p. 48.

2. Maxim Gorky, *Reminiscences of Leo Nikolaevich Tolstoy*, trans. S. S. Koteliansky and Leonard Woolf (New York: Huebsch, 1920), pp. 54–56.

3. According to Max Weber, the recognition of charismatic authority is prepared in the devotee by "despair [or crisis, or need], enthusiasm, or hope" ("Not, Begeisterung oder Hoffnung"). See Weber, *On Charisma and Institution Building*, p. 49.

4. Fred Vermorel and Judy Vermorel, *Starlust: The Secret Life of Fans* (London: W. H. Allen, 1985).

5. Angela of Foligno, *Complete Works*, trans. Paul Lachance (New York: Paulist Press, 1993), p. 126. My thanks to Valerie Wilhite for pointing out this passage.

6. John F. Schumaker, "Starlust: Worship of Celebrity Casts a Dark Shadow," *Australian Financial Review*, March 5, 2004: "CWS" (celebrity worship syndrome) is "an obsessive-addictive disorder."

7. Joseph Roach, *It* (Ann Arbor: University of Michigan Press, 2007), presents a wide range of phenomena of the cult of personal presence ("abnormally interesting people"). On the cult of Elvis Presley, see Benson P. Fraser and William J. Brown, "Media, Celebrities, and Social Influence: Identification with Elvis Presley," *Mass Communication and Society* 5 (2002); Erika Doss, *Elvis Culture: Fans, Faith, and Image* (Lawrence: University of Kansas Press, 1999).

8. "Slash" writing is a perfect expression of this form of inspiration. Slash has developed in American fan culture. The writer thinks out and extends the world of the admired fictional character, writes new scenes, creates sexual, esp. homosexual, relations between the characters of a TV show. *Star Trek* has served as inspiration. See the studies by Constance Penley, *NASA/Trek: Popular Science and Sex in America* (London: Verso, 1997), and Henry Jenkins, *Textual Poachers: Television Fans and Participatory Culture* (New York: Routledge, 1992), and the essays in Jenkins, *Fans, Bloggers, and Gamers: Exploring Participatory Culture* (New York : New York University Press, 2006).

9. See David Freedberg, *Iconoclasts and Their Motives* (Maarssen, Netherlands: Schwartz, 1985).

10. Leo Tolstoy, *War and Peace*, trans. Louise Maude and Aylmer Maude (New York: Knopf, 1992), vol. 1, pp. 311–13 (book 1, part 3, chapter 8).

11. Arthur Schweitzer juxtaposes Hitler working hard to inflate his legend to Lenin resisting legend-making, discouraging the cult of his own personality, in *The Age of Charisma* (Chicago: Nelson-Hall, 1984), pp. 182–83 ("Legendary Charisma").

12. Garry Wills, *Reagan's America: The Innocents at Home* (New York: Penguin, 1988), p. 2.

13. See Bryan R. Warnick, *Imitation and Education: A Philosophical Inquiry into Learning by Example* (Albany: State University of New York Press, 2008).

14. See George Steiner, *Lessons of the Masters* (Cambridge, Mass.: Harvard University Press, 2003); and C. Stephen Jaeger, *The Envy of Angels: Cathedral Schools and Social Ideals in Medieval Europe, 950–1200* (Philadelphia: University of Pennsylvania Press, 1994).

15. Ralph Waldo Emerson, *Essays and Lectures* (New York: Library Classics of the United States, 1983), pp. 624–31.

16. Erving Goffman, *The Presentation of Self in Everyday Life* (Woodstock, N.Y.: Overlook Press, 1973).

17. *The Book of the Thousand Nights and One Night*, trans. Powys Mathers from the French trans. of J. C. Mardrus (New York: St. Martin's, 1972), 4:531.

18. Fellini was more succinct in *The Clowns* (1970). A journalist interviewing Fellini during the filming of a clown show, asks, "What message do you want to send?" Before Fellini can answer, a bucket falls on his head; before the journalist can formulate a meaning, another bucket lands on his. The director wants interpretation silenced, his own and that of his commentators.

19. See the comments by W. J. T. Mitchell in *What Do Pictures Want?* (Chicago: University of Chicago Press, 2005), pp. 52–55.

20. Quoted here from Honoré de Balzac, *Selected Short Stories: Contes Choisis*, ed. and trans. Stanley Appelbaum (Mineola, N.Y.: Dover, 2000).

21. Hans Belting's *The Invisible Masterpiece* (Chicago: University of Chicago Press, 2001) takes the Balzac story as a parable of the impossibility of the masterpiece in the modern era.

22. Charles Peirce, "The Algebra of Logic" (1885), quoted in Robert Redfield, "Art and Icon," in *Anthropology and Art: Readings in Cross-Cultural Aesthetics*, ed. Charlotte M. Otten (Austin: University of Texas Press, 1971), p. 44. Joseph Roach notes the ability of a charismatic actor to dissolve the boundary between illusion and reality in the mind of audience—the "It effect" (quoting Michael Quinn): " 'The shift of perception that celebrity allows is a key one, and is extraordinarily powerful: the audience's attitude shifts from an awareness of the presence of fictional illusion to the acceptance of an illusion, however false, of the celebrity's absolute presence.' Behind the refractory celebrity of which Quinn speaks lurks the prior condition of It, emerging from an apparently singular nexus of personal quirks, irreducible to type, yet paradoxically, the epitome of a type of prototype that almost everyone eventually wants to see or be like." *It*, p. 6, quoting Michael Quinn, "Celebrity and the Semiotics of Acting," *New Theatre Quarterly* 22 (1990): 156.

23. Georges Poulet, "Phenomenology of Reading," *New Literary History* 1 (1969): 53–68, passages cited pp. 57–59.

24. On epiphany in literature and literary analysis, see Gerald Gillespie, *Proust, Mann, Joyce in the Modernist Context* (Washington, D.C.: Catholic University of America Press, 2003), 50–67 ("Epiphany: Applicability of a Modernist Term").

25. Sigmund Freud, The Future of an Illusion, in *The Standard Edition of the Complete Psychological Works of Sigmund Freud*, ed. James Strachey (London: Hogarth Press, 1966), vol. 21, pp. 30–31ff.

26. In the final editing of this manuscript, I realized the relevance of Plato's idea of the "noble lie" for this discussion (*Republic*, 414b–417). While banishing poets from the Republic, Plato/Socrates allowed the value of a certain kind of narrative

which would firm up the stability of the state. This form of ingenious invention is reserved for the guardians of the state and forbidden to all others. For this staunch upholder of Justice and Truth in the Republic, the "lie" is justified in this one case by its service to the political order. In full awareness of its falsehood, i.e., its mythical character, the rulers of the Republic are enjoined to create founding narratives which legitimize and firm up the structure of the state (e.g., God or a god is its founder and protector). It is important for citizens to be persuaded of the truth of such narratives, and Plato/Socrates gives guidelines for making such noble lies plausible. The affirming, stabilizing force of illusion overrides the obligation to truth. Though showing its manipulative character plainly in the context of political deceit, the "noble lie" is clearly a parallel to a charismatic fiction. See Jonathan Lear, "Allegory and Myth in Plato's *Republic*," in *The Blackwell Companion to Plato's* Republic, ed. Gerasimos Santas (Oxford: Blackwell, 2006), 25–43. Lear reads Plato's idea in the context of the education of children. For a classic statement of "noble lies" as a threat to justice in political life, Karl Popper, *The Open Society and its Enemies: Vol. 1: The Spell of Plato*, 7th ed. (New York: Routledge, 2007).

27. A web search of the term "Matrix defense" produces much information. E.g. http://edition.cnn.com/2003/LAW/05/21/ctv.matrix.insanity. Also http://www.baltimoresun.com/news/maryland/balte.md.drawings05dec05,0,899366.story.

28. On emulation and envy, see René Girard, *Deceit, Desire and the Novel: Self and Other in Literary Structure*, trans. Yvonne Freccero (Baltimore: Johns Hopkins University Press, 1965). In later works Girard developed his idea of "triangular desire" into "mimetic desire," usable both in religious and literary relationships. See also *Violence and the Sacred*, trans. Patrick Gregory (Baltimore: Johns Hopkins University Press, 1979), esp. pp. 143–68.

29. See Michael Taussig, *Mimesis and Alterity: A Particular History of the Senses* (New York: Routledge, 1993).

30. Edmund Burke, *A Philosophical Enquiry into the Sublime and Beautiful and Other Pre-Revolutionary Writings*, ed. David Womersley (London: Penguin Books, 1998), p. 95 (*Sublime and Beautiful*, pt. 1, sect. 16).

31. Charles Spalding on John F. Kennedy: "He had something nobody else did. It was just a heightened sense of being." Quoted in Bruce Mazlish, "Kennedy: Myth and History," in *John F. Kennedy: Person, Policy, Presidency*, ed. J. Richard Snyder (Wilmington, Del.: Scholarly Resources, 1988), p. 29.

32. Hans-Georg Gadamer, *Die Aktualität des Schönen* (Stuttgart: Reclam, 1977); trans. Nicholas Walker, in *The Relevance of the Beautiful and Other Essays*, ed. Robert Bernasconi (Cambridge: Cambridge University Press, 1986). Also the article by Gottfried Boehm, "Zuwachs an Sein: Hermeneutische Reflexionen und bildende Kunst," in Hans-Georg Gadamer, *Die Moderne und die Grenze der Vergegenständlichung* (Munich: Klüser, 1996), 95–125.

33. See C. Stephen Jaeger, "Introduction" and "Richard of St. Victor and the Medieval Sublime," in *Magnificence and the Sublime in Medieval Aesthetics: Art, Architecture, Literature, Music*, ed. C. Stephen Jaeger (New York: Palgrave Macmillan, 2010).

See also the lengthy skeptical discussion of the subject in modern aesthetic theory in James Kirwan, *Sublimity: The Non-Rational and the Irrational in the History of Aesthetics* (New York: Routledge, 2005). Citing many premodern sources on "elevation" through the sublime, Kirwan casts serious doubt on what he refers to as "life-enhancement" or any lasting effect of the sublime; see esp. pp. 153–56. The educating effect of the sublime and charisma in art challenges his skepticism. See below, Chapters 4 and 8.

34. Longinus, *On the Sublime*, trans. W. H. Fyfe, rev. Donald Russell, Loeb Classical Library 199 (Cambridge, Mass.: Harvard University Press, 1995), p. 161.

35. "Winckelmann und sein Jahrhundert: Schilderung Winckelmanns," in Johann Wolfgang Goethe, *Ästhetische Schriften 1806–1815,* ed Friedmar Apel, Goethe Sämtliche Werke, 1st Abt., Bd. 19 (Frankfurt am Main: Deutscher Klassiker Verlag, 1998), p. 184.

36. Jaeger, *The Envy of Angels.*

37. Penley, *NASA/Trek.*

38. Henry Jenkins, "*Star Trek* Rerun, Reread, Rewritten: Fan Writing as Textual Poaching," in his *Fans, Bloggers and Gamers,* p. 40. On fandom and "participatory culture," see, in general, Matt Hills, *Fan Cultures* (London: Routledge, 2002), with extensive bibliography.

Chapter 2. Living Art and Its Surrogates

Note to epigraph: David Freedberg, *The Power of Images: Studies in the History and Theory of Response* (Chicago: University of Chicago Press, 1989), p. 22.

1. Bronislaw Malinowski, *A Diary in the Strict Sense of the Term*, trans. Norbert Guterman (Stanford: Stanford University Press, 1989; orig. published London: Routledge and Kegan Paul, 1967), pp. 254–55 (entry of April 18, 1918). Emphasis in original.

2. The exhibition "Body Art: Marks of Identity" at the American Museum of Natural History, New York, November 1999–May 2000. See also Karl Gröning, ed., *Decorated Skin: A World Survey of Body Art*, trans. Lorna Dale (London: Thames and Hudson, 2002).

3. Here I am following Peter Gathercole, "Contexts of Maori *Moko*," in *Marks of Civilization: Artistic Transformations of the Human Body*, ed. Arthur Rubin (Los Angeles: Museum of Cultural History, University of California, Los Angeles), pp. 171–77; N. Tannenbaum, "Tattoos: Invulnerability and Power in Shan Cosmology," *American Ethnologist* 14 (1987): 693–712; Alfred Gell, *Wrapping in Images: Tattooing in Polynesia* (Oxford: Clarendon, 1993); James Cowan, *The Maoris of New Zealand* (Christchurch, N.Z.: Whitcombe and Combs, 1910); H. G. Robley, *Moko, or Maori Tattooing* (London: Chapman and Hall, 1896). The classic study is Karl von den Steinen, *Die Marquesaner und ihre Kunst: Studien über die Entwicklung primitiver Südseeornamentik nach eigenen Reiseergebnissen und dem Material der Museen*, 3 vols. (1925–28; reprint, New York: Hacker Art Books, 1969), vol. 1 on tattooing.

4. Claude Lévi-Strauss, *Structural Anthropology*, trans. Claire Jacobson and Brooke Grundfest Schoepf (New York: Basic Books, 1963), p. 255. See von den Steinen, *Marquesaner*, 1:49–51, on seduction as a purpose of tattooing.

5. Gathercole, "Contexts of Maori *Moko*," p. 175.

6. Cowan, *Maoris of New Zealand*, p. 190.

7. Von den Steinen, *Marquesaner*, 1:90–91.

8. Cowan, *Maoris of New Zealand*, p. 190.

9. Lévi-Strauss, *Structural Anthropology*, p. 259.

10. Gell, *Wrapping in Images*, p. 244.

11. Von den Steinen, *Marquesaner*, 1:49.

12. The aesthetics of Maori art in general, body art or wood carving, associate beauty and elegance with the path to the gods and ancestors. See Sidney Moko Mead, "Nga Timunga Me Nga Paringa o te Mana Maori: The Ebb and Flow of Mana Maori and the Changing Context of Maori Art," in *Te Maori: Maori Art from New Zealand Collections*, ed. Sidney Moko Mead (New York: Abrams, 1984), pp. 20–36, esp. 22: "Whakairo is quality, the difference between crudity and elegance. . . . It is uplifting, taking the human spirit close to the rarefied and beautiful world of the gods. . . . Whakairo represents the triumph of mana Maori (power) over the environment and represents a gift from the ancestors to their descendants born and yet unborn." There is "mana," sacred force, in carving. It is connected with the worship of ancestors that registers in Maori art, songs, and narratives. "We who are living at present are their reflections and their descendants. We are *te kanohi ora* (the living faces). . . . As individuals we have no identity except by reference to them. We are beings only because they prepared the way for us" (Mead, pp. 27–28).

13. Robley, *Moko, or Maori Tattooing*, pp. 114–16.

14. Lévi-Strauss, *Structural Anthropology*, p. 261. See also George W. Harley, *Masks as Agents of Social Control in Northeast Liberia*, Papers of the Peabody Museum, vol. 32, no. 2 (Cambridge, Mass.: Peabody Museum, 1950). See Howard Morphy, "From Dull to Brilliant: The Aesthetics of Spiritual Power Among the Yolngu," in *Anthropology, Art and Aesthetics*, ed. Jeremy Coote and Anthony Shelton (Oxford: Clarendon, 1992), pp. 186–87. Morphy describes the *mardayin*, or "sacred law," among the Yolngu (an aboriginal people of northern Australia). It consists of a set of songs, dances, paintings, sacred objects, and ritual incantations received from ancestral beings and is meant to represent the actions of those ancestors in creating the world and the Yolngu customs. The ancestral patterns are manifested in body painting, sand sculpture, string, bark painting, and so on. Painted on a coffin lid, the ancestral design may help the recently deceased to the land of the dead. See also Jarich Oosten, "Representing the Spirits: The Masks of the Alaskan Inuit," in Coote and Shelton, *Anthropology, Art and Aesthetics*, pp. 113–34, esp. 115, where the author discusses words in the Inuit language that link "mask" with "soul" and "a vital force representing a chain or continuum of all individual spirits."

15. Lévi-Strauss, *Structural Anthropology*, pp. 259–61.

16. "Bantu" is the name of a language group of some four hundred tribes spread throughout central and southern Africa.

17. Norman Mailer, *The Fight* (New York: Vintage, 1975), pp. 38–43, passage quoted, p. 38.

18. But I should add, I didn't rely on Norman Mailer as my only informant on Bantu philosophy. Also Janheinz Jahn, *Muntu: African Culture and the Western World*, trans. Marjorie Grene (New York: Grove, 1990; orig. 1961); and Alexis Kagame, *La philosophie bantu comparée* (Paris: Présence Africaine, 1976).

19. See Whitney Davis, "Abducting the Agency of Art," in *Art's Agency and Art History*, ed. Robin Osborne and Jeremy Tanner (Malden, Mass.: Blackwell, 2007), 199–219, esp. 212, 214.

20. Marcel Proust, *In Search of Lost Time, Volume VI: Time Regained*, trans Andreas Mayor and Terence Kilmartin, rev. D. J. Enright (New York: Random House, 1993), pp. 116, 276–77.

21. Hélène Cixous, *Three Steps on the Ladder of Writing*, trans. Sarah Cornell and Susan Sellers (New York: Columbia University Press, 1993), p. 30. The chapter cited is called significantly "The School of the Dead."

22. See Harley, *Masks as Agent*, p. ix, on masks and body painting operating on the same logic as tattooing and Bantu sculpture.

23. Alfred Gell, *Art and Agency: An Anthropological Theory* (Oxford: Oxford University Press, 1998), pp. 69–70; also "The Technology of Enchantment and the Enchantment of Technology," in Coote and Shelton, *Anthropology, Art and Aesthetics*, pp. 40–63.

24. Shirley F. Campbell, *The Art of Kula* (Oxford: Berg, 2002), 129. Campbell sees the prowboards as significant within the psychology of identity and stature for men. The carved boards are "consummate visual 'texts' defining how men would like their renown to be perceived. She is skeptical of the interpretation by Giancarlo Scoditti, which sees them as representations of a secret myth about a culture hero, a narrative of his mythical adventures and attributes. See Giancarlo Scoditti, "A Kula Prowboard: An Iconological Interpretation," *L'Uomo* 2 (1977): 199–232. But Scoditti's reading seems to me not inconsistent with Campbell's own interpretation.

25. Scoditti, "A Kula Prowboard," p. 215.

26. Ibid., pp. 217–19, and p. 221: "The whole *lagim* may even be read as a head bowed over the chest of a body taking wing or jumping into the air."

27. Robert Redfield, "Art and Icon," in *Anthropology and Art: Readings in Cross-Cultural Aesthetics*, ed. Charlotte M. Otten (Austin: University of Texas Press, 1971), 39–65.

28. Herman Melville, *Moby-Dick*, chap. 110.

29. See Jahn, *Muntu*, pp. 156–57.

30. Roman ancestor masks were common, very realistic, made during the lifetime of the person, worn after death by actors, for instance, in funeral processions or on the occasion of elections. The purpose seems to have been social and political rather

than part of a death cult. See Harriet I. Flower, *Ancestor Masks and Aristocratic Power in Roman Culture* (Oxford: Clarendon Press, 1996), esp. p. 91: "The primary use of the *imagines* . . . was in the funeral procession of a Roman office-holder. Their *raison d'être* was to allow the ancestors to be represented as living and breathing Roman magistrates at the height of their careers, who had reappeared in the city to accompany their newly-dead descendant on his last journey."

31. Not only in the West. See Jeremy Tanner, "Portraits and Agency: A Comparative View," in Osborne and Tanner, *Art's Agency and Art History*, 70–94. Tanner points to portraits of Buddhist abbots, "pre-eminent religious figures . . . set up by religious communities in part in order to transmit the charisma or 'agentive capacity' of those figures beyond the limits of their own lifetime" (p. 72).

32. Christoph Ransmayr, *Die letzte Welt* (Nördlingen: Greno, 1988), pp. 157–58. Here and throughout, translations are my own unless otherwise noted.

33. Jean-Paul Sartre, *The Words*, trans. Bernard Frechtman (New York: Braziller, 1964), pp. 193–95.

34. Werner Jaeger, *Paideia: The Ideals of Greek Culture*, trans. Gilbert Highet, 2nd ed., 3 vols. (New York: Oxford University Press, 1986), 2:17–18.

35. Roland Barthes, *Camera Lucida: Reflections on Photography*, trans. Richard Howard (New York: Hill and Wang, 1982), p. 14.

36. The same emotional dynamic is at work in the move from a literal to a symbolic interpretation of the Eucharist. One of the deep, conservative desires of the faithful is "real presence." The assertion that this is unattainable, and that bread and wine only "stand for" body and blood, was and still is troubling to simple faithful and to many of the more sophisticated. The desire for the real presence is intense enough that a doctrine had to be promulgated that made sacramental bread into "the body of Christ under the outward appearance of bread." A process related to "impanation" or transubstantiation made charismatic art what it is, a living human being or place, event, or experience, under the outward appearance of art.

37. E. H. Gombrich, *Art and Illusion: A Study in the Psychology of Pictorial Representation*, 2nd ed., Bollingen Series 35.5 (Princeton: Princeton University Press, 2000), p. 128.

38. Thomas Mann, *Death in Venice and Seven Other Stories by Thomas Mann* (New York: Vintage, 1958), pp. 46–47. I've adapted the translation of H.-T. Lowe-Porter.

39. See the commentary of Ernst Gombrich, *Art and Illusion*, pp. 93ff.: "Without the underlying promise of this myth, the secret hopes and fears that accompany the act of creation, there might be no art as we know it" (p. 94).

40. Ernst Kris and Otto Kurz, *Legend, Myth, and Magic in the Image of the Artist* (New Haven, Conn.: Yale University Press, 1979; orig. 1934), p. 74.

41. Fulgentius, cited in Kris and Kurz, *Legend*, p. 85; on the depiction of eyes in legends, see pp. 83–84.

42. Valerius Maximus, *Facta et dicta memorabilia* 9.4.1; cited in Freedberg, *Power of Images*, p. 47.

43. Theognis 237ff.; cited in Werner Jaeger, *Paideia*, 1:196.

44. Kris and Kurz, *Legend*, pp. 75–76.

45. Gombrich, *Art and Illusion*, p. 125.

Chapter 3. Odysseus Rising

1. Homer, *The Odyssey*, trans. E. V. Rieu, rev. trans. D. C. H. Rieu (London: Penguin Books, 2003), p. 75. English from this translation except where noted. I also quote by book and line numbers according to Homer, *Odyssey*, with an English translation by A. T. Murray, rev. by George E. Dimock, Loeb Classical Library 104–5 (Cambridge, Mass.: Harvard University Press, 1995), here 5.488ff.

2. See the great study of Homeric style by Erich Auerbach, *Mimesis: The Representation of Reality in Western Literature*, trans. Willard R. Trask (Princeton, N.J.: Princeton University Press, 1953), pp. 3–23, "Odysseus' Scar."

3. Athene beautifies Odysseus during the athletic games (8.19ff.). The passage recurs word for word as in book 6 during the recognition scene of Penelope and Odysseus (23.156ff.).

4. I take the term "skin ego" from Didier Anzieu, *The Skin Ego* (orig. *Moi-peau*), trans. Chris Turner (New Haven, Conn.: Yale University Press, 1989).

5. Virgil adapted the Nausicaa scene in book 1 of *The Aeneid*. Venus makes her son Aeneas irresistible to the chaste queen Dido to disastrous effect. Goethe also planned a Nausicaa drama, in which the princess would die tragically for having confessed her passion for Odysseus (*Italian Journey*, May 8, 1787). Roman goddesses were more cruel and eighteenth century heroines more frail, clearly, than Homeric. But in all three cases the poets followed (Goethe would have followed) the logic of charismatic seduction.

6. The interpretations of the scene that see "rebirth" and the return from magically charged god-dominated realms, I believe, miss the essential thrust of the scene: that Odysseus is charged with the same forces that flow in Scheria. See Cedric H. Whitman, *Homer and the Heroic Tradition* (Cambridge, Mass.: Harvard University Press, 1958), and Charles Segal, *Singers, Heroes, and Gods in the "Odyssey"* (Ithaca, N.Y.: Cornell University Press, 1994), pp. 12–36.

7. See the commentary on this phrase and its context in magic by W. B. Stanford in his edition of *The Odyssey of Homer*, 2nd ed., 2 vols. (London: Macmillan, 1965), 1:394.

8. The queen's comment has troubled more than one reader. Cf. R. D. Dawe, *The Odyssey: Translation and Analysis* (Sussex: Book Guild, 1993), p. 448: "Into the void the hostess Areteé steps with a crudity quite at variance with what we have come to expect of her. . . . Even those of us who do not adorn drawing rooms ourselves will deem the allusion to Odysseus's physical appearance an irrelevance."

9. I've cited the translation of E. V. Rieu: "his looks, his presence and the quality of his mind." Chapman gives, "this man, / So goodly person'd, and so matcht with

mind," and Samuel Butler, "Is he not tall and good looking, and is he not clever?" A. T. Murray, "looks, stature, and the balanced mind within him." Richmond Lattimore: "Phaiakians, what do you think now of this man before you / for beauty and stature, and for the mind well balanced within him?" A reasonable paraphrase of *mégethos*, as it describes Odysseus at the end of his stories, might be "grand presence" or "magnificent presence." Neither "stature" nor "presence" by itself conveys the sense of embodied greatness the Greek word expresses in Homer's usage and thereafter. "Presence" is a vague modern counterpart, minus the aggrandizing force. It suggests the ghostly radiation magnifying the living person—that is, a term like "aura"—but it remains neutral without a modifier: grand presence, curious presence, loathsome presence.

10. Homer, *The Odyssey*, trans. Robert Fagles (New York: Penguin, 1997), p. 260 (11.381–82): " 'Phaecians! How does this man impress you now, / his looks, his build, the balanced mind inside him?' "

11. Aristotle, *Poetics*, trans. Stephen Halliwell, in *Aristotle: Poetics; Longinus: On the Sublime; Demetrius: On Style*, Loeb Classical Library 199 (Cambridge, Mass.: Harvard University Press, 1995; repr. with corrections, 1999), 7.34ff. (1450b): "a beautiful object, whether an animal or anything else with a structure of parts, should have not only its parts ordered but also an appropriate grandeur: beauty consists in magnitude and order." I've taken liberties with Halliwell, who gives "magnitude" where I've translated "grandeur." Size or magnitude, is indeed at issue, but should not be separated from the ethical-aesthetic quality conveyed by "grandeur."

12. Longinus, *On the Sublime*, p. 161: the author's predecessor, writing on the sublime style, "thought it unnecessary to deal with the means by which we may be enabled to develop our natures to some degree of grandeur" (*eís posein megethous epidosin*). The author can use *megethos* as interchangeable with "the sublime" (*hypsos*). See par. 8, pp. 180–81.

13. Nemean 7, in *The Odes of Pindar*, trans. Richmond Lattimore (Chicago: University of Chicago Press, 1947), pp. 114–15.

14. See Gregory Nagy, *Pindar's Homer: The Lyric Possession of an Epic Past* (Baltimore: Johns Hopkins University Press, 1990), esp. pp. 199–214. Also Werner Jaeger, *Paideia: The Ideals of Greek Culture*, trans. Gilbert Highet, 2nd ed. (New York: Oxford University Press, 1986), 1:40.

15. Demosthenes, *Orations 60–61: Funeral Speech; Erotic Essay; Exordia-Letters*, vol. 7 of *Demosthenes*, Loeb Classical Library no. 374 (Cambridge, Mass.: Harvard University Press, 1949), p. 53. *Erotikos* 61. 16.

16. Sophocles, *Oedipus the King*, trans. David Grene (Chicago: University of Chicago Press, 2010), p. 64, lines 1200–1204.

17. *Antigone*, lines 662–66, *Sophocles I: Oedipus the King, Oedipus at Colonus, Antigone*, trans David Grene, 2nd ed. (Chicago: University of Chicago Press, 1991), p. 185.

18. Nemean 6, in *Pindar's Victory Songs*, trans. Frank J. Nisetich (Baltimore: Johns Hopkins University Press, 1980), p. 256.

19. Cedric H. Whitman, *Sophocles: A Study of Heroic Humanism* (Cambridge, Mass.: Harvard University Press, 1951), p. 7.

20. John H. Finley, Jr., *Homer's "Odyssey"* (Cambridge, Mass.: Harvard University Press, 1978), p. 41.

21. Max Weber saw revelation significantly joined to charismatic authority in the figure of the prophet. See Weber, *On Charisma and Institution Building: Selected Papers,* ed. S. N. Eisenstadt (Chicago: University of Chicago Press, 1968), "The Sociology of Charismatic Authority," p. 24: "The specifically charismatic form of settling disputes is by way of the prophet's revelation, by way of the oracle"; and "The Prophet," p. 254: "The Prophet's claim [to authority] is based on revelation and charisma." Weber was, understandably, not interested in "revelation" as a narrative mode. The preference for the enigmatic mode among critics and theorists is an intellectualist position, based on a radical privileging of the problematic and indeterminate in art. Whereas revelation seems to involve a relaxing of the critical sense, enigma nourishes and provokes it. Critical judgment regards revelation by and large as out of its sphere, perhaps even vulgar and popular. Cf. Adorno's claim that art is true precisely in its "enigmatic character," its refusal or denial of any comprehensible and stable "truth content." Theodor W. Adorno, *Ästhetische Theorie*, ed. Gretel Adorno and Rolf Tiedemann (Frankfurt am Main: Suhrkamp, 1995; orig. 1970), pp. 182–86. The totalizing view that "all works of art and art as a whole are enigmas" is defensible only from presuppositions that exclude much in literature, art and cinema.

22. See my article "Aura and Charisma: Two Useful Concepts in Critical Theory," *New German Critique* 114 (2011), 17–34. Originally published in *Eadem utraque Europa* 2 (2006): 125–54.

23. Auerbach, *Mimesis*, pp. 3–23 ("Odysseus' Scar").

24. See the commentary by Alice Mariani, "The Renaming of Odysseus," in *Critical Essays on Homer*, ed. Kenneth Atchity (Boston: G. K. Hall, 1987), 211–23, p. 214: "the story of Odysseus' naming and the gaining of his scar is in itself a revelation of identity, an exploration of who Odysseus is which reaches back into the beginnings of selfhood."

25. Georg Lukács, "To Narrate or Describe?" from *Probleme des Realismus*, trans. Hanna Loewy, cited in *Homer: A Collection of Critical Essays*, ed. George Steiner and Robert Fagles (Englewood Cliffs, N.J.: Prentice-Hall, 1962), p. 87: "Objects have their poetic life only through their relationships to human destiny."

26. Pindar, Olympian 1, 28ff., in Nisetich, *Pindar's Victory Songs*, pp. 82–83.

27. Homer, *The Iliad*, trans. Robert Fagles (New York: Penguin, 1990), p. 489 (19, 43).

28. See my study of "charismatic" culture and education in *The Envy of Angels: Cathedral Schools and Social Ideals in Medieval Europe, 950–1200* (Philadelphia: University of Pennsylvania Press, 1994). Also Bryan R. Warnick, *Imitation and Education: A Philosophical Inquiry into Learning by Example* (Albany: State University of New York Press, 2008).

29. Eric A. Havelock, *Preface to Plato* (Cambridge, Mass.: Harvard University Press, 1963), argues that Plato's rejection of *mimesis* is a rejection of poetry as an instrument of education, the one that predominated in Hellenic culture.

30. *The Collected Dialogues of Plato Including the Letters*, ed. Edith Hamilton and Huntington Cairns, Bollingen Series 71 (Princeton, N.J.: Princeton University Press, 1987), p. 832 (*Republic* 606e–607a).

31. Plato, *Phaedrus*, ed. Hamilton and Cairns, p. 492 (245a). Quoted and discussed in Henri I. Marrou, *A History of Education in Antiquity*, trans. George Lamb (Madison: University of Wisconsin Press, 1982), pp. 12–13 ("The Imitation of the Hero").

32. I'm following Werner Jaeger, *Paideia*, 1:35–56 ("Homer the Educator").

33. *Paideia*, 1:205. Jaeger's discussion of Pindar develops the equation of athlete's body to work of art in detail. See esp. *Paideia*, 1:212: "The comparison was obvious: for in Pindar's time sculptors carved only images of the gods or statues of athletic victors. But the resemblance goes deeper. Statues of that period show the same attitude as Pindar's poetry to the victor whom they depict: they do not record his personal features, but the ideal male body trained for the contest. . . . The attitude of both the sculptor and the poet is directly dictated by the character of an Olympian victory and the underlying Greek conception of man's nature." See also Deborah Hawhee, *Bodily Arts: Rhetoric and Athletics in Ancient Greece* (Austin: University of Texas Press, 2004).

34. Froma Zeitlin, "Visions and Revisions of Homer," in *Being Greek Under Rome: Cultural Identity, the Second Sophistic and the Development of Empire*, ed. Simon Goldhill (Cambridge: Cambridge University Press, 2001), 195–266.

35. Ibid., p. 201. See also Peter Green, "Caesar and Alexander: Aemulatio, Imitatio, Comparatio," *American Journal of Ancient History* 3 (1978): 1–26.

Chapter 4. Icon and Relic

1. An essay by Cynthia Hahn sharpened my understanding of the reliquary as a potential transmitter of charisma, an effect which I originally doubted: Cynthia Hahn, "The Spectacle of the Charismatic Body: Patrons, Artists, and Body-Part Reliquaries," in *Treasures of Heaven: Saints, Relics, and Devotion in Medieval Europe*, ed. Martina Bagnoli et al. (Baltimore: Walters Art Museum; London: British Museum, 2010), pp. 163–72.

2. John of Damascus, *An Exact Exposition of the Orthodox Faith* 4.15, in *Saint John of Damascus: Writings*, trans. Frederic H. Chase, Jr. (Washington, D.C.: Catholic University of America Press, 1958), pp. 368–69: "In the Law, anyone who touched a corpse was accounted unclean. But these of whom we speak [i.e., the saints] are not dead. Because Life itself and the Author of life was reckoned amongst the dead, we do not call these dead who have fallen asleep in the hope of resurrection and in the faith in Him. For how can a dead body work miracles?"

3. I mean the attested relic that had the faith of the worshipper in its genuineness. Wholesale fraud was of course part and parcel of the trade in relics.

4. See Ernst Kitzinger, "The Cult of Images Before the Age of Iconoclasm," in his *Art of Byzantium and the Medieval West: Selected Studies*, ed. W. Eugene Kleinbauer (Bloomington: Indiana University Press, 1976); Hans Belting, *Bild und Kult: Eine Geschichte des Bildes vor dem Zeitalter der Kunst* (Munich: Beck, 1990), pp. 164–84; Peter Brown, "A Dark Age Crisis: Aspects of the Iconoclastic Controversy," in his *Society and the Holy in Late Antiquity* (Berkeley: University of California Press, 1989), 251–301. Charles Barber tries to rescue the "art" of the icon from the theological discourse that tends to obscure or at least underplay its aesthetic aspects in *Figure and Likeness: On the Limits of Representation in Byzantine Iconoclasm* (Princeton, N.J.: Princeton University Press, 2002).

5. James A. Francis, "Living Icons: Tracing a Motif in Verbal and Visual Representation from the Second to Fourth Centuries C.E.," *American Journal of Philology* 124 (2003): 575–600, here p. 585. Passage quoted from *The Works of the Emperor Julian*, trans. Wilmer C. Wright, 3 vols., Loeb Classical Library, nos. 13, 29, 157 (Cambridge, Mass.: Harvard University Press, 1996–99), 1:449 (161A).

6. *Works of the Emperor Julian*, 2:311 (*Letter to a Priest*, 294C–D).

7. Kitzinger, "Cult of Images," p. 91.

8. See Belting, *Bild und Kult*, chaps. 3, 6, and 8.

9. On the theology of the image, see Gerhard Ladner, "The Concept of the Image in the Greek Fathers and the Byzantine Iconoclastic Controversy," *Dumbarton Oaks Papers* 7 (1953): 3–34; Kitzinger, "Cult of Images," pp. 140–55; Belting, *Bild und Kult*, pp. 164–84.

10. *Encyclopedia of Religion*, ed. Lindsay Jones, 2nd ed. (Detroit: Macmillan Reference USA, 2005), 7:4353.

11. See Anna Kartsonis, "The Responding Icon," in *Heaven on Earth: Art and the Church in Byzantium*, ed. Linda Safran (University Park: Pennsylvania State University Press, 1998), p. 64.

12. Ernst Kitzinger, *Byzantine Art in the Making: Main Lines of Stylistic Development in Mediterranean Art, 3rd–7th Century* (Cambridge, Mass.: Harvard University Press, 1995), p. 118.

13. This is not to suggest diminished quality. The conventionality of the emblems is consistent across portraits of Christ Pantocrator because—the painter would claim—the consistency shows the authenticity of the representation.

14. Gilles Deleuze and Félix Guattari, *A Thousand Plateaus: Capitalism and Schizophrenia*, trans. Brian Massumi (Minneapolis: University of Minnesota Press, 1987), pp. 167–91, esp. 167–68. My thanks to Rafael Cuir for this reference.

15. *Orthodox Faith* 4.16 (Chase trans., p. 373).

16. Brown, "Dark Age Crisis," p. 272. Brown also suggests that the face of the image may have had greater power to comfort than the living presence of the saint, which beamed "a too crushing sense of the holy" (p. 273).

17. David Freedberg, *The Power of Images: Studies in the History and Theory of Response* (Chicago: University of Chicago Press, 1989), p. 210.

18. See the discussion and text of the "Lentulus" letter, an apocryphal description of Christ dating probably from the thirteenth century, in Freedberg, *Power of Images*, p. 210. It describes him as "A man in stature middling, tall, and comely, having a reverend countenance . . . having hair of the hue of an unripe hazel nut . . . a brow smooth and very calm, with a face without wrinkle or blemish, which a moderate colour makes beautiful . . . in rebuke terrible, in admonition kind and lovable, cheerful yet keeping gravity . . . in stature of body tall and straight, with hands and arms fair." Cited from Freedberg, who refers to *The Apocryphal New Testament,* ed. M. R. James (Oxford: Clarendon, 1924), pp. 477–78.

19. See *Ancient Faces: Mummy Portraits from Roman Egypt,* ed. Susan Walker (New York: Routledge, 2000).

20. See Paul Binski, *Becket's Crown: Art and Imagination in Gothic England, 1170–1300* (New Haven, Conn.: Yale University Press, 2004), pp. 209ff.

21. Longinus, *On the Sublime,* trans. W. H. Fyfe, rev. Donald Russell, in *Aristotle: Poetics; Longinus: On the Sublime; Demetrius: On Style,* Loeb Classical Library 199 (Cambridge, Mass.: Harvard University Press, 1995), p. 163.

22. Michael Psellos, *Scripta minora,* ed. E. Kurtz and F. Drexl (Milan: Vita e pensiero, 1941), 2:220–21. Quoted in A. P. Kazhdan and Ann Wharton Epstein, *Change in Byzantine Culture in the Eleventh and Twelfth Centuries* (Berkeley: University of California Press, 1985), p. 199. See also Belting, *Bild und Kult,* p. 296.

23. Kartsonis, "Responding Icon," p. 65: "The icon manifests its prototype alive and capable of presence, thought, will, action, interaction, and dialogue with the viewer. The reality of the prototype is projected onto the icon, which then responds as a live image with a soul, and operates as the seal and guarantee of the prototype." See also Henry Maguire, "Truth and Convention in Byzantine Descriptions of Works of Art," *Dumbarton Oaks Papers* 28 (1974): p.113, 128–29; Belting, *Bild und Kult,* pp. 292–330 ("beseelte Malerei"); Robin Cormack, "Living Painting," in *Rhetoric in Byzantium,* ed. Elizabeth Jeffreys (Ashgate: Aldershot, 2003), pp. 235–53. James A. Francis treats late Roman precedents in "Living Icons." Photius, the patriarch of Constantinople, Photiusgave a sermon in 867, inaugurating the image of the Virgin and Child in the apse of the church of St. Sophia. Like Psellos, he praised the "life" in the portrait and pointed especially to the color of the flesh in her lips: "To such an extent have the lips been made flesh by the colours, that they appear merely to be pressed together and stilled as in the mysteries, yet their silence is not at all inert neither is the fairness of her form derivatory, but rather is it the real archetype." Cyril Mango, ed. and trans., *The Homilies of Photius, Patriarch of Constantinople* (Cambridge, Mass.: Harvard University Press, 1958), p. 290 (Homily 17.2).

24. See Kartsonis, "Responding Icon," p. 60.

25. Bissera V. Pentcheva, "The Performative Icon," *Art Bulletin* 88 (2006): 631–55. Her book *The Sensuous Icon* appeared too late to include.

26. Kartsonis, "Responding Icon," p. 65.

27. Ladner, "Concept of the Image," p. 12, quoting Origen, *In Lucam homil.* 8. Commenting on Genesis 1:26 ("Image and likeness"), Origen writes, "The son of God is the painter of this image [i.e., the image of God in man]."

28. Quoted in Belting, *Bild und Kult*, pp. 292–93.

29. See the article by Victor V. Bychkov, "Icon," in *Encyclopedia of Aesthetics*, ed. Michael Kelly (New York: Oxford University Press, 1998), 2:448.

30. Kazhdan and Epstein, *Change in Byzantine Culture*, p. 200.

31. Mango, *Homilies of Photius*, p. 294 (Homily 17).

32. Peter Brown, "The Rise and Function of the Holy Man in Late Antiquity," in *Society and the Holy*, p. 143. See also his revisions on the occasion of the twenty-fifth anniversary of the article: "The Rise and Function of the Holy Man in Late Antiquity, 1971–1997," *Journal of Early Christian Studies* 6 (1998): 353–76.

33. Brown, "Holy Man," in *Society and the Holy*, p. 143.

34. Ibid., p. 140. On the relation between the charismatic religious leader and the portrait as a means of preserving his charisma, Jeremy Tanner, "Portraits and Agency: A Comparative View," in *Art's Agency and Art History*, 70–94.

35. Brown, "Dark Age Crisis," p. 269.

36. Peter Brown, *The Cult of the Saints: Its Rise and Function in Late Christianity* (Chicago: University of Chicago Press, 1981), p. 85. On the condition of the dead after life (but before resurrection) in the Middle Ages, see Otto Gerhard Oexle, "Die Gegenwart der Toten," in *Death in the Middle Ages*, ed. Herman Braet and Werner Verbeke (Leuven: Leuven University Press, 1983), pp. 19–77.

37. See the wide ranging study of icons and their function in society by Peter Dinzelbacher, "Die 'Realpräsenz' der Heiligen in ihren Reliquiaren und Gräbern nach mittelalterlichen Quellen," in *Heiligenverehrung in Geschichte und Gegenwart,* ed. Peter Dinzelbacher and Dieter R. Bauer (Ostfildern: Schwabenverlag, 1990), pp. 115–74.

38. Freedberg, *Power of Images*, p. 27.

39. Belting, *Bild und Kult*, p. 335. In general on relic theft, see Patrick J. Geary, *Furta Sacra: Theft of Relics in the Central Middle Ages* (Princeton, N.J.: Princeton University Press, 1978).

40. Bernard, *Liber miraculorum Sancte Fides* 1.13, trans. Pamela Sheingorn, in *The Book of Sainte Foy* (Philadelphia: University of Pennsylvania Press, 1995), pp. 78–79; see also *Liber miraculorum Sancte Fidis*, ed. A. Bouillet (Paris: Picard, 1897), pp. 47–49.

41. Belting, *Bild und Kult*, p. 338. Dinzelbacher and others, however, claim it's the humanizing of the relic cult. Hahn proposes a tendency toward charismatic representation evident in reliquaries as bodies ("The Spectacle of the Charismatic Body"), the charismatic effect intensified by the spectacle and theatricality of the reliquary.

42. Christof L. Diedrichs, *Vom Glauben zum Sehen: Die Sichtbarkeit der Reliquie im Reliquiar: Ein Beitrag zur Geschichte des Sehens* (Berlin: Weissensee Verlag, 2001).

43. See Arnold Angenendt, *Heilige und Reliquien: Die Geschichte ihres Kultes vom frühen Christentum bis zur Gegenwart* (Munich: Beck, 1994), pp. 155–58; Diedrichs,

Die Sichtbarkeit der Reliquie, pp. 168–73; Renate Kroos, "Vom Umgang mit Reliquien," in *Ornamenta Ecclesiae: Kunst und Künstler der Romanik,* ed. Anton Legner (Cologne: Stadt Köln, 1985), 3:33.

44. But see also Hahn, "Spectacle of the Charismatic Body," who argues for a charismatic effect of the reliquary itself.

45. Jacques Berlioz, in his *Saint Bernard en Bourgogne: Lieux et mémoire* ([Dijon]: Les Editions du Bien Public, 1990), p. 123, mentions Troyes as follows: "En 1862, le chef fut transféré, avec celui de saint Malachie, dans la châsse de Saint-Alban et déposé au Trésor de la cathédrale de Troyes. Il ne restait que l'os frontal et les deux maxillaires supérieurs (description du 20 juillet 1874, par P. Cartheron et Ch. Forest, docteurs en médecine). Depuis 1874 un fémur a été placé mystérieusement derrière le crâne. Les autorités religieuses ont admis qu'il s'agissait d'une relique du saint."

Chapter 5. Charismatic Culture and Its Media

1. Hildebertus, *Carmina minora,* ed. A. Brian Scott (Leipzig: Teubner, 1969), pp. 22–24, Carmen 36 (My translation). For commentaries, see C. Stephen Jaeger, "Charismatic Body—Charismatic Text," *Exemplaria* 9 (1997): 117–37; Wolfram von den Steinen, "Humanismus um 1100," in his *Menschen im Mittelalter: Gesammelte Forschungen, Betrachtungen, Bilder,* ed. Peter von Moos (Bern: Francke, 1967), pp. 196–214, esp. 201–3. Peter von Moos, *Hildebert von Lavardin, 1056–1133: Humanitas an der Schwelle des höfischen Zeitalters,* Pariser Historische Studien 3 (Stuttgart: Hiersemann, 1965), pp. 240–45, 251–58.

2. The male gendering is that of the system itself and its values, which until the twelfth century admitted no women, and then only briefly.

3. Goswin of Mainz to his student Walcher, in *Apologiae duae: Gozechini Epistola ad Walcherum . . .,* ed. R. B. C. Huygens, Corpus Christianorum Continuatio Mediaevalis 62 (Turnhout: Brepols, 1985), pp. 31–32 (*Epist.,* chap. 27). Quoted in C. Stephen Jaeger, *The Envy of Angels: Cathedral Schools and Social Ideals in Medieval Europe, 950–1200* (Philadelphia: University of Pennsylvania Press, 1994), p. 223.

4. Hugh of St. Victor, *De institutione novitiorum,* chap. 8, *Patrologia Latina* (hereafter *PL*) 176.933b–c.

5. See the essay by Martino Rossi Monti, "'Opus es magnificum': The Image of God and the Aesthetics of Grace," in *Magnificence and the Sublime in Medieval Aesthetics,* ed. C. Stephen Jaeger (New York: Palgrave Macmillan, 2010), 17–29.

6. See Jaeger, *Envy of Angels,* passim, esp. pp. 76–117. For further recent historical studies, see Mia Münster-Swendsen, "Masters and Paragons: Learning, Power, and the Formation of a European Academic Culture, c. 900–1230" (Ph.D. diss., University of Copenhagen, 2004); Sita Steckel, *Kulturen des Lehrens im Früh- und Hochmittelalter: Autorität, Wissenskonzepte und Netzwerke von Gelehrten* (Cologne: Böhlau, 2010). On the teacher-student constellation in ancient Greece, see Eric Havelock, *Preface to Plato*

(Cambridge, Mass.: Harvard University Press, 1963), p. 23 and n. 17: the guardians of the state learn their craft by "an education in which they are trained to 'imitate' previous models of behavior" (with reference to Plato, *Republic* 395c, where *mimesis* = "imitation of a virtuous model" as the basis of education for the ruler of the republic).

7. See Werner Jaeger, *Paideia: The Ideals of Greek Culture*, trans. Gilbert Highet, 3 vols. (New York: Oxford University Press, 1986), 2:13ff.; and Henri I. Marrou, *A History of Education in Antiquity*, trans. George Lamb (Madison: University of Wisconsin Press, 1982).

8. Seneca, *Epistles 1–65*, trans. Richard M. Gummere (Cambridge, Mass.: Harvard University Press, 2002), p. 27 (*Ad Lucilium* 6.5.). I've taken some liberties with Gummere's translation. Another much quoted passage on the same theme: "Cherish some man of high character, and keep him ever before your eyes, living as if he were watching you, and ordering all your actions as if he beheld them" (*Epist. ad Luc.* 11.8, trans. Gummere, p. 65).

9. For a broader study in the context of history of education, see Bryan R. Warnick, *Imitation and Education: A Philosophical Inquiry into Learning by Example* (Albany: State University of New York Press, 2008).

10. Wibald of Stablo, *Wibaldi epistolae*, no. 91, in *Bibiotheca rerum germanicarum*, vol. 1, *Monumenta Corbeiensa*, ed. Philipp. Jaffé (1864; repr., Aalen: Scientia, 1964), p. 165.

11. Lampert of Hersfeld, *Annales* (on the year 1065), in *Lamberti Monachi Hersfeldensis Opera*, ed. O. Holder-Egger, Monumenta Germaniae Historica (hereafter MGH), Scriptores rerum germanicarum in usum scholarum (hereafter SS rer. Germ.) (Leipzig: Hahn, 1894), p. 99.

12. Adelman of Liège, quoted in A. Clerval, *Les écoles de Chartres au moyen âge* (Paris, 1895; repr. Geneva: Slatkine, 1977), p. 60; Jaeger, *Envy of Angels*, p. 79.

13. See Jaeger, *Envy of Angels*, p. 79.

14. Hugh of St. Victor, *De institutione novitiorum*, chap. 7, *PL* 176.932d–933a.

15. Benzo of Alba, *Ad Heinricum IV. Imperatorem libri VII*, ed. and trans. Hans Seyffert, MGH SS rer. Germ. 65 (Hanover: Hahn, 1996), p. 606 (bk. 7, chap. 3).

16. Baudri of Bourgueil, *Poèmes*, ed. Jean-Yves Tilliette, 2 vols. (Paris: Les Belles Lettres, 1998, 2002), 2:60 (poem 153, line 49).

17. Jaeger, *Envy of Angels*, p. 186, n. 16, quoting Sigebert's *Passio Thebeorum*, ed. Ernst Dümmler, Akademie der Wissenschaften, Berlin, Phil.-Hist. Kl., Abh. 1 (Berlin, 1893), p. 69 (Prohem. 2.21–22).

18. Meinhard, *Briefsammlungen der Zeit Heinrichs IV.*, ed. Carl Erdmann and Norbert Fickermann, MGH, Briefe der deutschen Kaiserzeit 5 (Weimar: Böhlau, 1950), Weitere Briefe Meinhards, epist. 1, p. 193.

19. *Gottfried von Reims: Kritische Gesamtausgabe*, ed. Elmar Broecker (Frankfurt: Peter Lang, 2002), pp. 187–89 (lines 28–76).

20. John R. Williams, "Godfrey of Rheims, a Humanist of the Eleventh Century," *Speculum* 22 (1947): 44.

21. Guibert of Nogent, *Autobiographie*, ed. Edmond-René Labande, Classiques de l'histoire de France au Moyen Âge 34 (Paris: Les Belles Lettres, 1981), p. 64 (*De vita sua* 1.11).

22. Hildebert, Epist. 18, *PL* 171.294c; Wibald of Stablo, *Epistolae*, no. 167, in Jaffé ed., p. 286.

23. *Vita prima* 3.1, *PL* 185.303c.

24. *Sancti Bernardi Opera*, ed. J. Leclercq, Charles H. Talbot, H. M. Rochais, 9 vols. (Rome: Editiones Cistercienses, 1957–77), 2:314, Sermon on the Song of Songs 85.10; translation freely adapted from *Bernard of Clairvaux on the Song of Songs IV*, trans. Irene Edmonds, Cistercian Fathers Series 31 (Kalamazoo, Mich.: Cistercian Publications, 1980), pp. 206–7.

25. *Sancti Bernardi Opera*, 1:104, lines 5–7 (*Serm. Cant.* 18.1); Bernard of Clairvaux, *The Works of Bernard of Clairvaux 2: On the Song of Songs I*, Cistercian Fathers Series 4, trans. Killian Walsh, p. 113; Jaeger, *Envy of Angels*, p. 465 n. 20.

26. *Vita prima* 3.7, *PL* 185.314d–315a.

27. *Fictio* had (among others) the meaning of "invented narrative" in classical Latin, and while it's less common in medieval Latin than the meaning "fake," the former seems to be included in the intention in the lines quoted. "I'm not conscious of being a fake" doesn't construe well. Nor does the claim *"miracles are sometimes performed by fakes."* If they are fakes, they presumably cannot perform miracles, though fictional characters are regularly credited with them.

28. *Vita prima* 3.8, *PL* 185.320c.

29. *Sancti Bernardi Opera, 7: 287–91* (epist. 113). On the question of her fictional versus historical character, see Jean Leclercq, *La femme et les femmes dans l'oeuvre de Saint Bernard* (Paris: Tequi, 1983), pp. 57–62.

30. On classical Athens, fifth to fourth century, as "performance culture," see Simon Goldhill, "Refracting Classical Vision: Changing Cultures of Viewing," in *Vision in Context: Historical and Contemporary Perspectives on Sight*, ed. Teresa Brennan and Martin Jay (New York: Routledge, 1996), pp. 15–28, esp. 18–21. Also Kevin Robb, *Literacy and Paideia in Ancient Greece* (New York: Oxford University Press, 1994).

31. *La chronique de Saint-Hubert dite Cantatorium*, ed. Karl Hanquet, Commission Royale d'Histoire: Recueil de textes pour servir à l'étude de l'histoire de Belgique (Brussels: Kiessling, 1906), p. 44 (chap. 17).

32. My reading of the debate: C. Stephen Jaeger, "Gerbert versus Ohtric: Spielregeln einer akademischen Disputatio im 10. Jahrhundert," in *Spielregeln der Mächtigen: Mittelalterliche Politik zwischen Gewohnheit und Konvention*, ed. Claudia Garnier and Hermann Kamp (Darmstadt: Wissenschaftliche Buchgesellschaft, 2010), 95–120; and "Philosophy, ca. 950–ca. 1050," *Viator* 40 (2009): 17–40.

33. Seen from the point of view of changes in representation, this transition has much in common with the transformation of consciousness that Walter Benjamin observed from the end of the nineteenth to the twentieth century in his famous essay "The Work of Art in the Age of Its Technological Reproducibility," which I'll discuss

in Chapter 11. The essay is included in Walter Benjamin, *Selected Writings*, vol. 4, *1938–1940*, trans. Harry Zohn and Edmund Jephcott, ed. Howard Eiland and Michael W. Jennings (Cambridge, Mass.: Harvard University Press, 2003), pp. 251–83.

34. Otto Schmitt, *Gotische Skulpturen des Strassburger Münsters*, 2 vols. (Frankfurt am Main: Frankfurter Verlags-Anstalt, 1924), p. 18.

35. Willibald Sauerländer, *Gothic Sculpture in France, 1140–1270*, trans. Janet Sondheimer (New York: H. Abrams, 1972), p. 50.

36. Erwin Panofsky, *Renaissance and Renascences in Western Art* (New York: Harper and Row, 1972), p. 62.

37. *De institutione novitiorum*, chap. 12, *PL* 176.942a.

38. Werner Jaeger, *Paideia*, 1:185. Ernst Gombrich has also argued the disjuncture between classical sculpture and the ideals it recaptures at a time when they were already transformed into widely held social ideals, no longer the prerogative of an aristocracy, in *Art and Illusion: A Study in the Psychology of Pictorial Representation*, 2nd ed., Bollingen Series 35.5 (New York: Bollingen, 1961), pp. 116–45.

39. John of Garland, *Morale scholarium*, chap. 30, in *The Morale Scolarium of John of Garland (Johannes de Garlandia), a Professor in the Universities of Paris and Toulouse in the Thirteenth Century*, ed. and trans. Louis John Paetow, *Memoirs of the University of California*, vol. 4, no. 2 (Berkeley: University of California Press, 1927), p. 174. The passage is cited and discussed in Paul Binski, *Becket's Crown: Art and Imagination in Gothic England, 1170–1300* (New Haven, Conn.: Yale University Press, 2004), p. 259.

40. Thomas Aquinas, in a "Disputed Question," debates whether it is possible for an individual to teach anything at all and comes to the conclusion that teachers mediate knowledge. They do not embody it. The teacher relates to the student as a doctor to a patient, a skilled mediator of knowledge or health, nothing more.

41. On table arrangements at London and Canterbury under Becket, see Jaeger, *Envy of Angels*, pp. 301–8. Cf. John of Garland, *Morale scholarium*, chap. 9.

42. *Morale scholarium*, chap. 13, lines 292ff.

43. Petrarch, *Epistolae familiares*, bk. 6, epist. 4, in *Francisci Petrarcae Epistolae de Rebus Familiaribus et Variae*, ed. Joseph Fracassetti (Florence: Le Monnier, 1859), 1:339.

Chapter 6. Romance and Adventure

1. Chrétien de Troyes, *Lancelot, or The Knight of the Cart (Le Chevalier de la Charrete)*, ed. and trans. William W. Kibler (New York: Garland, 1981). I cite this translation but refer to the text by line number.

2. See Erich Auerbach's discussion of Chrétien's style in *Mimesis: The Representation of Reality in Western Literature*, trans. Willard R. Trask (Princeton, N.J.: Princeton University Press, 1953), pp. 123–42 ("The Knight Sets Forth").

3. Chrétien's German adapter Hartmann von Aue is a good interpreter of Chrétien's allusiveness. He reacted to the hints and suggestions in his source and gave stronger highlight to the Christian allusions.

4. Walter Haug has called this moment "the discovery of fictionality: "Die Ent-
deckung der Fiktionalität," in Haug, *Die Wahrheit der Fiktion: Studien zur weltlichen
und geistlichen Literatur des Mittelalters und der frühen Neuzeit* (Tübingen: Niemeyer,
2003), pp. 128–44.

5. David Crouch has studied the pre-courtly ideals of French and English noble
society and shown the persistence of an ideal of prowess that is tinged with a lofty self-
conception comparable but not identical to courtliness: *The Birth of Nobility: Con-
structing Aristocracy in England and France, 900–1300* (Harlow, U.K.: Pearson, 2005).

6. Hartmann von Aue, *Gregorius / Der arme Heinrich / Iwein*, ed. and trans. Volker
Mertens, Bibliothek des Mittelalters 6 (Frankfurt: Deutsche Klassiker Verlag, 2004),
pp. 338–48, dialogue quoted, lines 483–552. English translations are my own.

7. Auerbach, *Mimesis*, p. 135: "[the outcome of the adventure shows Calogreant
to be] one of the chosen, a true knight of King Arthur's Round Table . . . a true
knight worthy of adventure." See also Helmut de Boor in his *Die Höfische Literatur:
Vorbereitung, Blüte, Ausklang, 1170–1250*, 5th ed., vol. 2 of *Geschichte der deutschen
Literatur von den Anfangen bis zur Gegenwart*, ed. Helmut De Boor and Richard New-
ald (Munich: Beck, 1962), p. 65.

8. Auerbach, *Mimesis*, p. 136.

9. The double plot of Chrétien's Perceval is a remarkable innovation, one with a
grand future. In later adventures plotlines tripled and quadrupled. What Eugène
Vinaver has called the "poetry of interlace" developed out of plot multiplications: *The
Rise of Romance* (Oxford: Oxford University Press, 1971), pp. 68–98.

10. Walther von der Vogelweide, *Leich, Lieder, Sangsprüche*, ed. Christoph Cor-
meau (Berlin: Walter de Gruyter, 1996), p. 179 (54, xiii).

11. *Lancelot–Grail: The Old French Arthurian Vulgate and Post-Vulgate in Transla-
tion*, vol. 2, *Lancelot*, part 1, trans. Samuel N. Rosenberg (New York: Garland, 1993),
pp. 58–59.

12. The German version by Gottfried von Strassburg, left as a fragment of some
19,000 lines at the author's death ca. 1210, is the classic version of the romance. Gott-
fried's source was an Anglo-French poet, Thomas of Brittany, whose version has sur-
vived only in a few bits and pieces; remarkably, the main fragment of Thomas begins
where Gottfried's work breaks off. I will refer to Gottfried's version and will quote the
classic translation of A.T. Hatto, Gottfried von Strassburg, *Tristan: With the Surviving
Fragments of the "Tristran" of Thomas* (London: Penguin, 1967).

13. Wibald of Stablo, *Wibaldi epistolae*, no. 167, in *Bibiotheca rerum germanic-
arum*, vol. 1, *Monumenta Corbeiensa*, ed. Philipp Jaffé (1864; repr., Aalen: Scientia,
1964), p. 286.

14. Marcel Proust, *In Search of Lost Time*, Volume 2: *Within a Budding Grove*,
trans. C. K. Scott Moncrieff and Terence Kilmartin, rev. D. J. Enright (New York:
Modern Library, 2003), pp. 510–11.

15. On the parallel of schoolmaster and courtly damsel as administrators of virtue,
see Georges Duby, *Love and Marriage in the Middle Ages*, trans. Jane Dunnett (Chi-
cago: University of Chicago Press, 1994), p. 33.

16. Andreas Capellanus, *De amore* 1.4, ed. and trans. P. G. Walsh, in *Andreas Capellanus on Love* (London: Duckworth, 1982), p. 39, Walsh's translation with some liberties taken.

17. See C. Stephen Jaeger, *Ennobling Love: In Search of a Lost Sensibility* (Philadelphia: University of Pennsylvania Press, 1999), chap. 5, "Love in Education, Education in Love," pp. 59–81.

18. Joachim Bumke, *Studien zum Ritterbegriff im 12. und 13. Jahrhundert*, 2nd ed. (Heidelberg: Winter, 1976), pp. 147–48; trans. W. T. H. Jackson and Erika Jackson, as *The Concept of Knighthood in the Middle Ages* (New York: AMS Press, 1982); also *Höfische Kultur: Literatur und Gesellschaft im hohen Mittelalter* (Munich: DTV, 1986), pp. 439–46, cited here from *Courtly Culture: Literature and Society in the High Middle Ages*, trans. Thomas Dunlap (Woodstock: Overlook Press, 2000), pp. 316–21.

19. Heinrich Rückert, ed., *Der Wälsche Gast des Thomasin von Zirclaria* (1852; repr., Berlin: Walter De Gruyter, 1965), lines 527–1162.

20. *Lancelot*, prologue to the edition Rouen, 1488. The Prose *Tristan*, which appeared in the following year, had an equally exuberant pitch. The purpose of the book is "to excite and move noble hearts to live gloriously and virtuously and to conform themselves to the manners and customs of the excellent knights of bygone days" (Rouen, 1489). Quoted from Cedric E. Pickford, *L'évolution du roman arthurien en prose vers la fin du moyen âge* (Paris: Nizet, 1966), p. 265.

21. See Malcolm Vale, *The Princely Court: Medieval Courts and Culture in North-West Europe, 1270–1380* (Oxford: Oxford University Press, 2001); Elspeth Kennedy, "The Knight as Reader of Arthurian Romance," in *Culture and the King: The Social Implications of the Arthurian Legend*, ed. Martin B. Shichtman and James P. Carley (Albany: State University of New York Press, 1994), pp. 70–90; Maurice Keen, *Chivalry* (New Haven, Conn.: Yale University Press, 1984); C. Stephen Jaeger, "Courtliness and Social Change," in *Cultures of Power: Lordship, Status, and Process in Twelfth-Century Europe*, ed. Thomas N. Bisson (Philadelphia: University of Pennsylvania Press, 1995), pp. 287–309.

22. Scott Lightsey, *Manmade Marvels in Medieval Culture and Literature* (New York: Palgrave Macmillan, 2007).

23. For a discussion of this sort of imaginary building, see Paul Frankl, *The Gothic: Literary Sources and Interpretations Through Eight Centuries* (Princeton, N.J.: Princeton University Press, 1960), chap. 9, "The Architectural Fantasies of Mediaeval Poets."

24. Werner Jaeger, *Paideia: The Ideals of Greek Culture*, trans. Gilbert Highet, 2nd ed. (New York: Oxford University Press, 1986), 1:42.

Chapter 7. Albrecht Dürer's Self-Portrait

1. See Chapter 10 on Rilke. This notice can stand for the further references to Rilke's "Archaic Torso of Apollo" in this chapter.

2. See Harry Berger, Jr., "Fictions of the Pose: Facing the Gaze of Early Modern Portraiture," *Representations* 46 (1994): 87–120.

3. On the inscription, see David Hotchkiss Price, *Albrecht Dürer's Renaissance: Humanism, Reformation and the Art of Faith* (Ann Arbor: University of Michigan Press, 2003), pp. 94–95; and Joseph Leo Koerner, *The Moment of Self-Portraiture in German Renaissance Art* (Chicago: University of Chicago Press, 1993), p. 185.

4. Koerner, *Moment of Self-Portraiture*, p. 185.

5. Erwin Panofsky, *The Life and Art of Albrecht Dürer* (Princeton, N.J.: Princeton University Press, 1955), p. 43.

6. On the influence of Byzantine icon painting on the Munich self-portrait, see Daniel Hess, "Dürers Selbstbildnis von 1500: 'Alter Deus' oder 'Neuer Apelles'?" in *Mitteilungen des Vereins für Geschichte der Stadt Nürnberg* 77 (1990): 66–68.

7. Koerner, *Moment of Self-Portraiture*, p. 85. Dürer's self-representation as Christ continues in an engraving of 1513, in which the image of Christ on Veronica's veil takes the features of Dürer's face and in his late *Self-Portrait as the Man of Sorrows* (1522; see Figure 10). See Price, *Dürer's Renaissance*, pp. 91–92.

8. See Dieter Wuttke, "Dürer und Celtis: Von der Bedeutung des Jahres 1500 für den deutschen Humanismus: 'Jahrhundertfeier als symbolische Form'," *Journal of Medieval and Renaissance Studies* 10 (1980): 73–129.

9. *Der Laie über den Geist: Idiota de mente*, trans. Martin Honecker (Hamburg: Meiner, 1949), p. 78; cited in Koerner, *Moment of Self-Portraiture*, p. 132.

10. Peter Brown, "The Saint as Exemplar in Late Antiquity," *Representations* 2 (Spring 1983): 1–25.

11. See Berger, "Fictions of the Pose."

12. Carl Strehlke, *Pontormo, Bronzino and the Medici: The Transformation of the Renaissance Portrait in Florence* (Philadelphia: Philadelphia Museum of Art, 2004).

13. Lisa Jardine, *Erasmus, Man of Letters: Constructing Charisma in Print* (Princeton, N.J.: Princeton University Press, 1993).

14. Erich Auerbach, "Figura," in Auerbach, *Gesammelte Aufsaetze zur romanischen Philologie* (Bern: Francke Verlag, 1967), pp. 55–92.

15. Nicholas of Cusa, *De visione Dei*, chap. 5, sect. 15, lines 1–2, cited from Jasper Hopkins, *Nicholas of Cusa's Dialectical Mysticism: Text, Translation, and Interpretive Study of De Visione Dei* (Minneapolis: Banning, 1985), p. 131.

16. *De visione Dei*, chap. 4, sect. 12, lines 16–19, trans. Hopkins, p. 127.

17. *De visione Dei*, chap. 4, sect. 11, line 12, trans. Hopkins, p. 127.

18. Price, *Dürer's Renaissance*.

19. Ibid., p. 92.

20. Cited in Ibid.

Chapter 8. Book Burning at Don Quixote's

1. Miguel de Cervantes Saavedra, *The Adventures of Don Quixote*, trans. J. M. Cohen (Harmondsworth, UK: Penguin, 1973), book 1, chap. 6, pp. 56–63. Subsequent references are to this translation. I give them in this form: (1.6, pp. 56–63).

2. The study by Anthony Close, *The Romantic Approach to "Don Quixote": A Critical History of the Romantic Tradition in "Quixote" Criticism* (Cambridge: Cambridge University Press, 1978), sets up this stark dichotomy and aims at discrediting the romantic projection of the conflict between creative imagination and reality onto Don Quixote. For Close the novel was intended and is to be read as burlesque comedy.

3. "The Enchanted Dulcinea," in Erich Auerbach, *Mimesis: The Representation of Reality in Western Literature,* trans. Willard R. Trask (Princeton, N.J.: Princeton University Press, 1953), pp. 334–58.

4. See William J. Entwistle, *Cervantes* (Oxford: Clarendon, 1940), pp. 7–40.

5. Harry Levin stressed the role of the inn as "social microcosm," but quotes Viktor Shklovsky's term "a literary inn," which is closer to our purpose, but still short of the "forest of Broceliande" kind of hyperrealism of the place. See Harry Levin, "The Example of Cervantes," in *Cervantes's Don Quixote: Modern Critical Interpretations,* ed. Harold Bloom (Philadelphia: Chelsea House, 2001), p. 138 (orig. in *Contexts of Criticism* [1957]).

6. On this debate topic as a conventional form, see Ernst Robert Curtius, *European Literature and the Latin Middle Ages,* trans. Willard Trask (Princeton, N.J.: Princeton University Press, 1990), pp. 178–79.

7. Entwistle, *Cervantes,* p. 119.

8. These references are taken from the fascinating study by Irving A. Leonard, *The Books of the Brave: Being an Account of Books and of Men in the Spanish Conquest and Settlement of the Sixteenth-Century New World* (New York: Gordian, 1964), pp. 21–23. This book is the most extensive study I know of chivalric fiction influencing behavior.

9. See the study by Ullrich Langer, "Humanism's Antidote to Romance: *L'amant resuscité de la mort d'amour* (1555)," in *Conjunctures: Medieval Studies in Honor of Douglas Kelly,* ed. Keith Busby and Norris J. Lacy (Amsterdam: Rodopi, 1994), pp. 281–92.

10. *Boswell's Life of Johnson,* ed. G. B. Hill, rev. L. F. Powell, 3 vols. (Oxford, 1934), 1:49.

11. Leonard, *Books of the Brave,* pp. 75–90.

12. There is much literature on the subject. See C. Stephen Jaeger, "Grimmelshausen's Jupiter and the Figure of the Learned Madman in the Seventeenth Century," *Simpliciana: Schriften der Grimmelshausen-Gesellschaft* 3 (1981): 39–64; and more recently, Jeremy Schmidt, *Melancholy and the Care of the Soul: Religion, Moral Philosophy and Madness in Early Modern England* (Aldershot, U.K.: Ashgate, 2007).

13. See the classic study by Raymond Klibansky, Erwin Panofsky, and Fritz Saxl, *Saturn and Melancholy: Studies in the History of Natural Philosophy, Religion, and Art* (New York: Basic Books, 1964).

14. See Lawrence Babb, *The Elizabethan Malady: A Study of Melancholia in English Literature from 1580–1642* (East Lansing: Michigan State University Press, 1952). For the eighteenth century, see Hans-Jürgen Schings, *Melancholie und Aufklärung: Melancholiker und ihre Kritiker in Erfahrungsseelenkunde und Literatur des 18. Jahrhunderts* (Stuttgart: Metzler, 1977).

15. The standard bibliographic work is Heinrich Laehr, *Die Literatur der Psychiatrie, Neurologie und Psychologie von 1459–1799*, 3 vols. (Berlin: Reimer, 1900). For further literature, see Jaeger, "Figure of the Learned Madman."

16. See Oskar Diethelm, *Medical Dissertations of Psychiatric Interest Printed Before 1750* (Basel: Karger, 1971).

17. As argued by Michel Foucault in *Madness and Civilization: A History of Insanity in the Age of Reason*, trans. Richard Howard (1965; New York: Vintage, 1988).

18. Otto Fenichel, "Scoptophilic Instinct and Identification," in *The Collected Papers of Otto Fenichel* (New York: Norton, 1987), 1:373–97, here pp. 376, 380. My thanks to Andrea Goulet for this reference.

19. For examples from literature, see Harry Levin, "The Quixotic Principle: Cervantes and Other Novelists," in *The Interpretation of Narrative: Theory and Practice*, ed. Morton W. Bloomfield (Cambridge, Mass.: Harvard University Press, 1970), pp. 45–66.

20. Georges Poulet, "Phenomenology of Reading," *New Literary History* 1 (1969): 53–68, here pp. 57, 59.

21. For instance, James Strachey, "Some Unconscious Factors in Reading," *International Journal of Psychoanalysis* 11 (1930): 322–31. Thanks again to Andrea Goulet for this reference.

22. Theodore Sarbin, "The Quixotic Principle: A Belletristic Approach to the Psychological Study of Imaginings and Believings," in *The Social Context of Conduct: Psychological Writings of Theodore Sarbin*, ed. Vernon L. Allen and Karl E. Scheibe (New York: Praeger, 1982), pp. 169–86, here p. 176.

23. *Dort wo man Bücher verbrennt: Stimmen der Betroffenen*, ed. Klaus Schöffling (Frankfurt am Main: Suhrkamp, 1983).

Chapter 9. Goethe's *Faust* and the Limits of the Imagination

1. I have used the standard text, *Goethe: Faust, Der Tragödie erster und zweiter Teil, Urfaust*, ed. Erich Trunz (Munich: Beck, 1996). This and the other standard text edited by Albrecht Schöne number lines consistently from the beginning of part 1 to the end of part 2. I'll quote only by line number. Translations are my own, though I've consulted the translation of Stuart Atkins, *Faust I & II*, vol. 2 of *Goethe's Collected Works* (Cambridge, Mass.: Suhrkamp/Insel, 1984). The incompleteness of beauty without charm is probably a reference to Friedrich Schiller's "On Grace and Dignity," which begins with a discussion of this topic. On Goethe's ideas of beauty in general and with reference to the Helen of Troy episode, see Wolfgang Schadewaldt, "Faust und Helena," in his *Goethestudien: Natur und Altertum* (Zurich: Artemis, 1963), 165–205. He draws on the distinction in the Greek *to kallon* (ideal beauty) and *charis* (charm, joy, grace, liveliness, life), p. 171.

2. In a second draft of a prose summary of the Helen episode from 1826; in the end Chiron hardened into the role of realist and Manto became the advocate of impossible quests. *Faust*, ed. Erich Trunz, p. 449.

3. "Winckelmann und sein Jahrhundert: Schilderung Winckelmanns," in Goethe, *Ästhetische Schriften 1806–1815*, ed Friedmar Apel, Goethe Sämtliche Werke, Part 1, vol. 19 (Frankfurt am Main: Deutscher Klassiker Verlag, 1998), p. 184.

4. Schadewaldt, "Faust und Helena," p. 181.

5. Italian Journey, September 6, 1787.

6. See Schadewaldt, "Goethes Begriff der Realität," in *Goethestudien*, pp. 207–49.

7. For an overview and critical reading of the sources, see Norman Austin, *Helen of Troy and Her Shameless Phantom* (Ithaca, N.Y.: Cornell University Press, 1994).

8. Also the interpretation of Albrecht Schöne in *Faust: Kommentare,* ed. Albrecht Schöne, 7.2 in Johann Wolfgang Goethe, *Sämtliche Werke* (Frankfurt am Main: Deutscher Klassiker Verlag, 1994).

9. "Philostrats Gemälde," in Johann Wolfgang Goethe, *Ästhetische Schriften 1816– 1820: Über Kunst und Altertum I–II*, ed. Hendrik Birus, Sämtliche Werke 1. Abt., Bd. 20 (Frankfurt am Main, 1999), p. 295.

10. Goethe's own formulation. Paralipomena to *Faust*, P63 (composed for his autobiography *Dichtung und Wahrheit* but not included). *Faust: Texte*, ed. Albrecht Schöne, Sämtliche Werke I, Abt. Bd. 7/1 (Frankfurt: Deutscher Klassiker Verlag, 1994), p. 595.

11. Quoted in Schöne, *Faust: Kommentare*, p. 583.

12. Pierre Hadot, " 'Only the Present Is Our Happiness': The Value of the Present Instant in Goethe and in Ancient Philosophy," in Hadot's *Philosophy as a Way of Life: Spiritual Exercises from Socrates to Foucault*, ed. Arnold Davidson, trans. Michael Chase (Oxford: Blackwell, 1995), pp. 217–37.

13. The movie *Tom Jones*, full of exquisite moments and an intensely experienced present, ends with a voice-over speaking these lines. They are not in the Fielding novel.

14. Eckermann's *Conversations with Goethe* is available in many editions and translations. Cited here by date of Eckermann's entries.

15. As do many scenes. See Jane K. Brown, *The Persistence of Allegory: Drama and Neoclassicism from Shakespeare to Wagner* (Philadelphia: University of Pennsylvania Press, 2007).

16. "Polygnots Gemälde," *Ästhetische Schriften 1771–1805*, ed. F. Apel, Sämtliche Werke Part I, vol. 18, p. 911. Cited in Schadewaldt, "Faust und Helen," pp. 167–68.

17. Schadewaldt, "Faust und Helena," p. 168.

18. See Karen Bassi, "Helen and the Discourse of Denial in Stesichorus' Palinode," *Arethusa* 26 (1993): 51–75.

19. See Froma Zeitlin, "Travesties of Gender and Genre in Aristophanes' *Thesmophoriazousae*," in *Reflections of Women in Antiquity*, ed. Helene Foley (New York: Gordon and Breach, 1981), pp. 169–217.

20. Stephen Greenblatt, *Renaissance Self-Fashioning from More to Shakespeare* (Chicago: University of Chicago Press, 1980), pp. 31–32.

21. In Chapter 11, I quote a movie fan and aspiring actress, in Sam Shepard's play *Angel City*: "I don't know who I am. I look at the movie and I am the movie. I am the

Notes to Pages 245–262

star. I am the star in the movie. For days I am the star and I'm not me. I'm me beingthe star."

22. See Chapter 13 on Woody Allen's *Zelig*.

23. As is commonly asserted; cf. Oskar Walzel, "Goethe und das Problem der faustischen Natur," in *Vom Geistesleben alter und neuer Zeit* (Leipzig: Hirzel, 1922), pp. 366–89.

24. "Helena: Zwischenspiel zu *Faust*" (composed in 1826/27), in *Ästhetische Schriften, 1824–1832*, ed. Anne Bohnenkamp, *Sämtliche Werke* 1, vol. 22, p. 390.

25. It is possible to see in God's distance and apparent passivity a confidence in a system that always works to create the good. That system includes Mephistopheles, who introduces himself as "a part of that force that always seeks evil and always does good."

26. See lines 460–513.

27. Goethe's own term; the "Klassische Walpurgisnacht" is a "classic-romantic phantasmagoria."

28. Goethe, *Schriften zur allgemeinen Naturlehre, Geologie und Mineralogie*, ed. Manfred Wenzel, *Sämtliche Werke* 1, vol. 25 (Frankfurt: Deutscher Klassiker Verlag, 1989), p. 114 ("Betrachtungen und Aphorismen," no. 120).

29. See Erich Heller, "Goethe and the Idea of Scientific Truth," in his *The Disinherited Mind: Essays in Modern German Literature and Thought* (1952; expanded ed., New York: Harcourt Brace Jovanovich, 1975), pp. 3–36.

30. Goethe, "Epirrhema," in *Gedichte 1800–1832*, ed. Karl Eibl, *Sämtliche Werke* 1, vol. 2, p. 498.

31. Knabe Wagenlenker, 5531–32, act 1, "Large Hall."

32. Walter Benjamin, *Selected Writings*, vol. 2, *1927–1934*, trans. Rodney Livingstone et al., ed. Michael W. Jennings, Howard Eiland, and Gary Smith (Cambridge, Mass.: Harvard University Press, 1999), p. 180.

33. See Julie D. Prandi, *"Dare to be Happy!": A Study of Goethe's Ethics* (New York: University Press of America, 1993).

34. Book 2, chap. 1, *Sämtliche Werke* 10, p. 421.

35. See *Dichtung und Wahrheit*, part 4, bk. 20, Sämtliche Werke 1. vol. 14, pp. 839–42.

36. Thomas Mann, *Essays II, 1914–1926*, ed. Hermann Kurzke (Frankfurt: Fischer Verlag, 2002), pp. 911–12.

37. Friedrich von Müller, *Unterhaltungen mit Goethe: Mit Anmerkungen versehen und hrsg. von Renate Grumach* (Munich: Beck, 1982), p. 53, February 9, 1821.

38. W. von Humboldt, "Über die Eigenthümlichkeit von Goethes Einwirkung auf Kunst und Wissenschaft," in Goethe, *Ästhetische Schriften, 1824–1832,* ed. Bohnenkamp, p. 610.

39. Gerd Tellenbach, *Die Deutsche Not als Schuld und Schicksal* (Stuttgart: Deutsche Verlagsanstalt, 1947).

40. W. Daniel Wilson, *Das Goethe-Tabu: Protest und Menschenrechte im klassischen Weimar* (Munich: DTV, 1999), p. 7.

41. *De l'Allemagne*, part 2, chap. 23.

42. Ferdinand Gustav Kühne, "Faust und kein Ende," in *Zeitung für die elegante Welt* (1835); cited in Hans Schwerte, *Faust und das Faustische: Ein Kapitel deutscher Ideologie* (Stuttgart: Klett, 1962), p. 87.

43. Fritz Neubert, "Balzac und Deutschland," in his *Studien zur vergleichenden Literaturgeschichte* (Berlin: Duncker & Humblot, 1952), pp. 120ff.

44. See also his essay "Germany and the Germans" (1945).

45. Max Kommerell, *Geist und Buchstabe der Dichtung* (Frankfurt: Klostermann, 1956), p. 21.

Chapter 10. The Statue Changes Rilke's Life

1. *Auguste Rodin*, cited from Rainer Maria Rilke, *Sämtliche Werke*, ed. Rilke Archive, Ruth Sieber-Rilke, and Ernst Zinn (Frankfurt: Insel, 1976), pp. 139–242, here p. 192.

2. He speaks of an "impassable magic circle" protecting the sculpltures of Rodin and isolating them from the spectator. *Tagebücher aus der Frühzeit*, cited in Eudo C. Mason, *Rilke* (Edinburgh: Oliver and Boyd, 1963), p. 47.

3. Walter Benjamin, "Ueber einige Motive bei Baudelaire," in his *Schriften*, ed. Theodor W. Adorno and Gretel Adorno (Frankfurt: Suhrkamp, 1955), 1:461. The brief comment has taken root. See Georges Didi-Huberman, *Ce que nous voyons, ce qui nous regarde* (Paris: Éditions de Minuit, 1992); also James Elkins, *The Object Stares Back: On the Nature of Seeing* (San Diego: Harcourt Brace, 1997).

4. David Freedberg, *The Power of Images: Studies in the History and Theory of Response* (Chicago: University of Chicago Press, 1989), pp. 317–44.

5. Perhaps it is not so uncommon to experience in reality the aura of a charismatic person as an unnatural intensification of the charismatic's visual power. Gorky said of Tolstoy, "The effect of his [spoken] words did not come only from the intonation and the expression of his face, but from the play and light in his eyes, the most eloquent eyes I have ever seen. In his two eyes Leo Nikolaevich possessed a thousand eyes." Maxim Gorky, *Reminiscences of Leo Nikolaevich Tolstoy*, trans. S. S. Koteliansky and Leonard Woolf (New York: Huebsch, 1920), p. 65.

6. "Historical Greatness" is a section of Burckhardt's *Reflections on History* (*Weltgeschichtliche Betrachtungen*), not a book composed by Burckhardt, but rather a collection of notes from his lectures edited his nephew, Jakob Oeri, first published in 1905, English trans., 1943).

7. *The Birth of Tragedy*, chap. 7.

8. See the recent study by Robert E. Norton, *Secret Germany: Stefan George and His Circle* (Ithaca, N.Y.: Cornell University Press, 2002).

9. Edgar Salin, *Um Stefan George: Erinnerung und Zeugnis*, 2nd ed. (Munich: Küpper, 1954), pp. 11ff. In the following quotations I have added emphasis to phrases and passages to which I'll refer in the commentary that follows.

10. Well observed by Norton, *Secret Germany*.

11. Friedrich Gundolf, *George* (Berlin: Bondi, 1920).

12. Wolf Lepenies, *Between Literature and Science: The Rise of Sociology* (Cambridge: Cambridge University Press, 1988), p. 262.

13. Rudolf Borchardt writing to Hofmannsthal, August 15, 1915; cited in Lepenies, p. 224. On poetry envisioned as a redemptive force widely in Germany, Lepenies's chapter "Hostility to Science and Faith in Poetry as a German Ideology," pp. 202–19.

14. Rilke's essay on Rodin appeared in two parts: part 1, 1902; part 2 (the text of a lecture), 1907.

15. Rilke, Letter to Heinrich Vogeler, September 17, 1902.

16. On the transition from "future inspiration to that which is summoned and held firm," see Rilke's letter to Clara Rilke, August 9, 1907, in *Briefe aus den Jahren 1906 bis 1907*, ed. Ruth Sieber-Rilke and Carl Rilke (Leipzig: Insel, 1930), p. 305.

17. Letter to Lou-Andreas Salomé, August 8, 1903.

18. The comparison of Rilke's creative stagnation with that of Hugo von Hofmannsthal, expressed in his "Letter of Lord Chandos," is instructive. Also apparent is the affinity of Rilke's discovery of "life" and reality with that of Thomas Mann's Tonio Kröger. Mann's story appeared in the same year. Some of the phrases in Rilke's letter to Lou-Andreas Salomé are very close to Tonio's letter to Lisaveta Ivanovna at the end of the story stating a new commitment to life, simplicity, reality, of the artist crippled by guilt and excesses of reflection.

Chapter 11. Grand Illusions

1. This situation becomes a cliché of comedies in the 1940s. See Martha Wolfenstein and Nathan Leites, *Movies: A Psychological Study* (1950; repr., New York: Hafner, 1971), p. 246ff.

2. An observation of Norman Mailer about Marilyn Monroe fits the Fred Astaire/ Ginger Rogers movies as well: "Her personality infuses every corner of the film as if she had even picked the scenery to work for her. . . . So the movie rises above its pretext, its story . . . and becomes at its best a magic work, yet it is a comic bubble, without weight or solemnity." Mailer, *Marilyn: A Biography* (New York: Grosset and Dunlap, 1973), p. 104.

3. *Top Hat* received four Oscar nominations in 1936 in the categories of best film, best music (song), best dance direction, and best art direction. It was the most profitable picture from RKO Studio in the thirties. *Swing Time* won for best music (song) in 1937. *Shall We Dance* was nominated in that category in 1938. For some information on the popularity and impact of the Rogers-Astaire team, see Arlene Croce, *The Fred Astaire and Ginger Rogers Book* (New York: Outerbridge and Lazard, 1972), p. 5ff. See also Peter Carrick, *A Tribute to Fred Astaire* (Salem, N.H.: Salem House, 1984).

4. Grand opera is a charismatic form that deserves a section of this book to itself. It shows the hypermimetic mode in an extreme form; it relegates realism to minimal

importance. It has a power to enchant and rouse identification and empathy greater than virtually any other form of representation. Its omission is one of my many regrets.

5. Tino Balio, *Grand Design: Hollywood as a Modern Business Enterprise, 1930– 1939*, History of the American Cinema 5 (New York: Scribners, 1993), p. 220.

6. *The Birth of Tragedy*, chap. 1.

7. The terms "charisma" and "charismatic" have not loomed large in commentary on stars and fan psychology, though see Richard Dyer, *Stars*, new ed. with Paul McDonald (London: British Film Institute, 1998), pp. 30–32; and Dyer, "Charisma," in *Stardom: Industry of Desire*, ed. Christine Gledhill (London: Routledge, 1991), pp. 57–59. But Dyer's take on film charisma is deconstructive, unmasking. I don't know of film commentary that sees the psychological effects of stardom as an instance of a much broader psychological phenomenon.

8. The fascist period in Italy and Germany produced a popular cinema in parallel to the American, and that orientation helped discredit the popular film in Europe in the postwar period.

9. Meyer Schapiro, "Abstract Art," in *Modern Art, 19th and 20th Centuries: Selected Papers* (New York: Braziller, 1996), pp. 185–86.

10. José Ortega y Gasset, *The Dehumanization of Art and Other Essays on Art, Culture, and Literature* (Princeton, N.J.: Princeton University Press, 1972; Spanish orig., 1925).

11. See Hans Belting, *The Invisible Masterpiece* (Chicago: University of Chicago Press, 2001).

12. I will quote from the newer translation, "The Work of Art in the Age of Its Technological Reproducibility," in Walter Benjamin, *Selected Writings*, vol. 4, *1938– 1940*, trans. Harry Zohn and Edmund Jephcott, ed. Howard Eiland and Michael W. Jennings (Cambridge, Mass.: Harvard University Press, 2003), pp. 251–83, though I have occasionally called on the earlier translation by Zohn in *Illuminations*, ed. Hannah Arendt (New York: Schocken, 1969), pp. 217–51. The title in *Selected Writings* is literally closer to the original, though little is gained in return for its clunkiness in comparison to "The Work of Art in the Age of Mechanical Reproduction."

13. Cf. Belting, *The Invisible Masterpiece*, pp. 18–19.

14. The pathetic exception is Gustaf Gründgens, who starred in a remarkably progressive film *Tanz auf dem Vulkan* in 1938 (dir. Hans Steinhoff), glorifying the revolt of a gifted young artist against political tyranny. But Gründgens eventually became a tool of the government, one more argument for the claim that it was impossible to work against the system from within. The film *Mephisto* is about his career.

15. Richard deCordova, *Picture Personalities: The Emergence of the Star System in America* (1990; Urbana: University of Illinois Press, 2001).

16. This comment, and much of this chapter, applies to "A-list" movies, which is a small percentage of total production. B-movies dominated in the quantity of production. Gangster films, westerns, light comedy and screwball comedy, could thrive without the great star and the fabulous character, though of course they helped.

17. John Kobal, avid collector of star photos and film memorabilia, noted that he never, in years of collecting, paid attention to the tag identifying the photographer. He published his collections of shots by studio photographer George Hurrell, whose star photos are glamour-soaked and ooze sex, charm, allure, mystery. In Hurrell's photos the stars even ooze intelligence and cultivated charm (Norma Shearer, Douglas Fairbanks, Jr.). The poses, the lighting and staging, the makeup, are works of genius, calculated with the scruples of a great artist. And yet we accept the stunning photos as if the stars simply came that way, and we must be reminded who the artist-photographer was. See John Kobal, *George Hurrell: Hollywood Glamour Portraits* (New York: Schirmer, 1993), p. 7.

18. The facile criticism of Jeanine Basinger, *The Star Machine* (New York: Knopf, 2007), is a common take on the studio system. Basinger stresses the techniques of star-making and invites readers to sneer at the inhuman artifice of a "machine" turning out products. Her focus on second-string stars facilitates the reductive view and allows her to disregard the stars whose talent came with them and was only enhanced by the "machine."

19. Robert Dance and Bruce Robertson, *Ruth Harriet Louise and Hollywood Glamour Photography* (Berkeley: University of California Press, 2002), pp. 122–24. Basinger, *Star Machine,* sees this process as a kind of rape of the individual.

20. Jackie Stacey, "Feminine Fascinations: Forms of Identification in Star-Audience Relations," in Gledhill, *Stardom,* pp. 141–63, here 150. Annette Kuhn (with co-authors Frances Borzello, Jill Pack and Cassandra Wedd) has a hard-edged, deconstructing view of the same phenomenon, and views glamour in the same terms, but negatively, in the essay "Living Dolls and 'Real Women,'" in *The Power of the Image: Essays on Representation and Sexuality* (London: Routledge and Kegan Paul, 1985), p. 12: "Glamour is understood generally to imply a sense of deceptive fascination, of groomed beauty, of charm enhanced by means of illusion. . . . A glamorous image of a woman . . . is peculiarly powerful in that it plays on the desire of the spectator in a particularly pristine way: beauty or sexuality is desirable exactly to the extent that it is idealised and unattainable."

21. On the gap between the realms of Western art and American film, see Tom Holert and Heike Munder, eds., *The Future Has a Silver Lining: Genealogies of Glamour* (Zurich: Migros Museum and JRP/Ringier, 2004), pp. 17–18.

22. See esp. Vivian Carol Sobchack, "What My Fingers Knew: The Cinesthetic Subject, or Vision in the Flesh," in her *Carnal Thoughts: Embodiment and Moving Image Culture* (Berkeley: University of California Press, 2004), pp. 53–84.

23. Alexander Walker, *Stardom: The Hollywood Phenomenon* (London: Joseph, 1970), p. 19.

24. Ibid., p. 52.

25. John Lahr, "The Voodoo of Glamour," *New Yorker,* March 21, 1994, pp. 113–22, quote at 113.

26. The seriousness of this claim is evident in the remarkable collection of Woody Allen dreams collected and published by Dee Burton, *I Dream of Woody* (New York: Morrow, 1984).

27. Lahr, "Voodoo," pp. 113, 120.

28. Mailer, *Marilyn*, p. 19.

29. In Kobal, *George Hurrell: Hollywood Glamour Portraits*, p. 10.

30. Lahr, "Voodoo," p. 113.

31. See the essays in *Hollywood Goes Shopping*, ed. David Desser and Garth S. Jowett (Minneapolis: University of Minnesota Press, 2000).

32. See Balio, *Grand Design*, pp. 37–72.

33. See esp. Jib Fowles, *Starstruck: Celebrity Performers and the American Public* (Washington, D.C.: Smithsonian Institution Press, 1992), esp. pp. 155–83 ("What Stars Do for the Public").

34. Dance and Robertson, *Glamour Photography*, p. 107.

35. Nietzsche, *Birth of Tragedy*, chap. 3.

36. On that point Aristotle and Sigmund Freud agree. Aristotle in the *Nicomachean Ethics* and Freud in *Civilization and Its Discontents*. On the harmonies and dissonances of the two views, see Jonathan Lear, *Happiness, Death and the Remainder of Life* (Cambridge, Mass.: Harvard University Press, 2000). Psychoanalytic method has shifted its goal in recent decades from Freudian management of neurosis to the patient's happiness. There is now a serious scholarly journal devoted to the subject, *Journal of Happiness Studies*.

37. Lear, *Happiness*, p. 23.

38. Benjamin, *Selected Writings*, 4:389 ("On the Concept of History," Thesis 2).

39. René Girard, *Violence and the Sacred*, trans. Patrick Gregory (Baltimore: Johns Hopkins University Press, 1979), p. 145: "The subject desires the object because the rival desires it. In desiring an object the rival alerts the subject to the desirability of the object. The rival, then, serves as a model for the subject, not only in regard to such secondary matters as style and opinions but also, and more essentially, in regard to desires."

40. Sam Shepard, *Angel City*, in his *Fool for Love and Other Plays* (1984; New York: Dial, 2006), p. 77.

41. Maxim Gorky, *Reminiscences of Leo Nikolaevich Tolstoy*, trans. S. S. Koteliansky and Leonard Woolf (New York: Huebsch, 1920), p. 57.

Chapter 12. Lost Illusions

1. While Victor Fleming received screen credit as director of both *The Wizard of Oz* and *Gone with the Wind*, he took over *Wizard* when the story was fully developed, large portions of the filming complete, and three other directors had preceded (Norman Taurog, Richard Thorpe, George Cukor). King Vidor finished filming when

Fleming took over the direction of *Gone with the Wind*. Neither production was a director's film; both were put together by teams of creative talent under the guidance of a single producer (Mervyn LeRoy, David O. Selznick).

2. See Ian Jarvie, "Knowledge, Morality, and Tragedy in *The Killers* and *Out of the Past*," in *The Philosophy of Film Noir*, ed. Mark T. Conard (Lexington: University of Kentucky Press, 2006), pp. 163–85, esp. 168–69: the movies of the midforties "played on the differences between reality and appearance," with reference to Martha Wolfenstein and Nathan Leites, *Movies: A Psychological Study*, 2nd ed. (New York: Atheneum, 1970). See also Sheri Chinen Biesen, *Blackout: World War II and the Origins of Film Noir* (Baltimore: Johns Hopkins University Press, 2005). For a longer genealogy, see Robert Durgnat, "Paint It Black: The Family Tree of Film Noir" (1970), in *Film Noir Reader*, ed. Alain Silver and James Ursini (New York: Limelight, 1997), pp. 37–51.

3. In the postwar years the same mood overtook the Italian cinema, which turned away from the pomposity of Italian thirties films and politics, to a "neorealism," dedicated to the hard-shelled exposure of life at its rawest: poverty, suffering, humanity rescued in extreme circumstances, but also human beings relating to each other by greed, lust, and grasping power relationships. Italian neorealism discovered a truth-value in illusion-free realism, and the extravagance and grandeur of the thirties seemed a pack of lies as gross as those that Mussolini had fed to the country.

4. Other Hitchcock films with noir elements: *Shadow of a Doubt* (1943); *Strangers on a Train* (1951); *I Confess* (1953).

5. The original title of the book from which Hitchcock and crew adapted the film: *D'entre les morts* (From Among the Dead), by Pierre Boileau and Thomas Narcejac. The Hitchcock film retained the title *From Among the Dead* well into the creation of the script. See Dan Auiler, *Vertigo: The Making of a Hitchcock Classic* (New York: St. Martin's, 2000), p. 28ff.

6. See Lesley Brill's reading, *The Hitchcock Romance: Love and Irony in Hitchcock's Films* (Princeton, N.J.: Princeton University Press, 1988), pp. 207–8.

7. Laura Mulvey, "Visual Pleasure and Narrative Cinema," in her *Visual and Other Pleasures* (Bloomington: Indiana University Press, 1989), pp. 14–26.

8. Walter Benjamin, "On the Concept of History," in *Selected Writings*, vol. 4, *1938–1940*, trans. Harry Zohn and Edmund Jephcott, ed. Howard Eiland and Michael W. Jennings (Cambridge, Mass.: Harvard University Press, 2003), p. 390.

9. Marcel Proust, *In Search of Lost Time, Volume 3: The Guermantes Way*, trans. C. K. Scott Moncrieff and Terence Kilmartin, rev. D. J. Enright (New York: Modern Library, 1998), p. 172.

10. Zizek reads this as a kind of Platonism. The suggestion of a metaphysical purpose is a stretch, however, as is his reading of Scottie's sexuality (he is distant to Midge and Judy because he wants to masturbate). Slavoj Zizek, "Vertigo: The Drama of a Deceived Platonist," *Hitchcock Annual* 12 (2003/4): 67–82.

11. See Ernst Kris and Otto Kurz, *Legend, Myth, and Magic in the Image of the Artist*, pref. E. H. Gombrich (New Haven, Conn.: Yale University Press, 1979; orig.

1934); and E. H. Gombrich, *Art and Illusion: A Study in the Psychology of Pictorial Representation*, 2nd ed., Bollingen Series 35.5 (New York: Bollingen, 1961), p. 125.

12. "Too late" is a leitmotif of the film. Madeleine to Scottie on the mission lawn: "Too late, too late. . . . There's something I must do." Scottie to Judy, his last words before her death: "Too late. There's no bringing her back." Possibly Hitchcock or the writers alluded to or borrowed from the movie *One Touch of Venus* (1948), also a Pygmalion story, where a department-store window dresser (Robert Walker), setting up a statue of the goddess Venus (Ava Gardner), kisses her, she comes to life and falls in love with him. She stays alive only for a day, during which time the clerk, with phony prudery, resists her charms until it's too late. She sings the haunting Kurt Weill song "Speak Low" (lyrics by Ogden Nash) with its refrain, "We're late, darling, we're late." After she reverts to stone, he finds her again, this time embodied, alive, and de-divinated, a new employee of the store.

13. See Brill, *Hitchcock Romance*, p. 205.

14. Robin Woods's summary of the meaning of the whole scam for Scottie: "Madeleine . . . represents wish-fulfillment on a deeper and more valid level than that normally offered by the Hollywood film. . . . She has evoked in us all that longing for something beyond a daily reality which is so basic to human nature." Quoted from Charles Barr, *Vertigo* (London: British Film Institute, 2002), p. 78.

15. Jules Amthor (Otto Kruger), the villain in *Murder, My Sweet* (1944), calls Philip Marlowe (Dick Powell) "a dirty, stupid little man living in a dirty, stupid world."

16. The ending of *La Strada* pleased Italian Catholics, while it alienated intellectuals, who accused him of betraying neorealism. See André Bazin, "The Crisis of Neo-Realism: *La Strada*," in *La Strada: Federico Fellini, Director*, ed. Peter Bondanella and Manuela Gieri (New Brunswick, N.J.: Rutgers University Press, 1991), pp. 199–203; Hollis Alpert, *Fellini: A Life* (New York: Atheneum, 1986), pp. 98–100.

Chapter 13. Woody Allen

1. The film was directed by Herbert Ross, not Woody Allen, but from Allen's stage play and Allen's script. Sam Girgus gives a nod to Ross's directorial talent, but credits Allen with the creative force of the film: "Allen's creative imagination as articulated and presented in the screeplay clearly dominate the film and place it within the Allen canon." Sam Girgus, *The Films of Woody Allen*, 2nd ed. (Cambridge: Cambridge University Press, 2002), p. 12.

2. *Crimes and Misdemeanors* takes "eyes" as a leitmotif and theme: the main character, an ophthalmologist treating his rabbi as he goes blind, commissioning the murder of a former mistress, and yet going unseen by "the eye of God."

3. *Epist. ad Luc.* 11.8. See above, Chapter 5.

4. See Girgus, *Films of Woody Allen*; and Sander H. Lee, *Woody Allen's Angst: Philosophical Commentaries on His Serious Films* (Jefferson, N.C.: McFarland). In Girgus's psychoanalytic reading, Allan Felix forms a masculine sexual identity out of his

feminine side. The relation to Bogart is damaging rather than productive. "Felix over-compensates for the feminine part of his nature by fantasizing about ridiculous notions of exaggerated masculine sexual prowess in the form of the Bogart hero" (*Films of Woody Allen*, p. 21). Bogart is not a mentor but a false model, Girgus argues. Felix "abandons" him to accept himself as he is, not as he becomes under Bogart's tutelage (pp. 22–23). Lee goes to some trouble to unmask the romantic elements both of *Play It Again* and of *Casablanca*: "Rick Blaine is not really a heroic figure until the film's end." The fog into which Louis, Rick, and, in the later film, Allan walk, confirms the insubstantiality of the ethos represented, in Lee's reading (*Woody Allen's Angst*, pp. 25ff.). It is "the fog of pretense." These readings cannot come to terms with the replay in San Francisco of the Casablanca airport scene, the real moment of emergence.

5. See above, Chapter 8.

6. Theodore Sarbin, "The Quixotic Principle: A Belletristic Approach to the Psychological Study of Imaginings and Believings," in *The Social Context of Conduct: Psychological Writings of Theodore Sarbin*, ed. Vernon L. Allen and Karl E. Scheibe (New York: Praeger, 1982), pp. 169–86. Other relevant studies by Sarbin include "The Poetics of Identity," *Theory and Psychology* 7 (1997): 67–82; and a number of essays in *Believed-In Imaginings: The Narrative Construction of Reality*, ed. Joseph de Rivera and Theodore R. Sarbin (Washington, D.C.: American Psychological Association, 1998), esp. Sarbin's "Believed-In Imaginings: A Narrative Approach," pp. 15–30, and "The Poetic Construction of Reality and Other Explanatory Categories," pp. 297–307.

7. Garry Wills, *Reagan's America: The Innocents at Home* (New York: Penguin, 1988), p. 1.

8. That is one critical take on the ending. See also Douglas Brode, *Woody Allen: His Films and Career* (Secaucus, N.J.: Citadel, 1985), p. 255 ("needing perfection, she resumes her addictive movie-going"); Lee, *Woody Allen's Angst*, p. 186 ("Cecilia smiles slightly as her moistened eyes cling to the screen . . . she obviously hopes that what happened once may happen again, that if only she stays long enough and believes hard enough, Fred will dance down from the screen and whisk her up to 'heaven'"); and Girgus, *Films of Woody Allen*, p. 105 ("Ironically, it strains credibility to see her return to the Jewel Theater only to smile and lose herself in *Top Hat* without having learned from her own fictional experience with reality. The end leaves her *without creative choice*").

9. Marcel Proust, *In Search of Lost Time, Volume 2: Within a Budding Grove*, trans. C. K. Scott Moncrieff and Terence Kilmartin, rev. D. J. Enright (New York: Modern Library, 2003), pp. 539–40. The state described is generated by the atmosphere of the Rivebelle restaurant in Balbec and Marcel's tipsy state.

10. There is an interesting parallel to Cecilia's "rescue" in the life of the Portuguese fado singer Amália Rodrigues. Told that she had a tumor, perhaps cancer in her throat that had to be removed, at peril to her voice, she came to New York for the operation with a large supply of sleeping pills and suicidal thoughts. But she gave up the plan after watching Astaire-Rogers movies. See the documentary *The Art of Amália*,

directed by Bruno de Almeida (2000) and the NPR report at http://www.npr
.org/templates/story/story.php?storyId = 130357207.

11. While this book was in the last stages of revision and editing, two movies by
Woody Allen appeared which are relevant to the topic: *You Will Meet a Tall Dark
Stranger* (released in United States September 22, 2010) and *Midnight in Paris*
(released June 10, 2011). Both turn on the theme of transformation through big illu-
sions. In *Tall Dark Stranger,* the doddy, aging main character, Helena, abandoned by
her husband of forty years, finds happiness through a fortune-teller's prognostications.
While more sensible and sophisticated characters revile Helena for her lunacy, the
lives of those characters collapse in the course of the film; Helena's blossoms into
happiness. The movie ends with the line quoted at the beginning of this chapter:
"Sometimes the illusions work better than the medicine."

Midnight in Paris makes the city into an enchanted realm, a great work of art, in
which the past is accessible and dispenses the redemptive power of big illusion. Holly-
wood hack Gil Pender, on track for a catastrophic marriage, has his life transformed
by a few evenings hobnobbing with F. Scott Fitzgerald, Ernest Hemingway, Gertrude
Stein, and other artist-intellectuals of the "lost generation." The film is a textbook of
charismatic effects. Woody Allen returns to old crises (an empty universe, God doesn't
exist, death is inevitable) and asserts the redemptive force of courage and love. The
extravagant romanticism of the film finds space for a positive role of the artist in an
otherwise senseless world. Gertrude Stein (Kathy Bates) says, "We all fear death and
question our place in the universe. The artist's job is not to succumb to despair but to
find an antidote for the emptiness of existence."

Conclusion

1. *The Envy of Angels: Cathedral Schools and Medieval Social Ideals, 950–1200*
(Philadelphia: University of Pennsylvania Press, 1994).

2. Bruno Bettelheim, *The Uses of Enchantment: The Meaning and Importance of
Fairy Tales* (1975; repr. New York: Vintage, 1989). See also Maria Tatar, *Enchanted
Hunters: The Power of Stories in Childhood* (New York: Norton, 2009), with an interest-
ing collection of comments by authors and readers on the impact of stories read in
youth (pp. 206–39).

INDEX

ACKNOWLEDGMENTS

The University of Illinois supported my work on this book with a generous research fund attached to the Gutgsell professorship. My thanks are due especially to the Institute for Advanced Study, Princeton, and the Getty Research Institute, Los Angeles. Research leaves at those institutes made the basic work and the writing of this book possible. I am grateful to the friends and colleagues who read and commented on this manuscript.

Jerry Singerman, Humanities Editor for University of Pennsylvania Press, has supported my work over many years and has put special effort into *Enchantment*, for which I am particularly thankful.